PRAISE FOR *ALT*"Equal parts rock journalism and true crime.... Bringing the famous concert and its various backstories into sharp, vivid focus."
—*San Francisco Chronicle*

"Employing the help of a private investigator and dozens of interviews with crew members and performers (including David Crosby and the Grateful Dead's Mickey Hart), Selvin lays out how what was supposed to be the 'Woodstock of the West' turned deadly.... Brings new details to light about other deaths that received less media attention."
—*Rolling Stone*

"Four out of four stars.... Selvin triumphs with a detailed, unsentimental exploration of who, what, when and where, drawn from interviews with those who were there—from the medical staff and stage crews to the musicians themselves—and extensive documentation.... With this lurid yet deeply cautionary tale, Selvin shows what a bad, strange trip it was."
—*USA Today*

"*Altamont* serves as a valuable document, cutting through the hallucinogenic haze of the times to provide greater understanding of an American tragedy."
—*Dallas Morning News*

"Deeply researched.... Selvin merges the hundreds of voices that inform his account into one coherent vision. It takes what might have been a collage of disparate voices and turns it into a smooth page-turner. The book is a pleasure to read.... It offers the reader a sense of certainty as to just what happened, and who is to blame."
—*New Republic*

"A fascinating account of the festival and its repercussions, this is also a cultural historical portrait of the West Coast rock scene, a history of the bands involved, and of the counterculture itself. Will be of interest to rock and pop culture fans."
—*Library Journal*

"The first book-length account of the disastrous 1969 concert that became symbolic of the flower children's loss of innocence and marked the ugly end to the idealism of the '60s. . . . A longtime rock critic for the *San Francisco Chronicle*, Selvin puts the story of Altamont in the context of that time."

—*Marin Independent Journal*

"Selvin's book is a page-turner that unfolds the decisions that made Altamont possible before diving into the muck and mayhem of the concert itself." —*Santa Cruz Sentinel*

"An incisive account of the most infamous concert debacle in rock history. . . . This book provides context and perspective, showing the sea change in rock that was taking place as the Rolling Stones attempted to reassert themselves amid the increasing dominance of San Francisco psychedelia and the spirit of Woodstock. . . . Compelling." —*Kirkus Reviews* (starred review)

"[A] methodical history. . . . Selvin's presentation of Altamont busts the myth of innocence lost; in fact, Altamont just made the reality harder to ignore." —*Publishers Weekly*

"It was worse than you think. A lot worse. . . . An account that moves at movie pace, Selvin cuts through woolly cop-out rhetoric, offering clarity and detail. . . . Altamont was a tragedy in the classical sense—a disaster born of hubris and folly—and Selvin nails every last shred of both." —*MOJO* magazine

ALTAMONT

To Frank Weimann

Know it? I wrote it.

HarperCollins books may be purchased for educational, business, or sales promotional use. For information please e-mail the Special Markets Department at SPsales@harpercollins.com.

A hardcover edition of this book was published in 2016 by Dey Street Books, an imprint of William Morrow Publishers.

FIRST DEY STREET BOOKS PAPERBACK EDITION PUBLISHED 2017.

Designed by Paula Russell Szafranski

Title page photograph by Beth Bagby

Library of Congress Cataloging-in-Publication Data has been applied for.

ISBN 978-0-06-244426-4

HB 03.29.2023

ALT

The **Rolling Stones**, the **Hells Angels**, and the Inside Story of **Rock's Darkest Day**

DEY ST.
AN IMPRINT OF WILLIAM MORROW *PUBLISHERS*

ALSO BY JOEL SELVIN

CONTENTS

CONTENTS

PART

1

PART

1

1

Pipe Dreams

Rock Scully had passed through Heathrow Airport in London many times before. Growing up as the stepson of a respected international scholar and journalist, Scully had spent years living abroad, attending private schools and universities in Europe. He was not especially alarmed to be greeted in the almost friendly, official tone of the British passport officer.

"Mr. Scully? Right this way, sir."

In October 1969, six weeks after Woodstock, it had become increasingly common to see visitors to England arrive wearing long hair and hippie garb, but Scully—the twenty-four-year-old manager of the Grateful Dead, ringleader of the most resolute gang of San Francisco freaks, house band to the dawning of the LSD apocalypse and pioneer explorers of inner space—was a prince among California hippies and looked it. Scully appeared like nothing so much as Rasputin, his scarecrow frame topped with scraggly dark hair and an unkempt wispy beard. He had taken so much LSD, his pupils were little more than molten brown orbs floating in buttermilk. He was dressed head to toe in

denim, his feet encased in exquisite hand-tooled cowboy boots. He had the odd feeling he had been expected.

Rock had arrived with Frankie Weir, the formidable girlfriend of Dead guitarist Bobby Weir, close enough to him to have assumed his last name, who was headed to London to take a job with Derek Taylor, press secretary for The Beatles and Apple Records. It was only on the flight to England that Rock realized that his ticket, which had been arranged for him by Lenny Hart, the father of Dead drummer Mickey Hart, who had recently taken over some management responsibilities in regard to the Dead's business affairs, was one-way. That struck him as odd, but so did a lot of things, and he put it out of his mind. Rock had their ticket stubs in his pocket.

Rock was coming to London to show the Brits how real San Francisco hippies threw free concerts in the park. He was to meet with a production company called Blackhill Enterprises, which only three months before had presented a huge free concert in London's Hyde Park with the Rolling Stones. The company had invited Scully to meet with them to discuss similar possible concerts with the Dead and Jefferson Airplane, the other leading San Francisco hippie rock band. The Dead and the Airplane were closely associated, and Scully had gone to the airport straight from a meeting at the Airplane mansion in San Francisco to discuss the prospect of the London concerts. In addition to talking business, Airplane guitarist Paul Kantner had handed Rock a small brown vial filled with pure Merck pharmaceutical cocaine. Scully tucked the vial in his pants pocket and headed for London.

The passport official took Rock upstairs and showed him to a small room in Heathrow where two customs officers waited. One of the agents had a newspaper clipping with a headline about the Grateful Dead planning an LSD fest in Hyde Park. They started to paw through Rock's luggage. The first thing that came to their attention was Rock's mojo, the eagle feather

and bear claw and other Native American artifacts that he routinely traveled with. He had also loaded up on turquoise jewelry and bracelets that he knew the English would love. But when they picked up the Polaroid film canister and shook it, dozens of tiny purple pills fell out and rolled all over the floor.

It was the finest LSD in the world, Owsley Purple, manufactured by Augustus Owsley Stanley III himself, longtime benefactor, resident audio genius, and elixir mixer to the court of the Grateful Dead, the first private party in the world to synthesize the mind-altering compound. More worried about the marijuana in his luggage, Rock had practically forgotten about the LSD. It wasn't a lot of doses—maybe fifty or sixty. The small pills resembled the tiny jacks of heroin dispensed to addicts in England.

"What's this? Morphine?" said the customs agent.

The two men whisked Rock away by his arms into an interrogation room and he was quickly stripped to his boxer shorts. The younger man started thoroughly going through Rock's pants, while the older agent played with the bear claw and the feather, fascinated by the exotic Americana. Then he pulled out another bottle of pills, Rock's Entero-Vioform, diarrhea medicine. The older agent recognized the prescription. "Do you have a problem?" he asked.

"Yes, I do," said Scully, "and I actually need to go to the bathroom—right now."

He reached out and snatched his pants, clutched his stomach, and was led out of the room by the younger agent to a small bathroom. The agent let Rock inside, who closed and locked the door behind him and retrieved the vial of cocaine from the pants' watch pocket. With one massive snort, he inhaled the contents.

He pulled out Frankie's ticket stub, tore it into pieces, and flushed it down the toilet. Without that, there was no way the authorities could connect them. He rinsed the empty brown vial in the sink and put it back in his pants pocket. Outside, the

younger agent waited to take him to yet another room where now the police wanted to talk with him. They sat him down and started asking questions, but Scully couldn't speak. The cocaine had completely frozen his larynx. The best he could manage were some distressed, garbled squawks.

They arrested Rock for importing a controlled substance and took him to the Feltham police station, a small jail in a remote London borough adjacent to Heathrow largely used for airport arrests, and as a result a tidy, welcoming neighborhood establishment that did not truck with the usual criminal element but attracted a higher-class clientele. They served Rock tea and left his cell door open, even took him with them when they went on their rounds. He passed the weekend pleasantly enough in custody.

Frankie Weir went to town and worked the phones, beginning a long trail of calls. She raised bail from Lenny Holzer, a New York City scenester who was living in London at the Dorchester Hotel and had first met Rock years before when the Dead played the roof of the Chelsea Hotel. Frankie also called Rolling Stones guitarist Keith Richards and Sam Cutler of Blackhill Enterprises, the rogue concert producer who'd invited Rock over in the first place. In turn, Cutler contacted Chesley Millikin, who was running Epic Records in England at the time and consulting with Rock about landing a record deal for the Dead with mighty CBS Records. Millikin then phoned home to Marin County, California, and spoke with Rock's new girlfriend, Nicki Rudolph, who flew to the rescue. With money suddenly needed for Rock's legal defense, Nicki arrived in England the next day, four and a half months pregnant, her bra filled with thousands of hits of acid. The English had little or no access to this quality product, and the California contraband disappeared in one smooth transaction.

On Monday, with Holzer's money in his pocket, Millikin picked up Cutler in his well-worn Bentley and drove to the

police station to fetch Rock, smoking a joint and chatting about Brian Jones, the Rolling Stones guitarist who had drowned in his swimming pool that July, only a few days after being fired from the band. They took Rock by Keith Richards's place on Cheyne Walk in Chelsea to pick up keys to a flat Millikin had arranged for Rock, a giant Victorian home nearby with a grand staircase in the middle, sometimes inhabited by members of the Pink Floyd crew and shared by a pair of blonde Scandinavian hookers. But when Richards learned that Rock had left high-grade California marijuana in his unclaimed luggage back at Heathrow, he insisted that Rock go pick it up immediately.

Wrapped in tinfoil, the weed was concealed in large star-shaped Christmas candles, Big Sur bud unknown to England. Inside the candles were branches containing fat clumps of sinsemilla, a new wrinkle in marijuana cultivation and a great leap forward—female plants deprived of male companionship that produced rich, fragrant, especially potent flowers with no seeds. A botanical miracle fresh from the greenhouses of enterprising, imaginative California pot growers and a wonder from the New World on the other side of the Atlantic, the marijuana was something that Richards was adamant could *not* be left behind.

With some reasonable trepidation—he was fresh from the weekend in jail—Rock dressed in a suit and tie and took a cab back to the airport. He had himself dropped off at the underpass that leads to Heathrow and waltzed into the cavernous arrivals hall. He had no passport—they had taken it when they arrested him—and he had no claim checks, but there was his luggage sitting there waiting. He picked up the bags, walked outside, and hailed a cab. That night, he took the pot over to Keith Richards.

The Rolling Stones were coming out of a long dark period, and Scully's fresh West Coast pot was just the beginning of daylight. The band had not been seen much in public for the past three years. The rock scene was a different world, and the Stones were unsure of their position in the altered landscape.

They were currently planning their first U.S. tour since 1966, back when the Dead and the Airplane weren't known outside a few neighborhoods in San Francisco. Now these San Francisco bands were leaders of the new rock movement, and Scully was an esteemed emissary from the faraway land of California. In London, Rock was like Marco Polo returned from the Orient, bearing precious jewels.

In the years since 1966, the fashion-conscious English pop scene had been transformed by West Coast psychedelic rock, although British impressions of what that was were formed largely by speculation and inference. LSD itself was rare in the U.K. The members of Pink Floyd, for instance, had built England's top psychedelic band without the benefit of having actually taken LSD (vocalist Syd Barrett was the sole exception). The English rock poster artists imitated what they saw from San Francisco. The culture was being passed around on scraps of paper. In England they were adopting new traditions they had heard about but didn't entirely understand, like the free concerts in the park.

In San Francisco, free outdoor concerts had been a fixture since the start of the rock scene. The whole Haight-Ashbury rock world sprung up in a neighborhood adjacent to the enormous Golden Gate Park and bordered by a block-wide median called the Panhandle that extended several blocks from the park. While Golden Gate Park's meadows sometimes held larger, more formal gatherings, it was the Panhandle where the impromptu performances by neighborhood rock bands had the hippie girls dancing barefoot in the park. Jefferson Airplane, the Dead, and Big Brother and the Holding Company all lived within blocks of each other and routinely threw unscheduled shows in the grassy, tree-studded strip. One Sunday afternoon in June 1967, Jimi Hendrix played in the Panhandle for a crowd of a few hundred on a flatbed truck that belonged to the Airplane. When the Dead had moved out of the Haight in March 1968, the band

simply pulled up two flatbeds into an intersection and blocked traffic for hours while crowds filled Haight Street for blocks. The Dead played all afternoon, running extension cords out of nearby apartment windows for power, and the police stood by helpless, the entire neighborhood overrun.

Over the years, bands like the Dead and the Airplane, who also enjoyed giving unplanned shows in the sunshine, had developed careful strategies for dealing with—or evading—the rules and regulations of the powers that be, but it was almost always a stealthy operation carried off with an outlaw sensibility.

Word of this new movement spread around the rock scene in the United States, eventually finding its way across the Atlantic and beginning to influence the musicians and rock scene there. In London, Blackhill Enterprises, the managers of Pink Floyd, had thrown the first large free concert in Hyde Park in June 1968. Called "Midsummer High Weekend," the show featured Roy Harper, Jethro Tull, Tyrannosaurus Rex, and Pink Floyd. As the headliner of the event, Pink Floyd was introducing new guitarist David Gilmour, who was replacing founding member Barrett, and celebrating the release of the band's second album, *A Saucerful of Secrets*.

The following year, Blackhill was again enlisted to make the public debut of the new band formed by Eric Clapton after Cream had broken up. The Blackhill fellows convinced the new band's powerful manager to pay for them to stage a free concert in London's Hyde Park for the first show by the group named, with some irony, Blind Faith. Along with Clapton, the band included his former Cream mate Ginger Baker and vocalist-keyboardist Stevie Winwood of Traffic (along with lesser light Rick Grech on bass). The uneventful concert in June 1969 by what would prove to be a short-lived enterprise drew a massive crowd of more than one hundred thousand, who amazed authorities by doing little more than peacefully listening to the music.

The concert was a landmark London cultural occasion, and

backstage, rock luminaries such as Paul McCartney and Donovan came out to enjoy the day. Mick Jagger and his girlfriend, Marianne Faithfull, took a full inspection tour of the production. Shortly after the successful event, the Stones office contacted Blackhill about producing another free concert in the park the next month.

Scheduled for early July 1969, the Hyde Park Rolling Stones show was originally planned to pull back the curtain on the new era for the band, introducing new member Mick Taylor on guitar, celebrating the band's recent hit, "Honky Tonk Women," and staking their claim to a post in the rapidly evolving rock world. All that changed when, two days before the concert, the guitarist whom Taylor had replaced—founding member Brian Jones—died under suspicious circumstances, drowned in his swimming pool at his home in the English countryside. In an instant, the Hyde Park concert became a memorial.

Dressed in a white tunic, Jagger had the impossible task of quieting down the crowd at the start so he could read some unfathomably bathetic romantic poetry by Shelley, another tragic young Brit killed through misadventure:

He is not dead, he doth not sleep—
He hath awakened from the dream of life.

At the end, white butterflies brought in for the occasion were freed from their boxes, many of which had already suffocated, and what few remained expended their last breaths escaping captivity only to expire in midair above the band. Their carcasses littered the stage.

The Stones, who had not performed in public since a European tour in the spring of 1967, went on to put on one of the worst shows in the band's history—rusty, sloppy, ill-rehearsed, guitars out of tune. The crowd didn't care. The huge audience had a great time. There were no arrests, and afterward, every-

body who stayed to help clean up was given a copy of the new Rolling Stones single. They left the park immaculate.

Also, following the model of the West Coast free concerts they had heard about, read about, and seen photos of without having actually attended, the concert producers used members of the Hells Angels biker club as security guards. These British bikers fancied themselves overseas cousins of the real-life California ass-kickers, but they were nothing like that. They hung around the stage, drinking tea and wearing old Nazi army helmets and swastikas, but left the security work to the police. These were pretend Hells Angels; their "club" had no official connection with the California-based organization. They stood around backstage and looked colorful, but they served no genuine purpose and were nothing like the real thing. These candy-ass imitations had their colors drawn on their motorcycle jackets in chalk, for Christ's sake.

Even the worldly Keith Richards knew little about the new San Francisco scene beyond what he had read in *Rolling Stone* magazine the night Rock Scully and his girlfriend showed up with the Christmas candles from his suitcase. Sitting around a Moroccan hammered copper coffee table in the low light of a brass Arabian table lamp, Rock broke open the candles and extracted the bright green, sticky clumps of marijuana that smoked with a fresh, fruity flavor, almost like tropical lawn clippings. Rock spun golden tales of life in the Wild West, better living through chemistry, a land beyond the sea with rock and roll in the parks and magical marijuana growing in the woods. Richards was intrigued. Rock was deftly verbal, someone whose ability to articulate the inexplicable marked him for leadership in a group as innately subversive as the Grateful Dead. The pot. The hash. London. The late-night cross-cultural summit meeting. Rock was on a roll.

He began to envision the Rolling Stones playing for free in Golden Gate Park. He told Richards he knew how to do it. It would be simple. They would arrange the proper permits with

the city to throw a concert in one of the meadows under the name of the Dead or the Airplane and spring the Stones on the unsuspecting public—and parks department—as a surprise guest. It would make a perfect ending to the big American tour the band was planning, he said.

Dreams filled the room. The Stones at Stonehenge. The Taj Mahal. The Hyde Park concert was just the beginning. Much laughter, more smoke. Sometime in the middle of the night, Keith ground up a Nembutal and passed the plate to Rock, who took a healthy honk before realizing it wasn't cocaine. Later, in the sleepy early hours, Rock and Nicki staggered back to their flat in the foggy Chelsea morning.

The two weeks before Rock's hearing flew by. Nicki's estranged husband, Ken Connell—known as "Goldfinger"—found them. He was an international drug smuggler who had lost a hand to an airplane propeller. He was in town with a girl-friend and simply showed up in a white silk suit with a hook for his left hand, looking dapper and dangerous. Goldfinger was crazy and he harbored dark and violent fantasies toward his ex-wife. Rock and Nicki met him at the Chelsea Tea House, where he tried to kidnap Nicki. Later at their flat, when he tried to rape her, Nicki screamed for help and Rock came, only it was Nicki who got the black eye. She wore the injury to an Apple Records party the next night.

But more than the drug charges Rock faced or the ominous presence of Goldfinger, what threw him into a panic in London was a casual conversation he happened to have with Joe Smith, vice president of Warner Brothers Records, whom Rock ran into while visiting the company's London office. Smith congratulated Rock on the band's new contract with the company. Rock went into shock. While he was out of the country, Lenny Hart had conspired behind his back to re-sign the band to Warner Brothers. Lenny had convinced the band to sign the papers backstage at a San Jose concert and told them the $75,000 advance would

go to their tax obligations. Halfway around the world, Rock was frantic. Lenny had deliberately waited until he was out of town to pull this off. Did it explain the one-way ticket? Rock had been only that week laying plans with Chesley Millikin to sign the band to Columbia Records for big money. He saw that the situation had veered disastrously out of his control and he needed to rush back to Marin County to find out what was happening.

By the time Rock went to his hearing and was ordered deported, he couldn't wait to get out of England and back to the Dead. In his hurry, he had almost forgotten about telling Keith Richards he could fix it for the Rolling Stones to play a free concert in Golden Gate Park.

2

Money Trouble

In early 1969, the Rolling Stones were broke. Keith Richards wanted to buy a house on historic Cheyne Walk in Chelsea, down the block from where Mick Jagger lived, but he had problems coming up with the £5,000 down payment. Jagger himself had spent eighteen months pulling together the money to buy his place. Bassist Bill Wyman was writing bad checks. They belonged to one of the most popular rock bands in the world and they led luxurious, glamorous, even decadent lives, but there is nothing more pathetic than rich people without money.

For five years, the Rolling Stones had ruled the rock scene with a procession of hit singles and albums only surpassed by the group's sole real rival, The Beatles. The group's most recent album, *Beggars Banquet,* released in December 1968, was a tour de force that showcased the growing studio mastery of guitarist Keith Richards. Founding member Brian Jones, drug-addled, sickly, and increasingly absent, had been largely marginalized within the group, moving from making important musical contributions to something more akin to cameo appearances on the

group's records. Without Jones, Richards and Jagger were moving the band in new and exciting directions.

While finding themselves at a popular and creative musical peak, the Stones were hamstrung by personal issues and money trouble. The mounting financial pressures would lead the band to take serious action and set in motion a series of events, not knowing where they would lead. The Stones needed cash desperately and the band had to find new avenues for revenue.

The Stones' financial problems all came from the band's manager, Allen Klein. He controlled their finances. A ruthless, combustible, heat-packing, semi-scrupulous New York accountant, he had spent part of his childhood in a Jewish orphanage. He cut his teeth handling New York music business clients such as Sam Cooke and Bobby Vinton, but he had jumped into the nascent British music scene early on, representing British record producer Mickie Most, renegotiating favorable contracts for his acts The Animals and Herman's Hermits, and cutting a record deal for the Dave Clark Five.

Klein signed the Stones in 1966, promising the fellows they would be paid more money than any other pop musicians before. And they were. By Jagger's own count, the Stones had made more than $17 million in three years, but only a fraction actually trickled down to band members and they had blown through the lousy few million.

Klein had created his own American company through which all the Stones' income was funneled, and he was free to bottleneck any funds he wanted. Frantic telexes demanding money from his New York office routinely went unanswered. Klein himself was increasingly unavailable. In February 1969, he had also taken over business management for The Beatles and was busy gutting what remained of their record label, Apple Records. Ironically, it had been Jagger who first introduced Klein to John Lennon, although by the time The Beatles actually signed with Klein, Jagger was backpedaling on the recommendation. Klein

had the Stones under his thumb, and the band members were growing increasingly agitated and anxious.

Just in time, Jagger found the man who would solve their problems: Prince Rupert Loewenstein, an aristocratic Austrian private banker who didn't know either Jagger or the Rolling Stones when they met. He did take an interest in representing Jagger, who he assumed was wealthy. Prince Rupert was astonished to discover, as he sorted through the truckload of financial documents that arrived at his office, that Jagger was essentially broke. His debts far outweighed his assets. Loewenstein also quickly realized that the Stones were tied to albatross contracts with both Klein and Decca Records.

Jagger, the rare British rocker who had grown up in a middle-class home and even attended the London School of Economics before dropping out to play music, was quite taken with the aristocracy. They, in turn, treated him as a social novelty, an exotic beast tame enough to pet. Prince Rupert arranged for Jagger and Richards to stay on vacation in early 1969 at a large plantation house three hundred miles north of Rio de Janeiro owned by Brazil's top banker. While there, they wrote a cowboy song called "Honky Tonk Women." Richards cribbed the guitar tuning and opening riff from Los Angeles guitarist Ry Cooder, whom the Stones had hired as a sideman on recent recording sessions.

Back in England on June 1, the Stones went into Olympic Studios to record the new song; Brian Jones, the drugged-out and angry Stones guitarist, was not there. Like the group's finances, the increasingly alienated and undependable Jones was another problem that had to be dealt with. In addition to his erratic behavior, Jones's 1967 drug conviction effectively barred the band from entering the United States to tour, and touring loomed large as the best and easiest way to make fresh money. Jones had been a member from the beginning, but he had long before used up his reservoir of goodwill with his bandmates. He was dead weight and he needed to be cut loose.

In his place, the Stones brought guitarist Mick Taylor from John Mayall's Bluesbreakers into the studio. With Taylor on guitar, the band tried several passes at making "Honky Tonk Women," but it took producer Jimmy Miller sitting down at the kit and showing drummer Charlie Watts how the rhythm pattern needed to go. Miller then grabbed a cowbell and cranked the band into gear.

The next week, after mixing the song in the studio, Jagger and Richards drove out one night to Jones's home, Cotchford Farm in Sussex, to fire him from the group he had started. They brought along ecumenical drummer Watts for support. Two weeks later, the band called a press conference to announce that Taylor would be replacing Jones in the group and his public debut would take place at a free concert July 5 at Hyde Park.

For a band that hadn't played live in years, the concert was always going to be significant, but the mysterious drowning death of Brian Jones in his Sussex swimming pool on July 3 instantly made the show front-page news. The Stones were at Olympic Studios in the middle of the night, working on the Stevie Wonder song "I Don't Know Why," when they got the news. Still, the band turned up as scheduled at ten o'clock the next morning to tape "Honky Tonk Women" for the BBC and only then repaired to their Maddox Street office to decide the fate of the concert, which they determined would go on as scheduled.

That night, Jagger and Marianne Faithfull attended the elegant White Ball thrown by Prince Rupert and his wife, Josephine, at their Holland Park residence. A pop star with her own hit records, the twenty-three-year-old Faithfull had been living with Jagger for three years and could be a wild and willful free spirit. Ignoring the dress code, she committed a faux pas that night by dressing in all black. In contrast, Jagger wore a white Greek dress made for a man, ordered by Sammy Davis Jr., that designer Michael Fish loaned to him. (Jagger would also wear

the outfit the following day at Hyde Park.) At the lavish party, the Stones' singer met movie star Peter Sellers and danced with Princess Margaret.

The next morning, Jagger and Faithfull arrived at the Londonderry House, a less-smart neighbor of the Park Lane Hilton Hotel, near the concert site on Park Lane to play before the largest audience in the band's career, Jagger clutching a volume of poetry and nursing a case of laryngitis. When Allen Klein inexplicably tried to buttonhole him over money matters, Jagger would have none of it.

"Not now," Jagger hissed. "Not here."

Jagger slipped out early from the postconcert party at the hotel, claiming he wanted to get to bed early before leaving in the morning with Marianne Faithfull to play their roles in the Tony Richardson film *Ned Kelly,* to be shot in Australia. Instead he went to the apartment of his other girlfriend, actress Marsha Hunt, and spent the night there before joining Faithfull for the plane down under.

In the hotel suite in Sydney, as Jagger slept off his jet lag still wearing his boots, Faithfull ordered hot chocolate from room service. She had been playing Ophelia in a West End production of *Hamlet* for six weeks up until Hyde Park and dying onstage every night. As she clasped a bottle of 150 sleeping pills, she looked in the mirror and saw Brian Jones staring back at her.

"Death is the next great adventure," he told her, echoing something she used to say.

She gulped down pills by the handfuls with the hot chocolate. When Jagger woke, he found her lying beside him comatose. Six days later, she came back to life in a hospital room with a distraught Jagger hovering over her.

"I thought I'd lost you," he told her.

"Wild horses couldn't drag me away," she said groggily.

In spite of her suicide attempt, Jagger had a movie to film, and in a few days' time he was stranded on location in the remote

Australian desert while his girlfriend was recovering hundreds of miles away in an Australian hospital. Jagger had only taken the role because the money for his film work didn't pass through Allen Klein's hands, instead going straight into his own bank account, but now that he was disconnected from everything in the middle of Australia, even that hardly seemed worth it. He squabbled with the film's director and struggled to deliver his lines in a phony Irish brogue, acting with his girlfriend's stand-in. But what made matters worse was that he was totally isolated from the rest of the band.

Jagger may have been hard-pressed to keep a long-distance connection with the Stones' plans, but he somehow managed from a movie set smack in the middle of the vast Australian wilderness. He called Prince Rupert, who had completed his initial study of the Stones' sorry finances. Loewenstein told Jagger that extricating the Stones from those contracts would undoubtedly involve long, unpleasant, and expensive litigation on both sides of the Atlantic. He had reached the conclusion that the only reliable way for the band to raise much-needed cash was touring. Although he cared little for any kind of rock and roll music, Prince Rupert had seen the band at Hyde Park. He recognized Mick Jagger as a consummate performer and knew the group would always be able to make money performing. He also understood that the band would have to set up a touring operation separate from Klein's office and that the tour would have to be financed by cash advances from the American promoters. Prince Rupert was also recommending that the Stones prepare to move out of England to avoid the onerous tax burden on the wealthy in that country.

Jagger started trying to plan the U.S. tour outside of Klein's reach. He placed a call from Alice Springs, way outback in the red desert, to speak with Chip Monck, the stage manager at the recent Woodstock Music & Art Fair in August 1969, and Bill Belmont, road manager of Country Joe and the Fish. Belmont,

who had worked with Monck at Woodstock, knew the U.S. touring scene. Over the phone, Jagger grilled him about the prospects for a fall U.S. tour by the band, asking him specifically about promoters and ticket sales. Jagger also spoke with Ronnie Schneider, Allen Klein's nephew, who had served as tour accountant for the Stones on their 1966 U.S. tour, feeling him out about handling the tour outside his uncle's offices. No longer able to trust Klein, Jagger had to be careful what associations he pursued beyond the Stones' inner circle and who he was talking to about what, but he needed to move forward and he was going to have to find new people to make that happen.

Like Richards and the rest of the Stones, Jagger was out of touch with the American rock scene. The last time the band had toured America, they had whipped through twenty-five-minute sets at the top of a lengthy program of one- and two-hit wonders while teenage girls in the audience shrieked. The earth had cooled considerably since then. Audiences actually listened. Bands from the British scene such as Cream, the Jimi Hendrix Experience, and The Who had made a huge impact on the American market through dynamic live appearances. West Coast rock bands from San Francisco and Los Angeles— Jefferson Airplane, the Grateful Dead, The Doors, The Byrds, Creedence Clearwater Revival—had brought robust, vital new sounds to pop music. Increasingly sophisticated groups like The Band and Crosby, Stills & Nash were making adult fare out of what had been teenage music. The heroes of Woodstock were freshly minted, and while nobody disputed the band's Olympian status, the Stones were untried and untested on the current-day scene.

With Jagger off in Australia filming *Ned Kelly,* recording sessions stopped and any progress toward a new album ground to a halt. The band's American label fashioned a second greatest hits album around the number one success of the hit single "Honky Tonk Women," called *Through the Past, Darkly,* which

featured Brian Jones prominently in the cover photo. Richards's girlfriend, Anita Pallenberg, gave birth to their son, Marlon, in August, and Richards spent a lot of time hanging around his country home, Redlands, uncharacteristically enjoying his domesticity for the time being.

Georgia "Jo" Bergman, a short, commanding gal from Los Angeles in ankle-length hippie skirts and lavish Jewfro hairdo, ran the Stones' Mayfair office. She contacted Sam Cutler, compere and stage manager of the band's Hyde Park concert, and asked if he would accompany Keith Richards and Charlie Watts to the Isle of Wight Festival to see Bob Dylan and The Band on the last weekend in August. Dylan would be the first of the big three—The Beatles, Stones, and Dylan—to take the stage since 1966 and continue the subsequent rock revolution that they had led. With a return to the concert stage of their own under consideration, at least some representatives of the Stones needed to attend.

Dylan's reemergence was a major cultural event, "the British Woodstock" that Fleet Street headlines trumpeted. Dylan had almost pointedly ignored the Woodstock festival, held practically in his backyard earlier that month, but instead chose to play this remote British festival run by amateurs because, he told one interviewer, he had always wanted to see the home of Alfred, Lord Tennyson, Queen Victoria's poet laureate. Dylan's climactic performance came at the end of the three-day-long festival before an audience of more than 150,000 that included Roger Vadim and Jane Fonda, Elizabeth Taylor and Richard Burton. Three of The Beatles came (McCartney's wife was having a baby), and George Harrison brought an acetate of their new album, *Abbey Road,* and played it backstage before the show for Dylan through a guitar amplifier.

Dylan's performance August 31 did not turn out to be the anticipated epic. The Band only took the stage after a more than two-hour break while the sound system was repaired, past ten

o'clock at night at the end of a long weekend. For his part, Dylan, looking oddly uncomfortable in an ice-cream-white suit, with short hair and a neatly trimmed beard, rattled off fifteen songs in fifty minutes—a broad cross section of his work, including acoustic songs he played on George Harrison's guitar—and left the stage before returning for a brief two-song encore. The audience, primed for weeks by extravagant speculation from the British press, was underwhelmed.

With the Stones, Cutler proved his worth at the show, not only navigating the fellows through the festival grounds, but catching the restaurant overcharging the dinner party afterward. Bergman took Cutler to dinner in London shortly after he returned. She swore him to secrecy and then told him about the plans to tour. She explained that the band wanted to hire Ronnie Schneider away from Allen Klein and set up their own company. She wanted to bring Cutler into the team.

Cutler was eager. His rise through the London rock scene had been rapid. Only two years before, he had junked his life as a teacher at a school for disabled children and moved to Swinging London to get involved in the music world. Now he could be leading the Rolling Stones on the band's first tour since rock was young. Like a man shot out of a cannon, twenty-six-year-old Cutler had skyrocketed to the top of the British rock scene.

Cutler came by his ambition naturally. A clever, politically aware East End tough with a college degree and beatnik bent, he had been adopted at age three—his father was killed in the war and his mother, a young unmarried Irish girl, gave him up. He was raised by a fervent Communist mother and left-wing father. His adopted father died when he was eight years old and his widowed mother placed him for care with another married Communist couple. His new surrogate mother took him to walk picket lines and participate in street protests. When his adopted mother remarried and brought teenaged Sam to live with them in the suffocating London suburb of Croydon, he retreated into

adolescent resentments and silence. He discovered folk music—and hashish—and took up the guitar, inwardly seething at his circumstances. After graduating from college, he was working as a teacher when he took his first LSD trip, which loosened the grip conventional life held on him. Before long, he had left his post and relocated to central London, where he became immersed in the music scene, starting out as little more than a hanger-on.

He attended demonstrations against the Vietnam War and frequented the new rock scene at All Saints Church Hall in Notting Hill. He scrounged psychedelic mushrooms off deer feces in Richmond Park. He also managed an abrasive, offensive rock group called Screw. He was introduced by Pink Floyd drummer Nick Mason, whose sister Cutler was dating, to the band's managers, Peter Jenner and Andrew King. He picked up casual work around the offices of their Blackhill Enterprises running errands and doing stage work.

One afternoon, Cutler ran into Alexis Korner on Portobello Road. The Welshman was the fountainhead of blues in England; his bandstand provided important early exposure to the young musicians who would go on to form the Rolling Stones, Cream, and other significant British rock groups. Korner was a kind older musician who always had time for anyone with an enthusiasm for the blues. Cutler and Korner spent the afternoon in Korner's flat smoking joints, drinking tea, and talking music. Cutler convinced Korner to play the All Saints Church, and Korner offered Cutler a job working as his road manager on a short upcoming swing of European dates. They played a festival in Holland, some clubs in Germany, and an American army base, and came home a week later. Cutler lugged Korner's two guitars and small amplifier and did the driving while Korner slept. Cutler discovered what he wanted to do with his life, and Blackhill turned out to be the right place to be to get noticed. Working on tour with the Rolling Stones would be his dream job.

Jo Bergman called Cutler and asked him to pick up Keith Richards at his house and bring him to the Stones' office for a meeting with Allen Klein, who was in London. Klein walked in screaming about the Stones hiring away his nephew Ronnie. He demanded to know where Jagger was, and when Cutler said Mick was in Australia, Klein glared at him.

"Who the fuck are you?" he demanded.

Richards, sitting with his back against the wall, explained to Klein that the band was not going to work with him any longer and that his nephew would be handling the upcoming U.S. tour for the Stones.

"We'll fucking see about that," Klein yelled, then threatened the band and stormed out.

Cutler was shocked at Klein's ferocity. He looked at Richards. "Weren't you scared?" he said.

Richards pulled out a switchblade from his pocket, sprung the release, and stabbed it into the table, grinning like a naughty schoolboy.

"Fuck him," he said.

The next day, Bergman called Cutler and officially offered him the position of tour director for the Rolling Stones' upcoming U.S. tour. On September 14, two days after Jagger returned to London from Australia, the Stones announced the plans for the tour.

3

Hippie Business Ethics

Without question, San Francisco was the center of the rock music universe in 1969. The explosive combination of electric rock and psychedelic drugs had led to a quickly burgeoning underground scene that first emerged in the city in the fall of 1965. What started in a few select neighborhoods quickly spread around the world.

Word of the new community springing up in the Haight-Ashbury district captivated young people everywhere. The so-called hippies were questioning conventional values, resisting authority, and fashioning a modern life from a liberated perspective, a new youth culture centered around dancing to LSD-inspired rock music. The audience was indistinguishable from the musicians, dressed in Salvation Army castoffs with their hair growing over their collars.

The music was little more than a rumor at first, unheard outside the San Francisco dance halls, until S.F. bands stormed into the national spotlight and stole the stage at the 1967 Monterey Pop Festival, the first weekend of what the national news

media was calling the Summer of Love. That watershed weekend in Monterey had been the turning point in the ascendancy of underground rock with the emergence of such pivotal figures as Jimi Hendrix, The Who, soul singer Otis Redding, and unknown San Francisco bands such as the Dead, Big Brother and the Holding Company, Quicksilver Messenger Service, Moby Grape, the Steve Miller Blues Band, and the public debut of guitarist Mike Bloomfield's new band, Electric Flag. With the exception of Jefferson Airplane, none had performed off their home turf before. Not only did the festival instantly define the new rock music, but Monterey also established San Francisco as the undisputed home of America's rock counterculture.

The two action-packed years since then had only entrenched these drastic changes in the geography of American rock. By 1969, all of the year's biggest new bands came from San Francisco—Jefferson Airplane was one of the most popular rock groups in the country, and their new album, *Volunteers,* had become another big hit. Big Brother had a number one album that year; Creedence Clearwater Revival released three albums and had hits all over the radio. The momentum of sounds coming out of San Francisco reached a crescendo with Woodstock, when a number of bands from the city—Sly and the Family Stone, Country Joe McDonald, and Santana—became the surprise stars of the festival, further signaling to the country that Northern California was the country's leading incubator for rock talent.

The dominance of the San Francisco bands at Woodstock was aided by the fact that while the festival had been an unsuspecting event at the outset, it ended up commanding the country's attention. The immense rock festival in upstate New York that August 15–17 had caught the mainstream media by surprise and captured the imagination of a generation. When a half million long-haired youths descended on the rolling hills at Max Yasgur's farm, shutting down the New York State Thruway and

camping in rain and mud with relative peace for three days, the entire world took notice, from the upper right-hand corner of the front page of the *New York Times* on down. It was as if the rest of the country suddenly discovered the mass constituency the new rock had developed. The mainstream media portrayed Woodstock as an astonishing display of love, peace, and cooperation among the younger generation that couldn't be found at, say, a professional football game.

While Woodstock became an instant, simple symbol of the new community built around rock music, the popular narrative of the day was not an entirely accurate picture. Woodstock was far from peaceful. The promoters originally expected a crowd of around 200,000 and indeed sold 186,000 of the eighteen-dollar tickets in advance, but a much larger crowd showed up, broke down the fences, and hijacked the festival. Nobody planned for it to be a free concert. Festivalgoers outraged over the high prices at the concessions burned down the hot-dog stand. Medical volunteers from the Hog Farm hippie commune treated more than four hundred bad acid trips. At one point, Governor Nelson Rockefeller considered sending in the National Guard. The event was ill-prepared, badly managed, and logistically daunting. That nothing more went wrong than did was a miracle.

But with the extravagantly laudatory coverage, Woodstock instantly took on a larger meaning. The festival came to represent the triumph of the new rock music and the values associated with the rising youth culture. The stars of the show were a fresh constellation of faces along with some of the giants first anointed at Monterey Pop—Jimi Hendrix, The Who, Jefferson Airplane, Crosby, Stills, Nash & Young, Janis Joplin, The Band, Creedence Clearwater Revival, the Grateful Dead, Country Joe and the Fish, Sly and the Family Stone, Santana, and others. The music had swept through a generation, and the sprawling tribal gathering served notice of the power and breadth of the movement.

And while Woodstock had been an East Coast phenomenon, the heart of the festival was all San Francisco.

In 1969, San Francisco ruled the rock world, and in the middle of the San Francisco scene was producer Bill Graham, the first business titan of the new rock. Graham would literally invent the modern rock concert, but at the time of Woodstock he was a scrappy promoter running prosperous concert halls in San Francisco and New York, beginning to expand his horizons into management, booking, and even the record business. A Holocaust survivor who was orphaned by the Nazis and raised by foster parents in the Bronx, Graham was a volatile, often overbearing bully who was not part of the LSD generation. His original desire was to be an actor, but after bombing in Hollywood, he moved to San Francisco and began managing a street theater group called the San Francisco Mime Troupe. When police arrested the actors on charges of indecency for performing a sixteenth-century Italian play, Graham discovered his calling when he produced a legal defense fund benefit that packed an overflow crowd into the Mime Troupe's tiny loft. With his street smarts, hustle, and moxie, he went on to build a prosperous concern, making it up as he went along, and he vigilantly protected his territory.

The San Francisco bands, who all knew him well, disliked dealing with the autocratic Graham, so the Airplane, the Dead, Big Brother, and Quicksilver had partnered up to open a vacant Swing-era dance hall called the Carousel Ballroom upstairs at the corner of Van Ness Avenue and Market Street. That happy cooperative effort soon floundered in a morass of hippie business ethics and utter chaos. Graham had taken over the lease to the Carousel Ballroom in July 1968 and renamed the fifteen-hundred-capacity room Fillmore West. He presented three bands weekly, moving out of the smaller Fillmore Auditorium, where he had been throwing weekly shows since January 1966. In March 1968, he had also expanded to the East Coast, opening his thriving New York concert hall, Fillmore East.

Graham loomed over the San Francisco scene like a float at the Macy's Thanksgiving Day Parade. His only competition teetered on the verge of extinction. Chet Helms, the hippie zealot behind the Avalon Ballroom, had mismanaged that operation out of existence and relocated to an abandoned slot car raceway at the edge of the ocean called Family Dog at the Great Highway, where he was struggling to stay in business.

By mid-1969, few people were as well poised to capitalize on San Francisco's new home at the center of rock as Bill Graham. He not only ran the town's most successful dance hall, but his management firm, Shady Management, also handled Santana (the Airplane had fired him). His booking wing, Millard Agency, represented the Dead and others. With both San Francisco–based acts and rock bands from around the country making the Fillmore West stage a rite of passage, business was thriving.

But not all of the developments since Monterey Pop and the Summer of Love had been good for San Francisco rock. In the two short years since 1967, the Haight-Ashbury scene had shifted away from peace, love, and flowers. Speed was now epidemic in the Haight. Methamphetamine was a pernicious influence on the street. It made users jittery, unpredictable, violent—far from the more benign intoxicants originally favored by hippies. Speed brought a dark, dangerous side to the scene. The streets were crowded with runaways and petty criminals, flotsam and jetsam that washed up on the sidewalks. Despite the mainstream media coming late to the party and just now lauding the peace-loving "Woodstock" generation, in truth, the cracks in the counterculture were beginning to show.

They could be seen by anyone paying attention during the same month of August 1969 that saw Woodstock take place, when radicals shocked the San Francisco rock scene by forcing the cancellation of a massive free outdoor rock festival.

The Wild West Festival, set to take place over eight stages in Golden Gate Park, was supposed to be a giant love-in. The

massive free event was to be underwritten by three ticketed nighttime concerts at the park's Kezar Stadium. The idea was to present the abundance of the San Francisco music scene in the fullest possible way. All the major local bands were represented on the steering committee, run by kingpin underground radio disc jockey Tom Donahue. More than two hundred artists were slated to appear over the three days. The event was scheduled for August 22–24, the weekend following Woodstock, until the grand plans were undermined by a dark current in the underground.

The festival received typical resistance not only from expected quarters—the mayor's office, police department, parks commission, Musicians' Union—but also from other, less anticipated segments of the community. An ugly undetected rift in the underground emerged into the open with an unexpected assault on the plan by leftist elements in the counterculture. Political activists turned on the event and black militants questioned it. "How do you expect children in the ghetto to relate to spending $300,000 for three days of grooving in the park?" demanded one black minister at a public meeting held by the festival staff at Glide Memorial Church that shortly thereafter disintegrated into a shouting match between the reverend and Bill Graham. These two men perfectly reflected the divide between culture and politics.

Graham had driven straight to the meeting from another community powwow at the Family Dog at the Great Highway, where people had gathered to mediate the strike by the light show artists, who created the swirling, immersive psychedelic light shows at the San Francisco ballrooms. More strife in the underground. At that meeting, Graham had erupted and stomped out. "Don't touch me, you little man," he screamed at one poor hippie as he dashed out the door and drove madly across town to the Wild West meeting.

He strode into the church, still furious, and took the microphone away from the staff member who was speaking with the

angry black minister. "What did you say, motherfucker?" Graham yelled.

The reverend simply yelled back, giving as good as he was getting. As the two men screamed at each other and bad vibes filled the room, the Hare Krishna dancers, who were waiting to perform, decided to act. In an attempt to dispel the negative energy, they came prancing down the aisles, their finger cymbals clanging, hand drums pounding, as the heated debate dissolved in a cloud of clinking and chanting.

Disc jockey Donahue and festival organizers held a press conference and invited greater community participation, but there was little response. Instead, radical groups from the San Francisco Mime Troupe to the Los Siete de la Raza escalated the attacks. The Mime Troupe picketed the Wild West and spread leaflets:

If you don't own a radio station (commercials), a newspaper (ads), or a concert hall (tickets), then don't do nothing for free because you can't make nothing from it. CHANGE IN LIFE-STYLE!!!!!!!!!!!

PAY ALL PERFORMERS.
GIVE AWAY 10,000 FREE TICKETS TO THE POOR—US
VENCEREMOS! POWER TO THE PEOPLE!

The fierce dispute shook and surprised the underground, revealing a split between the hard-core politicos on the left and the sybaritic hippies, who were more interested in dancing and grooving than overthrowing the state. A week before the ambitious, sprawling festival was scheduled to take place, organizers held another press conference in the crowded backyard of the Victorian house that served as festival headquarters, this time to announce the cancellation. Death threats had been received. Hippies didn't mind arguing, but this was a different matter.

But death threats weren't the only difference. Unlike so many other festivals that had been done in by the powers that be, the Wild West was sunk by forces from inside the counterculture.

The nearly universal approval that had met Monterey Pop just two years earlier, and had apparently been present at Woodstock back east only a week before, did not apply to the Wild West. Large outdoor rock shows were now the subject of fierce debate in San Francisco, no longer a simple tribal rite of the underground.

Tension was rising and money was at the center of it. The next week, Bill Graham blew his fuse again, announcing loudly and clearly in different newspaper interviews that he was closing the Fillmore in January 1970 and retiring. There was a deal pending for the sale of the building that housed the dance hall to the restaurant and hotel chain Howard Johnson's, and a bitter and angry Graham was fed up with all the strife.

"I'm supposed to get up in the morning and say, 'I'm sorry, world, for being a success'?" he said. "I'm sorry for making a good living? For bringing good music to this town? Apologize for what? Feel guilty about what?"

After the deal with Howard Johnson's collapsed, it was a promise he would not make good on for another year and half, but it was a clear indication of how explosive the emotional landscape had become. In the Haight, the flower children were gone and what was left were the street people.

Unnerving as this was, few outside the scene had any idea of the rifts that had formed; the cancellation of the Wild West and the bitter divide it revealed did little to dampen San Francisco's rule over rock music in 1969. Another reason for that was the hometown media. From the bully pulpit of his five-times-a-week column in the *San Francisco Chronicle,* journalist Ralph J. Gleason ran what he considered the bulletin board of the city's music scene. A contentious Irish jazz buff in a deerstalker hat, owl-eyed glasses, and tweed jackets, he leveraged tremendous influence with his indictments and prognostications. He was the first regular jazz critic at any American daily newspaper when he started contributing to the *Chronicle* in 1950, and he always

covered the vast array of the popular music diet—from Hank Williams to Fats Domino—outside his home base of the jazz world. As the new rock music exploded under his feet in San Francisco, Gleason was there every step of the way, cheering the growing scene along and helping expand the audience. His enthusiasm for the music led wags to joke that he was a forty-eight-year-old man trying to decide if he was two twenty-four year-olds, three sixteen-year-olds, or four twelve-year-olds.

Gleason loaned his considerable prestige and some valuable money to a UC Berkeley college newspaper rock critic named Jann Wenner to start his underground rock magazine, *Rolling Stone,* in November 1967. He contributed a weekly think piece, and as the San Francisco—based magazine grew to become the international journal of the mushrooming rock culture, Gleason's power and influence expanded beyond all others in the press. He was known for sharp opinions, flinty integrity, and occasional sappy sentimentality. The presence of that kind of media exposure gave the San Francisco music scene a kind of worldwide prominence shared only by London and New York. Gleason followed closely all news of the pending U.S. tour by the Rolling Stones. One of his columns would cause the Stones to blink.

WITH THE HAIGHT-ASHBURY community struggling as the utopian experiment disintegrated, the Grateful Dead had actually abandoned the city more than a year before, recentering the band's operations forty-five minutes north of town. It was there that drummer Mickey Hart had rented a ranch outside Novato on the edge of Marin County. Hart built a recording studio in the old barn and kept horses. He liked to come back from shows at the Fillmore West and go for long horseback rides into the dawn, giving LSD to himself and his horse, the dose adjusted for body weight. Prior to leaving San Francisco, the Dead had been living in

the center of the Haight at 710 Ashbury in a rambling Victorian rooming house where Garcia and Mountain Girl shared the attic and other band members, crew, and girlfriends were scattered throughout the other three floors and another nearby house. The house was a community center and the members of the Dead a continual presence around the neighborhood. Mountain Girl—whose real name was Carolyn Adams—commonly could be found sitting on the stoop with friends in the late afternoon, smoking joints, as fingers of fog slithered in from the ocean. Nothing was more emblematic of the Haight's decline than the Dead's ceremonial decamping from the neighborhood for the North Bay in March 1968.

The ranch quickly became a focal point of the Northern California music scene, not just for the Dead but for other artists as well. Stephen Stills moved into Hart's ranch during the summer of 1969. Stills fancied himself a horseman, and he and Hart would go for long rides together as Stills regaled Hart with arcane accounts of Civil War battles. Stills's musical partner, David Crosby, had taken a house in nearby Larkspur, not far from where Jerry Garcia was living with Mountain Girl. Dead drummer Billy Kreutzmann kept a teepee on Hart's property, where Crosby and Stills sat down with the members of the Dead and taught them harmony vocals. Crosby and Stills showed them how to blend their singing. Even though the men in the Dead didn't have that pair's golden voices, Garcia, Bobby Weir, and bassist Phil Lesh found their own idiosyncratic approach to singing together. Crosby and Stills also demonstrated how to stack overdubbed vocals in the recording studio.

New vocal arrangements were just the start for the Dead. Also living with Garcia was the new Dead lyricist, Garcia's longtime buddy Robert Hunter. The pair had been turning out songs all spring, Hunter's typewriter clacking through the floor as Garcia put the stanzas to music downstairs. Garcia and Hunter were very much under the spell of *Music from Big Pink,*

the debut album by The Band, admiring its clapboard authenticity and the rough-hewn sound that proudly left the roots showing. Harmony howling. The Dead had largely exhausted the psychedelic arabesques of their third album, *Aoxomoxoa,* and had recently finished a new double-record set cut at San Francisco's Fillmore West and Avalon Ballroom, *Live Dead,* that depleted their existing catalog of songs. None of the group's albums sold well, and the Dead found themselves deep in debt to their record label. They needed new songs for a new album.

The Dead had summoned Hunter to bring his Joycean literary touch to their enterprise. His first lyrics were for the psychedelic epic "Dark Star." It was a long way from Cole Porter, but Hunter's work suited the band's sensibilities. The Dead did not play simple pop music. They specialized in dense, often disjointed compositions built on improvisation, and rarely performed the same way twice. The complexity could be daunting to listeners, but the band did not cater to the public. After drummer Mickey Hart joined, the Dead began experimenting with exotic polyrhythms. They were an acquired taste.

Still, songwriting had never been the group's strong suit, and as Garcia and Hunter turned their attention to learning songcraft, signaling the start of a shift for the band, what they were working toward wasn't entirely clear. In June, Garcia cut acoustic demos of new songs that hewed back to the Dead's beginnings as a bluegrass/jug band and included a country-flavored, updated version of "Casey Jones," the first sketch of these fresh and wayward ideas.

The ranch provided an accommodating clubhouse for the band, and the rustic surroundings helped inspire the new sounds they were trying to cultivate. Hells Angels, dope dealers, and Indian medicine men hung out with the musicians and were welcome. The Dead identified with outlaw gangs, commonly brandishing firearms at the ranch, and saw the band as living

outside the law, rebels who stayed true to their own code. They
flouted convention, authority, and whatever else you had.

The mixture of characters on the ranch could not have mir-
rored the band's personality better—by the summer of 1969, the
Grateful Dead had become a disorganized, anarchistic group
of chemically altered contrarians. Twinkly eyed guitarist Jerry
Garcia, an erstwhile beatnik with a brilliant, nimble mind, had
an insatiable appetite for music. While Garcia reigned as the
unacknowledged leader, the other band members also added
their own characters to the mix. The Dead may have enjoyed
a cultish reputation in the underground, but not only did the
group's records not sell well, the radio also rarely played their
music and their box-office appeal was limited. They were lit-
tle known outside hip circles beyond San Francisco. The Dead
could attract an audience at the Fillmore East in New York City
and anywhere in San Francisco, but their drawing power else-
where was doubtful. They never made any real money. That
year, they were struggling to make ends meet. They were an
attraction on the summer festival circuit, but they couldn't go
far on the $2,250 they were paid to play Woodstock. The musi-
cians and their outsized extended family lived in genteel hippie
poverty.

The hippie musicians in the Dead rejected money as a goal.
What they wanted to make was music. The Dead were more
social/musical laboratory than rock band. Caring about money
was uncool, beside the point. But the band members were liv-
ing hand-to-mouth. Mountain Girl wasn't above shoplifting the
occasional basket of strawberries for her kids. Their existing
management team did not include any businessmen, only hippie
philosophers. In April 1969, Mickey Hart had called the band
and crew together for a meeting at his barn.

"All right, we have a problem," Hart told the assembled
group. "We need someone to help us solve it. Enter Lenny Hart,
my father."

Lenny had been coming and going from his son's life since Mickey was a youth. He had been a military-style drummer and passed on to his son his lifelong love of percussion. They ran a drum store together in the South Bay for a while before Mickey joined the Dead in September 1967, when his father disappeared again. When Lenny returned, the former Jew was now a born-again Christian, who had experienced a conversion miracle in the Miami airport and become an evangelical minister preaching the word of Jesus.

A compact, stocky man with a bushy head of salt-and-pepper hair who bounced on the balls of his feet when he spoke, he delivered a passionate fire-and-brimstone sermon in the barn at Mickey's ranch before the assembled multitude, stalking the concrete walkway that ran through the center of the barn and rallying the troops in a bid to take charge of the Grateful Dead mission.

"I am the Reverend Lenny Hart and I am here to save the Grateful Dead," he said. "You've been fucked around. Now, I don't ask you to believe in Jesus, but believe in me. Fill the vessel. We're talking about the spirit. Talking about the spirit of God, talking about the spirit of the devil. It's all the same thing. We're talking about the spirit—the spirit that's in the music."

Prior to Lenny's arrival, there was no one figure at the helm of what might laughingly be called the Dead's business desk. Rock Scully and his partner, Danny Rifkin, had served as the band's management since the early stages. They were idealists and hustlers. They were smart and glib. But they weren't businessmen. After some length, they inveigled a poet friend of theirs named Jon McIntire to take on the duties. They took him to a rehearsal hall on Potrero Hill in San Francisco the Dead used and handed him a cardboard carton into which every bill, receipt, and other documents that had accumulated in the past had been unceremoniously dumped. McIntire was only marginally better equipped to handle the band's business affairs than Scully and Rifkin had been.

After Lenny's speech, the band went along with him managing the money, although Rock and Rifkin were not alone in harboring silent doubts. Lenny made the band pledge a lifelong commitment. The Dead, who truly didn't care about money and wished the problem would simply go away, ceded all control over their finances to him. He started stealing money almost the next day.

The Dead may not have wanted money, but they did want a dependable sound system. The band was frequently saddled with inferior sound that promoters provided. The answer was to build and carry their own system. To design, create, and finance that kind of investment the Dead turned to their longtime resident audio genius and patron, Augustus Owsley Stanley III, known as "Bear." Owsley was the first person to find out how to make LSD. He had spent two weeks in the Dow Library at UC Berkeley in 1964 reading scientific documents until he figured out the formula. At his Bear Laboratories in his Virginia Street home in Berkeley, he produced the first million doses of acid to hit the streets. He was the Johnny Appleseed of LSD.

He was also an extraordinary character—abrasive, opinionated, haughty, and brilliant. Among his more idiosyncratic theories was his all-meat diet. He learned electronics while serving in the Air Force, and his work with the Dead's audio gear was groundbreaking. He was the first engineer to deliver stereo sound live. He invented stage monitors so the musicians could hear themselves sing simply by turning around a separate set of smaller speakers to face the stage. He'd first met the band at the Muir Beach Acid Test, one of the early free-form happenings that introduced psychedelics to the public, held by author Ken Kesey and his Merry Pranksters, LSD evangelists, where the Dead served as house band. Kesey had discovered acid as a volunteer for psychiatric experiments at the Stanford Veterans Hospital, but without Bear's supply, the LSD revolution would never have got off the ground. Bear quickly became an integral

part of the scene. He made a small fortune manufacturing LSD and underwrote the Dead during the band's early days.

To help solve the problem of the band's sound equipment they enlisted Ron Wickersham, whom they met at Pacific Recording, a San Mateo studio near where Wickersham worked for Ampex, the electronics company that owned the patent for stereo. Bear and the band were fascinated by the new sixteen-track recorder, the Ampex MM 1000, the latest in recording technology, which used two-inch tape. Bear convinced Wickersham to quit Ampex and come to work with the Dead. Bear had big ideas, a sweeping vision for the enterprise. Famously obsessive, he was fastidious about quality. Nothing but the best would do. Wickersham agreed and he, along with his wife, Susan, showed up at the band's office in Novato the same day Lenny Hart started work as the band's manager.

For a rehearsal hall and band office outside Mickey Hart's Novato ranch, the Dead had found a Pepto-Bismol-pink warehouse right off the freeway not far away, between a shopping center and a school, a little spit of land surrounded on all sides by Hamilton Air Force Base, where they made their headquarters. There was a meeting room and three small offices in the front, and a warehouse space in the back where the band rehearsed. Artist Bob Thomas, who served as caretaker, lived in the mezzanine. Under the mezzanine was a cozy lounge with a faded burgundy sofa and television set. The old bus that belonged to Ken Kesey and the Merry Pranksters—with "Furthur" as the destination on the front—was parked in the parking lot, where Prankster Ken Babbs lived with his girlfriend, Gretchen Fetchin'. The place collected people. Harleys parked out front meant the Hells Angels were around. Dealers came and went. Somebody was always sitting around rolling joints.

This was the world of the Dead that Rock Scully returned to fresh off his trip to London in October. Shortly after his arrival

back home, Rock huddled with Jerry Garcia and told him his idea of presenting the Stones in the park. A shrewd observer of the scene, Garcia liked to toy with convention, relishing his subversive streak. As rich and famous as the Stones were, Garcia knew they wanted something the Dead could give them: the Stones wanted to be cool. He enthusiastically endorsed Rock's plan of telling the parks commission that the Airplane and the Dead were going to play and only announcing the Rolling Stones as a surprise guest the day before the show. The subterfuge strategy amused Garcia—it fit with the band's outlaw creed—and seemed easy to accomplish. As Scully had told Richards that night in London, they had done this hundreds of times before.

Garcia was enthusiastic about throwing a free concert with the Stones—not only was he a fan (the Dead started out as an electric rock band playing a Stonesey R&B-style repertoire of Jimmy Reed and Slim Harpo blues songs), but it offered a chance to produce a show with some meaning. The concert in the park would be a triumphant merging of British and West Coast schools of rock, an international summit meeting, a fitting capper to rock music's greatest year right in their own backyard.

Scully contacted Bert Kanegson, who had been the band's specialist in park permits. Kanegson originally came to the West Coast to organize a draft resisters' league, but burned out on the antiwar work and instead discovered psychedelics. He joined the Diggers, the loose-knit council of the Haight-Ashbury, through which he became involved with the Dead. Kanegson was the one who had originally located the pink warehouse in Novato for the band. He had lost interest in drugs and gone back to the East Coast at the beginning of the year, where he'd volunteered at Woodstock.

On the phone, Scully told Kanegson to come back to San Francisco. He needed his help setting up a free concert with the Rolling Stones.

4

Hollywood

The Rolling Stones arrived in Hollywood on Saturday, October 17. They established headquarters at 1401 Oriole Drive, a Hollywood Hills rental mansion once owned by some Du Ponts, a few minutes off the Sunset Strip in a neighborhood where all the streets are named after birds. George Harrison wrote "Blue Jay Way" while staying around the corner.

Jo Bergman, along with Allen Klein's nephew Ronnie Schneider, took over the Oriole House. Five phone lines were installed. Limousines and drivers waited outside twenty-four hours a day. Journalists lounged around the living room, collecting quips and comments from Charlie Watts, who was staying there with his wife, Shirley, and their baby daughter. Bill Wyman and his girlfriend were temporarily housed at the Beverly Wilshire while a suitable rental was located. Meanwhile, Jagger, Richards, Mick Taylor, and Sam Cutler were parked over the hill in Laurel Canyon at a home currently owned by Stephen Stills that the Stones had located through the Dead. The house had previously belonged to Peter Tork of The Monkees and, years

before, Brazilian bombshell Carmen Miranda. A rehearsal room was located in the wine cellar.

In September, Schneider had been enlisted to book the tour, starting his own company, Stones Promotions Ltd., to handle the job. While at first he operated out of his uncle's office in New York, that quickly proved difficult, leading him to move the office to London. His first job once there was to raise the money to pay for the tour, demanding an unprecedented fifty percent of the band's fees in advance from promoters. Working with a young agent at the William Morris Agency starting in September, he also pushed ticket prices beyond twice the usual amount, facing some initial resistance with promoters. It was an aggressive position, especially for a band that hadn't been in the country in three years.

All doubts vanished as soon as tickets went on sale. After two nights at Madison Square Garden sold out instantly, Schneider gave the hall a third show. He added late shows on the same day in Los Angeles and San Francisco. The only shows on the tour that did not sell out in advance were Phoenix and San Diego. A Nashville date was scrubbed and moved to the University of Illinois campus at Champaign. Another college date was shoehorned into the schedule in Auburn, Alabama, because the band wanted to play at least one date in the South. Schneider also kept a date open at the end of the fourteen-city tour for a rock festival in West Palm Beach, Florida. He was waiting for the promoters to come up with the heavy bread. The monthlong tour was set to begin on November 7.

Chip Monck, the stage manager whom Jagger had spoken to on the phone from his Australian film shoot, was brought on board to handle the tour production. Monck was the top man in his field. In addition to managing the stage at Woodstock (and being the gentle voice on the public address system: "The brown acid that is circulating around is not specifically too good"), Monck ran the lights at the Fillmore East and had worked with

every rock band on the road. He had been on the scene since running lights at a downtown jazz club called the Village Vanguard in the 1950s. For the first time on a tour, the Stones would carry a sound system of their own and perform on a stage they had designed. Jagger hated the small stages and other adverse conditions the band frequently faced on the road.

Jo Bergman handled all the details, a phone constantly stuck in her ear. Bill Belmont dealt with transportation logistics and other duties. A guy named Phil Kaufman came with the house as a kind of concierge and ran errands of all sorts. The Oriole House hummed with activity from the moment the first visitors arrived that weekend.

But the tour and the activity around it were only one part of the chaos. In the next three weeks, the Stones would not only have to promote, prepare, and rehearse the band's first tour in three years, but also complete the new album they had been making for almost a year. With the rock scene in Hollywood greatly changed from the last time they came to town, not only would the band experience a new, exalted position in America, but they would discover an array of resources that they would quickly absorb into their music. Three weeks in Hollywood would give them a crash course in the new American scene.

Ralph Gleason's Sunday column in the *San Francisco Chronicle* greeted the band the next day, October 19: INEQUITIES IN THE CONCERTS read the headline. Gleason started out railing about the recent tour by the new Eric Clapton band, Blind Faith, but quickly set his sights on the upcoming Stones juggernaut:

> The Rolling Stones tour which is now coming up is another such case. We all want to see them. They put on a good show, but the prices they and their managers demand (guarantees such as $25,000 and up a night against take home percentages running over $59,000) are exorbitant. The Stones managers offered Ike & Tina an average of $1200 a night to be on the

show with them. This is really some kind of artistic and moral crime, in my book.

Can the Rolling Stones actually need all that money? If they really dig the black musicians as much as every note they play and every syllable they utter indicates, is it not possible to take out a show with, say, Ike & Tina and some of the older men like Howlin' Wolf and let them share in the loot? How much can the Stones take back to Merrie England after taxes, anyway? How much must the British manager and the American manager and the agency rake off the top?

Paying five, six and seven dollars for a Stones concert at the Oakland Coliseum for, say, an hour of the Stones seen a quarter of a mile away because the artists demand such outrageous fees that they can only be obtained under these circumstances, says a very bad thing to me about the artist's attitude toward the public. It says they despise their own audience.

Gleason considered himself the conscience of the scene and voiced a hip, slightly cynical perspective very much in keeping with the times. A popular sentiment of the day held that music should be free. It was a kind of convoluted thinking emanating from the myth of the San Francisco bands playing in the park, but bands all over took up the cause. After all, it was in this spirit that the crowds had shown up at Woodstock and simply overwhelmed the fences, turning the for-profit concert into a free festival. While Bill Graham had no problem making money off the music, his capitalist point of view was far from common in the music world. As long as the Rolling Stones prioritized money so highly, they would float above the subversive cool of the underground—they might sell tickets, but it wouldn't make them cool. With the Gleason column's publication, and its echoes the criticisms that had sunk the Wild West Festival, the gauntlet had been thrown down.

Back at the Oriole House, Charlie Watts sat in the living room, listening to old jazz by the Count Basie Kansas City Six, and asked journalist Stanley Booth about Gleason's piece. Booth was a Memphis writer who hoped to land a book contract on the Stones tour. Watts, a longtime jazz fan, knew Gleason slightly, but was quite aware of his reputation.

"I met him last time we were in San Francisco," Watts said. "I'd like to ask him why he is so set against us."

Before much more could be said, in walked Mick Jagger, Keith Richards, and Mick Taylor. With them was Gram Parsons of the Flying Burrito Brothers, a close friend of Richards who'd met the Stones the year before in London when he belonged to The Byrds. A smart, elegantly wasted gentleman from Waycross, Georgia, with a trust fund, Parsons was cultured and bright—he had attended Harvard—but he masked a lot of pain in his life. His father committed suicide on Christmas Day 1958 when Parsons was twelve years old. His mother drank herself to death on the day of his high school graduation. When he joined The Byrds, he brought his near-encyclopedic knowledge and his uncanny feel for country music to the breakthrough folk-rock group of 1965 ("Mr. Tambourine Man"). Parsons practically invented country rock with The Byrds as he directed the group into a whole new sphere on sessions with Nashville sidemen that produced the 1968 album *Sweetheart of the Rodeo.*

That album was a favorite in the Stones office during the summer of '68. When The Byrds came to London to play on their way to dates in South Africa, Parsons met the Stones. After The Byrds' Royal Albert Hall concert, Richards and Parsons spent the evening getting high. Richards explained to Parsons what apartheid was. The Byrds were scheduled to leave for South Africa the following day, but Parsons announced he was quitting the band rather than go. Whether he was standing on principle or simply wanted to hang out with the Stones, he was no longer happy in The Byrds. His previous manager had refused

to allow him to sing on the *Sweetheart* album, and Columbia Records took his lead vocals off three songs and replaced them with the main Byrds vocalist, Roger McGuinn.

From the start of their friendship, Parsons enchanted Richards with his love and knowledge of country music, introducing the Stones guitarist to American music with reel-to-reel mix tapes that featured Hank Williams, George Jones, Louvin Brothers, Kitty Wells, and other classic country artists. They also shared an enthusiastic appetite for drugs.

A party of twenty dined that night at the trendy Japanese restaurant Yamoto-E. A drunken older woman appraised shaggy-haired Richards as he made his way to the bathroom. "You'd look cute with a rinse in your hair," she said.

"You'd look cute with a rinse on your cunt," said Richards.

The Rolling Stones were back in town.

After dinner, the party repaired to the Ash Grove, a small Melrose Avenue nightclub that had been the center of the Los Angeles folk scene for years. The Stones crowded in the back of the tiny room to watch Arthur "Big Boy" Crudup, whose song "That's All Right" Elvis Presley sang on his first record. The sixty-four-year-old Mississippi bluesman was backed up by the band of Taj Mahal, who was also appearing. The tall, young, college-educated Taj Mahal had played the previous year as the Stones' guest on their unreleased TV special *The Rolling Stones' Rock and Roll Circus*.

The next morning, Monday, October 20, the band and associates piled into limousines and headed down to the Beverly Wilshire Hotel to meet the press. A raucous, packed room was waiting for the band, but the dialogue took on a much different tone from the hostile and sarcastic encounters with the American press the Stones remembered from past meetings.

Jagger faced the mob with a self-satisfied smirk, while Richards sulkily sucked down cigarettes. Cutler, cool behind aviator shades, took the questions and attempted to keep order.

ABC-TV gossip queen Rona Barrett seemed to ask every other question. It didn't take three minutes for the question of ticket prices to come up.

"Ralph Gleason in the *Sunday San Francisco Chronicle* stated that your prices for tickets to your concerts and other performances were too high and a lot of people who would like to see it can't afford to," asked one reporter. "Would you like to comment?"

"Is that right?" said Jagger. "Well, if there's people who want to see us and can't afford to, we'll have to do something about it. If there really is a lot of people who can't afford it, maybe we'll try to fix something up for those people."

"A free concert?" asked another reporter.

"I don't know," said Jagger. "Is there really a lot of people?"

"Yes," said the reporter. "That's a lot of money."

"We can't set the prices of tickets," said Jagger. "I don't know how much people can afford. I mean, I have no idea."

When the question of ticket prices came up again a few minutes later, Richards started to answer, but Jagger interrupted him, literally bouncing in his chair like an eager schoolboy.

"Wait, I can answer that one," he said. "I have it all together. We're offered a lot of money to come to America, a lot of money in front before we left Europe, really a lot of bread. We didn't do it 'cause we didn't think the shows were going to be any good. They would have been too expensive because of the amount of money we would be getting. But on this particular tour we did not say that unless we walked out of America with X amount of dollars we ain't gonna come. No, we didn't do that. We just said that we wanted to come to America and play about fifteen cities and have a lot of fun. We're really not into that economic scene. I mean, either you're really gonna sing and all that crap or you're going to be fucking economists, and we're not. We're sorry people can't afford to come. We don't know that this tour is any more expensive than local bands or Blind Faith when they come. You'll have to tell us."

"Twice as much," said the reporter.

"Really?" said Jagger.

Despite his disingenuous replies, Jagger left the press conference acutely aware of his key publicity problem. He was furious about being grilled over ticket prices. The Stones had been adopted by the underground—in some ways, even more than Dylan and The Beatles—and Jagger wanted to be careful to cultivate that precious endorsement. Rock bands were heroes, leaders of a movement, not some grubby businessmen. Any mercenary motives were suspect. If the Stones wanted to be cool, the band could not be seen as fast-buck hustlers. They needed to be above such common commercial concerns or risk losing important face in the underground.

Of course they were doing it for the money, but they couldn't be *seen* as doing it for the money.

WHILE THE TOUR pieces fell into place, the Stones busied themselves. Fueled by drugs and the excitement of Hollywood nights, the band went into a whirlwind of activity. The night of their first press conference, a fleet of limousines waited outside the Whisky a Go Go on the Sunset Strip, where the Stones and company went to see the grand old man of rock and roll, Chuck Berry. His songs had been the cornerstone of the Stones' music since the band's first single in England, and were still very much alive in their current repertoire.

Then the group whisked off into the night for the long drive into the hills to The Corral in Topanga Canyon to catch the Flying Burrito Brothers, the band Gram Parsons had put together the year before with his former bandmate from The Byrds, bassist Chris Hillman. Shortly after Parsons had left The Byrds, he'd talked Hillman into also leaving the group. After they started the Flying Burrito Brothers, they recorded the band's debut album, *Gilded Palace of Sin,* for A&M Records. Although the other members of the band were barely scraping by, trust

funder Parsons drove a Mercedes, lived at the elegant Chateau Marmont, and didn't have to worry about money.

The Corral was a rustic roadhouse in the artsy, woodsy enclave tucked above the Pacific Ocean. Fewer than a couple dozen people were in the house. When the Stones walked in, they sucked the air out of the room.

Dancing in front of the stage at The Corral in a low-cut rhinestone-studded black velvet dress was one of Hollywood's elite groupies, Pamela Miller, known as Miss Pamela. A beautiful fawn, she belonged to a loose collection of similarly inclined females called the GTOs (Girls Together Outrageously) who had actually made an album with Frank Zappa of the Mothers of Invention. She was currently carrying a torch for her true love, Led Zeppelin guitarist Jimmy Page. Jagger fastened his eyes on her immediately.

From the bandstand, Parsons noticed Jagger's attraction. "Watch out for Miss Pamela," he warned Jagger for all to hear. "She's a beauty, but she's tender-hearted."

Jagger introduced himself and kissed her hand. He invited Miss Pamela and her GTO associate Miss Mercy back to Laurel Canyon and they went. Miss Mercy gave everyone a tarot reading. Jagger begged and beseeched Miss Pamela to go to bed with him. Mick Jagger had been her dream date since she was a teenybopper. They kissed under the full moon sitting beside the pool, but Miss Pamela was resolute and left at six in the morning. Jagger got no satisfaction.

Phil Kaufman was sent to the airport to pick up Marianne Faithfull, back from death's door after a lingering convalescence in Australia, where she had finally been released from the hospital. He sequestered her in a bungalow in the Hollywood hills and fed her fruit juice and vitamins. After a week of this health treatment, she was delivered to Jagger. She hung out at swimming pools with lady friends, sipped cocktails in air-conditioned bars, and sniffed a little coke. She went out to a club one night

with the band and was astonished at the effect they had simply walking into a room. It was obvious to her that the band had graduated to some new mythic status. Still, she rejected Jagger's invitation to join him for the tour. Faithfull knew better than to submit to life in that bubble, and she yearned to be free of Jagger.

Despite the partying the band was doing, there was work to be accomplished. Sessions to finish their long-in-progress album started on Tuesday, October 21, at a studio called Sunset Sound. Stones producer Jimmy Miller and engineer Glyn Johns had flown in from England. The band had been cutting songs for more than a year; it was time to finish an album. The Stones had been recording versions of "Midnight Rambler" since the sessions for *Beggars Banquet*. "You Can't Always Get What You Want" had also been worked on for more than a year. As with *Beggars Banquet,* Richards took charge of the band musically in the studio, often overdubbing multiple guitar parts or playing bass. They had cut a number of tracks with Mick Taylor in June and July at London's Olympic Studios. In Hollywood, the band had three tracks to finish.

Gram Parsons was the one who suggested the band use fiddler Byron Berline to play on "Country Honk," the hillbilly version of "Honky Tonk Women." The basic track had been recorded in London. Parsons knew Berline from when he played with Dillard & Clark, a Los Angeles–based bluegrass group. In an effort to capture some elusive "atmosphere" in recording the fiddle part, Jagger insisted Berline play on the curb outside the studio with the street noise in the background. Wearing earphones and standing on the sidewalk in his cowboy suit next to a microphone with a long cord, Berline hit it after Sam Cutler sat in a parked car and honked twice on the car horn to give him the downbeat.

Later that week, the Stones went out to the San Fernando Valley to catch Delaney and Bonnie and Friends at a small club

called the Brass Ring. The band had attracted modest attention with a new album on Elektra Records that featured the husband-and-wife vocalists Delaney and Bonnie Bramlett, but had been directed by bandleader and keyboardist Leon Russell, a longtime Los Angeles session musician. At the club, the Stones were glad to refresh their acquaintance with saxophonist Bobby Keys, a Texan teddy bear they'd first met when he played with teen idol Bobby Vee at the San Antonio Teen Fair of Texas in 1964. Keys had grown up in Lubbock, Texas, and was childhood friends with Buddy Holly. The next day, Keys and Russell joined the band in the studio to put horns on the Stones track "Live with Me." The Stones had found a sweet spot in Hollywood.

Sessions ran on vampire hours. The Stones were constitutionally late, Richards even more than the others. They lived by their own clock. After Bonnie Bramlett spent fruitless hours trying to cut the key background vocal part on the last track they needed to finish, "Gimme Shelter," at three o'clock in the morning, the band finally relented and put out a call to a session vocalist named Merry Clayton, who had been recommended by Jack Nitzsche, the noted Hollywood arranger who had played keyboards on a number of Stones sessions. Clayton was unimpressed, annoyed to be wakened in the middle of the night and in an advanced state of pregnancy. She didn't know who the Rolling Stones were and was ready to decline the offer. Her husband, however, did know who the Rolling Stones were and convinced her to get up and go to the studio. She stood there, her hair still in curlers, and took three passes at singing a searing background vocal part—*Rape! Murder! It's just a shot away*—to "Gimme Shelter." Each take sent shivers down the spines of everyone in the room.

With that, the sessions were over. The album was in the can, ready to be mixed. Titled *Let It Bleed,* the release was set for November 28.

The next night, they went to see Little Richard at the Whisky a Go Go. The King of Rock and Roll was in fine form. His ten-piece band barely squeezed onto the tiny Whisky stage with Richard and his grand piano. Dressed head to toe in sparkly gold lamé, he addressed the Stones in the audience.

"They told me you were out there," he said. "Tonight we have with us Mick Jagger and Keith Richards from the great Rolling Stones. And I taught them everything they know."

Heads turned in the crowd, but the Stones were hidden in the shadows of a booth under the balcony in the back of the room.

"I know you're out there. Keith. Mick. This is Little Richard. Tell them I taught you everything you know. Go on. Tell them I'm beautiful."

He paced the stage, looking into the house. Keith Richards broke the silence.

"You're beautiful," he said, loud enough for everyone to hear.

"You bet I'm beautiful," said Little Richard.

With the album done, rehearsing for the tour might have become a priority for another band. But the Stones lacked that kind of focus. Rehearsals proved difficult to pull together. At one point, the band started playing in Stephen Stills's basement while Richards lolled by the pool smoking cigarettes. Phil Kaufman's girlfriend was dispatched to tell him that the practice had started.

"I know," he told her. "Tell them they sound great."

Joining the cast of characters at Stills's house was Tony Funches, a twenty-one-year-old African American giant and Vietnam veteran who ran security for Los Angeles–area concert promoters while he attended college, where he also served as student body president. Funches did not suffer fools gladly. He weighed 285 pounds and had a thirty-four-inch waist.

He went over to Laurel Canyon, met with Cutler, dug his chutzpah, and took the job as bodyguard. He knew who the Stones were, but was not impressed. They paid him handsomely

for spending his days sitting in a parked Volkswagen at the end of the driveway. He grew to be fond of the musicians as he worked with them. Richards even introduced him to the joys of cocaine late one night in the kitchen when he saw Funches was tired.

Also turning up mysteriously around this time was a shadowy figure who called himself Jon Jaymes. Years later, it would be revealed that he was John Clifford Ellsworth, a refugee from the Witness Protection Program with a background in organized crime, but all anybody knew at this point was that he said he could supply a fleet of cars for the tour. The pudgy young man with the muttonchops headed something he called Young American Enterprises Inc. The company owned the merchandising rights to a popular television show, *Laugh-In,* and marketed a foam rubber "Fickle Finger of Fate," although that hardly qualified him to work with the Rolling Stones. Introduced to Chip Monck by a well-known New York radio deejay called Cousin Brucie, Jaymes ingratiated himself into the Stones' touring circle by promising to provide free transportation. He told the Stones he worked for Chrysler Motors, but he had told Chrysler that he worked for the Rolling Stones. Though he was never on the Stones' payroll, he quickly embedded himself, always hovering on the edge of the action, and summoned a half dozen off-duty narcotics cops from New York to serve as a security force that sat armed and intimidating around Oriole. While his personal agenda was not entirely clear to anyone, he wasted no time worming his way into the tour's inner circle.

As the date for the tour opening approached, the Oriole House was a buzzing hive. Allen Klein was around, but he was largely ignored other than huddling with Jagger over the details of various business deals. One item that Jagger wanted to consider was the possibility of a movie about the upcoming tour. He knew the movie from Woodstock was going to be released by a major Hollywood studio and was well aware of other rock concert films. He decided to explore the idea of making a film on the tour. He

first sought out the most obvious candidate. Filmmaker D. A. Pennebaker had made the groundbreaking musical documentaries *Don't Look Back* with Bob Dylan and *Monterey Pop,* and spent some time talking to Jagger about the prospect of filming the band during the tour, but Pennebaker, a crusty veteran independent filmmaker who valued his artistic instincts more than commercial success, didn't like the scene and backed out. Jagger also met with Oscar-winning cinematographer Haskell Wexler, whose new movie *Medium Cool* was a landmark work of cinema verité, but Wexler found Jagger distracted and frustrating, however genial he was. Jagger told Wexler the band wanted to throw a giant free concert after the tour, which he thought might help make the movie, but he didn't know where and didn't have a date. Wexler passed on the project and suggested the Stones contact documentary filmmakers Albert and David Maysles.

On the broadcast front, the band met with television producers. Tommy Smothers came over to convince the Stones to play his show, *The Smothers Brothers Comedy Hour.* Instead they chose the old reliable *Ed Sullivan Show.* A parade of newspaper and magazine interviewers trooped through the living room—*Saturday Review, The New Yorker, Esquire.* This kind of media attention was wholly new to the Stones.

Chip Monck showed up at the Stills house with a bunch of plans for stage plots and lighting designs. Monck, who had seen the band perform on the 1966 tour in Boston and had not been especially impressed, was certain he could transform the Stones from a raw, scraggly garage band into international superstars. Unable to get Jagger's attention, he took the vocalist out by the pool, where he laid out the papers and weighed them down with stones and bricks. Jagger looked at the plans Monck had whipped together in less than two weeks for only a few minutes before his eyes glazed over. The wind caught some of the pages and blew them into the pool. "Fuck it," said Jagger, standing up to walk away. "Do it."

Monck put together a lighting scheme like no rock band had

ever carried before, working with Jagger on wardrobe. For this tour, Jagger would appear on a generous stage atop a custom-made purple carpet with a white starburst in the center, boldly illuminated by six Super Trouper spotlights. Monck went about building the impressive set.

After a few days of haplessly bashing it out in the Laurel Canyon basement, the Stones moved rehearsals to a sound-stage at the Warner Brothers lot in Burbank that had recently been used for the movie *They Shoot Horses, Don't They?* Monck had erected the stage set. With the first concert five days away, rehearsals turned more serious. Sort of.

Keith Richards rode in on a bicycle carrying a sign that said PROPERTY DEPARTMENT—RESERVED PARKING FOR KIRK DOUGLAS and placed it in front of Jagger's microphone. Working on a stage still dressed for the film about thirties marathon dance contests beneath a giant sign that read ?HOW LONG WILL THEY LAST? and, under that, COUPLES REMAINING and HOURS ELAPSED, the Stones finally put together a forty-five-minute set, a dozen songs. They thought the show was done.

On November 5, Keith Richards threw a birthday party for Gram Parsons. The two had been inseparable since the Stones hit town. Miss Pamela even thought they were getting to be so much alike, it was as if they were turning into each other. Richards gave Parsons clothes. Parsons started wearing eye makeup and silk scarves like Jagger with his custom-made Nudie cowboy suit, camping it up onstage like a rock star lead vocalist. Jagger had to chase Parsons out of the studio one night because he had a Burritos show he was going to miss, scolding him to be responsible. Jagger was not particularly fond of Parsons and was leery of his relationship with Richards. At the party at the Stills house for his twenty-third birthday, Parsons met Gretchen Burrell, the sixteen-year-old daughter of a Los Angeles newscaster. They were instantly smitten. He took the astonishingly beautiful girl back to the Chateau Marmont.

The next day, Jagger and Richards stayed home and gave

serial interviews, while the crew struck the set at the Warner Brothers lot and headed out to start the tour. John Carpenter of the *Los Angeles Free Press*, the town's leading underground newspaper, talked separately to both Jagger and Richards. Carpenter asked Richards about the rumors of a free concert by the Stones. Richards offered the first official confirmation and told him that was the plan.

"Yeah, there is going to be one," Richards said. "But I don't want to say where or when right now. We've still got to get 'round the country and get things together. At the end, we'll get it all together and do the free show."

That night, Richards went to see Bo Diddley at the Whisky and didn't return until six in the morning. The band left on tour later that morning.

5

On the Road

Rock may have become young America's mass obsession in the years since the Stones last toured the country, but even as the band prepared to take the stage for their first date, they had no idea what they were getting into. What should have been a quiet, uneventful out-of-town tune-up show instead became an introduction to an entirely new world for the Rolling Stones. That chilly night in the Rockies, nobody had any idea where this road would end. But then a Holiday Inn in Fort Collins, Colorado, hardly seemed like the starting point of an epic journey.

The people in the audience at Colorado State University's Moby Gym were a complete cross section of contemporary collegiate youth—hippies, straights, students, dropouts, coeds, jocks, fraternity brothers, and sorority sisters. They filled the bleachers and folding chairs on the gym floor for the first show on the tour, Friday, November 7, in Fort Collins, about sixty miles outside of Denver.

Promoter Barry Fey had pestered Ronnie Schneider until he gave him the date. Fey was a young, hustling concert producer

who had thrown the massive Denver Pop Festival that summer, where cops battled would-be gate crashers with tear gas and arrested dozens outside Mile High Stadium, home of the Broncos football team, while Iron Butterfly, Creedence Clearwater Revival, and the Jimi Hendrix Experience performed inside.

The Stones left Los Angeles International Airport around eleven thirty on Friday morning on a commercial flight bound for Denver. Limousines drove them the hour to Fort Collins. This would be the band's opportunity to meet the new American rock audience face-to-face.

After the sound check at the gym, the Stones repaired to the Holiday Inn, where Richards sprawled across a bed while Jagger asked Bill Belmont, tour manager for Country Joe and the Fish, who was handling the band's logistics on the tour, for comments on the show. Road-tested Belmont told them the set was too short; it needed to be an hour long. They decided to throw in a couple of old blues numbers on acoustic guitar.

At the gym before the show, the Stones used the student athletes' Lettermen's Lounge for a dressing room, Jagger sitting around picking out country blues on an acoustic guitar. The band was as expectant as the audience.

"I wonder what these kids are like now," said Richards. "I mean, do they watch TV or are they turning on in the basement?"

"Or watching *Easy Rider*?" said Jagger.

Cutler and Schneider had gone over details of the show on the plane to Colorado. They realized somebody would have to introduce the band. They consulted Jagger, who suggested Cutler handle the introductions. Onstage that night, Cutler grabbed the mike and made his announcement.

"Okay, Fort Collins, we made it, we're here, and so I want you to give a big western welcome to the group you've been waiting for . . . the Rolling Stones."

As the band slammed into "Jumpin' Jack Flash," a strange

phenomenon was taking place with the crowd. Bill Wyman thought he was seeing the audience in close-up. There wasn't as much distance between the band and the fans. He could see their faces. It wasn't all girls and they didn't scream. The Stones could tell the difference immediately. For the first time, the audience was listening.

That was okay—the Stones could play.

Prior to those opening chords, the Stones honestly had no idea how their act would go down in America. While the three weeks the band had spent in Hollywood had already made it clear that they—and indeed the entire rock scene—had been greatly elevated in pop culture, even this did not reveal the true picture that the thousands of fans in front of the stage showed them. The tour had been hastily thrown together because it was the easiest solution to the band's money problems, but although the high-priced tickets had been snapped up, ticket sales couldn't explain how far the public's taste had evolved in three years. The hot new rock band of the fall was Led Zeppelin, whose second album, *Led Zeppelin II,* burst into prominence almost immediately on release in October. Zep was enthralling American audiences with two-hour performances that featured extravagant guitar solos from bandleader Jimmy Page and a sometimes half-hour drum solo by John Bonham. This was a long way from the last time the Stones came around playing a twenty-five minute set that nobody listened to.

The show went well enough. The sound system worked. The new gear was capable. The band was blown away by Chip Monck's staging. But there was no strategic postmortem. No notes were taken. Fort Collins was the shakedown; the real opening night would be the next night at the Forum in Los Angeles. The Stones and company returned to Los Angeles around dawn, greeted at the airport by Jon Jaymes and his thugs holding out keys to new Dodges.

The two shows on Saturday, November 8, in Los Angeles

were presented by Concerts Associates, run by two promoters named Jim Rissmiller and Steve Wolf. With two shows on the same date, seven and eleven o'clock, the thirty-six thousand tickets on sale had quickly sold out. Although the promoters added an extra dollar to the usual top price ticket ($8.50), they also held back a number of VIP tickets that they sold privately for $12.50. The concert's $260,000 box office broke a record set by The Beatles for the highest-grossing music concert. Concerts Associates announced a third show for November 20 that the Stones would cancel before the weekend was over.

Crowds this size inevitably drew the attention of the police, and Jagger hated cops. He had watched as European police used tear gas, batons, dogs, and water cannons on unruly audiences. Jagger himself had been injured in some of these riots. His arm had been broken. He had been punched. He had a chair broken over his head that left a small scar above his eye. From the very start of negotiations for this tour, Jagger had been adamant: no uniformed police would be allowed inside any concert hall where the Stones were performing. It was written into all the band's contracts with promoters. As a result, when the band pulled up backstage at the Forum, they were greeted by a large cadre of LAPD in full riot gear—white helmets, black leather jackets, jodhpurs—massed *outside* the arena.

Things proved similarly chaotic inside. Before long, rock tours would become a smooth science, but at this stage everything was an experiment being tried for the first time. Bands did not travel with their own sound, lights, and staging. The Stones never had before, and even routine matters in this new world could prove vexing. They couldn't produce an accurate seating map. Speaker placement blocked the view of more than two hundred seats. Still more disastrously, the National Hockey League already had a game scheduled for the Forum on the same date the concerts were booked. The hockey game was hurriedly shifted to the afternoon and a board was placed over the ice after

the game. Installing and getting the Stones' sound system to operate took longer than expected with a small eight-man crew.

The first show started only one hour and forty minutes late, but opening act Terry Reid still spent the first half of his set singing into a dead mike. Sound problems continued through B. B. King's set. Ike and Tina Turner went over well enough. At least the equipment worked. The Stones finally hit the stage after eleven o'clock.

"Sorry you had to wait," said Jagger, "but we had to wait, too, y'know."

Backstage after the first show, a drunken Bukka White, older cousin to B. B. King who inspired the younger relative in his career in music, was lounging with an equally inebriated Gram Parsons. White had opened for the Burritos the previous week at the Ash Grove. Keith Richards was strumming a National steel guitar, an unusual model that Bukka White also happened to play. Richards riffed a taste of the Mississippi Delta, "Dust My Blues." Jagger joined him for a couple of choruses and then "Key to the Highway." The elder bluesman was suitably impressed.

"That's good," he said. "These boys is good. Has you ever made any records?"

Richards allowed he had.

"I knew good and well you had," said White, who held his hand over Richards's head and began to address the entire room. "This is a star. This is a Hollywood star. If I'm lying, I'm dying."

In between shows, Jon Jaymes took Sam Cutler aside to warn him about Goldfinger. The one-handed international adventurer and drug dealer had ingratiated himself with Cutler and the Stones during their stay in Hollywood. Goldfinger finagled his limousine backstage at the Forum and hit up Cutler for passes. Cutler took care of him and his girlfriends. Goldfinger reciprocated with generous gifts of drugs, which he passed out in a backstage dressing room guarded by one of Jaymes's off-duty New York cops. Jaymes wanted Cutler to know that

the pasty-faced redhead was wanted by police and was a known drug dealer.

"We simply can't have him around the band," he said.

That made no sense to Cutler whatsoever, who shrugged his shoulders and walked off.

The second show started three hours late. Terry Reid never even played. The Stones took the stage around four in the morning.

"Welcome to the breakfast show," said Jagger. "If we'd known we were going to be this late, we would have brought our toothbrushes."

From the second he hit the stage, Jagger was intent on riveting the audience's attention. Wearing an Uncle Sam top hat, a shirt emblazoned with the Omega sign, long black pants with silver conchos down the seams, and an Isadora Duncan–length scarf, he worked the front of the stage like a stripper, bumping, grinding, mugging. Twelve thousand watts of Super Trouper spotlights caught him in their crossfire. Back in the shadows by his amplifier, Richards kicked off the second song, Chuck Berry's "Oh Carol," with acrobatic moves of his own. By the third song, "Sympathy for the Devil," Jagger had everybody under his spell. This band didn't simply exude confidence; this band oozed omnipotence.

The powerhouse set drew largely from *Beggars Banquet,* although the group did include "Midnight Rambler" and "Live with Me" from the forthcoming *Let It Bleed.* "Midnight Rambler," in particular, was the dramatic centerpiece of the set, Jagger stripping off the silver belt Marianne Faithfull had found for him in Chelsea and slapping it savagely on the stage. Jagger and Richards sat down to play a couple of old blues songs on acoustic guitar. The band resurrected a little gem from the early days, "I'm Free," that somehow seemed to take on new meaning in the Age of Aquarius. A rearranged "Under My Thumb" passed for an oldie in the context, and "Little Queenie" was another

obscure slice of Chuck Berry. The Stones drove the sixty-five-minute show to a frantic close with "Satisfaction," "Honky Tonk Women," and "Street Fighting Man," which *Los Angeles Times* reviewer Robert Hilburn called "the three best rock songs of the 1960s" in his rave review. At the last song, Jagger ordered the house lights turned up ("Let's have a look at ya"). He showered the front rows with rose petals from a basket and scampered off.

When the show let out a little after five in the morning, the sun was coming up over the parking lot—the dawning of the Stones' second golden era had begun.

As the show proved, the arrival of Mick Taylor was to be a crucial ingredient to this revitalized mixture, bringing a welcome touch of the guitar virtuoso to the Stones' new sound and helping to transform the band right before the audience's eyes. Although only twenty years old, Taylor was far from green. He had toured all over the United States and Europe the previous two and a half years with John Mayall's Bluesbreakers, where he replaced lead guitarist Peter Green, who had left to form Fleetwood Mac, in a guitar hot seat previously held by Eric Clapton. Taylor's stinging, soaring solos with the Stones allowed Richards to return to his favored role in the band's engine room, stoking the furnace with chugging rhythms. The band never sounded better.

With that triumphant performance, the Stones proved what they needed to for themselves. The show unarguably established the Stones as the premier rock band of the day. The old hits sounded like towering classics. The new material was suffused with a haughty, foreboding grandeur, sex and violence wrapped in the blues. The powerful band delivered the goods like a ton of bricks. These swashbuckling rockers had thoroughly made their case.

THAT AFTERNOON, SUNDAY, November 9, the band flew to Oakland, the tour's next stop, and held a press conference in a

sleazy motel on the edge of the airport. This confab, less formal than the Los Angeles fiasco, was a bunch of long-haired kids with tape recorders. These people would want to know where the Stones stood on political issues. While the band remained heroes to the underground, hailed as rebels, some more militant quarters of the movement questioned their political motives.

"Why haven't the Stones made any statements concerning the U.S. youth movements, marches, and pitched battles with the police?" asked one reporter in Oakland.

"We take it for granted that people know we're with you," said Richards.

"We admire your involvement," said Jagger, "but we're primarily musicians. And last night, the crowd . . . weren't ready to relax. They wanted to be cool and intelligent and it took them a long time to get to the frame of mind where it's just fun. We want them to get up and dance."

San Francisco Chronicle columnist Ralph Gleason wouldn't leave the Stones alone. In the *Chronicle* a week before the Oakland show, he took the band to task over ticket prices all over again and made mention of Jagger's comments ("Really?") at the Beverly Hills press conference:

> Now, many attractions specify top ticket prices or minimum prices for seats or a minimum for the total possible gross of a hall and have for years. If Jagger does not know this, he has been deceiving us, posing as a man with a lot of smarts. The truth of the matter is that the Stones' tour prices are dictated by what the Stones management wants, not by the impresario in each city and Jagger's comments are a complete cop-out and a dodging of the issue as bad as anything any politician ever did on TV. . . .
>
> He did say they might do a free concert at the end of the tour, which doesn't do much for the people on the West Coast, I must say. . . .

If the Stones really believed what they say, they could do something about it. Meanwhile I personally have very little sympathy for the devil who is simply charging as much as the traffic will bear. Like any dealer.

At the early show at the Oakland Coliseum Arena, neophyte road manager Sam Cutler was already at the mercy of the Stones' caprice. He took the stage at Oakland forty-five minutes after the scheduled showtime for the first of the two shows that evening to address the issue with the audience. With the Stones lolling around backstage, Cutler simply lied about the delay.

"Could I just explain something?" he said. "When we arrived in Oakland we got off the plane to be met by some cars to bring us to this place. There were no cars. We are getting it together as quickly as possible. We will be here in literally two minutes. Literally. Please be patient. We won't be a second."

As soon as the band finally did take the stage and started "Jumpin' Jack Flash," the amplifiers failed. The Stones had accepted free Ampeg amplifiers from the manufacturers, brand-new from the factory. The band was happy to save the money. The company also provided two technicians to tour with the gear and paid for their travel.

"Oh baby, we're sorry," said Jagger. "I don't know who's going to get it together up here, but I can't hear me. Keith? We're completely . . . the electricity failed us. Why don't we do the acoustic numbers? If we can't get it together, we'll just hang out. We're really sorry about this. I can do without this shit. Can you hear that? Keep playing, Keith."

In the audience, the Grateful Dead were seated together in one long row and the band's soundman, Augustus Owsley Stanley III—Bear—dispatched some of the Dead's road crew to whisk over to the old Fillmore Auditorium across the bay in San Francisco, where the band was set up from a gig the night before, and borrow the Dead's equipment in time for the second show.

Promoter Bill Graham, who had never before presented a concert in a building near the size of the Oakland Coliseum, stalked the front row, augmenting his own stage security against people trying to crash the stage. At one point, Charlie Watts, who did not know Graham, pointed him out to Sam Cutler because Graham was manhandling a young girl trying to climb up on the stage. Cutler pulled Graham away from her.

"Don't you know who I am?" screamed an enraged Graham, as the Stones were playing "Satisfaction." "I'm Bill Graham. This is my stage."

"This is the Rolling Stones' stage, mate," said Cutler, who threw a wild punch at Graham that missed his face but caught his shoulder. The two went down in a pile onstage beneath the piano, rolling around and pummeling each other in full view of the audience while the band played on. Their respective security people pulled them apart. The band was furious. Keith Richards stormed into the backstage dressing room after the first show ended and kicked a trash can. "Cunt," he said.

Big Tony Funches took his post outside the dressing room door. Bill Graham and Ronnie Schneider got into an argument in the hallway and Schneider swung the attaché case he was carrying into Graham's crotch and dashed into the safety of the Stones' dressing room. Graham demanded to see Jagger. He was screaming about canceling the second show.

Graham was a proud and vengeful man, but even before this episode he'd had frustrations with the Stones. The month before, he had already been humbled by the arrogant Schneider when Graham met with him in New York to pitch producing the entire Stones tour. Graham laid out to Schneider his successes at the Fillmore West in San Francisco and Fillmore East in New York.

"That's great, Bill," Schneider had said, "but have you ever done anything that was big?"

Schneider eventually gave Graham the two shows in Oak-

land and a second date the following night in San Diego, which were actually the three biggest shows Graham had done.

Jagger positioned himself in front of the dressing room mirror applying makeup, and Graham was ushered in. Outraged and humiliated, he let loose a torrent of profanity. Jagger turned and leveled a withering glare at him.

"Who are you?" he asked.

"I'm Bill Graham," he said. "I'm the promoter."

"Didn't we speak once on the telephone?" said Jagger.

Graham acknowledged they did.

"I remember you," Jagger said. "You yelled at me over the telephone. Appallingly bad manners. I can't stand people with bad manners. We'll be on in a few minutes, Mr. Graham. Sam works for me. I will decide what happens with Sam." Jagger swiveled back to the mirror and his makeup.

"The show must go on," he said.

Graham left and Richards walked over to where a poster of Graham flipping the finger was taped on the wall above the fancy $300 buffet. Somebody had scrawled a quote balloon out of Graham's mouth reading, "That's where my head is at." Richards stuck his fingers into the cheese dip and wiped it across Graham's face.

The room was still buzzing about what an asshole Graham was when Rock Scully of the Grateful Dead showed up in a plaid cowboy shirt. Ramrod, Rex Jackson, and Sonny Heard from the Dead road crew were swapping out gear on the stage for the Stones' second set. They joined the Stones crew for the rest of the tour that night.

Jagger left to watch Ike and Tina Turner open the late show. His friend from Hollywood, Miss Pamela, came to the concert after spending a couple of disappointing days in Sausalito with her love, Jimmy Page of Led Zeppelin, and seeing him off at the airport. She declined Jagger's invitation to fly back with him to Los Angeles after the show.

Bill Graham was a topic that Rock Scully could enthusiastically discuss. He called Graham a "capitalist pig." Richards was pissed off at San Francisco. He said Ralph Gleason was Graham's "bootlicker." He dismissed the jazz critic.

"Why don't he go on writing about Art Blakey and Monk and people like that," Richards said. "He's just an opportunist who's climbed on the rock bandwagon."

What Scully mainly wanted to talk about was the free concert in Golden Gate Park he and Richards had discussed that night in London three weeks before. He told the room about the Human Be-In in Golden Gate Park's Polo Field in January 1967 that had drawn more than one hundred thousand peaceful fans. The Hells Angels had acted as kind of ad hoc security guards. The San Francisco rock bands and the motorcycle club had a long and congenial relationship, Scully told them.

"The Angels are really some righteous dudes," he said. "They carry themselves with honor and dignity."

Richards would later remember Scully saying that.

6

Back to Hollywood

Returning to Hollywood on November 17 for a weeklong break from touring, the band moved into the Oriole House after Stephen Stills had reclaimed his place. The rest of the party checked into Hollywood's official rock and roll hotel on the Sunset Strip, the Continental Hyatt House, known universally as the Riot House.

Hollywood provided a useful respite following the tour's first leg, which had taken them to Chicago and back. After the Oakland show, hubbing out of Los Angeles, the band had chartered a private jet for $4,000 to fly from the Phoenix date and stopped in Las Vegas. The Stones party settled into tables in the middle of the night at a casino, playing with cash dispensed by Ronnie Schneider from the Phoenix take, which he carried in an attaché case handcuffed to his wrist. The casino public address system announced their presence, but the seen-it-all gamblers at the Circus Circus Room didn't even look up. At the Dallas gig, the band was visited by a renowned groupie who called herself the Butter Queen. She carried a pound of butter in her purse

and planned to spread it over Jagger's body and lick it off. But her timing was off. She was running late to pick up her child from school, so she was willing to substitute any open-minded member of the band for Jagger. Ultimately she had to make do with a crew member.

Though the tour was under way and things seemed to be in place, the various characters around the band still elicited questions. Cutler found himself wondering anew about mystery figure Jon Jaymes, who referred to himself as "the man from Chrysler," after a conversation with a couple of the half dozen off-duty New York City cops whom Jaymes had brought along as tour security. Though they were weeks into the tour, still no one seemed to understand who Jaymes was, why he was there, or how he came to be there. With each passing day he seemed to be working his way into the middle of the tour, yet the only things anyone knew about him for certain were that he came with off-duty cops and lots of excess cars and he was not being paid by the Rolling Stones. One of the cops served as dispensing pharmacist for the tour, doling out cocaine to anyone who brought him a metal film canister behind a guarded dressing room door. The off-duty police, who were not on the Stones' payroll either, could protect the band from local constabulary, but when Cutler was talking with two of the cops, he learned they were worried about Goldfinger, last seen backstage at Los Angeles, because he was wanted by the feds. Jaymes's cops also outfitted Cutler with a two-shot .32 derringer he tucked in his boot, after trying it out on a bathroom stall deep in Dallas's Moody Coliseum.

Also in Dallas, news reports reached Jagger of his lady love Marianne Faithfull. The *Daily Mail* located her in Rome, where she was openly conducting an affair with Italian painter and drug addict Mario Schifano, living in his squalid apartment with her four-year-old son, Nicholas. "I am happy," she told the *Mail*. "I am absolutely penniless. I am going to start from scratch. People can help by just forgetting me." This was going

to trouble Jagger in the weeks to come, although there was nothing he could do about it at the time.

The Stones chartered the Playboy jet to fly from Dallas to Auburn, Alabama, a hairy flight through a snowstorm to perform before a gymnasium full of clueless Southern debs and their equally out-of-it escorts. They finished up the tour's first leg in Chicago, where Chicago Eight defendant Abbie Hoffman made his way backstage. Author of the book *Revolution for the Hell of It*, Hoffman was a clownish hippie provocateur who knew the value of rock's appeal. He had gotten himself smacked on the head by guitar-wielding Pete Townshend of The Who at Woodstock after he tried to commandeer the microphone for a political rant. Backstage at Chicago, Hoffman hit up Ronnie Schneider for a loan for his legal defense fund. Schneider barely acknowledged him. Undeterred, Hoffman turned to Jagger.

"Could you lend us some money for our trial?" he said. "It's expensive making the revolution."

"We've got our own trials," said Jagger, slipping into his deerskin moccasins.

"Bunch of cultural nationalists," muttered Hoffman to nobody in particular as he left.

Once off the road in L.A., the first order of business was the free concert. The first night the Stones were back in Hollywood, Rock Scully showed up from San Francisco at the Oriole House to meet with Jagger and Richards. Scully came draped in turquoise and denim, tall, scraggly, and stoned, reeking of the Grateful Dead, and along with him came Emmett Grogan.

Grogan was a charismatic louche character. A hint of the East Coast thug he once was lingered over him. He was part visionary, part con man. He had first turned up in town as an actor with the San Francisco Mime Troupe, but soon took his instinct for drama to a larger stage. He was one of the founding forces of the Diggers, an anarchistic cooperative in the Haight that ladled out free soup to all comers every afternoon in the Panhandle.

The Diggers were the organizers behind the miraculous Human Be-In in January 1967, where a hundred thousand people came to the Polo Fields in Golden Gate Park to hear all the San Francisco bands and acid guru Tim Leary told the crowd to "tune in, turn on, and drop out." The peaceful day astonished both the massive crowd, who had not realized that their movement had spread so far until they all assembled that Saturday in the park, and the establishment, who marveled that this many people could come together peacefully and even leave the park spotless when they left. It was even more surprising to everyone that the notorious Hells Angels had acted as security, guarding the flimsy extension cord that supplied power to the stage that the crowd kept unplugging. They'd even handled the lost children. Talk about the lions lying down with the lambs.

Grogan had been a driving force behind the Be-In, and he was smitten with the concept of free. Free food quickly gave way to free concerts, free dope, free clothes, free city. The Diggers opened a Free Store on Haight Street where all merchandise was given away. They produced and distributed an endless series of circulars articulating the precepts of the movement as they saw it. They staged agitprop events in the streets and parks.

To British rock stars like Jagger and Richards, Scully and Grogan looked like supremely authentic California hippie royalty. Both Scully and Grogan sounded enthusiastic and confident about plans to present the Rolling Stones as special guests on a bill featuring the Grateful Dead and Jefferson Airplane in Golden Gate Park at the end of the tour. The plan called for the Stones to be announced twenty-four hours ahead of showtime. Grogan proposed that the Hells Angels act as a kind of honor guard to take the Stones through the crowd.

"We'll have a hundred Angels on hogs escort the Stones," Grogan said. "Nobody'll come near the Angels, man. They wouldn't dare."

Scully painted a picture of a new community rising in San

Francisco. All the other bands wanted to participate, he said. There was a spirit of cooperation and brotherhood. He promised a large stage, plenty of backstage area, good sightlines for the audience. Scully could be extravagantly verbal. Even Ronnie Schneider was going along.

Grogan envisioned a large festival, encompassing all parts of the community. He thought there should be performers on stages all throughout the park. He also raised concerns about how the huge crowd would be handled. He brought up more mundane issues. He wanted to know about food and water, medical care, provisions for so many people. Nobody was especially interested. Jagger virtually dismissed his concerns.

"Practical realities," he said, "can be addressed at a later stage."

The date selected was December 6, one week after the final scheduled show on the tour. After they left, Gram Parsons couldn't find the chunk of hash they had been smoking and suspected—probably correctly—that Grogan had stolen it. He complained that the hash cost him his previous night's pay. Richards poured out some cocaine on a Buck Owens album cover and the meeting dissolved.

Jagger may have been innocent about logistics, but looming over plans for the free concert was the myth of Woodstock. Hasty planning hadn't gotten in the way of an exceptional show for them—instead it had become a countercultural moment, one that the Rolling Stones had missed. Now perhaps they could make up for that.

THE DAY AFTER the band arrived back in Hollywood, Cutler flew that morning, November 18, to San Francisco, taking a taxi to the Dead's headquarters, the pink warehouse in Novato, where he was supposed to meet Rock Scully. It was his first time in San Francisco and his first encounter with the native population in their natural habitat.

Lenny Hart, in hand-tooled cowboy boots and western-style suit, met him at the door. He told Cutler that he was a Christian minister, and Cutler did notice a Bible on his desk. Scully, typically, was late. When he did arrive, he took Cutler into the crew quarters, lit up a joint, and started talking. They would be going to a noon meeting about the concert at the nearby ranch of drummer Mickey Hart, whose father was indeed the band's strange manager Cutler had just met.

At the ranch they were greeted by Mickey himself astride a white Arabian stallion riding between the parked cars.

"You the guy from the Stones?" he said, pointing the way to the barn.

A large, weathered American flag hung on the side of the barn. Chickens scratched in the yard. David Crosby was leaning against somebody's new Jaguar XKE parked in the dirt. Inside, thirty or forty people arrayed themselves on hay bales, beat-up sofas, upturned buckets, anything, passing joints and talking, women, children, dogs. In the corner sat Dead guitarist Jerry Garcia, wearing a light blue poncho and slight smirk. Cutler felt like he had been dropped in Munchkin Land.

Nothing could have prepared the phlegmatic Cutler for what came next. As someone accustomed to the regimentation and strict order of polite British society, he could never have anticipated the chaotic anarchy of the West Coast hippies. He sat, quietly stunned, as this barn full of shaggy freaks exploded in useless but earnest chatter. The meeting started with Scully speaking, but quickly descended into a jumble of crosstalk and random interjections. Anyone clearly felt free to say anything. One suggestion that the best way to move forward was to have the Stones come hang out at the ranch received widespread approval. Cutler listened, secretly wondering if this collection of weirdos and numbnuts could possibly produce a concert on the level the Stones would require. These people were speaking a different language, he thought. It was hard to imagine a

partnership that felt more out of step with the way the Stones went about their business, but it was even harder to envision the Rolling Stones actually playing the kind of show that the hippies at the Dead's ranch seemed to have in mind.

Cutler represented the Stones. The hippies listened when he was introduced. He wanted to advise the group to show some discipline and professionalism. He laid out the Stones' perspective. He told the meeting the band wanted to play the free concert with the Dead, but the event needed to be organized. The Stones could not be expected to show up and play from the back of a flatbed truck. Cutler made it clear the band insisted on the same level of production as their regulation concerts. The Dead would prepare the production. Chip Monck, the tour technical director, would be in charge of the staging. The Stones would come and play.

When Cutler returned to the Dead office, he sat in a car in the parking lot smoking a joint with one of the girls from the office. A Harley-Davidson pulled up alongside bearing a fearsome giant in Hells Angels colors sporting a coiled bullwhip, Terry the Tramp. His visit inside was brief, and as he left, he stopped to say a word to the secretary.

"Tell Bear I dropped by," he said and roared off on his bike.

That night, Scully took Cutler over to Ken Kesey's place in North Beach to meet the Hells Angels.

7

$500 for Beer

The Hells Angels' first turn on the San Francisco rock scene was not their volunteer work at the Human Be-In. From the start, the Angels had belonged to Haight-Ashbury street life and the San Francisco rock underground. Their Harleys routinely lined the sidewalk in front of the Carousel Ballroom, where the Angels once held a wild and crazy fund-raiser featuring Big Brother and the Holding Company. They spilled so much beer, it leaked through the floor into the carpet showroom downstairs.

Their bikes regularly cruised Haight Street. The San Francisco chapter held meetings at the Victorian on Ashbury Street where S.F. chapter president Bob Roberts lived. Some of the more colorful members were well-known figures on the Haight, where the Angels mixed amiably enough with the hippies. They wore their colors backstage at shows and showed up on their bikes to all the concerts in the park, parking in inviolate clusters. They liked the music scene. And everybody there knew what it meant to touch one of those bikes, even the cops.

Some of the Angels hung out with the bands. The Dead crew

were pals with Angels and they would even ride bikes together. It was not uncommon to see Harleys parked outside the Dead headquarters and Angels sitting around inside. The Angels also knew the members of the Airplane and the other bands. Gut Turk, an Oakland member from Fresno, not only designed album covers for Jefferson Airplane, but also put together and managed the power rock trio Blue Cheer, whose record of "Summertime Blues" had made the band a favorite the previous year at the Fillmore. Angels were an accepted presence in the inner circles. The bands embraced the outlaws.

The audiences also knew to expect them. Hells Angels had been a fixture at outdoor rock festivals in the San Francisco Bay Area since the first one. In June 1967, Fantasy Fair and Magic Mountain Music Festival, on top of Mount Tamalpais in Marin County, could be reached only by one small access road. The audience was bused in from parking lots below, but the road quickly clogged. The Angels were the saviors that day as they carried the performers up the hill on their bikes. However, at the Northern California Folk-Rock Festival in San Jose in 1968, Angels unceremoniously dumped people off the stage. They may have been part of the scene, but everybody knew they could mean trouble.

In spite of the danger, the hippies saw the Angels as fellow rebels from straight society. When cops on Haight busted a couple of especially popular Angels, Hairy Henry and Chocolate George, on dubious parole violations in December 1966, hippies surrounded the Park Station police headquarters and held a candlelight vigil for the release of the arrested bikers. Musicians, hippies, and Angels alike shared an enthusiastic interest in drugs and saw the police as a common enemy. Police hated the Angels. They stopped and ticketed the bikers for the slightest infraction: broken taillight, expired registration, any excuse. At the sight of Angels colors, officers forgot all their training. They also walked carefully around the bikers because they knew them to be trouble. But cops didn't like hippies much either.

The bands credited Ken Kesey with taming the Angels. He'd forged an unexpected common ground with the outlaw biker club through LSD. After discovering acid as a hospital test subject, the bestselling author of *One Flew over the Cuckoo's Nest* avidly embraced the chemical. He retreated to a mountaintop compound in the hills above Palo Alto, where he surrounded himself with a passel of like-minded freaks and reprobates who called themselves the Merry Pranksters and started a campaign to bring LSD to the public through a series of public events they called Acid Tests, "happenings" in the parlance of the day, that mixed sounds, lights, and improvisational rock music from a band of former folk musicians who had turned to electric rock until the influence of LSD. They called themselves the Warlocks, but were soon to change their name to the Grateful Dead.

The Angels knew Kesey. When he invited the motorcycle club to his place in the hills of La Honda in August 1965, the forty or so motorcyclists could be heard coming from miles away. They were surprised to be invited—nobody invited them anywhere. By the time the band of Angels in "running formation" arrived at the compound, they were trailing a squadron of police cruisers, lights flashing. They were greeted by a three-foot-high red, white, and blue sign reading THE MERRY PRANKSTERS WELCOME THE HELLS ANGELS. After the Pranksters closed the gate on them, the police waited quietly outside, their red lights bouncing off the trees.

Kesey, the former champion wrestler in his buckskin shirt, was the Angels' kind of guy. They were more impressed by his having been arrested for possession of marijuana than his being a bestselling author. That meant nothing to them. Serving time was a badge of honor.

The epic bacchanal lasted two days. Journalist Hunter Thompson, who was writing a book about the Hells Angels, attended and dropped acid for the first time. Beatnik poet Allen Ginsberg was there, as was Tim Leary's associate Richard

Alpert (who later became the spiritual teacher Ram Dass). The Pranksters stocked plenty of beer for the Angels. They always had copious amounts of LSD, and that day they introduced a number of the Angels to the chemical's deranging delights. The Angels loved drugs. Some of them, in fact, had already experimented privately with acid.

Sonny Barger, the rough-hewn president of the Oakland Angels chapter, knew about acid. He and his wife had tried it at their home earlier in the year, and Barger thought it was great. He worried about telling the other Angels because he thought the drug might be misunderstood by some of the Neanderthals in the club. He kept it private at first, but he was too enthusiastic for his secret not to slip. By the time he led his troops into La Honda, Barger was a seasoned acidhead.

While acid tended to make the Pranksters active and outgoing, the chemical seemed to have the opposite effect on the brutish Angels, who wandered around the grounds stoned, blissful, and calm. Bob Dylan records boomed out of the speakers in the trees. No confrontations took place. No heads were busted. The bikers did accommodate one compliant lady Prankster who was taking on all comers, but the Pranksters apparently wrote that off to overzealous partying by all involved. Angels will be Angels.

The Angels liked the San Francisco hippies, who only wanted to get high and groove. The left-wing Berkeley politicos, on the other hand, offended the Angels' patriotic sensibilities. Two months after the affair at Kesey's La Honda place, the bikers attacked antiwar protestors marching on Vietnam Day in Berkeley and kicked hippie ass in full view of the Oakland police, who didn't know whose heads to bust. Kesey and Ginsberg met with the Angels later to broker a peace treaty. Head honcho Barger agreed because he felt the Angels had made their point.

When Barger started the Oakland chapter in 1957, motorcycle clubs were springing up in the wake of the film *The Wild*

One, the 1953 movie starring Marlon Brando based on a 1947 incident in Hollister, California, where a sanctioned American Motorcycle Association race turned into a pitched battle as renegade motorcyclists rioted. Motorcycle club members were frequently alienated World War II or Korean War veterans, young working-class white men pissed off at the system and opting out. Barger himself had been kicked out of the army when they discovered he was underage. Some members affected Nazi regalia and swastikas simply to piss off the squares. When the American Motorcycle Association announced that "99 percent" of people riding motorcycles were upstanding, decent, law-abiding folks, the Angels began wearing patches that read "1%."

After the Hells Angels terrorized the podunk Central Valley town of Porterville during a Labor Day run in 1964, the club emerged as a major menace to polite society. In 1966, California attorney general Thomas Lynch issued a report condemning the club. According to Lynch, the Hells Angels had 450 members (a more accurate figure would have hovered around 100) in the state, who boasted a record of 874 felony arrests (300 convictions) and more than 1,000 misdemeanors. The report noted that those figures would have been higher were it not for the Angels' habit of intimidating witnesses. Charges included attempted murder, assault and battery, destruction of property, drugs, weapons, and sexual aberrations. In a most unkind stroke, the report noted that "both club members and female associates seem badly in need of a bath."

By November 1965, Hells Angels Terry the Tramp and George "Baby Huey" Wethern controlled distribution of LSD in the Haight, handling Owsley's superior product. At one point they were moving more than fifty thousand hits a week. Angels were seen on the Haight daily as the grizzled cowboys in black leather stalked the streets.

The outlaw gang had struck a nerve with the public as some kind of contemporary equivalent of old-time western bank rob-

bers like the Younger boys, the James brothers, or Butch Cassidy and the Sundance Kid. Hollywood called. Squeaky-clean television personality and movie producer Dick Clark signed the Angels to appear in a cheesy cycle movie, *Hell's Angels '69*. They played nice with Clark, but it could prove dangerous to romanticize the Angels. Their antics were anything but harmless. These were real hard men who lived by their own code.

Hells Angels followed strict rules. No shooting dope. No messing with other members' women. No lying to another member. When an Angel fought a nonmember, other Angels were expected to join. The five-dollar fine levied for fistfights between members never proved much of a deterrent. But these men took their responsibilities to one another seriously. In their own way, the Angels were trustworthy—whatever they said they would do, they did. They understood the Bob Dylan line—*To live outside the law, you must be honest.*

After Cutler's trip to Mickey Hart's ranch, Scully and Emmett Grogan took him that night to Kesey's apartment in North Beach to meet with members of the San Francisco chapter, a relatively civilized bunch by Angels standards. They went to see "Pistol" Pete Knell and Bill "Sweet William" Fritch, who had celebrated Christmas the year before with the Apple Records staff in London, where they spent weeks ensconced in an office at the behest of George Harrison, allegedly recruiting new chapters of the club in England. They had met Harrison in Los Angeles and he sent a memo to the office asking them to make the Angels welcome. Knell and Sweet William shipped over a chopper and hung around the Savile Row offices for weeks, living off the largesse of The Beatles. They went to the office Christmas party, where John Lennon played Santa Claus. They were not impressed with the Rolling Stones. They weren't that impressed with The Beatles.

Also attending the meeting at Kesey's was a daring young motorcycle rider called Flash, a second-generation biker whose

father had belonged to an early motorcycle club called the Mofos. Flash had earned his Hells Angels patch the day after he graduated from Mission High School in 1967.

Cutler told the Angels that the Stones wanted to do this free concert as a gift to the people of San Francisco. Knell suggested that the Angels pick up the band at the airport and take them to the Panhandle, where they would have a stage setup waiting.

"All they have to do is bring their guitars," Knell said.

Cutler thought he was speaking with a highly placed official in the organization. Although Knell was a solid, well-respected Angel, he vied for leadership of the S.F. chapter with the actual elected president, Bob Roberts, a short, tough son of a bitch and take-care-of-business fellow who never went out of character; though Roberts was a knockout artist, if he was pissed off at someone, he would beat him up slowly. His vice president, Pete Knell, was a modern-day Viking. Physically powerful, scrupulously honest, Knell liked hippies. He loved to party and was a master at the native Angels art form of chopping bikes—redesigning and rebuilding Harleys into wholly original creations, hot-rod motorcycles. Their bikes loomed large in the lives of the Angels as works of art and treasured possessions. Knell lived in a basement apartment of a Haight-district Victorian with wire-mesh windows and a monster dog. His garage floor was always covered with several motorcycles in various stages of repair. He was close friends with Diggers like Emmett Grogan. They worked on their bikes together.

Sweet William was a reformed beatnik who was married to Lenore Kandel, the hippie poet whose collection *The Love Book* became the unexpected center of controversy when police arrested the owners of the Psychedelic Shop on Haight Street for selling the book. He was a former merchant marine who did time as a youth for robbing banks after being arrested as one of what newspapers called "the Panama Hat Robbers." He learned airplane mechanics in prison and was working at Pan Am, married

with two kids, when he met Kandel and threw it all away for a bohemian life. They lived in hippie splendor in the Haight and he became associated with the Diggers, as well as the Hells Angels.

After listening to Knell's ideas, Cutler told him he wanted the Angels to act as security.

Of course, having the Angels work security for the Stones wasn't exactly a new idea—the band had already used the British counterparts at their Hyde Park show a few months earlier. Because the Angels from the London club had worked security peacefully and without incident, it was easy to imagine the same thing happening in California.

But these Angels were a very different sort, and Cutler had no idea who he was dealing with. The Hells Angels who guarded the stage at the Rolling Stones concert in Hyde Park were a joke. They rode mopeds. They wore clean, polished leathers. He didn't understand these California originals. There was a culture gap as wide as the Atlantic Ocean.

From the distant vantage point of Great Britain, the entire San Francisco rock scene had been little more than a delicious rumor until recently—Jagger and the rest of the Stones may have been taken with their vision of the scene, but they couldn't distinguish the details. Now that Cutler was finally viewing it up close, that vision remained nearsighted. As far as he or the band could tell, the Hells Angels came with the hippies and concerts in the park; it was all part of this mythical West Coast ethos. The Stones aspired to what came naturally to the San Francisco bands—authenticity. While the Stones clearly did not understand the nuances of the day's U.S. rock scene—let alone the strange, fragile relationship between the Hells Angels and the counterculture—they clearly hoped to borrow some of the currency of the underground, recalibrated, of course, to suit their grand scale. They wanted the whole deal, Angels included.

Even Knell was immediately wary. "We ain't no cops," he said.

Cutler assured him that the Stones carried their own security force, thinking of Jon Jaymes's people, and he wasn't asking the Angels to act as police. He sketched out a more amorphous role, with the Angels responsible for helping people, giving directions, keeping the civilians out of backstage. He wouldn't dream that he could hire the Angels as a security force. He invited the Angels to park their bikes by the generators, as they always did, and join the party.

"We like beer," said Knell.

In what would become one of the most famous financial transactions since the Dutch bought Manhattan from the Indians for $24, Cutler agreed to provide $500 for beer.

CUTLER RETURNED TO Hollywood the next day, where he found only slight interest in his report of the meetings up north. He was dubious of the Dead's organizational skills and suspicious of the rise of Jon Jaymes with his shady connections and obvious ambition. Jagger brushed off his concerns. The plan still called for the show to move forward with the Dead organizing and the surprise reveal of the Stones on the bill at the last minute.

While Cutler was in San Francisco, Jagger and Richards had been busy in Hollywood's Elektra Studios with last-minute touches on the impending *Let It Bleed* album. They were also preparing to promote it. The day Cutler went to San Francisco, the band had filmed three songs for the boring old *Ed Sullivan Show* at CBS Television City, next to the Farmers' Market in Hollywood.

"We wanted to do something more far-out," Jagger had told a Chicago press conference, "but there really isn't anything more far-out. It doesn't matter what you do because one minute you're a washing machine, the next something else. It's like an antique show."

The Stones had been doing *The Ed Sullivan Show* since the band's first tour. As far as they knew, appearing on the old-

fashioned variety show was what you did, even though by 1969, Sullivan was looking long in the tooth and there were other, fresher shows on American television. Of course, the band ignored all the other options and went with what they had always done, lip-synching their new record to the American audience on a dated program that was by that time widely considered the most unhip show on TV.

Performing in front of a wall of crumpled purple-and-violet tinfoil, the Stones pretended to play their instruments while Jagger sang to a prerecorded track. After the first song, "Gimme Shelter," Sullivan, known as "Dad" to everyone on the set, wandered out from the wings.

"That was great, Mick," he said. "Glad to have you back on the show. What are you going to sing for us now?"

Stunned at this preposterous moment, Jagger couldn't help himself and burst into laughter. Sullivan looked mystified. Richards started to laugh too, and dashed behind the tinfoil wall. The audience tittered. "Cut," came a voice from the dark. Two more takes and the Stones were on their way back to the house.

The night before the band left for tour again, Jagger finally caught up with Miss Pamela. They had managed one other close encounter before the band left Hollywood the first time. Miss Pamela had made a shirt for Jagger and she brought it to him at the Ike and Tina show at the Hollywood niterie PJ's. He got her alone later and managed to push up her short little skirt and slobber all over her thighs, but Miss Pamela remained resolute. That was before her disappointing rendezvous with Jimmy Page in Sausalito.

With the Stones back in town one last time, and no longer feeling like she needed to stay loyal to Page, Miss Pamela outfitted herself like a coquette cream puff and headed out to the Whisky to see The Kinks on the assumption that the Stones would be in the house. The group was indeed seated at booth

number one, and the twenty-one-year-old beauty was promptly ushered into the seat next to Jagger, who was dressed in a green velvet suit. She reached under the table and curled her fingers around Jagger to let him know tonight was the night. The band left for New York to resume the tour the next morning. Richards, who had gone clothes shopping with Gram Parsons, almost missed the flight.

8

Back on the Road

By the time the Stones rolled into New York City on Sunday, November 23, they were the hottest rock band in the world. They could see they had become something more than a fashionable pop group on the hit parade. They had become a social/cultural force all their own. For the first time, Mick Jagger could glimpse a future where the Rolling Stones were bigger than The Beatles. It was an intoxicating vision.

The band would quarter in Manhattan for the second leg of the tour, which would culminate with three sold-out Madison Square Garden shows. It had been a brilliant stroke, however unintentional, to start the tour in the remote West Coast and let the ecstatic word of mouth and excitement from all the previous concerts build into ever-increasing waves that crashed on the East Coast about the same time the band arrived there. With the new album on the cusp of release and Garden shows about to take place, the Stones had the media capital of the world, New York, at their feet.

Jagger could see what was happening. Radio stations were

pounding Stones records. Tracks from the new record mingled with classic hits. The stations couldn't get enough. "The Rolling Stones are in New York," deejays crowed. Newspapers and magazines clamored for interviews. Invites flooded the band. *The Ed Sullivan Show* appearance aired nationwide that Sunday night. Everybody wanted a piece of the Stones. Famed fashion photographer Cecil Beaton asked Jagger to pose for *Vogue* while he was in town.

As famous as they had been, this was a heady new world for the band. The new album, *Let It Bleed,* due to be released the week after the tour ended, had already sold more than a million copies prerelease and was clearly destined to be the bestselling Stones album yet. The label wanted to record the Madison Square Garden shows for a live album. The band checked into the Plaza Hotel overlooking Fifth Avenue and Central Park, a long way from the Holiday Inn at Fort Collins.

Once he landed at the hotel, Keith Richards grabbed Sam Cutler and longtime Stones road manager Ian Stewart and took a cab to Manny's Music on 48th Street, where he bought a dozen guitars and repaired to his hotel room for the rest of the evening. Jagger went out to dinner. Charlie Watts went to hear some jazz, and the other Stones likewise dispersed. Cutler passed the evening over drinks in the hotel bar with his friend Chesley Millikin, in town from London for the shows. The next morning the band flew to Detroit to resume the tour.

In Detroit on Monday night, November 24, fresh from the week's layoff in Hollywood, the band uncorked the finest performance of the tour to date. With the crowd sprinkled with far more black faces than at any previous show, Jagger was in his element—sassy, animated, and utterly convincing. The band went off like detonating grenades behind him. The Stones returned to New York that night and traveled to Philadelphia the next night. Returning to the Plaza around midnight from Philly, Cutler was amazed to see a distinguished-looking bellman in full

uniform wheeling across the lobby a giant blue tank of nitrous oxide. Another bellboy struggled with a load of luggage, and, behind them, directing the enterprise, was a man with a tangled mass of red hair and a missing hand. Goldfinger was in town.

The next day, Jagger invited Albert and David Maysles, the filmmakers Haskell Wexler had recommended to the Stones in Los Angeles before the start of the tour, to his suite. The Maysles brothers were leaders in the burgeoning world of cinema verité, a highly personal approach to documentary filmmaking. With no previous experience making films, Albert Maysles shot his first movie, about mental hospitals in the Soviet Union, in 1955 as an extension of his work with a research project at Massachusetts General Hospital. He and his brother continued to make news films for television, but their work with documentary directors D. A. Pennebaker and Richard Leacock, who would later make the concert film *Monterey Pop,* gave the Maysleses new focus and energy. Their 1966 film *A Visit with Truman Capote* pointed them in the direction of his "nonfiction novel," *In Cold Blood.* The Maysleses determined they wanted to make nonfiction films going forward. They spent three years putting together their breakthrough work, *Salesman,* the landmark 1969 movie that followed the lives of four ordinary Bible salesmen.

The Maysleses were genial, down-to-earth older gentlemen. They knew next to nothing about the Rolling Stones. Jagger went over the songs the band would be performing, noting what he thought the highlights were. He described the show and talked about the lighting. Jagger was clearly intent on making a movie, even if he didn't make the scope of the project obvious to the filmmakers. Al Maysles thought he was being hired to shoot the Madison Square Garden shows—nothing was said about a free concert in California.

Since they had never seen the Stones, the brothers decided to go to Baltimore that night and watch the band before making up their minds. The Stones made the trip by Learjet; the rest of

their party traveled by bus. The Maysleses came on their own and arrived late. They caught only the last three numbers, but what they did see convinced them that the Stones were probably the best rock band in the world and that they should make the movie. The next morning, they signed a short, hastily drawn agreement with Ronnie Schneider and received $14,000 from the Stones. Then they quickly hustled together a crew to shoot the show that night at the Garden.

Stanley Goldstein was hired to record audio for cameraman Albert Maysles. Goldstein, a former recording engineer, had been the first employee hired to help organize Woodstock. He carried a Sennheiser microphone, a Nagra tape recorder, and a bag of tapes over his shoulder. One of Jagger's chief concerns was that no concessions be made on behalf of the film crew. There would be no change in the lighting or the staging and the film crew members needed to be out of the way of the audience's view.

Maysles positioned himself in front of the stage, but couldn't get the angle he wanted. Goldstein handed the bag of tapes to another cameraman, future Oscar winner Barbara Koppel, and propped Maysles on his shoulders, while Koppel braced his back, forming a kind of human tripod.

Even for jaded New York City, the concert was a big deal. The $3.50 cheap seats for the Madison Square Garden shows were being scalped for $20 a pair, if you could find them. The gross box office for the three shows topped $286,000. The day tickets went on sale, the box office opened two hours early to accommodate the 6,000 people already waiting. In eleven hours and forty-five minutes, all 30,936 tickets to the two shows were gone. The first concert was Thanksgiving night, November 27, with the second on Friday night, November 28. A Friday matinee was added and also sold out. At the first show, the crowd rushed the stage at the first number and jammed the aisles, while people stood on their chairs and stayed there through the rest of the show. The scene was repeated at all the other shows.

Backstage sparkled with big-city glitz and celebrities. Leonard Bernstein in a black turtleneck brought his family to visit the band and they caught the show from behind the amplifiers. Murray the K, the New York deejay who had presented the first U.S. show by the Stones in 1964, was around. In the audience were Leonard Cohen, Paul Simon, Woody Allen, and Andy Warhol. Jefferson Airplane were in town and came to the show. Allen Klein was there. Producer Glyn Johns manned the remote recording truck outside, thinking about making a double-record set that would feature opening acts Ike and Tina Turner, B. B. King, and Terry Reid on one record and the Stones on the other.

BACK IN SAN Francisco, Bert Kanegson, the park permit guru of the Grateful Dead whom Rock Scully had enlisted to clear the way for the secret Stones show, had lined up the support he needed in private talks with parks commissioners, but they felt for an event of this magnitude they wanted the vote of the full board. They added the Dead's permit request for the Polo Fields in Golden Gate Park to the agenda for the next morning's meeting for what was expected to be rubber-stamp approval. That afternoon, Kanegson received a disturbing phone call from Rock Scully.

"You have to cancel the meeting with the commission," he said. "I just got a call from Sam Cutler. The Stones are going to handle this directly with the mayor."

"That won't work," Kanegson said. "What going on?"

"You have to cancel the meeting," Scully said.

"Rock, I thought this was our show," Kanegson said. "Who's in charge here?"

"I don't know who's in charge," said Scully.

With Scully's admission, Kanegson's heart sank. He knew in an instant that the situation was beyond their control and there would be no retrieving it. Kanegson had the permit approval arranged with park commissioners he knew. If the Stones' front

office, whoever that was, planned to take matters up directly with the mayor's office, there was going to be trouble. There would be no permits.

Mayor Joe Alioto was no friend of the hippies. He had met the growing problems in the Haight with an increased police presence. Violent encounters between hippies and cops grew to become commonplace in the wake of the Summer of Love. An avowed law-and-order mayor, Alioto wasn't going to countenance any grooving in the park with the Rolling Stones, and anybody who wanted to represent the Stones' case to the mayor's office would soon find that out. Kanegson knew better, but for the Stones camp, Jon Jaymes, the self-styled "man who can fix everything," stepped up to take charge of the negotiations with the city.

"We can have permits in forty-eight hours," he told Scully—strong words from someone not only unknown in the San Francisco music scene, but also largely unknown to the Stones as well.

Still, it was impossible to ignore that in a matter of weeks an apparent shift of power inside the brain trust of the Rolling Stones tour was moving Jaymes into a more prominent leadership role. Only a short time earlier, Cutler had returned from his disorganized meeting with the Dead at the Novato ranch, only to have his concerns about working with the Dead ignored by Jagger. Now suddenly the whole show was drifting away from a partnership with the Dead. Whether it was because of Cutler's concerns or other elements in the Stones organization remained to be seen, but the result was that Scully's vision for the show, the vision that had started all of this in the first place, was disintegrating.

What was emerging in its place was a Rolling Stones concert that would apparently be done on their terms, an event that had seemingly left Jaymes with a larger share of control over the free concert than he'd had at any point during the tour. Jaymes, the

man whom no one knew. Jaymes, the man who had worked his way into the tour's inner circle using off-duty East Coast cops and cars from Chrysler. Jaymes, the only guy in the bunch not on the Stones' payroll, was now apparently in charge of securing permits and paving the way for the biggest free concert that Northern California had ever seen.

The plan didn't take long to fail. Without any understanding of San Francisco or its politics, Jaymes thought that the power of the Rolling Stones name would be all the influence he would need to gain the permits, but of course Scully and Grogan knew better. The Rolling Stones name only poisoned any possibility of using Golden Gate Park. As soon as the mayor's office caught a whiff of the affair, the park was out of the question. Another site had to be found.

The Stones were a runaway force of nature far outside the humble world of the Dead. Kanegson grew worried about what they had wrought and what would happen next. If they weren't in control, he wondered who was.

News of the Stones' free concert first broke that Friday in the *Los Angeles Free Press* under the headline COME CELEBRATE. Ralph Gleason followed the announcement with more details in the *San Francisco Chronicle* on Monday. At this stage, as rumor turned into reality, the misinformation in the initial reports reflected the lack of exact plans on the part of the Stones. Both reports, for instance, thought the concert would still be held in Golden Gate Park, when the Stones actually had no idea where the show might take place, having already blown the park.

According to Gleason, the event would take place in Golden Gate Park on either December 6 or 7. He said the bill would also include the Grateful Dead, Dr. John the Night Tripper, folk-singer Fred Neil, and also possibly The Band and Indian saro-dist Ali Akbar Khan. Gleason noted that permits for the park had yet to be applied for.

Gleason also said that Haskell Wexler would be filming the

event and, quoting a source "involved in setting it all up" (probably Grogan), proceeds would be distributed to groups "that do things free." The San Francisco Mime Troupe would appear elsewhere in the park, and various ethnic musicians would supply additional music, Gleason said. He speculated that the crowd could be "bigger than Woodstock."

"Plans call for the Hells Angels to be a part of the day-long free show," Gleason wrote. "They are to staff a truck with free ice and free beer."

IN NEW YORK the morning of Friday, November 28, the Rolling Stones hosted a press conference high above Rockefeller Center in the Rainbow Room. With an open bar and every itinerant music journalist in town guzzling the free drinks as fast as they could, the place was a Manhattan zoo, untamed enough to make the raucous Los Angeles press confab look like a tea party.

As soon as the Stones arrayed themselves behind the tangle of microphones, the mob pressed forward and started shouting questions. Cutler tried to bring them to order. Behind the Stones, a dozen beefy torpedoes in dark glasses stood along the wall, scanning the room impassively. Jon Jaymes, back on his home turf, had delivered this cadre of tough guys who followed the Stones everywhere as soon as they hit New York.

Wearing a white tailored sport coat and peach-colored ruffled shirt, open at the neck, Jagger engaged in inane banter with the press corps ("How do you like mob scenes like this, Mick?") with a vaguely haughty air of bemusement. A reporter spoke up.

"You sang you couldn't get 'no satisfaction,'" she said. "Are you any more satisfied now?"

"How do you mean, sexually or other?" said Jagger, cracking a smile. "Sexually satisfied. Financially, no. Philosophically, trying."

The next reporter, less than three minutes into the event,

dropped the headline question. "I read in the paper that you were planning to do a free concert in San Francisco . . ."

"Ah," interjected Jagger, ready to make his announcement. "Yes, we are doing a free concert in San Francisco on December . . . uh [Ronnie Schneider behind him muttered, "Six"] . . . six and, uh, the location is not Golden Gate Park, but somewhere adjacent which is a bit larger, which I won't know until seven thirty this evening. But it's definitely on. And it's on all day December the sixth."

Schneider and Jaymes had only that morning told Jagger about losing Golden Gate Park. They also told him they were looking into alternative sites, although none had yet come to light. It would take five more days to find another location.

"Why don't you do a free concert in New York?" shouted one reporter over the din.

"Because New York is too cold," said Jagger. "We're going to do it outside, man. And San Francisco is really into that sort of thing."

The press conference degenerated from there. The news had been broken. The announcement had been made. The game was afoot. And now, of course, the show must go on, even if Jagger didn't know where it was going to be. Al Maysles showed up late and missed any mention of a free concert in San Francisco.

That night at the Garden, after another sensational show at the matinee, Jimi Hendrix visited backstage before the evening concert. He sat quietly, almost shyly, next to Mick Taylor, who handed him his guitar. Hendrix smiled apologetically. Taylor was a right-handed guitarist, and for Hendrix to play his guitar, the left-hander would have to restring Taylor's entire instrument. Still Hendrix couldn't help riffing up and down the fretboard, bending everyone's head with what he was playing. A drunken Janis Joplin stood around grinning. When it came time for Cutler to clear the room before the show, Joplin resisted.

"Hey, don't you know who I am, man?" she asked Cutler.

Cutler, wise in the ways of backstage politics, knew better than to get heavy with the inebriated diva. "Janis, how would you like a line of cocaine?" he asked.

She brightened right up and told him to break it out.

"Not here," said Cutler. "Come with me."

He took Joplin down the hall to a room guarded by one of Jaymes's thugs, where Goldfinger sat behind a table with a bag in front of him.

"Ken, you old bastard," shouted Joplin, jumping to hug him. "What are you doing here?"

Goldfinger helped the wobbly Joplin to the side of the stage to watch the show. She was celebrating having sung a number with Ike and Tina Turner before the Stones set and was feeling no pain. If Goldfinger hadn't found her a chair, she would have fallen down.

Cutler, swept up in the New York fervor, abandoned his customary terse introductions for the band onstage.

"Everything seems to be ready," he said to the crowd. "Are you ready? We're sorry for the delay. Is everybody ready for the next band?"

Cheers.

"Are you ready, New York? Ready for the biggest band to visit New York in a long time? They've done the West Coast. They've done all sorts of other places in America. Now they're in New York. Let's be cool. Have a fantastic time. Now let's really hear it . . .

"Let's welcome the greatest rock band in the world—the Rolling Stones . . . The ROLLING STONES."

For the third time in two days, the band simply destroyed the hall. New York had fallen. The Rolling Stones were masters of their universe. America had surrendered. The Stones had achieved total domination. Bigger than The Beatles? These had been unimaginable heights for these men. And they did it with five guys on borrowed gear and the music. Jagger was in a supremely confident mood onstage.

"I think I've busted a button on me trousers," he said. "I hope they don't fall down. You don't want me trousers to fall down, do you?"

At the end of the show, Jagger threw the whole basket of roses into the audience, not just handfuls, and petals rained down on the crowd.

The Maysles followed the Stones to Boston the next night, Saturday, November 29. As the party left Logan Airport, a throng of reporters and television cameramen were waiting on the sidewalk. News of the free concert in California spread quickly. One reporter thrust a microphone in Jagger's face.

"Mick, will this be a free concert?" he asked.

"Ask the promoter," said Jagger, sliding into a waiting limousine.

The next day the band left the Plaza in New York late for the Marine Air Terminal to board a chartered jet to the last date of the tour, Sunday, November 30, at the Palm Beach Pop Festival in Florida. The pilot informed them that they had lost their place in line and departure would be delayed. The hours ticked past. A snow flurry came and went. Air Force One ferrying Richard Nixon held them up. They continued to wait on the tarmac. The band, due to close the climactic Sunday show at midnight, finally left the ground at ten o'clock after changing planes, eight hours late.

The Stones had been monitoring the situation at the three-day festival. Inflamed by reports of open drug use and sex at Woodstock, Florida law enforcement came down hard on the event. The sheriff positioned 150 deputies around the speedway where the festival was being held. They arrested more than 150. The governor of Florida felt compelled to visit the site and praise the police.

More than forty thousand hardy souls braved the event, which also featured stars of Woodstock such as Janis Joplin, Sly and the Family Stone, Jefferson Airplane, and Iron Butterfly. A chilling rain dropped temperatures below forty degrees.

With the festival producers' approval, the audience tore down the wooden bleachers and burned them for warmth. At four in the freezing morning, when the Stones finally arrived, only a fraction of the audience remained. Cutler asked them to wake up. The Stones finished their set and the tour came to an end as a thin red crack opened up along the horizon.

An hour later, an LSD-crazed kid from the concert ran screaming into the highway and was killed by a dump truck.

9

On to San Francisco

With the advance team of Sam Cutler, Chip Monck, and Jo Bergman off to San Francisco to pull together the free concert in California six days away, the Rolling Stones (followed by the Maysleses) went to Muscle Shoals, Alabama, for a few days' recording. With the band's best album yet, *Let It Bleed*, released that week and the group energized by their powerful new sound on this tour, the Stones wanted to keep pumping out new material.

Since the Stones' visas limited the band to live performances, recording had to be done off the books. The group already had run into problems with the Musicians' Union in Los Angeles, but had been able to send those guys away with a few autographed albums. More important, they also needed to keep the sessions secret from ex-manager Allen Klein, who might think he had some contractual interest in the resulting masters.

While he was in New York, Jagger had made arrangements to use Muscle Shoals, the remote studio in the Tennessee River Valley, through Atlantic Records president Ahmet Ertegun,

who was no stranger to subterfuge and dearly hoped to sign the Stones when the band's contract with Decca expired the next year. Some of the greatest soul records of the past couple of years had come out of this cotton patch—Percy Sledge's "When a Man Loves a Woman," Wilson Pickett's "Mustang Sally," Joe Tex's "Show Me." Atlantic Records producer Jerry Wexler first went down when he brought Aretha Franklin in 1967 to record her stunning Atlantic debut, "I Never Loved a Man (The Way I Love You)." Atlantic subsequently practically adopted Muscle Shoals as a base of operations. Ertegun made sure there would be no problems with the Stones holding secret sessions.

Muscle Shoals Sound Studios were run by musicians Roger Hawkins and Jimmy Johnson, session players who split with producer Rick Hall and his nearby FAME Studios, where they had first established Muscle Shoals as a recording center. In April 1969, Hall signed a million-dollar deal with Capitol Records that he failed to adequately share with his rhythm section. They felt, no doubt with some justification, that they were at least partly responsible for his success. The musicians picked up their gear and opened their own eight-track studio in an old coffin factory on Jackson Highway. Wexler loaned them $50,000 of Atlantic's money to fund the enterprise.

The Stones were always huge fans of American rhythm and blues. The highlight of the band's first U.S. tour in 1964 was two days of recording at the hallowed Chess Records studios in Chicago, where the band's heroes such as Chuck Berry, Bo Diddley, Muddy Waters, and Howlin' Wolf had made their records. Muscle Shoals was the perfect hideaway studio for the Stones. The band checked into a Holiday Inn across the river in Florence, Alabama, and went to work.

Tight as lug nuts after a month on the road, the band started the first night running a new song called "Brown Sugar," Jagger scribbling the lyrics on a yellow legal pad in the studio. The next day, they cut the track in two takes. Richards had a song he had

written, a lullaby for his baby son, Marlon. Jagger rewrote the lyrics as a devotional love song built around Marianne Faithfull's hospital bed exclamation, "Wild Horses." Ian Stewart, who had been with the band since the tour's first rehearsal, played piano on "Brown Sugar," as he frequently did on Stones sessions, but wouldn't touch "Wild Horses" because it contained a minor chord and Stewart would not play the black keys. It was a matter of principle to the boogie-woogie pianist. Pianist Jim Dickinson had been alerted to the sessions by writer Stanley Booth, who was traveling with the Stones and writing a book, and made the three-hour drive from Memphis. Dickinson, the only other musician in the room, slipped in behind the keyboard. They did "Wild Horses" in two takes.

The band tucked away those two tracks—along with a cover of the Mississippi Fred McDowell Delta blues "You Got to Move"—in four nights, covering the wide corners of the Stones' new sound, building off the framework of *Let It Bleed;* from the crunching rock of "Brown Sugar" to the countrified melancholy of "Wild Horses" to the acoustic country blues of "You Got to Move." These recordings pulsed with the band's fresh perspective and confidence, the growing sense of self that had been emerging since they first hit the States in October.

Jagger stayed in touch with progress on the California concert by telephone. He spoke on the phone to *Rolling Stone* from the studio, where he told them he was "fishing." Asked if he was catching anything, he said, "Mostly grass."

The concert team in San Francisco was frantically seeking a new site now that Golden Gate Park was not possible. When *Rolling Stone* asked about the free concert, a frustrated Jagger said, "It all depends on whether we can get a place. There are so many obstacles put in front of us. It's gotten so fucking complicated."

But trying to be upbeat, Jagger expressed enthusiasm for the festival program, looking forward, he said, to "not just play one set and then go, but make a day of it."

He was asked when the band had decided to do a free concert. "It was when we first fucking got to Los Angeles, the first stop," he said. "We decided right then to do it after the tour was over. We wanted to do Los Angeles because the weather's better. But there's no place to do it there, and we were assured we could do it much more easily in San Francisco."

Asked about the expense associated with the free concert, cheeky Jagger turned mock serious. "Well, I wanted to do the whole tour for free, because, y'know, I'm richer than the other fellas and I can afford it," he said.

"I'm just joking," he added.

In San Francisco, Cutler, Bergman, and Monck found mass confusion and near chaos. Cutler arrived by himself on Tuesday, December 2, with $1,000 in cash and no hotel room. Nobody met him at the airport. He grabbed a cab to the Dead offices forty-five minutes north. The organizers had set up operations at the Dead warehouse in Novato, where Scully, a handful of volunteers, and the ladies in the office had been swamped with the plans for the concert.

The film producers also scrambled to keep up with onrushing events. They had followed the Stones from New York to Boston, Florida, and Muscle Shoals, only learning about the free concert on the West Coast in the last minutes. Clearly this was the climactic scene of the film that Jagger had long envisioned, but in his distracted, often haughty way had neglected to inform the filmmakers about. They needed to scramble to expand the crew and arrange the daunting logistics.

When Al Maysles finally learned about the plans for the free concert, the Maylseses dispatched Stanley Goldstein to San Francisco to advance the film shoot and put together a crew at the last minute. When Goldstein arrived, he found the entire situation dangerously close to collapsing—not only were they still missing a venue for the show, but no one seemed to have any idea who was in charge.

Goldstein contacted the well-known San Francisco attorney Melvin Belli, a flamboyant character who courted both celebrities and controversy. The self-styled "King of Torts" had famously represented Jack Ruby, the killer of Lee Harvey Oswald. Not shy, Belli operated in a giant, cluttered Victorian ground-floor office stuffed with law books, curios, and whimsical knickknacks, fully visible to passersby from large windows on the street in the busy financial district. Christmas wreaths were hung on his windows. A stout man, with a gold watch chain always straining against his bulging vest, he had a puffy, blotchy face framed by circular horn-rimmed glasses and a stately silver mane, cowboy boots on his feet, a Dickensian lawyer in a Wild West setting. Ultimately, Belli would contribute little beyond bluster and posture, but Goldstein thought his local connections and influence might prove useful.

In search of a location, Scully took Monck and Cutler up to the Sears Point Raceway outside Sonoma, about a half hour from the Dead office. It was a freak idea someone came up with brainstorming at the Dead office, trying to think of somewhere in the region to hold a massive free concert. Founder Craig Murray was a tough, dynamic visionary, a former stockbroker who put together the original partnership to build the raceway. He had held the first race a year before and had recently completed the sale of the raceway to corporate interests. Murray thought this would be a tremendous opportunity.

Sears Point had a lot to offer. Sitting at the intersection of two major highways, the thousand-acre raceway was well prepared to deal with large crowds. There was parking for one hundred thousand cars, toilets, concession stands, water, electricity, room for a large backstage area. Security was already in place and police support close at hand. The inside of the track created a huge bowl effect with a twenty-foot rise at the end that, sculpted by a bulldozer, would make a perfect setting for a stage. It would provide a natural barrier between the audience and the stage.

Monck was enthusiastic, but Cutler thought the site "aesthetically unpleasing." He may have been thinking about the movie.

Belli sent Cutler to another piece of land, owned by clients of his, the Knights of Columbus, also off Highway 101 in Marin County, which Cutler found entirely unacceptable—little more than a derelict orchard with no access roads—much to Belli's displeasure.

Despite Cutler's skepticism, Belli was taking control. He had held lengthy conversations on the phone with Ronnie Schneider and met with Jon Jaymes, who had already showed up in San Francisco. Cutler couldn't tell who was in charge.

Another community meeting was held that Tuesday night at the Dead headquarters in Novato. Members of the Dead and Santana settled into chairs and sofas or sat on desks alongside crew members, women from the office, a handful of Hells Angels, Chet Helms and the Family Dog at the Great Highway crew, band members' girlfriends, various and sundry hippies, and a few dogs. There was a lot of discussion and a fair amount of dissension. The San Francisco Mime Troupe, one of the groups responsible for scuttling the Wild West Festival, had already released a statement belittling reports that they were going to participate in any way in what they saw as this pig capitalist enterprise. They were committed to the movement. Music belonged to the people. The discussion grew heated. Voices were raised. *Rolling Stone* reporter John Burks, who was covering the meeting, was so appalled at the idea of the Hells Angels providing security that he stepped out of his press persona to speak out. Emmett Grogan, who'd discussed the show with Jagger and Scully down in Hollywood, worried about who the vendors were going to be, hippies or sleazy capitalists. Everyone had an opinion and none of them were aligned—the counterculture eating its own once again.

Cutler watched in shock at the chaos. The concert was less than four days away. It seemed impossible to do. It seemed

impossible to stop. At one point, Grogan quietly went to the blackboard and wrote, "Charlie Manson Memorial Hippie Love Death Cult Festival."

Cutler called Jagger and told him the whole thing was falling apart. Jagger told him to talk to Ronnie Schneider, who would be arriving the next day, Wednesday, December 3, but by the time Schneider got there, things had grown even more confusing. Jon Jaymes had begun to take even more of a leadership role, conferring with Belli like he was the client, not the Stones. Schneider and Jaymes met with Sears Point owner Craig Murray to cut a deal for the raceway. Murray offered the site for the concert for free provided all necessary permits were obtained, insurance was purchased, and all expenses connected with preparing the site for the concert were covered. Murray also wanted any profits from any recordings or films to go to a Vietnamese orphans' fund. Jaymes promised Craig Murray he would provide a hundred off-duty East Coast police officers as security.

"The only reason we're partaking in this is because the cause is a good one—Vietnamese war relief," a visibly nervous Murray told the press late that afternoon at the site. He was told as many as two hundred thousand people might attend; his biggest previous crowd had been forty thousand.

Rock Scully told reporters at the racetrack that they would raise the stage and build the production in "a three-day blitz." He warned the public that no overnight camping would be allowed and gates to the raceway would not be opened until 7 a.m. Saturday morning. "Our carpenters are going to be working around the clock. They mustn't be hindered," Scully said.

Swept along by the momentum of the event, Scully accepted Sears Point as a reasonable alternative to Golden Gate Park, but Terry the Tramp had warned him that moving the concert out of San Francisco would change the jurisdiction among the Hells Angels. If the concert had been held in San Francisco, the local chapter would be in charge. One of the more civilized chapters,

the San Francisco club played nice with the hippies. Tramp understood that Sears Point would be vastly different than another concert in the park with the Dead. In Sonoma, there would be no chapter in charge, and Tramp knew that could spell trouble. Off the S.F. Angels' turf, it would be anyone's game.

Chip Monck had the scaffolding delivered for his light towers and stage at Sears Point. Three days was enough to accomplish what he needed. From the Dead's camp, Bear was putting together the sound system. Phone lines were installed. Gear was provided by a number of companies. Stagehands, equipment guys from all the bands, and plain civilians volunteered. Dan Healey, soundman for Quicksilver Messenger Service and a veteran of Dead audio, was there. He was well versed in Bear's idiosyncrasies and knew to step up when Bear's attention wandered, which it inevitably did. One of the local radio stations loaned the production their traffic helicopter.

The Bay Area radio stations had adopted the concert like a prize promotion, competing savagely against one another for the latest scoops, the hottest news, the most Stones tracks on the air. Not only the FM rock stations like KSAN, the granddaddy of underground radio, jumped on the concert, but also the Top Forty stations that blanketed most of Northern California with their broad-beam AM radio signals. Each station promised to be the first with the latest news—stay tuned. Kids all over the state, no, all over the country, were already making their way to San Francisco that weekend. The radio stations were whipping up the hysteria and spreading it far and wide. By late afternoon Wednesday, the news of the Sears Point location had leaked and the stations were blasting the news.

On Thursday morning, December 4, Ken Clapp, vice president of the Sears Point Raceway and one of the original partners who had opened the track in October 1968, drove onto the site and headed up to the north end of the property. There a small army of hippie workers were driving stakes into the ground,

putting up tents, laying out the stage, and building the sound towers. Trucks were stacked with scaffolding and staging. The twenty-seven thousand pounds of lighting were being hung. A bulldozer had sliced away the hill at the end of the property where they would build the stage.

Clapp was appalled. Sonoma was a small, conservative town. Nothing from the motor sports world had prepared him for the sight of dozens of haphazardly parked cars, vans, and VW buses painted with flowers and the mass of long-haired volunteers, stepping all over each other, trying to get the speedway ready for the concert. A teenage girl was dragging a newly born infant behind her in a blanket.

Clapp went back to his office a mile away and called Craig Murray at home in San Francisco. He told Murray to get out to the track as soon as he could.

"This will kill us," he told Murray. "It will put us out of business."

He phoned the Sonoma County sheriff, who headed out to the site and called an ambulance for the infant. To Clapp, it was clear that there was no leadership, no strategy, no order. He saw nothing but disaster. Murray was a military veteran who had worked in motor sports his entire adult life, and this was a new world to him. He was furious. When Murray arrived, they decided they would not make the deal they'd agreed to with Jaymes and Schneider the day before. Murray got on the phone to Melvin Belli.

Murray was also concerned because he felt Schneider and Jaymes had misrepresented the charitable aspect of the concert in their talks (privately Jagger had earlier in the tour dismissed the Vietnam War as an American issue). He told Belli that the Stones needed to handle health and safety and find a mutually acceptable charity before the concert could proceed. Negotiations stumbled to a halt.

It was the beginning of a barrage of calls. Belli next heard

from the Sonoma County sheriff, who had been alerted to the concert by Ken Clapp. Then Belli got the call from the president of Filmways, the corporation that owned the Sears Point Raceway, having acquired the track from Murray, Clapp, and their partners for $4.5 million in July 1969. In an strange turn of events, Filmways also happened to own Concerts Associates in Los Angeles, the company that had been responsible for putting on the Stones shows in L.A. and were still pissed at the Stones' heavy-handed negotiation tactics, as well as the sudden, unexplained cancellation of the planned third Los Angeles concert.

But this grudge against the band was only part of the problem. Filmways was also in the film and television business, responsible for a string of lowbrow TV programs such as *Green Acres, Mister Ed,* and *The Beverly Hillbillies.* When Filmways learned that the event was being filmed for a commercial movie and was not simply a free concert, the company demanded a $100,000 fee and distribution rights to any film made at the concert. Filmways made it clear that the company would not honor any agreement that had been made between Schneider and Murray. Schneider was apoplectic, but Filmways had the Stones over a barrel and they weren't about to let the opportunity pass.

Jagger refused to allow Schneider to negotiate the matter. He would not give up a nickel of the film's profits. An almost miraculous site that combined access, parking, built-in security, infrastructure enough to handle large crowds, Sears Point may have offered a safe harbor for the free concert once Golden Gate Park evaporated. Many of the logistics vital for successfully hosting a crowd of this size were naturally present at Sears Point, but the Stones would not budge. With both sides inflexible, once again the show would have to move.

While the behind-the-scenes drama unfolded, the band was thousands of miles away, still holed up in Muscle Shoals recording and not planning to arrive in San Francisco until Friday night. Jagger was unlikely to welcome this intrusion on his grand

plans. He had expected the universe to unfold perfectly, but the chaos and confusion—not to mention Jagger's intransience with Filmways—had boxed the band into a corner.

"We'll play in the streets if we have to," Jagger told anyone who would listen in Alabama.

On Thursday, yet another chef joined the kitchen, this time in the form of Michael Lang, one of the producers of Woodstock. An NYU college dropout who ran a head shop in Coconut Grove, Florida, Lang had promoted the 1968 Miami Pop Festival with Jimi Hendrix and others. After Lang moved to Woodstock and met Capitol Records executive Artie Kornfeld, the two decided to mount the giant rock festival that turned into the Woodstock Music & Art Fair in August. By December, Lang had cleaned up the concert site at Max Yasgur's farm. The movie of the concert was proceeding through postproduction. A million projects were walking into his office daily and he was trying to get his life together.

He came to San Francisco to lend a little Woodstock fairy dust to the Stones production. He didn't have that much actual experience with free concerts, but he joined the meeting Thursday morning at Belli's office and then left for the Dead headquarters in Novato to meet with Rock Scully, leaving the attorney to frantically negotiate with Filmways, who weren't budging.

Belli punched the buttons of his multiline call director, alternately barking and cajoling, in a room crowded with miniskirted secretaries, his Chinese American wife smiling behind designer dark glasses, emissaries from the Stones party, and a generous complement of newspaper reporters and television cameramen. Belli liked to operate under the full glare of publicity. He glanced around the room while he talked, his voice booming into the speaker phone. He was playing to an audience. Belli asked Murray to meet with him the following morning and got off the phone.

"There's no way to do the concert but in that location," said

Jon Jaymes. "As it stands now, you're going to have at least a hundred thousand kids there by Saturday morning."

Belli suggested contacting a judge and seeing if he could get a restraining order, essentially forcing Filmways to present the concert and work out the deal later. He was dubious, though. "If I was advising them," he said, "I'd tell them to hide out."

The debate continued, when, with playwright's timing, Dick Carter of the Altamont Speedway was on the line at Belli's office.

A onetime so-so race driver who had run a used car lot in Hayward, Carter had taken over the asphalt track about a year before. It was a desolate, remote location on the edge of southern Alameda County, where fierce winds whipped through the scrub and sage grass. They were still building the freeway and the track could only be reached off a small four-lane highway. Carter had held just a few successful events and was teetering on the edge of insolvency. A Stanford Business School student who was working with him as a class project heard about the Stones concert looking for a location and suggested Carter get in touch. Dick Carter was a desperate man. He didn't yet know how desperate the Rolling Stones were. He told Belli he didn't want any money; he was willing to do it for the publicity.

"You take the publicity," Belli said. "The Rolling Stones don't want any money. They're doing it for charity. So I'll take the money."

Michael Lang reported in by telephone from Novato, and listened as Belli told him about the possibility of moving the show at the last minute to Altamont. The Woodstock festival had changed sites four weeks before the concert, which proved hardship enough. With time running out at the second site, the Woodstock producers had had to choose between finishing the stage and putting up the fences and ticket booths. They decided to build the stage and unwittingly turned Woodstock into a free concert. The consensus around Belli's office before Lang called was that moving the festival at this late date would be impossible.

"We can do it," said Lang. "If we have to, we can."

Somebody needed to actually look at the site before pushing the button on moving the concert. Scully and Lang boarded the KGO helicopter in the shopping center parking lot next to the Dead headquarters in Novato and flew the sixty miles to Altamont. They cruised across the bay, over the East Bay hills, past Livermore, the last city on the route, and over the rolling hills beside the Altamont Pass that led down to the western edge of the Central Valley. The hills were barren and covered with dry grass, not a tree in sight.

As the copter came over the last rise and the hills dipped down to where the speedway sat at the bottom of the bowl, Scully looked out and wondered to himself how they could hold a concert in this godforsaken patch of scrubby land. He looked out over the racetrack and saw a landscape littered with wrecked cars, abandoned tires, oil stains, and broken glass. He didn't like what he saw. He was staring out at the land, his brain buzzing—he was trying to figure out how this site could work, struggling with his concerns.

Everything that Scully had put in motion with his trip to England had finally come to a head. Nothing had gone as planned, and, hovering in the air over this bleak scrap of land, he wondered how it had come to this. They were paying the price for the leadership vacuum that had defined things from the start and led to this dead-end speedway in the crook of two highways in the middle of nowhere. This wasn't how he'd wanted to do any of this, but he knew the concert had to happen now. Too much was in motion. There was no turning back.

That's when he heard Lang speak up.

"This is perfect," Lang said. "We can do it here."

Scully was surprised, shocked even. But this was the guy who did Woodstock. If anyone would know, he would. At least that was what Scully hoped. The decision had been made. Word went out—strike the set at Sears Point and move the concert. They had thirty-six hours.

PART 2

PART 2

10

Friday

Alameda County sheriff's deputy Dale Smith was just going off the graveyard shift at eight in the morning on Friday, December 5, when the phone rang at the tiny Santa Rita substation attached to the county jail. The captain and the day-shift lieutenant were busy, so Smith, on his way out the door, answered the phone. The caller asked if the police knew anything about the Rolling Stones holding a concert at Altamont Speedway. None of this made any sense to him, but Smith, who had never heard of the Rolling Stones, passed along the message, went home, and didn't think about the call again.

Altamont was on the far eastern end of the jurisdiction. Only two patrol cars worked out of the Santa Rita substation. One covered the nearby town of Dublin, leaving the other unit, Car 72, to handle the vast outlying areas, from east of Livermore to Pleasanton at the edge of Contra Costa County in the north and Sunol near Santa Clara County in the south, nine hundred square miles of land sprinkled with occasional ranches. The sergeant in charge of the Santa Rita station primarily ran the

county jail, while overseeing the two patrols as a kind of sideline. This part of the county needed little policing. What few people did live out east of Livermore lived far apart. Emergency calls could take a half hour to respond to simply because the distance was so great. If a deputy needed backup, they customarily called on the California Highway Patrol (CHP) since other police agencies were too remote.

The beat was lonely, especially at night. There were occasional calls for malicious mischief and trespassing. Every once in a while a dead body turned up dumped out in some cow pasture, but it was generally a quiet, sleepy patrol. Radio reception ended at the Altamont Pass and anytime a deputy went over the hill, he was on his own.

Smith, twenty-nine years old, married with three kids, had been on the force for only two years, but he had already seen plenty of action covering draft protests, the People's Park march, and antiwar rallies in Berkeley. He often joked that he spent so much time on the UC campus, they should give him a degree.

As he headed into work late Friday night from his home in Fremont, he noticed the unusual traffic congestion when he hit Highway 50 and started east through the Livermore valley to the jail. By the time he arrived at work to start his shift, the other officers at the station had long before learned about the concert at the speedway. As soon as Smith walked in the door at midnight, he was sent out to Altamont to see what was happening. He got in the police station wagon and made the familiar drive through the Altamont Pass, headed for the speedway.

Though he'd seen the increasing number of cars on his way into work, the thickening traffic heading toward the speedway still surprised him. He was used to having these roads to himself at night. As he started over the Altamont Pass, he began to see cars parked on the side of the road and people walking alongside the highway. As he got closer to the speedway, the four-lane highway was clogged with vehicles and people. The crowds spilled over the sides of the road. Traffic moved slowly.

Abandoning the highway for back roads, Smith found even Old Altamont Pass Road jammed. He turned and worked his way down Midway Road toward Patterson Pass Road. It was a scene out of a dream. Under the starless black sky, ghostly figures carrying blankets, sleeping bags, and supplies wandered down Midway Road in the same direction. Pedestrians swarmed over the stalled cars. Midway Road was a country lane with no shoulders. Autos were piled up willy-nilly on the side of the road, parked where nobody would remember the next day. As Smith slowly picked his way through the mass of people, he thought it was like driving through a herd of cattle. He was filled with apprehension, his fingers tense on the steering wheel. He had been told at the station that his backup would be the CHP, but he knew there was no way for their cruisers to get through the throng of people and tangle of cars. He inched his way through the crowd.

Smith managed to make his way to Patterson Pass in the mountains to the south, where he wound around the ridgetops on the other side of the hills, finally emerging on the crest where the valley and the speedway spread out below him. He couldn't believe what he saw.

From this vantage point, he could view the massive crowd, fifty thousand people already, all over the hillside. It didn't matter that it was dark. Under a faint fingernail moon, hundreds of small campfires sparkled across the field. At the bottom, giant highway construction lamps lit the area beside the speedway where a swarm of worker bees were raising a stage and building the sound system. Helicopters landed and took off from the racetrack oval. He could hear faint, distant noises, voices, hammers and saws, and even occasional guitar music. The empty, quiet countryside teemed with people in the middle of nowhere.

Smith had been told to go to the speedway and let his presence be known, but he quickly calculated there was little or nothing he could do there. He doubled back and headed to where he could get radio reception. He caught a call about a barn being

set on fire, but he could never find the place. There was another call about a burning bridge, but when he got there, the fire was out and he found no significant damage. He didn't see any genuine problems, but it was hard not to be concerned. Once these kids started drinking and using drugs the next day, he feared the crowd could become a problem. Whatever was going on was only getting started.

THAT FRIDAY MORNING at the Santa Rita substation, after Dale Smith had first taken the phone call about the concert and was on his way home, twenty-eight-year-old deputy George Vien was the acting daytime watch commander. His boss was on vacation. He arrived at work entirely unaware of what was going on, but he would quickly learn. It didn't take long for the concert down the road to fall out of the sky on the backward country jail. The phone rang continually. Local residents, with no knowledge of the concert, were terrified by the unexpected invasion. Two California Highway Patrol officers showed up in the front office with a naked woman wrapped in a blanket. She was barely coherent and clearly under the influence of a powerful drug, possibly LSD. They determined she was a 5150 and shipped her off to psychiatric care. Vien dispatched two deputies to take her in the backseat and deliver her to Fairmont Hospital in San Leandro.

Vien was relieved to receive a call from Chief Criminal Deputy Tom Houchins, who announced that he was coming out from downtown to take charge of the situation. Houchins rounded up a squad and headed for the concert site. Houchins was a cowboy cop, known to shoot from the hip, a fighter pilot in World War II who had commanded police troops in action at student protests throughout the East Bay the past couple of years. Some of his fellow officers thought he was a great cop; others thought he was an asshole. Nobody doubted his command presence.

Houchins established a base of operations at the Mountain

House Bar, a remote shack on the hillside about five miles north of the raceway that served beer and snacks. He convened his deputies, the CHP, and the California State Police. He took a group of officers and a bread truck down the hill to a spot above the west side of the stage that afforded a panoramic outlook. They posted themselves there and watched.

Deputy Cliff Diaz had grown up in the area and gone to the one-room Mountain House School. He drove out to the speedway around five on Friday afternoon in the Santa Rita station wagon. The station house had been fielding complaints about traffic and parked cars all day. He could still drive through the concert site over the fields. He slowly pushed his way through the crowd, which he estimated at around ten thousand and growing. He stopped to watch a group of crazy artists known as the Ant Farm, an artists' collective from Houston, erect a hundred-foot-square plastic pillow at the top of the bowl. A few years later, these characters would go on to bury a number of used Cadillacs in holes in the Texas prairie as an art piece, but at this stage they were working with oversized plastic inflatables.

Driving around the perimeter, Diaz encountered a group of local ranchers patrolling their property, rolling around in a pickup truck, armed to the teeth. He knew these people, had gone to school with them. He knew how they lived out here. These were conservative people whose nearest neighbors were a mile away. When they had problems, they didn't call the sheriff; they handled it themselves. They feared for their world. They were afraid of the fires and people trooping through their fields. Diaz convinced them to return home and wait it out. He made his way to the command post above the concert site and joined the officers. By midnight, there would be no more driving through the crowd. They watched and waited.

DICK CARTER SHOWED up Friday morning at Belli's office in San Francisco to sign the deal to throw the concert at his speed-

way. The place was still jammed with news reporters and TV cameramen, secretaries, and the Stones' representatives. Belli's office had become the de facto headquarters for the free concert in the past three days. The attorney was talking on his speaker phone with Sheriff Frank Madigan of Alameda County. The sheriff asked about parking—Carter estimated he had room for about twelve thousand cars—and Sheriff Madigan knew the Highway Patrol was going to be concerned about traffic on the highway. He did not sound happy.

Carter was a forty-four-year-old man in a necktie and silver sport coat, pencil-thin mustache above his sweaty upper lip. He was visibly out of his element, nervous and distracted. He had been operating the track for more than a year and was verging on extinction. The raceway had had several previous owners. It first opened in 1966 and soon lost its NASCAR affiliation. Altamont Speedway became a so-called outlaw track that hosted everything it could; stock cars, sprints, motorcycle races, demolition derbies. The track was located on the edge of nowhere at the intersection of two highways where gusts of wind rushed through the Altamont Pass and raked the field at thirty or forty miles per hour. The largest crowd Carter had managed to attract was sixty-five hundred people who showed up for a demolition derby.

Carter, who grew up in the East Bay city of Richmond, had been car crazy since he was a kid. He used to race for pink slips on the San Pablo Dam Road as a youth. He developed a love of motorcycles, rode with a motorcycle club named the Richmond Ramblers, and even worked as a stunt rider on a carnival circuit sideshow attraction called the Globe of Death. He worked as a car salesman and drove race cars on the side. Often racing under assumed names such as Will Bill Allen, Carter entered as many as four or five races a week. When he took over the Altamont track, he was already strapped for cash. After more than a year of operation, he had held only a few successful events. He jumped

at the chance to host the Rolling Stones, thinking that the concert would attract in the neighborhood of twenty or thirty thousand people. Dick Carter was happy. He was sure this would put Altamont on the map.

"I'm handing over the speedway at no cost—just for the publicity and to prove I'm a good guy," Carter told the press in Belli's office. "Of course, if it works out, I'll probably be presenting my own paid rock concerts there in the future."

Belli took the opportunity to hold an impromptu press conference. In addition to announcing the move to Altamont from Sears Point, the organizers took aim at Filmways for forcing them out at the last minute.

"Filmways reneged on our verbal agreement," Ronnie Schneider said, after Jon Jaymes told the press he would meet with attorney Belli on Monday to pursue the possibility of a lawsuit against the company.

Jaymes also announced that joining the Rolling Stones at the concert would be the Grateful Dead, Jefferson Airplane, Crosby, Stills, Nash & Young, and other groups. In that morning's *San Francisco Chronicle,* Ralph Gleason still reported the concert as being held at Sears Point despite a front-page article to the contrary, because the concert had been moved after the late afternoon deadline for Gleason's column. Information was sketchy, which was understandable since plans weren't set. Gleason said the only acts he could confirm Thursday afternoon were members of the Ali Akbar School of Music (who never did appear) and the Dead. "No other groups had been finally agreed on yesterday afternoon," he wrote, "but it all really depends on whom Mick Jagger wants, since it's obvious anybody will play who isn't contractually obliged to be elsewhere."

Belli drew up the contract for the use of the speedway. Carter signed the contract for the speedway, but signing for the Rolling Stones was not Sam Cutler or Ronnie Schneider or anyone who actually worked for the band, but Jon Ellsworth Jaymes,

whose company Young America Enterprises was named in the document as the producer of the concert. Belli had no idea who Jaymes was, other than how Jaymes represented himself. Schneider seemed willing to treat him like a responsible party. Belli couldn't know that Young America was the flimsiest of fronts for whatever hustle Jaymes was working. Jaymes may have even entertained fantasies of moving into some kind of partnership to manage the Rolling Stones with Schneider. Along with his shadowy associations, it was his barely concealed ambition that worried Cutler more than anything about Jaymes. Schneider and Jaymes had effectively cut off Cutler from any decision-making role, relegating him to dealing with logistics while they handled the business. Cutler, in fact, was entirely unaware of the specifics of the negotiations. He had long harbored suspicions about Jaymes. And now that his company was presenting the free concert by the Rolling Stones, Jaymes was officially in control.

At the same time that Jaymes and Carter were signing the deal in Belli's office in San Francisco, crews were already scrambling to tear down the equipment at Sears Point and ship it to the new site. Six helicopters ferried gear to Altamont all afternoon, a steady procession of choppers landing and taking off from the center of the speedway. The lights had to be taken down and shipped from Sears Point. McCune Sound, which ran the Sears Point audio, declined to loan equipment to the concert, but sound gear was airlifted out of both Sears Point and also the Dead's new, under-construction sound system from their Novato warehouse. The banana-shaped bass cabinets, freshly decorated by artist Bob Thomas, had never been used before. Each pilot needed to be paid in cash before he would take off again, and one of the crew stood by dispensing fistfuls of bills. With radio stations broadcasting regular appeals for volunteers to drive equipment from one site to the other, a convoy of trucks, vans, and VW buses showed up at Sears Point and hauled gear,

rigging, cables. They came in all sizes and kinds of vehicles, a rock and roll Dunkirk.

Monck rented an articulated A-frame crane to build his lighting towers. He constructed six forty-foot towers, each about a hundred feet from the stage. By four in the afternoon, the supplies had largely been delivered. Bear called for more gear. He had stayed at Sears Point until he was the last to leave and didn't sleep when he got to Altamont. Bear and Dan Healey drove to the new site at dawn, and as they rode over the Altamont Pass, they saw a weather rocket explode in the sky, a distant flare on the horizon, a foreboding note neither paid mind to at the time. Bear was going crazy trying to pull together a sound system and had been far too busy to cook up a special batch of acid for the festival. The Wickershams, the Dead's audio specialists, had stayed up all night at the office in Novato wiring cables. Bob Cohen, who owned the sound system from the Avalon Ballroom and had an office in a building with sound companies on all three floors, had cobbled together the rest of the system from his gear and others in the building. They drove it out Friday afternoon and went to work setting it up. The different equipment from multiple sources would have to be interfaced, no simple task under the best of circumstances. Electricians tapped the speedway lights and ran the current through a transformer to power the construction lamps that lit the work site. Otherwise the sole source of electricity came from two touchy gas-powered generators.

Towers were stacked with speakers lifted by derricks, although the crane operator disappeared during the night before his work was done, rendering that expensive piece of equipment useless. Most of the scaffolding was raised in the dark. Even more challenging was testing speaker phase with no light. By midnight, the stage was nearly complete, but work continued all through the night. People played touch football under the construction lights in front of the stage.

Around the site, a party was in progress, a backwoods Dionysian revel with tens of thousands of people stumbling around stoned in the dark. People tore down the neighboring fences for firewood and sat around stinky campfires of the creosote-soaked fence posts playing music, smoking joints, and having sex. Drugs were handed out freely. People marched in over the hills all night. Unlike San Francisco rock concerts in Golden Gate Park, where marijuana and psychedelics ruled the day, people were guzzling cheap wine, Red Mountain, $1.55 a half gallon. Hippies generally looked down on booze. They derisively called people who did drink "juiceheads." But this was not a Golden Gate Park kind of crowd.

AT THE FILLMORE West that weekend, the Grateful Dead tried out a number of the new Garcia-Hunter songs. The band's new music weighed more on their minds than Rock Scully's free concert with the Stones. The Dead always looked forward to large outdoor gatherings, and the Stones concert was something special to savor. Any problems with the logistics of the production would be solved. They had their best people on it. The band was excited to be playing the gig, but they would also be appearing all weekend at the Fillmore West. They were enthusiastically supporting this Stones concert, but the guys in the Dead weren't paying any more attention to what was going on than the Stones were. Maybe less. They did at least acknowledge the event prior to playing that night at the Fillmore West. On Friday, Sam Cutler and Rock Scully took the stage before the Dead's set to talk about the free concert.

"Excuse me for interrupting," Scully said. "Now that you've waited a half hour for the Grateful Dead to get together, now you have to listen to me. Sam Cutler told you about what was going on. Something's going to happen and it's getting good-crazy. I think that all of us knew it was going to come down to this when they wouldn't let us play in the park."

"Is that what you call a Teutonic standoff?" interjected Bobby Weir of the Dead. Weir was joking around, but since the previous May when the National Guard turned on People's Park protestors in Berkeley, there was tension in the air.

"Yeah, it's some kind of standoff," continued Scully, "but no confrontation. We've already been on that trip and seen what happened in Berkeley with private property and all that stuff. So we're going to have a good time at a party and good music. Everybody's going to come and take care of themselves, I hope. If you're going to come out there early, you should be prepared to help and prepared to bring something to share because it's cold and you know all those things. I don't have to tell you about those things." He paused and looked out in the audience, then announced the band: "This, ladies and gentlemen, is the Grateful Dead."

With that, the band kicked off with a couple of the new songs, "Me and My Uncle" and "Casey Jones," and played into the night. At the top of the set, the new material didn't startle the Deadheads, as the band slowly eased the songs into their show. If the Dead were turning a corner in rehearsals and the recording studio, they were slow to tip their hand. Cutler headed out to the speedway, but Scully stayed behind with his band. He didn't leave for the concert site until after the band finished at around two in the morning at the Fillmore West. Rock never got to sleep that night.

THE STONES ARRIVED at the Huntington Hotel on San Francisco's Nob Hill around ten Friday night, dancing around the hotel suite while the tape of the songs they had recorded in Alabama played. There were plans to make a late-night visit to Altamont. With a helicopter not available, a limousine was rustled up and Jagger and Richards headed out to the concert site with a party that included Ronnie Schneider, Stones bodyguard Tony Funches, Gram Parsons, and writer Stanley Booth. The driver

wasn't certain where Altamont was, but pulled up an hour later around midnight outside the locked gate to the cyclone fence topped with barbed wire.

A thousand campfires flickered. Crowds of people moved through the darkness. The Stones party waited at the gate for someone to come with the keys to open it. People gathered around asking for autographs, but nobody had any pens. Booth rattled the flimsy fence and suggested breaking it down.

"Ah, the first act of violence," said Richards.

Jagger wore a burgundy overcoat against the chill, and Richards had a leather Nazi greatcoat that would be left behind in the fury of the following night's exit. As the group stood outside the fence, the Maysleses scampered up behind, beaming bright lights in front of their cameras. Funches bummed a joint from someone and the group wandered off into the night, touring the campsites and the ongoing work on the stage, as a line of besotted, pixilated hippies trailed at a respectful distance. Sam Cutler, already on the scene, joined the procession. The Stones party went to leave and go back to the hotel. Nobody had gone to bed the night before after spending all night recording in Muscle Shoals, staying awake with judicious applications of pharmaceuticals. Richards decided to stay. Funches joined him to stand watch.

Richards may have been charmed, but Sam Cutler was appalled. Busy backstage since he arrived, Cutler had not had a chance to see what was amassing in the darkness; touring the campsites with Jagger, Richards, and the others was his first chance to meet the audience up close. Demented ghouls came out of the shadows offering him acid. He found the scene distressing, people tearing down fences and barns to make their little fires. To Cutler, the scene evoked images of a malodorous peasant army camping the night before the Battle of Agincourt. After the others left, Cutler, Richards, and Funches retreated backstage. Stagehands took note of Richards touring the back-

stage. The feeling was festive and inspired. A small army of hippie riggers and wood butchers swarmed over the stage, pulling together the massive production with pride and as much efficiency as they could muster.

Still, nobody was in charge. Cutler ran around madly, dashing in and out of the office setup in a small, dingy trailer backstage. Chip Monck directed the staging and lighting. He eventually curled up in the cab of a truck with the gas heater turned on while he slept. Bear supervised the sound system from his platform on the light tower, where he also caught a short nap during the night. Bear had thoughtfully brought portable parabolic propane heaters to warm the stage—the temperature would dip to thirty-seven degrees that night—and the entire scene was lit in eerie ochre light from giant highway construction lanterns hung from the speedway lamp poles. Everybody thought it looked like a Fellini movie. Completing the surrealistic picture, people stretched out in sleeping bags littered the field in front of the stage and into the darkness. Fires dotted the hillside.

In the makeshift backstage, equipment vans parked in a circle like covered wagons. The Grateful Dead women tie-dyed sheets to use as curtains. They were cooking turkey legs and preparing other food. Medical tents were being set up. Richards pulled up a chair in the caravan and happily held court. He was enchanted with what he was seeing and drinking it in. As Saturday's first light approached, he crawled under a table to sleep for a few hours.

11

The Day Dawns

At dawn, Grateful Dead associate Bert Kanegson, who had been foiled in his effort to land permits for the concert in Golden Gate Park, planned to hold a morning meditation on the stage. Kanegson had been busy the previous days hurriedly pulling together work crews. He drove some equipment over the night before and spent the night. He was dismayed by Altamont, all the rusted cars, oil stains, and broken glass, and hoped the meditation might help counterbalance the dark energy. As the sun came up and Kanegson and Pete the Monk, a Buddhist Vietnam veteran who'd slept in their truck, settled onstage, the massive crowd that had been waiting outside the cyclone fence surrounding the speedway broke it down, burst onto the field, and rushed the stage. Shocked, Kanegson and Pete the Monk quickly retreated. Serenity would have to wait.

The crowd had gathered under the dark of night, and as the sun came up, the people working backstage were stunned by what they saw. Obviously, they knew that during the night a crowd had assembled that they couldn't see—they could tell

from the campfires and the rumble of voices in the distance. But when dawn came and they first laid eyes on the vast expanse of people spreading out on the hillsides, now a hundred thousand strong, the reality went beyond what any of them had expected, and it was frightening.

Even before the music started that day, omens could be found, if one wanted to see them. Astrologists wondered why the producers had not charted the stars for the occasion; the Woodstock producers consulted astrologers before selecting the dates. On Saturday, December 6, the moon was in Scorpio—the forecast was heavy days, evil tidings, acts of violence. From the beginning, there was blood on the ground.

The *Rolling Stone* team brought a camper. An all-music newspaper that had emerged from the underground press, *Stone* had given the Woodstock festival extensive coverage and was even better situated to cover the Stones' free concert across the bay from the magazine's San Francisco headquarters. The newspaper had been doggedly covering the Stones tour and the plans for a free concert. Managing editor John Burks and chief photographer Baron Wolman were the key members. Wolman woke up early and stepped out into the morning sun to relieve himself. He heard a dog barking and the first thing he saw was a Doberman chasing down a rabbit, catching the animal and tearing it to pieces. He shuddered and pulled his zipper up.

Chip Monck woke up painfully in the truck cab where he had gone to sleep. He had left the gas heater running and burned his legs. Staggering to his feet, he went out to check the work that had been completed since he went to sleep. As he approached the stage, he was shocked to see that the custom-made cases he had built to carry the tour lighting had been destroyed. The crowd had taken the boxes and burned them for heat during the night. At $3,500 apiece, that was an expensive bonfire.

Jerilyn Brandelius worked as personal assistant to Chet Helms at Family Dog at the Great Highway, and Helms had

encouraged his staff to volunteer at Altamont. Brandelius had brought her five-year-old-daughter, Christina, and three-year-old son, Creek, out the night before to see what she could do to help. They rode out on the Family Dog bus and parked backstage. In the morning, somebody sent Brandelius up to the top of the access road to steer people away from driving down to the backstage area. A group of motorcyclists riding Hondas pulled up and Brandelius stepped out to turn them back. One of the riders reached out, grabbed her, and forcibly held her while his friends drove around. He let her go and took off after them. Shaken and angry, Brandelius realized these were not flower children.

A few minutes later, the Hells Angels bus owned by the San Francisco chapter, full of Angels and their old ladies, pulled up, and Jerilyn explained what had happened. In short order, one of the Angels came marching back up the hill to stand guard with her and there were no further untoward incidents.

Rolling Stone staff reviewer Greil Marcus had planned to bring his wife, but she knew better. Almost nine months pregnant, when she heard on the radio that the Hells Angels would be acting as security, she declined to attend. Instead, Marcus drove out with fellow writer Sandy Darlington of the underground paper *San Francisco Good Times* at about nine o'clock in the morning. Despite the traffic, they slipped along the highway until easily finding a parking place on the hill above the speedway.

For Marcus, there was never any question about not going. He had written a glowing review of the Oakland concert for *Rolling Stone*. He squeezed into a spot on the ground reasonably close to the front of the stage. Immediately he was aware there was not a good feeling in the air. This was no Woodstock. People were pushing and shoving, protective of their space. There was not a lot of friendly chatter. He felt uncomfortable. Nevertheless, in the spirit of Woodstock, he unwrapped his sandwich and

offered some to the fellow next to him. The man slapped Marcus's sandwich out of his hand to the ground. "I don't want your fucking sandwich," he said.

The signs were beginning to appear, but to the untrained eye, the day dawned peacefully enough. A hot-air balloon lent a festive touch to the scene. The air began to warm. Doug McKechnie, who had come out on Friday with sound equipment from San Francisco, set up his Moog synthesizer, one of only a handful in existence at that point. The electronic instrument would soon become a major new force in music, but at this point few people knew the synthesizer outside of a flukey bestselling 1968 album, *Switched-On Bach*. The Moog was still a highly experimental, expensive, and complicated piece of equipment, and McKechnie, as long as he was hauling sound gear out to the concert, had brought his Moog. He planned to play a simple sawtooth wave, taking the synthesizer from fifty-five cycles to twenty-five thousand cycles over a short ride. He tapped into the main sound system and opened up the instrument, starting with a low, subsonic bass rumble. There was no communication between the soundboard on the platform of the light tower and the main stage. Chip Monck had a few intercoms, but they were scarce and precious. At the soundboard, Bear didn't know about McKechnie's plans, and as soon as the powerful bass pinned the low frequency on his meters in the red, he panicked and shut off the feed. The synthesizer fell silent. This truncated attempt was one of the first public performances by any Moog synthesizer, an almost historic moment.

The crowd continued to pour in all morning. Lines of people walking over the fields streamed into the valley like swarms of insects. They came from all directions. Traffic was tied up for miles every which way. Cars were abandoned on all highways in the vicinity. People left their cars and walked off toward where they thought the concert was, often not knowing. The California Highway Patrol struggled to maintain a clear emergency lane.

Tow trucks couldn't keep up. By ten o'clock in the morning, the CHP was reporting a ten-mile backup in either direction. They estimated the crowd at two hundred thousand and growing. Two people headed for the concert from hundreds of miles south in Santa Maria died in a crash on their way. Young people overwhelmed this lost corner of the world. The bowl filled with people beyond the hilltops.

Sam Cutler was walking across backstage that morning to the speedway office when he ran into Goldfinger. The one-handed, redheaded devil wouldn't dream of missing this party. Goldfinger reached in his pocket and produced a large black chunk of opium. Cutler popped it in his mouth and chewed the brackish wad until he swallowed it. Breakfast of Champions.

He went to meet Dick Carter at the speedway office. Outside the office, Jon Jaymes was talking with Alameda County sheriff's deputy Dale Smith, who had been sent with his partner to serve a restraining order on the concert. Carter and Cutler huddled around and listened. Cutler laughed at the thought that the concert could be stopped now. He shrugged his shoulders and waved his arm at the massive crowd. The show must go on.

When Cutler learned from Carter that Jaymes had signed the contract with the speedway, he was at first disturbed by the apparent assumption of power by the sleazy Jaymes. As he thought it over, he started to wonder if that actually wasn't some sneaky maneuver by Ronnie Schneider to avoid any legal liability by the Stones. Carter also told Cutler that Jaymes had promised to indemnify him against any losses. Who knew about Jaymes's promises? The hundred security guards Jaymes had promised Sears Point certainly hadn't materialized when the show was moved to Altamont, although there were a half dozen heavies in sunglasses and golf jackets walking around backstage—more off-duty narcs who'd flown out from New York. Carter had supplied a few useless rent-a-cops. It was all beyond Cutler at this point anyway.

The production had come together almost miraculously, but the time crunch was beginning to show. Stagehands frantically scrambled to complete the final details. The Dead's audio gurus, Ron and Susan Wickersham, drove onto the site over the fields and through the crowd, after initially being turned away by the cops, carrying the cables they had spent all night making. Dozens of workers buzzed around the stage, haphazardly securing parts with gaffer's tape or anything else they could find. The stage sections were held together with twine tied in bows.

The stage practically invited disaster by itself. Since the Sears Point site had called for the stage to be built at the top of a bluff forming a natural riser, there had been no need for a tall stage above the crowd. Plans had called for a four-foot-high stage and four sixty-foot light towers. When the steel arrived from Sears Point at Altamont, Monck directed the light towers to be erected first, not knowing that the lights themselves would never arrive or that there would be no operators for them. When the towers were assembled, there was no extra steel left to raise the height of the stage, so stagehands put one together that stood a little over four feet tall.

Not only was it shorter than any stage the band had played on all tour, but it was incredibly short for a stage at a festival of this size. By contrast, Woodstock's stage had been fifteen feet high. At that and other big shows, the stage height served as a natural defensive barrier that prevented the fans from interfering with the musicians onstage. A high stage kept the audience in its place, making it an easier beast to tame.

But the bands at Altamont would have to do without it. In place of a high stage, a thin cord was strung between the front row and the stage. A piece of string to hold back the crowd.

WITH THE BAD signs starting to show along the periphery, the most insidious component began coursing through the crowd almost as soon as everyone woke up Saturday morning. Practi-

cally everybody at the concert wanted to get high, but these were no longer the happy, innocent days of LSD. This was a different world in so many ways, but especially when it came to the psychedelics getting passed around.

The drug scene had changed drastically in the two years since the Summer of Love. The original psychedelic chemists had been on a mission. They'd scrupulously made the purest LSD they could. Owsley Stanley was especially finicky. He manufactured special batches like his famed Purple Haze. Hendrix dropped a double dose before his set at the Monterey Pop Festival. But as LSD rapidly spread beyond the small contingent in San Francisco and Berkeley, the manufacture of the illegal drug shifted to less zealous chemists who were unafraid to take shortcuts and didn't mind turning out inferior product. After the Nixon administration clamped down on PharmChem, a nonprofit Bay Area laboratory that tested street drug samples, nobody could any longer be certain what the compounds actually contained. Some chemists added the poison strychnine to the recipe because it was said to extend the length of the trip. Some threw speed into the mix, which led to overstimulated users. One common symptom of speed-laced LSD was people stripping off their clothes and going naked.

Another new wrinkle old acidheads didn't understand was using alcohol with psychedelics. Hippies in the Summer of Love wouldn't have dreamed of mixing booze and acid. It was cultural and chemical heresy. But LSD use had spread far beyond its original cultural confines. No longer was it a path to enlightenment, an opportunity for raised consciousness or exploration of inner space; now it was simply another way to become intoxicated, somewhat more extravagantly. People were getting wasted on acid. Adding alcohol to the mix could produce dire symptoms: erratic, unpredictable behavior, often including violent outbursts. LSD was not only for hippies any longer.

These changes in drug manufacture and culture converged at

Altamont, often in unpredictable, dangerous ways. The psychic landscape was littered with booby traps. Cinematographer Joan Churchill had spent a cold and lonely night locked outside the cyclone fence, sleepless and hungry. A Los Angeles filmmaker, she had come up on Friday afternoon as part of a Southern California contingent put together by filmmaker Baird Bryant at the request of the Maysleses. Though the Maysles brothers had followed the Stones back from Alabama, they had yet to meet with their crew, and there was little direction for the crew that arrived first. Churchill, who came to town with her boyfriend, cinematographer Eric Saarinen, had been told to go out to the concert by herself Friday night, shoot some scenes around the campfires, and go backstage to sleep and eat. She'd helicoptered to the site. When she was done filming, nobody would let her backstage, so she spent the night wandering through the crowd shooting more film. She never slept or ate. When morning came, she finally found her way into the concert when the gates opened. She was carried along in a crush of people trying to get in. As she walked through the crowd, she accepted gifts of food and took a long drink from a bottle of orange juice someone handed her.

She slowly, carefully made her way through the crowd across the track. She picked up her camera and looked through the lens. Her Spectra light meter had rainbows shooting out of it like rays. In an instant, she knew she had been dosed.

Churchill had had a couple of previous experiences with LSD, but after her last trip had decided she was finished with acid. She knew what was happening to her and could tell that this particular acid was laced with something. Everything felt wrong. She was ascending at a terrifying rate. Her heart was racing and everywhere she looked, prisms of light bloomed in her eyes. She fought panic. She took her camera, crawled under the stage, and huddled in the dark, waiting for it to peak and subside. She knew she would be there for hours.

Another unsuspecting victim was Rosie McGee, who had

arrived Friday night with Jonathan Riester, the Dead equipment manager, with whom she had been having an off-and-on affair for some time. She had only recently broken up with Dead bassist Phil Lesh and was living in a shack on Mickey Hart's ranch. She woke up in the chilly, damp dawn from sleeping in the cab of the big-bed truck Riester had used to haul gear over to the concert. She wandered out into the audience in search of a port-a-potty on the edge of the crowd. After that, she wound her way up the hill through the subdued, waking crowd, which was starting to emerge from a night sleeping on the cold, hard ground, to get a panoramic view of the enormous throng that now filled the hills.

As she stepped over the endless carpet of supine bodies, she stopped and accepted proffered tokes and a couple of bites of food. She took a long pull from a bottle of orange juice and walked along. It didn't take much time before she realized the juice had been dosed. As she turned and made her way as quickly as she could toward backstage, she felt the drug take over her being. Her heart pounded and she filled with fear. This was no ordinary LSD, she could tell, but some toxic blend of psychedelic and amphetamine.

She finally arrived backstage and found Riester. He took her to an equipment van parked next to the stage and gave her a hug. She sat down on an equipment case and Riester told her to stay put. He also informed the rest of the crew about her situation so they could all keep an eye on her. The Dead were quite familiar with psychedelic accidents—the band had long maintained its own psychedelic assassination squad who specialized in dosing unsuspected parties, like the time they made psychedelic punch of the crew coffee pot on the set of Hugh Hefner's TV show, *Playboy After Dark*. McGee was surrounded by grizzled psychedelic veterans. She relaxed, knowing that these guys would watch out for her. She still had to battle the raging chemical, but she felt reasonably safe for the time being.

Even veterans of the scene were getting dosed. An Angel known as Badger from the Richmond chapter brought Chet Helms of the Family Dog at the Great Highway into the trailer where his assistant, Jerilyn Brandelius, was working.

"They said you know this guy," Badger said. "I think he's too high. He doesn't know what he's doing. I found him wandering around."

Her boss was indeed blasted out of his gourd. Helms had been accidently dosed. The tall, lanky Texan was one of the prime movers of the San Francisco scene and had certainly enjoyed his share of intentional psychedelic experiences. Helms approached being a hippie with joyful missionary zeal. He had started throwing dances at the Avalon Ballroom in 1966, and after that whimsically inept operation finally went under, he opened the place on the Great Highway at the beach earlier in the year. He had managed Big Brother and the Holding Company at the start of the band's career. He originally put the band together from a series of jam sessions he hosted in the ballroom of a Haight-Ashbury Victorian rooming house. Helms brought an old friend named Janis Joplin out from Texas to serve as the band's lead vocalist. At the moment, he was making more money selling in head shops across the country the psychedelic posters he commissioned for his dances than he was selling tickets and concessions at his new place on the ocean.

Brandelius asked Badger, a likable lummox well known on the rock scene, to keep his eye on Helms and they went out. Before long, Badger brought him back. Helms was not functioning, he told her. Brandelius took charge of the situation. She and her Hells Angel friend escorted Helms to a pickup truck and put him in the front seat with his girlfriend. Badger stood watch outside the cab.

Bad trips were an anticipated problem at rock festivals, and most made provisions to deal with acid casualties, but as the poisonous psychedelics at Altamont spread traumatic episodes

throughout the crowd from the start, the almost complete lack of emergency medical care quickly became all too apparent. Indeed, medical care at the concert came almost as an afterthought, all but forgotten in the rush to find a place to hold the show. The obvious candidate for the job, the Haight-Ashbury Free Clinic, declined the assignment after San Francisco concert producer Bill Graham, chief benefactor of the Free Clinic, called clinic founder Dr. David Smith and asked him specifically not to volunteer the clinic's services to the Stones show. Adamantly opposed to the Stones' free concert, Graham did what he could behind the scenes to undermine the effort and make sure that none of his people were involved.

Not only did the disorganized production put off a crucial detail like medical care until the last minute, but it also apparently couldn't even keep track of the volunteers who were coming in and offering those exact services. The Hog Farm commune contacted the producers about serving backstage, as they had at Woodstock, but could never get a clear answer. A few showed up anyway and volunteered at the medical tents with the Red Cross. A Berkeley political commune called Committee on Public Safety (COPS) contacted organizers about putting together a free food stand, as the Hog Farm had also done at Woodstock. All they ever got was a runaround.

At the concert that morning, a handful of COPS members harassed a couple of old guys selling Rolling Stones programs. "This is a free concert—there shouldn't be anything for sale," one said, throwing a handful of programs into the crowd. One of the vendors was so scared, he grabbed his table to shield himself. The two men quickly disappeared, leaving their programs behind on the ground. Power to the people.

The concert organizers only contacted Dr. Richard Fine of the Medical Committee for Human Rights (MCHR) on Friday afternoon about providing medical support for the concert. MCHR was founded in 1964 to protect civil rights protest

marchers in Mississippi, but spread beyond that. Dr. Fine had started the San Francisco chapter, which supplied medical aid to political rallies and protest marches. A committed leftist and onetime member of the Red Family commune, Fine was also the private physician to Janis Joplin (who eventually fired him after he recommended she stop drinking) and Black Panther leader Angela Davis. He pulled together a team of eight doctors, but realized soon after his arrival on Friday night that he was drastically understaffed and undersupplied. He was relieved to see the Red Cross show up uninvited and set up another medical tent on the hill backstage on Saturday morning, as well as four psychiatric residents from UCSF Hospital, who pitched their "calm center" tents high on the hill. However, no signs pointed patients to their services, and no announcements were made from the stage about the availability of medical care.

The psychiatric residents told the volunteers that the first line of defense would be hand-holding, guided imagery in a quiet place (although the chaos of the day was going to make that practically impossible). There were flowers in the tent to encourage people to focus their thoughts on an external object, away from the internal discomfort. The residents were to treat as many as they could with soothing talk and other non-drug-related therapies, reserving their limited drug supply for the most dangerous cases, saving the tranquilizer Thorazine for combative, violent patients. They left much of the care to Hog Farm volunteers, largely women, who were experienced in talking down acid victims.

With drug overdoses turning up at an astonishing rate that morning, it was clear that the medical staff were going to need all the help they could get. The doctors were completely taken by surprise by the cases they saw—people who didn't know what they had taken or how much. None had ever encountered such indiscriminate drug use. They recognized the symptoms of amphetamines mixed with psychedelics—aggressive, agitated,

wired-up patients, paranoid and violent—but they were still having difficulty interpreting what drugs they were on. In addition, the amount of alcohol the crowd was consuming caught them by surprise. Perhaps the most disturbing realization, though, was that, given the crowd conditions, they were seeing only the most extreme cases that could reach the tent. This was just the tip of the wave. Tens of thousands of people were tripping. The quality of the drugs was suspect. The conditions were oppressive and not conducive to positive LSD experiences. Whatever was causing them, bad trip after bad trip erupted in the crowd. Some kind of mass toxic psychosis was under way.

Trouble was only beginning to mass. All morning, Hells Angels had been funneling in backstage, assuming positions on the stage and around the backstage compound. They started to party early, recklessly drinking and drugging. Hells Angels were scary enough, but loaded on drugs and cheap red wine, they were all but uncontrollable. From their first appearance on the scene, the Angels injected an element of menace. The party was just getting off the ground.

The Angels from the San Francisco chapter who'd arrived early on their club's bus parked backstage, climbed up on the roof of their bus, cracked their beers, and began to celebrate. A gang from the San Jose chapter showed up with a large number of prospects—probationary members seeking to join the club who could be voted out by as few as two members. They were required to serve the club, set up chairs before meetings, run errands, and do the bidding of the members with full patches.

These prospects were men with something to prove. They provided an especially unstable element to the equation. Often unruly and uncontrollable, ready to act out to impress their seniors, they needed to win their way into the club. Some of them were little better than indentured servants who would never be truly considered for membership. Some of them were real bullies. One San Jose prospect waded out in the crowd col-

lecting full bottles of wine from unwilling donors and returned with jugs hanging from both hands for his brothers to drink.

At the same time, a number of Angels immediately made themselves helpful. Dr. Fine knew Moose from treating the behemoth Hells Angel at his hepatitis clinic. Moose, delighted to see his doctor, attached himself to Dr. Fine as bodyguard and chauffeur, the tough Angel with a metal plate in his head driving the peacenik doctor in his trademark leather hat on his chopper through the crowd to attend to medical emergencies. Other Angels carried out other duties, accompanying the film crew through the crowd, directing traffic backstage. Sweet William and other San Francisco chapter Angels stood watch on the short stage. The crowd had long before pushed past the flimsy string barrier, and the front row was leaning on the lip of the stage. Some of the San Jose riders gathered in front of the stage. The crowd swarmed over their bikes. Protecting their precious choppers would place the Angels on the precipice of a flashpoint that would only grow more dangerous as the day progressed.

The Angels were all alpha males, quick to resort to their animal brains, some more emotionally mature than others, some frankly psychotic. They lived outside the law and could be unpredictably violent. Only three months before, a group of Angels had taken offense with a neighbor of the S.F. chapter headquarters on Ashbury Street (across the street from the old Dead house) and beat his car with chains and tire irons. After getting punched in the face, the neighbor escaped and called the cops. The police showed up, and when they tried to handcuff and arrest one of the Angels' officers, the Angels house emptied out onto the street. The entire Park Station was summoned as reinforcements. A fierce battle ensued. When the fight was over, police held thirty-seven Angels and their girlfriends in custody, although cops admitted that a number escaped over the back fence. They charged the Angels with "lynching"—a police term for trying to free a prisoner. They confiscated four handguns,

eight bullwhips, ten machetes, and various pills and pot. The Angels sent five of their opponents to the hospital.

Mick Jagger had no idea who these men were; to him, they must have seemed like some kind of colorful centurions of the hippie realm, when they were anything but. These hard men could be ruthless in the protection of what they perceived as their territory. And now they were the flimsy line between the massing crowd and the musicians who would soon be onstage.

THE SIGNS MAY have been evident already backstage and around the stage, but the crowd streaming in remained largely ignorant. Those who'd spent the night in the cold knew about the lack of food, water, and bathrooms, but the full weight of the darkness creeping in remained hidden from those clogging the highways with their cars and walking on foot to the biggest rock concert California had ever seen.

These kids believed in rock music. Or at least they wanted to. This was a rite of passage that hundreds of thousands flocked to. They brought with them the spirit of Woodstock. They knew the Beatles song "All You Need Is Love." They had been going to concerts and seeing bands, experimenting with drugs, growing their hair, but this was a pinnacle experience, a day in the promised land with the Rolling Stones, and they knew that much before they even got there.

Jim McDonald had been hearing about the Stones concert at Sears Point on the radio all week and was excited to go. The nineteen-year-old surfer lived in Santa Cruz, about ninety minutes south of San Francisco on the coast, and held down a job at a fiberglass plant. He had seen the Stones in Oakland the month before and had gone to a big outdoor rock festival in October called Gold Rush in bucolic Amador County in the mountains of Northern California, where Santana and Ike and Tina Turner headlined. He had graduated from Pleasant Hill High School in Contra Costa County, where the Dead and Quicksilver Messen-

ger Service played dances. He had seen shows at the Fillmore. Although he owned his own Dodge van, McDonald decided to hitchhike to the concert at Altamont. He packed a knapsack and took a blanket because he had been hitchhiking through the Altamont Pass only a couple of weeks before and was well aware how cold it could get at night.

He quickly picked up a ride Saturday morning from an attractive bleached blonde in her thirties driving a Corvette. She took him all the way to Fremont in the East Bay. He started seeing other hitchhikers. He felt like the whole world was moving toward the concert, and it gave him goosebumps. Traffic slowed by the time he got to Livermore. When he reached the truck scales on Highway 50, cars were stopped on the road and parking where they stood. He picked up a ride in a VW van rolling at the speed of a shopping cart, stuffed with eighteen people, their feet sticking out the open door. By the time they reached Grant Line Road on the Altamont Pass, the van could no longer move and McDonald started walking between the stopped cars.

He felt the rumble under his feet before he heard it, as a dozen Hells Angels came rolling down the highway. They wore no helmets and looked right in the faces of the other concertgoers as they plowed slowly through the crowd. Someone said the Angels would be acting as security for the concert. McDonald felt good about that. He remembered seeing Angels standing around the stage with Big Brother and the Holding Company at Winterland when the band opened for Cream the year before.

McDonald made his way across the fields, working to the southeast corner of the site, high up on the hill. He stopped to admire the giant plastic pillow the Ant Farm had built. He recognized the hot-air balloon from the Amador County rock festival and even saw the same strapping naked black guy walking through the crowd whom he remembered from that show. He drank deeply from a bottle of Red Mountain laced with acid, but

that was no accident. The guys with the bottle assured him they had put plenty of LSD in the wine. McDonald wanted to adjust his reality. He ran into a couple of old high school friends, and the three of them hung out and partied on the hillside, getting high and carrying on. There was no way McDonald could have imagined how this day would end.

12

Alan and Patti

That Saturday morning, Alan Passaro pulled on a pair of black leather pants with silver conchos up the seams, his Angels colors, stuck a .25 automatic in his waistband, strapped a large hunting knife in a sheath around his ankle, and set off on his bike to Altamont.

Growing up, twenty-two-year-old Passaro was the kind of kid who'd learned to ski straight downhill. His brother could negotiate the slaloms and ride the powder, but all Alan wanted to do was ski as fast as he could. He was a short, nervy, reckless kid with a limp. He was born with a shortened ligament in his right leg and walked with his foot turned up at the heel. When he was in junior high school, he entered Shriners Hospital, a charity hospital for children in San Francisco, to have surgery to correct the condition. His cousin John tossed packs of Lucky Strikes to him through his hospital window.

He was the oldest of four boys (a fifth child, his sister, Linda, would be adopted when Alan was a teen). His father, Mike, was a barber born in Naples, Italy, while his mother, Kay, was a

Serbian who had followed her eleven brothers and sisters to San Francisco from Youngstown, Ohio, after meeting and marrying her husband. The family moved to suburban splendor in a three-bedroom house on Golf Drive on the outskirts of San Jose with fruit trees and a view of the foothills leading to Mount Hamilton out the back window. The house smelled of sausages and spices. Passaro's father worked at the Varsity Barber Shop on Alum Rock Boulevard.

Alan grew up swimming in the indoor pool at Alum Rock Park, diving fearlessly off the high board, camping with his uncle in the Sierras, or staying at his aunt and uncle's lodge near Dodge Ridge to ski. For a while, they kept horses in a nearby stable. Alan developed some skill at roping. He was a bad kid with a wicked sense of humor and a mean streak. His family was musical and Alan could sing. He sang beautifully at the Covenant Church in San Jose, where the family attended services, and rifled the cloakroom when his mother wasn't looking. He committed two-bit burglaries around the neighborhood, once stealing a motor scooter out of a neighbor's garage while the man was on vacation, crashing it, and returning the busted-up scooter to where he had taken it. The neighbor called the cops when he returned, but never suspected the kid across the street.

His father took the boys and some of their cousins one weekend to Playland-at-the-Beach, a decaying amusement park on the edge of the ocean in San Francisco, and dropped them off. While in the Fun House, Alan picked a fight with a black kid that spilled outside, where an eerie dummy called Laughing Sal presided over the entrance from a glass case. Alan was a tough fighter, but he quickly found himself outnumbered. He got his ass thoroughly kicked by a gang of black boys. He was not only hurt, but humiliated. The dummy's laughter echoed after him.

He fiddled with minibikes and go-karts endlessly in the family's detached two-car garage and started riding motorcycles when he was fourteen years old. He rode with a local club called

the Gents before joining the San Jose chapter of the Gypsy Jokers, the first Gypsy Jokers group outside of San Francisco. Passaro may have joined the Jokers, but he always wanted to be an Angel. He never got a Gypsy Joker tattoo.

He met a beautiful young blonde named Celeste Druge in art class at community college in Santa Clara. He was talented enough to pick up a few bucks painting Nativity scenes on gas station windows at Christmas. His mother was furious to discover the couple having sex in the Passaros' garage. When Celeste got pregnant, they were married. She was eighteen and he was seventeen. Al went to barber college and Celeste took classes at beauty school. Their son Michael was born in 1966. Alan went to work at Dalton's Barber Shop in Milpitas, and Celeste took a job as a hairdresser. Along with Alan's additional income from selling drugs and other questionable activities, they were able to afford a house in Alviso.

Al always owned cars and motorcycles. He built the frame to his chopper and dressed the bike out to his specifications. Celeste did not wholly approve of the Angels, but she knew to turn a blind eye. She was aware of what was going on and she liked the money. Al was always frank about who he was.

Throughout the three years of the motorcycle club's existence, the Gypsy Jokers were at war with the Hells Angels. The Daly City chapter of the Angels opened a San Jose chapter, squeezing the Jokers in their own territory. Although there were a few strong fighters in the Jokers, they were not in the same class as the Angels. They took ass-kicking after ass-kicking. In June 1969, the San Jose chapter of the Jokers brokered a peace and folded the club to join the Angels. The members were divided between the San Francisco chapter and a new San Jose chapter, headed by some Angels from Daly City. Al got a Hells Angels Death's Head tattoo. He proudly wore his prospect colors when he went to the Fillmore and dropped acid with one of his San Francisco cousins.

Al prospected for eight months with the San Francisco chapter and never had his own bike during that time. On the night he was to be voted in, he answered a classified ad from someone selling a Harley-Davidson, beat the owner senseless, and took his bike to the initiation.

Passaro had a long jacket. He did his first stretch in juvenile hall at age sixteen in 1963 for stealing a car. He was arrested again in 1968 on auto theft charges in San Jose and sentenced to two years' probation. In December 1968, San Jose police arrested him for assault on a police officer, battery, resisting arrest, and disturbing the peace. He was acquitted on all charges, but was jailed on a parole violation in January 1969. He was picked up for questioning in May 1969 on a possible charge of possession of explosives, but was released. In July 1969, he was arrested for possession of stolen property, grand theft, and conspiracy. Shortly thereafter, he was also arrested for possession of marijuana. He was out on bail from both those charges at Altamont. He had been convicted on the marijuana charge, but sentencing was delayed pending the outcome of the other trial.

He and Celeste had a turbulent relationship and were living apart that morning when Passaro rode off to Altamont. While she and their son were staying with her grandmother, Passaro was bunked up with a childhood friend named Dennis Montoya, also a Hells Angel. Passaro and Montoya headed out to Altamont together at about noon, but shortly after arriving, they became separated. Eventually, Passaro found his way in front of the stage, where he joined his fellow San Jose Angels for the riot already in progress.

AS PATTI BREDEHOFT got ready to head out to Altamont, she couldn't help but think about her boyfriend, Meredith Hunter, who would be picking her up any minute. She wore a simple black miniskirt, white blouse, and a crocheted vest her mother had made for her.

Patti always felt so lucky, walking around the park across the street from Berkeley High School on Meredith's arm. He was a tall, handsome, charming, stylish young black would-be gangster, a year older than she was. His friends called him Murdock. He was a real ladies' man, a flashy dresser with manicured nails and a cool line of patter. Crossing the park, he didn't walk; he would glide. Girls came up to him all the time. Patti felt good that he chose her. They had a powerful sexual chemistry. He was a sweet talker who could say the exact right thing to put her at ease and make her feel special.

Patti was a cute, curvy blonde seventeen-year-old high school senior who didn't comfortably fit into the social scene at high school. She was shy and quiet, not all that confident, someone who carried her low self-esteem around with her. She was a good but not great student and her studies were concentrated on business classes, typing and such, rather than college preparatory courses. She never got in trouble, but she never excelled. Her life was not at school, even when she did attend.

She lived in a house her grandfather built—her grandparents still lived next door—with her carpenter father and mother in the lower-middle-class flatlands of Berkeley. She had two older sisters and a younger brother and, like many middle children, was largely ignored in the family order. When her popular, socially successful older sister added an extra "n" to her name—Dianne—Patti countered by ending her name with an "i."

She and Murdock ran in the same circles and met at a party over the summer. Her friend's divorced mother was liberal with the kids and let them hang out at her house, smoke a little weed, drink their beers. Murdock showed up with one of his friends and they hit it off. They had been dating for several months. He had taken Patti to see the Temptations sing their Motown hits at a fancy San Francisco nightclub called Mr. D's a couple of weeks before. Murdock planned to take Patti to the Rolling Stones' free concert.

For someone from such a troubled background, Meredith Hunter was a bright, confident, and personable kid. His mother was schizophrenic, and he had largely been brought up by a sister, Dixie, ten years older, herself the product of a rape. She used to pull frogs out of his pockets after his "nature walks" in the park and read fairy tales to him in bed under a bare light bulb plugged into an extension cord. He kept pigeons in a backyard cage. Meredith was the youngest of four children and had been in and out of Youth Authority since he was eleven years old. The family originally lived in a neighborhood of West Berkeley where you didn't see white people, in a small cottage in back of another house. An older aunt, who acted more like a grandmother, lived on the block and made sure there was food in the refrigerator and generally watched over the kids. Their mother was barely responsible.

He was named after his father, Meredith Curley Hunter, a Native American who left the house when Meredith was still an infant. When Meredith was about nine years old, his mother took up with a fierce and abusive man who routinely beat her savagely and put her out on the streets as a prostitute. They moved in with him on the border of Oakland and the rest of the family worried about Meredith's oldest sister, Dixie, given the man's predatory nature. They arranged for her to live with another aunt in San Francisco, and Meredith's caretaker vanished. His sister Gwen was taken to live with a foster family, and the two boys, Donald and Meredith, ended up in juvenile hall. Meredith was first jailed on the vague charge of being an out-of-control youth. He served five months, but was back inside on a parole violation six weeks later. His sister never knew what crime he committed. At age thirteen, he went back to jail for another nine months on three counts of burglary. Five months later, he went down again on burglary charges. He had only been released in May, having spent most of his teen years behind bars.

Patti belonged to the Berkeley High School class of 1970, the first class to have been sent to the newly racially integrated West

Campus to begin their high school careers. Over the next four years, Berkeley would become a confusing, complicated place for teens to grow up. These two thousand students had moved to the main campus in downtown Berkeley in September 1967, right after the Summer of Love. The open campus was two short blocks from the University of California, ground zero for the student protest movement, copious drug experimentation, and wrenching social changes. These teens couldn't help but be buffeted by those forces.

Student body president Steve Wasserman first dropped acid with two female classmates when they were fourteen years old. With the head of the Black Student Union and Black Panther member Ronnie Stevenson, Wasserman successfully engineered a student strike that led to the creation of the nation's first black studies department in a high school. These students had gone through the assassinations of the Reverend Marin Luther King Jr. and Robert F. Kennedy the previous year. They had watched the National Guard patrol the streets of their hometown during the People's Park march that May.

Berkeley was a world apart in 1969. In high school, the divisions still remained: children who lived in the hills versus kids from the flats, stoners versus jocks, radical politicos versus conservatives, and of course, blacks versus whites. Community High was a progressive school established inside the regular Berkeley High curriculum. The drama department tried avant-garde works by Ionesco and Brecht. A good portion of the student body was on drugs. People could be found smoking joints every lunchtime at Provo Park, across the street from the campus, the presence of truant officer Pumpsie Green, a former major league baseball player, notwithstanding.

In this brave new world of psychedelic drugs, political protests, and social upheaval, interracial dating was still taboo, but rapidly grew in popularity when the class hit the main campus. Six young ladies, boldly dressed alike in knee-high boots and short shorts, who called themselves the Hot Pants Brigade were

open and explicit in their attraction to black males. They were not alone in their enthusiasm. Patti exclusively dated black guys. She had had bad experiences with white men. Murdock was special and they were growing close. She had visited the apartment where he lived with his mother and sister and thought he was a kind and thoughtful man. She knew he and his friends were petty criminals, but they weren't violent and weren't scary to her at all.

Patti was no hippie, but she smoked pot and took bennies. One of her classmates encountered her late one night, stumbling on a bus, apparently stoned on downers. He watched as she took her seat in the back and puked behind the bench.

Murdock had moved in with his sister Dixie only a couple of weeks before. Her husband had been killed in a freak accident when a fallen power line struck his pickup truck and he was electrocuted. Murdock helped with her kids and did his best to bolster his sister in the wake of this horrid tragedy.

He and his pal Ronnie Brown had gone out all night Friday, doing speed and running around, but Murdock was in a good mood when he called Patti on Saturday to tell her he was coming over. He arrived with Ronnie and another white girl, a redhead named Judy who was in the tenth grade at Berkeley High. Patti didn't know her. Murdock was decked out, looking gorgeous in a lime-green suit and black ruffled shirt. They piled into his brown 1965 Mustang and chattered happily as they headed out to Altamont.

They parked on the roadside near the canal and started to walk to the concert about half past two o'clock in the afternoon. A few minutes later, Murdock stopped.

"I've got to go back to the car," he said. "I forgot my gun."

Patti didn't know Murdock owned a gun.

They left Ronnie and Judy and went back to the car. He got his gun out of the trunk and tucked the long-barreled .22 automatic in his waistband under his coat.

13

Santana

They were passing around strawberry-flavored LSD to snort as the helicopter carrying Santana left from San Francisco's Ferry Building for the forty-five-minute flight to Altamont.

These fellows and their girlfriends were feeling quite regal—they were on their way to the top. The steel-edged Latin rockers from San Francisco's Mission District had never even played out of town before the band blew away the half million at Woodstock in August. In San Francisco, Santana was already a headline act at the Fillmore. The band not only played Woodstock, but was also one of the big attractions two months earlier at the small, sylvan Gold Rush rock festival in the Sierras. Now, the musicians were on their way to play another massive open-air festival, this time opening for the Stones at their free concert in Altamont.

The men in Santana were not hippies. They were a mix of Latinos from the Mission District—twenty-two-year-old Mexican-born guitarist Carlos Santana went to high school in San Francisco, but still only spoke English with some

difficulty—and suburban white kids like organist and vocalist Gregg Rolie and drummer Michael Shrieve. Their crisp, edgy rock sound leavened with Afro-Cuban rhythms from a battery of Latin percussionists had taken the San Francisco band from a headline attraction at the Fillmore, through their persuasive triumph at Woodstock, straight into the Top Ten with the release of the band's debut album. They were on fire. The band's two original managers had overruled their new partner, Bill Graham, and enthusiastically accepted the last-minute invitation to join the bill on the Stones concert. At the moment, Santana was one of the hottest new rock bands on the scene, a perfect, hip opening attraction for the Stones extravaganza.

Herbie Herbert had only been hired for the Santana road crew on Wednesday. Herbert had lugged gear for his high school buddies in an East Bay rock band called Frumious Bandersnatch and had been thinking about going to work for the Texas guitarist Johnny Winter or folksters Peter, Paul and Mary. Santana co-manager Graham talked him into taking a $75-a-week job with Santana. He convinced Herbert that Santana was going to be the next big band to break out of San Francisco after their bravura Woodstock performance. Herbert took the job and agreed to meet the band's other managers the following Monday at Fillmore West. On Friday, Graham called and told him to report for duty early for a last-minute concert the next day at someplace called Altamont.

When he arrived with the band's gear early Saturday morning, Herbert was shocked at what he saw. The junkyard full of hundreds of crashed, wrecked cars from the demolition derby stacked on top of each other, discarded by the side of the speedway, and the oil-stained track littered with broken glass looked grim enough, but the yellow light of the early morning gave the whole place a sickly, ugly pallor. The stage alarmed Herbert, this tiny platform, barely more than one step off the ground, entirely indefensible, with an audience bearing down from a

mile away. The Hells Angels around the stage were surly and mean. Herbert felt intimidated by the vibes, but he bent to the task at hand: assembling the conga drums for Santana percussionist Michael Carabello.

As Herbert, wrench in hand, and Carabello screwed together his drum stand on the stage, a large, friendly Hells Angel loomed over them. He held out a giant bottle of pharmaceutical drugs, Seconals and Tuinals—"reds" and "Christmas Trees"—and offered some to Herbert and Carabello. They politely declined and watched in amazement as the biker poured a handful of the pills into his mouth like sunflower seeds, even spilling some on the ground, and washed the mess down with a stein of beer.

Carabello looked at Herbert. "It's going to be a long day," he said.

The first death took place shortly before the music started. Leonard Kryszak, who would have turned nineteen years old the next day, was visiting from his home near Buffalo, New York. He climbed the cyclone fence by the California Aqueduct that whooshed along a concrete sleeve adjacent to the property. California state police officer Jim Windt saw Kryszak from the other side of the canal to the east of the speedway. Signs posted on the fence warned against entering. Windt waved his arms and screamed across the canal as he watched the kid take off his blue work shirt and strip down to his black jeans held up with a sash belt. Completing his hippie outfit, Kryszak wore beads, an earring, long hair, sideburns, and a mustache. He looked at the officer across the water, flipped him off, and slid down the bank feet first into the canal. He stayed afloat only a few seconds before the icy torrent pulled him under. They picked him out of a filter trap a couple miles down the canal two hours later. It would be days before they were able to identify the body.

He was not the first casualty. Earlier in the morning, a young man flagged down an ambulance, told the driver he was having a baby, jumped in the back, and stripped off his clothes. When the

ambulance slowed down on the overpass above Highway 50, he leaped out and jumped off the freeway. He was taken to Valley Memorial Hospital in Livermore, where he was listed in critical condition with a broken pelvis. Police suspected he was on drugs.

Sam Cutler, in a caramel-colored leather coat and white turtleneck, had been asking the crowd to move back all morning. High up on the hill, people lifted their picnic blankets and scooted back, but there didn't seem to be any more room down front after they did. Cutler repeated his pleas many times. He also made several futile announcements in an effort to get the dozens of people who had climbed the light tower scaffolding for a better view to come down. The patchwork sound system could barely be heard at the far end of the crowd anyway. Even before the first note had been played, Cutler was finding this massive beast of an audience difficult to control. He felt impotent, powerless. Finally, shortly before noon, he stepped to the mike again.

"The organizers, who number about twenty people," Cutler told the crowd, "would really like to thank the hundreds of people who came out here last night and worked all night to get this on. We've, in fact, managed to get the whole thing together, like I said, in twenty hours and we're still an hour and ten minutes earlier than we said we would start. That's at one o'clock. Still only ten to twelve. So thanks to everyone who helped. I would like to point out to everybody here that this could be the greatest party of 1969 that we've had. Let's have a party and let's have a good time. Ladies and gentlemen, we give you Santana."

With those hopeful words, the sound system lurched to life as the timbales-conga battery of Michael Carabello and José "Chepito" Areas charged to the fore. Santana kicked the concert into gear with "Savor," a high-energy Latin drive with organist Gregg Rolie pumping fat chords into the churning rhythm and guitarist Carlos Santana spraying the top with his machine-gun

riffs. The stage was jammed with Angels and others literally looking over the musicians' shoulders. The spell was cast. For a few lucid minutes, the music ruled.

That is, until the naked fat man began to make his way toward the stage.

In truth, any naked fat guy would attract the attention of the Angels, but this one in particular was causing a scene. A large Latino man, his tiny penis buried under folds of flesh, was rampaging around the front section. He was clearly high on some nasty acid and swigging from a gallon jug of wine. He was bouncing around erratically, trampling, under the guise of his ecstatic dancing, on people who were sitting down. Somebody he slammed into would push him away and he would look hurt and disappointed, as if he was the victim. He was out of control and calling attention to himself in the worst possible way. His very presence was an offense to the Angels. He made the mistake of venturing into their midst, inadvertently becoming their first target of the day.

Bert Kanegson was shocked to see the Angels start beating the poor bastard. Shocked, but not surprised. He knew the Angels from his days helping run the Carousel Ballroom. The Angels were admitted free, and Kanegson came to know S.F. chapter members like Terry the Tramp, Pistol Pete, and Freewheeling Frank. Although he had had a number of confrontations with the Angels at the dance hall, he had never lost his temper. But he never forgot the night they beat Dead equipment man Jonathan Riester—he knew they were not to be trifled with. He was at the Carousel the night the Angels wrecked the place, leaving broken glass, blood, and spilled beer all over the floor. He had vigorously resisted the idea that the Angels be involved in the Stones concert.

He looked from the side of the crowded stage and did not recognize any of the Angels pummeling the naked fat man. They were largely San Jose members and prospects. He jumped down

in between the Angels and the man. Kanegson, who had worked the front lines of many nonviolent war protests, started telling the Angels that all men were brothers and there was no need to resort to violence. He thought they were going to kill the guy. He pleaded with them.

Strangely enough, it worked. The Angels quit pounding him. They stood back and let him go. The man walked through the phalanx of Angels back into the crowd. As he passed the last Angel, he paused. Quickly, the fat naked guy punched the Angel in the face and disappeared into the crowd. The Angels turned on Kanegson.

That was when the pool cues came out.

Older Angels looked down on pool cues. As weapons for close-in fighting, they left something to be desired. Even sawed off, they tended to break easily. Like something out of *A Clockwork Orange,* however, these malchicks were all the scarier for their lack of efficiency. They came at Kanegson with their pool cues raining down on him. People in the crowd shrieked, jumped back, and held out the two-fingered peace sign, as if that would help.

Kanegson fell to the ground, where the Angels continued beating him. The pool cues predictably snapped. The feeding frenzy died as quickly as it came to life. The shark pack dissipated. Cutler called for medical help from the stage. A doctor managed to take Kanegson backstage. He had been severely beaten around the head and face. It took sixty stitches to close the wounds. They gave him some pain pills and wrapped his head in a bandage. Jonathan Riester placed a Stetson cowboy hat on top. The horror show had begun.

Fear flashed through the crowd in front of the stage. They had all seen the naked fat man, and the sudden explosion of violence, the thrashing pool cues; the screams from the crowd, louder than the music, sent a dark jolt through them. The Angels, suddenly and savagely, had made it clear they would stand their

ground no matter how outnumbered they were. They could no longer let their guard down.

Acid guru Tim Leary had been watching from in front of the stage wearing an Irish cable-knit sweater, puffing on some hash in a meerschaum pipe. He retreated backstage, where he was encouraged to take the stage and say something that would calm the Angels. Leary knew better. He demurred.

"These people are crazy and they're out of control," Leary said.

Santana drummer Michael Shrieve sensed the fog of evil as soon as he settled behind his kit and looked around. The stage felt claustrophobic and the audience packed up against it as tightly as they could. He saw one particularly menacing Hells Angel called Animal, who was wearing a coyote skin as a headdress— the flattened, dried-out head of the long-dead animal hanging grotesquely over his forehead. Something felt wrong from the start.

Organist Gregg Rolie, too, experienced some apprehension on arriving and sensing the tension in the air. He was a veteran of concerts in the parks. Those were customarily calm and cool. This was the opposite of that. Rolie watched in terror as the Angels walloped the fat naked man a few feet away. He couldn't avoid witnessing the mayhem from where he sat, trapped behind his keyboard. It took place directly in front of him. He flinched as he saw the Angels lay into people. Deeply disturbed, he burrowed into the music. The band's throbbing "Persuasion" had never sounded so urgent.

The Angels waded into the crowd flailing pool cues another half dozen times during the band's forty-five-minute set, chasing down a hippie photographer who refused to give up his film, smacking around some freaked-out kid trying to escape by climbing onto the stage. Each time, the ineffectual crowd would spread out in an instant while people screamed "Peace!" and flashed the peace sign. Angels were dashing from the back of the

stage through the band to leap into the fray. The Hells Angels party on the top of the S.F. chapter bus fired a fusillade of full beer cans at the stage. A couple of the San Jose members turned on one of their prospects and pounded him into the ground. He took his ass-kicking with equanimity, and within minutes was standing at their side again.

Twisted mindless by volatile cocktails of drugs and drink, the Angels' blood boiled as they began to stake a battle with the audience. Facing an endless, surging mass of humanity, their backs literally against the stage, they struck back. Once roused, they would not be easily quieted.

Even at this early hour, the criminally low stage was already adding to the volatility of the scene. During the last song of Santana's set, as the music built to a satisfying peak, a fan burst onto the stage from the side and raced across, straight through the band, two Hells Angels in hot pursuit. They grabbed him before he could get off the stage and into the audience. There, in front of the terrified musicians who were having a hard time believing what they were seeing, the two Angels stomped the kid to a pulp, right onstage while the band played.

The audience was already edgy from waiting in the sun on the barren hills with no food and water. All the violence and chaos from the stage only exacerbated the negative atmosphere. The putrid smell of extinguished campfires of burned potato chip bags and other garbage led some concertgoers to vomit. People were drunk and stoned. Some people from Berkeley laid a bag with more than a thousand hits of acid on the Angels, who freely distributed the pills from the S.F. chapter's bus backstage and in handfuls tossed out from the stage. There was a batch of yellow pills circulating through the crowd that was turning out bad trips by the dozens. The Angels were also gulping down vast quantities of reds—sleeping pills they bolstered with generous doses of speed—which in some circles were known as anger pills because of the tendency for users to erupt in violent displays of frustration.

While a number of Angels took on some of the duties and responsibilities Cutler had vaguely envisioned them carrying out—maintaining order around the stage and dressing rooms, working with the film crew, helping keep the crowd out of the way of the production—most came with no such idea. The vast majority were there to enjoy their privileged status at this signal event and have a good time, going after both with fierce single-mindedness.

THE MAYSLES FILM crew had coptered into the concert Friday night, although the Maysleses themselves returned to the hotel with the Stones, leaving their crew at Altamont to fend for themselves overnight at the site. Most of the crew were recent UCLA film school graduates who had flown up from Los Angeles on Friday afternoon. The dozen L.A.-based filmmakers had been pulled together in less than twenty-four hours by Baird Bryant, a respected older independent cinematographer best known for shooting the cemetery scene in *Easy Rider*. As a young man in his twenties, Bryant had lived in Paris, where he worked as a writer and befriended other beatnik writers such as William Burroughs, Allen Ginsberg, and Jack Kerouac, and expatriate jazz musicians like Chet Baker. He made the first translation of the erotic novel *The Story of O*. He made a short experimental film before returning to the United States in 1959, where he met Al Maysles on shipboard.

Bryant and his team assembled on Friday at a film production company office in Sausalito before moving on to Altamont. Stanley Goldstein, the Maysleses' advance man, had also stopped during the week at the American Zoetrope offices in San Francisco, where director Francis Ford Coppola was building a renegade independent film studio. Goldstein asked for volunteers. The film company would provide raw stock, but no equipment and no salaries. They would welcome any filmmakers with their own gear who might want the experience. Young filmmakers George Lucas and Walter Murch were preparing

to start filming Lucas's first feature, the science-fiction thriller *THX 1138,* and wanted to experiment with a new one-thousand-millimeter lens. Murch had done some postproduction work on Coppola's upcoming film *The Rain People,* but neither he nor Lucas had ever worked on a professional film crew before. They packed their gear into a truck and rode out to the concert. With the giant, forty-pound lens as big as a hog leg, AMERICAN ZOE-TROPE printed on the side, Lucas and Murch were sent to a far hilltop where the powerful lens provided a full shot of the stage from a mile away.

The Maysles brothers arrived about noon on Saturday and held the first meeting with their film crew backstage. Each team of cameraman and soundman was assigned a location and given a Hells Angel as bodyguard. The filmmakers were told to go out in the crowd and find stories. Of course, that didn't stop the acidhead cinematographers from taking endless shots of crows sitting in trees or trippy panoramas of branches against the sky that would never make the movie.

It quickly became clear that the Maysleses, who by following the Stones back to the hotel had avoided the rough night on the ground, had no idea what they were in for. Like many others, they thought they were attending another Woodstock. A few minutes after the meeting ended, David Maysles stopped a cameraman from filming a naked woman having a freakout backstage. She had been playing a strange game all morning. She would run up to men, throw her arms around them, and hug them. When they responded with the inevitable crude comment, she would jump back, startled and disgusted.

"Don't shoot that," Maysles told the cameraman. "That's ugly. We only want beautiful things."

The cameraman, who had been there since the previous night and seen far worse in that time, looked at Maysles in shock.

"How can you possibly say that?" he said. "Everything here is so ugly."

A number of the film crew dropped acid deliberately, while others, like Joan Churchill, did so without meaning to. Cameraman Bryant and his audio engineer, Peter Pilafian, were putting their gear together that morning when they, too, unsuspectingly dosed themselves with LSD by drinking from a jug of wine someone offered them. Bryant was a laughing Buddha of a man who could take a punch, and Pilafian was well familiar with the chemical from his days working with the Mamas and the Papas. They were not as debilitated by the acid as Churchill, although they soon decided they were not dealing with human interaction too successfully and headed up to the hill to take some wide shots of the crowd.

The acid casualties mounted. Hog Farm volunteers and the psychiatric staff were overwhelmed in the tents reserved for bad trips. Moans and screams could be heard coming from within. The medical doctors stayed busy dealing with a steady stream of injuries, including many lacerations from encounters with Hells Angels in front of the stage. Patients were lying around the ground outside the tents and people walked through without regard. Dr. Fine was surprised to be stitching up so many girls. Efforts were made at festivity. A couple of Hog Farmers found a supply of plastic coffee can lids and handed them out to the crowd, who tossed the yellow discs around like tiny Frisbees. The Hog Farmers also gave away the backstage sandwiches to the audience.

The injuries weren't only on the defenseless. Stones bodyguard Tony Funches arrived in the medical tent after a brief altercation with a pair of Angels. Prior to walking in, Funches had posted himself on the stage. In his tie-dyed purple T-shirt, head and shoulders above the rest of the crowd, he'd stood out for all to see on the stage. Keith Richards had kept him awake all night and he'd never slept. He tried to deter the initial beating of the fat man, leaning down from the stage and reaching out for the man's shoulder, but quickly realized how futile any serious

effort would be after he saw the Angels wail on Bert Kanegson. He retreated to his number one priority: keeping the Stones safe.

Still, he couldn't resist stepping in when he saw two Hells Angels in a fistfight on the stage. The black giant easily separated the two battling bikers. One of them directed a racially insensitive remark to Funches, and he invited the pair to step backstage.

Funches had been a champion boxer in the air force. He towered over the two Angels. They squared off. Funches hit the first Angel so hard, he broke his hand on the man's jaw. The Angel dropped like a bag of sand. Funches then turned on the second Angel, his hand screaming in pain, and hit him anyway. He punched the second Angel so hard, he broke his hand a second time. The other Angel joined his associate on the ground. Funches extracted a large Buck hunting knife from one of their belts as tribute and made his way to the medical tent to have his hand treated.

But when he found the medical staff in total disarray, Funches didn't bother trying to get the attention of the doctors. He reached into the supplies and grabbed a splint and an Ace bandage. He wound the tape around his hand and went back to his post on the stage. The Angels left him alone the rest of the day.

14

The Airplane

These were difficult days for drummer Spencer Dryden with Jefferson Airplane. Dryden, who was a few years older than the other band members and had only joined the group after their first album, was a caustic presence and chronic complainer. Making matters worse, his influence in the group had dimmed considerably since his romantic relationship with vocalist Grace Slick ended the year before. The other members were talking behind his back about getting rid of him.

Guitarist Jorma Kaukonen and bassist Jack Casady were especially hard on Dryden. Those two liked to take speed and engage in endless hyperenergetic bouts of improvisation onstage, driving Dryden into the dirt. They took delight in torturing him. His jazz-inflected playing simply did not have that kind of power, and more than once, the strain had left sickly Dryden pissing blood after gigs. Paul Kantner, who had formed his own personal alliance with the band's comely female vocalist in the wake of Slick and Dryden breaking up, was naturally confrontational and still angry with Dryden over his role in firing Bill Graham as the band's manager.

Jefferson Airplane had burst out of the San Francisco dance halls two years before, in 1967, with the band's second album, *Surrealistic Pillow,* the spearhead of the burgeoning West Coast rock movement. Far and away the most successful of the San Francisco bands, the Airplane had appeared on the cover of a special issue of *Life* magazine in June 1968 about the new music. They were irreverent, contentious, high-flying hippies who bought a giant Victorian mansion on the edge of Golden Gate Park where they lived like beatnik royalty. The band loved to sneak into the park for impromptu free concerts. Grace Slick captured the public's attention with her ex-model's good looks, potty-mouthed witticisms, and soaring vocals on the hit records "White Rabbit" and "Somebody to Love." The Airplane were every bit the resolute hippies the Dead were; they just had some dough to throw around. Unbought, unbossed, and uncensored, they were the epitome of the new breed of rock stars.

The Airplane had been on the road for what seemed like forever. After a Thanksgiving weekend run at the Fillmore East in New York (while the Stones appeared at Madison Square Garden), the band went to Florida to play the Palm Beach Pop Festival, where some observers thought the Airplane's set was better received than the Stones' late, late show at the close of the same festival.

Dryden had arrived for the West Palm Beach show neatly dressed in his natty western suit, wearing his favorite cowboy hat and carrying his inevitable Halliburton briefcase. The helicopter deposited the band on a strip of land surrounded by water. Dryden got off the copter straight into the water. Totally submerged, he lost his hat and briefcase and had to be taken back to the hotel to change clothes before the show. After two more college dates in Florida that week, the band boarded a late-night plane Friday night in Miami headed for San Francisco to appear the next day at Altamont.

When the Airplane had left San Francisco to go out on tour,

the plans still called for the band to play a free concert with the Dead in Golden Gate Park and the Stones appearing as surprise guests. Of course, while the band was out of town, those plans had disintegrated. Rock Scully had kept in close touch with Airplane manager Bill Thompson over the telephone, but the Airplane, no longer part of the organizing, could only watch from afar.

Dryden was furious about the concert. He launched into a loud argument with Jorma Kaukonen on the flight home from Miami. Dryden didn't like the way the concert was coming together. He said it wasn't the same thing they had agreed to do. Some racetrack near Tracy, California, wasn't Golden Gate Park. He threatened not to play the show. Kaukonen angrily countered by saying he would quit the band if Dryden didn't play. The argument continued all the way to the baggage carousel in the San Francisco airport at three o'clock in the morning.

Thompson finally took Dryden aside and told him that he would meet at seven o'clock in the morning at the Ferry Building, like everyone else.

"You are not going to be the guy who fucks it up for everyone," Thompson said.

Dryden and his girlfriend, Sally Mann, returned to the Airplane mansion for what sleep they could. When it came time to leave, Mann stayed behind, which didn't make Dryden any happier. He was in one foul mood when he boarded one of two large helicopters. Everyone was burned out. Grace Slick, behind a pair of prescription shades, had forgot to put in her contact lenses that morning. They flew to the Tracy airport, east of the concert site, and changed to smaller copters to take them to the speedway. Dryden, as he flew over the dirt-brown hillside swarming with ant-size people, thought he was looking at a landscape by Hieronymus Bosch. He made sure to drop some acid before taking the stage.

The stage was intensely crowded, too much even for the

veterans of the burgeoning festival scene. As road manager for Jefferson Airplane, one of the most popular hippie rock bands in America, Bill Laudner had been in plenty of tight spots the past couple of years. The Airplane had played every rock festival in sight this year, including a memorable sunrise set at Woodstock. But today, as the Airplane prepared to take the stage, he was immediately wary. He'd ridden the bus with Kesey and his Pranksters and knew the Angels well, but he had never seen them with so many drugs—bags of Orange Sunshine LSD and rolls of reds. Not only were they consuming vast quantities of drugs, but they were also drunk and laughing. And dangerous.

"There are a number of people on or around the stage who should not be here," Sam Cutler announced over the public address system. "The musicians are playing with something like two hundred people breathing down their necks. Now, I please ask everyone to leave the stage and we'll go back to playing music and nothing else."

Cutler, who knew he had lost control of the stage, sounded resigned as he introduced Jefferson Airplane. In truth, he was terrified, but he kept his voice intentionally flat, devoid of emotion. He was one of those tough English guys, born in the Blitz, who believed in keeping a stiff upper lip in the face of adversity. He was low on resources. He had not slept the night before or much through the entire tour. In addition to his formidable responsibilities as tour manager, Cutler frolicked with as many of the available women as he could and was drinking and drugging with the best of them. He took so much cocaine on the tour, he had lost twenty-one pounds over the six weeks he was in the country. But today the coke alone wasn't enough; he was also relying on the fistful of opium he'd taken earlier in the day. The opium soothed his panic. The coke kept him on his feet.

Determined not to spread fear or bad vibes, Cutler ruled out any stage announcements warning against tainted acid or raising any other alarms. He argued with angry people who insisted

he follow the protocols established at Woodstock, where Chip Monck routinely cautioned the audience about poor-quality drugs that were circulating. Cutler refused to budge. He had already glimpsed the pandemonium and feared opening the floodgates. He would not create any panic from the stage. Of course, that decision would cut off communication with the audience and risked dangerous consequences. But Cutler swallowed his fear and plodded ahead, numb from drugs, fatigue, and stress.

As the Airplane took up their positions onstage, Hells Angels sat along the lip of the stage drinking the cans of beer Cutler had bought. Vocalist Marty Balin had had a couple of drinks himself before going onstage and stood swaying to the music, his eyes closed behind dark glasses, as the band soared into a lengthy instrumental introduction. When he opened his eyes, he saw Angels fighting with fans in front of the stage. He felt anger rise in him.

As the band started to sing, Sweet William and Animal in his dead coyote headdress escorted some stoned hippie across the stage and threw him back into the crowd right in front of Balin. Another melee broke out before the stage and the crowd spread out as the Angels hammered some fan. The Angels on the back of the stage exploded to the fore. Grace Slick stopped singing and retreated behind the drum set, muttering, "Easy . . . easy" over the rolling rhythm Kaukonen, Casady, and Dryden kept up. Dryden stood behind the drum kit to try to get a view, but kept playing.

The Angels were beating a black guy, and Marty Balin threw his tambourine at them. Pissed off, Balin started yelling at the Angels onstage. Animal, the man with the taxidermy for a hat, ran up and smashed him in the face and Balin went down in front of the drum kit. Animal was a tough, twenty-year-old Hells Angel named Paul Hibbits, originally from Camarillo in the west end of the San Fernando Valley. He was so young when

he joined the club, he used to have to wait outside bars while the other members drank. He could be sweet and funny, but he did love to fight and didn't hesitate to act when he heard the Angels disrespected. He was high and dazed, but he smacked Balin down like a lightning bolt.

Balin recovered, shaken, stood, and charged to the lip of the stage. He pointed to the brawl and shouted at the Angels. Then he jumped down in the middle of the fight to try to stop it.

Kantner watched in shock. Grace Slick scrambled to see, but without her contact lenses, everything was a foggy blur. Terrified and disoriented, she tried to pour oil on the troubled waters.

"Easy," she said into the microphone. "Please be kind. Please be kind. Please be kind. Please be kind. It's all right. It's kind of weird up here."

The rhythm section finally came to a halt and a contentious Kantner took the mike.

"Hey, man, I'd like to mention that the Hells Angels just smashed Marty Balin in the face and knocked him out for a bit," he said. "I'd like to thank you for that."

Sitting on the stage drinking a beer, Sweet William stood up and took another microphone. "Hey, wait," he said. "Is this on? If you're talking to me, I'm going to talk to you."

"I'm not talking to you, man," said Kantner. "I'm talking to the people that hit my lead singer in the head."

"You're talking to my people," Sweet William said.

"Right," said Kantner.

"Let me tell you what's happening," said Sweet William. "You—you're what's happening."

Grace Slick tried to smooth the raw emotions. Her voice dropped to a gentle, conciliatory coo.

"No hassles with anybody in particular," she said. "You've got to keep your bodies off each other unless you intend love. People get weird and you need people like the Angels to keep people in line, but the Angels, also, you know, you don't bust

people in the head for nothing. So both sides are fucking up temporarily. Let's not keep fucking up."

Slick was scared and exasperated, knowing how futile her pleas were. Even these seasoned veterans of the San Francisco scene, a band with years of experience with the Hells Angels, were helpless to stop the violence. The platitudes of peace and flowers rang hollow—the Haight-Ashbury tapestry unraveling in violent, uncontrollable fashion for all to see. Her words wilted as she said them.

Road manager Bill Laudner had been crouched behind the amp line when Balin went over. He raced to the front of the stage, but when he saw what was happening down there, he decided he couldn't help and stayed where he was. Somebody handed him Balin's arm and Laudner dragged his inert body onstage. Laudner got him backstage to an equipment truck backed up to the stage that was serving as an impromptu dressing room. Sitting on an equipment case in the dark where he couldn't see her was Rosie McGee, still reeling from her acid overdose and trying to recover. Into the relative calm of the dark van, the unconscious body of Marty Balin was suddenly sprawled across her lap.

Animal, meanwhile, having been admonished that you can't go around stomping the band and expect the show to be any good, came to find Balin and apologize. He looked like some bearded, evil medieval warrior wearing a dead animal on his head. Having ingested formidable amounts of sundry drugs and other intoxicants, he was slightly emotional, even tearful, in his stumbling, mumbling explanation to Balin.

"You just can't say 'Fuck you' to an Angel," Animal concluded.

Bantam rooster Balin, barely three quarters the size of the hulking Angel, still dazed, probably in shock, stood up and faced Animal. "Oh yeah?" he said. "Fuck you."

In a heartbeat, an enraged Animal turned and slugged Balin in the face as hard as he could. Balin went down again.

Rex Jackson of the Grateful Dead road crew saw what hap-

pened onstage and was incensed. Jackson was a motorcyclist and rode with the Angels. He was the toughest guy on the Dead crew, the enforcer who had fought his way out of many difficult situations, once taking off his boot and knocking Rock Scully to the ground with it to make his point. Jackson knew the Angels loved the Dead, and, feeling betrayed in some primal way, he went after Animal. The other Dead crew recoiled in horror as Animal rabbit-punched him and hit him with a barrage— Jackson might have got in a shot or two—that left him stretched out unconscious on the stage.

With Rex Jackson out, coldcocked, his eye blackened, the bands' last line of defense went down and everybody backstage knew it. If anybody could have stood up to the Angels, it would have been Jackson, and now he was out of it. Whatever force the bands could bring against the Angels was lying facedown, unconscious. A blanket of despair settled on the stage as the sodden reality became apparent. After that, there would be no question backstage among the crew about whose stage it was. These hippies had no defense against this kind of ferocious savagery.

The Angels had caused problems before, but this was a raging violation. The musicians had never had reason to fear. They felt immune from the real world when they were performing. Nothing had ever penetrated that bubble before. It was an illusion kept in the best interests of both the musicians and the audience. This distinction was lost on the Angels.

Balin staggered back in time to join his band for the final number, "Volunteers," the incendiary pseudorevolutionary title track of the band's new hit album. Up against the wall, motherfuckers, indeed. Laudner warned him before he left the truck to leave the Angels alone. This was not a war they could win. The set lurched to a close without more violence.

Kaukonen approached Balin after the set and told him he was crazy. Balin was still pissed. He was the flower child of the band,

while Kaukonen always talked tough and walked with a swagger. Jorma had once threatened the band's lighting director with a knife.

"Where the fuck were you with all your machine guns, knives, and shit?" Balin said.

Manager Thompson, Balin's longtime friend, hustled him off to the next helicopter. Kantner and Slick decided they wanted to stay behind and watch the Stones. They met up backstage with their friend from Quicksilver Messenger Service, David Freiberg, who had heard about the concert on the radio that morning and driven over at the last minute from Marin County in his 1964 Dodge Dart, which he had abandoned on the roadside several miles back. In all the confusion, nobody noticed that Airplane drummer Dryden had wandered off.

15

The Flying Burrito Brothers

The Flying Burrito Brothers were set to follow the Airplane. Keith Richards had reserved a slot on the program for his best friend's band, which had increasingly become a sideline for Gram Parsons. With new member Bernie Leadon in tow, the Burritos had spent time in late November in the A&M Studios after the Stones left town, bashing out a selection of ill-prepared, sloppy renditions of old country songs for a second album. Parsons had written no new songs. Cofounder Chris Hillman was growing annoyed with Parsons. With $50,000 a year coming in from his trust fund, Parsons was not highly motivated to play nightclubs for $500 a night. Hillman still received royalties from his days with The Byrds, but Leadon and the other members needed to survive on gig money, plus occasional session work. There was no money in Altamont, not even expenses, but Parsons was so anxious to appear on the free concert with his heroes that he paid for the band to fly to San Francisco, rented a station wagon, and booked a couple of rooms by the bay in Sausalito. It would be the first public performance by the new lineup.

The band went to the heliport in Sausalito, but after waiting for a helicopter to arrive, they decided to drive to the concert in the station wagon. With steel guitarist "Sneaky Pete" Kleinow at the wheel, the Burritos hit the backup outside of Livermore. After inching along the highway for several miles, Kleinow drove up on the soft shoulder and started rolling about forty miles an hour past the line of stalled cars. All went well until someone up ahead pulled out in front of him and, swerving to avoid a collision, Kleinow drove the station wagon into a ditch.

Parsons got out of the car wearing his silk pants and scarf. He flagged down a Hells Angel driving down the highway between cars. He understood that the Angels were acting as security and explained that he and his band were opening for the Stones. Parsons climbed on back, and Leadon got aboard a second Angel's bike. The two musicians roared off on the backs of the Harleys, leaving the rest of the band to make their own way. When the bikers reached the top of the bowl, they turned off the road and drove straight through the crowd. People were jumping out of the way. Blankets were torn up and picnics crushed. The bikers wheeled all the way to the front of the stage and parked.

The rest of the band finally caught up with Parsons and Leadon. The band's equipment crew had driven the gear up from Los Angeles. Hillman walked backstage through the crowd, carrying his bass. Parsons was already hanging out with Keith Richards in the Stones' trailer. Richards, who had spent all night at the site taking LSD, smoking opium, and snorting coke, looked refreshed and clear-eyed.

As the Burritos performed, Michelle Phillips of the Mamas and the Papas stood in the wings of the stage. Phillips had come up from Los Angeles with a friend and, shortly after having a sip of somebody's apple juice, realized she had dosed herself. She tried to throw up, but to no avail. The LSD swirled inside her and she made her way backstage and found Gram Parsons. She told Parsons she had been dosed and he said he would take care

of her. She was standing onstage during the Burritos' set when one of the Hells Angels grabbed her arm and started to throw her off the stage. She snatched her arm back and angrily pointed at Parsons, telling the Angel that Gram was her boyfriend and that the band would stop playing if he "didn't fucking disappear."

The Angel regarded the slim blonde and broke into a smile. "You've got balls, little lady," he said, walking off.

The Angels calmed down during the Burritos' set. The beatings ceased as the band cantered easily through their trademark L.A. country rock. They hardly qualified as a major attraction, but the light, frothy zest of "Lucille" or "Six Days on the Road" on steel guitar beams soothed the crowd, who sat back and enjoyed the music. With the crowd seated, the surging in front of the stage ceased and the concert proceeded peacefully. Parsons wore one of his signature, custom-made bejeweled Nudie suit jackets, Thunderbirds on the front and a dancing Indian warrior on the back. The performance went down without incident.

Much of the details of what had happened onstage during the Airplane set were lost on the far reaches of the hill, where the sound was not especially clear and the violence in front of the stage not visible. On top of the hill, the Ant Farm's inflatable pillow served as an unofficial bad trips pavilion. One concert-goer named Mary adopted the group as a kind of house mother. She chased away kids from the tunnel holding the fan that kept the bubble inflated, convinced a Hells Angel to move his bike away from the intake, and generally supervised the place. The Texas conceptual artists, who had been invited by Rock Scully, had been forced to take the pillow down in the middle of the night when winds threatened to tear the giant plastic inflatable held down by netting. All afternoon, anxious, frightened people took refuge in the heaving, rolling, translucent cavern, the floor covered with ripples.

Down in front of the stage, the people in the first hundred yards couldn't escape the paranoia. Only the most intense—and often, most intoxicated—fans fought their way to the front. The proximity was dearly won and they were pressed together in a thick, squirmy mass, unable to move. There was nowhere to turn. Waves of movement swept people off their footing, but there was no room to fall. The shock and fear physically rippled through them.

Not only did the craziest, most intense fans push their way to the front, but once the Angels started fighting, they attracted would-be tough guys in the farther reaches of the crowd who made their way down specifically to take on the Angels. The bikers never appeared to have any problem with these fools, but they kept coming. The entire front section was like an over-crowded subway car full of stoned, drunk, and violent people.

The Angels had been placed in an untenable situation, serving as the lone bulwark between the crowd of three hundred thousand and the postage-stamp, ground-level stage. When men like the Angels feel fear, which they most certainly did, it translates into different responses than those of ordinary people. Fear is not part of their world. It must be defied through action. These are primitive beasts faced with a fight-or-flight dilemma, controlled by their amygdala. Flight would never be the answer. They were scared and on drugs. The audience was scared and on drugs. Nobody was rational. The hippies never expected this kind of violence from the Angels and had no idea what to do about it. The Angels, on the other hand, were quite aware that they were badly outnumbered and knew they could only hope to rule through intimidation.

Not all of the Angels rampaged. Flash, who had ridden out that morning on the S.F. chapter bus, was disgusted by the behavior of the reckless audience. He saw a group of people standing on top of a woman who had fallen down so they could get a better view. The woman struggled and screamed, but

nobody moved until Flash started knocking them off her. When he pulled her up from the ground, she thanked him for saving her life. He couldn't believe how crazy the crowd was. They were wild, stoned, and rabid. He felt like they would crush him. He was appalled at all the fools climbing the light towers. This was not like the groovy concerts he had attended in Golden Gate Park. These people were vicious. Every few minutes, another idiot would try to crawl onstage. Flash told people to get off the stage, and when they didn't leave, he would usher them off. He liberated a tub of turkey drumsticks backstage and passed them out to the audience.

Still, efforts like these couldn't stem the tide. As the day wore on, the med tents overflowed, not only from victims of Angels beatings, but also from drug overdoses driven into psychic terror by the violence. Psychiatrists were horrified by one fellow who had regressed to the point where he was groveling on the ground, grunting and eating dirt. The women from the Hog Farm wanted to talk him back, but when the doctor returned and the patient was getting worse, he gave him a shot of Mellaril, a powerful antipsychotic drug. A half hour later the man had come around and was thanking the doctor. He turned out to be a schoolteacher from the East Bay who had eaten six hits of Mr. Natural blotter acid. The psychiatrist, who had already seen a lot in his short time as a resident at UCSF, was astonished.

A young man about eighteen years old wandered into the bad trips tent. He was extremely frightened and crying uncontrollably. Nurse Jane, who had come out with her boyfriend—a psychiatric resident—treated him. The young man had no idea how he got to the concert or who he came with. She took his hand and led him out of the noisy, hectic tent. They walked to the edge of the venue where it was at least quieter. She spoke to him reassuringly and he calmed down, but stuck to Nurse Jane like a barnacle the rest of the afternoon. As she worked her way through the crowd, advising companions of people in obvious

distress to seek help at the medical tent, he clung to her every step. There was no shortage of clientele.

By the end of the day, the four psychiatrists working the bummer tent would treat more than two hundred patients by themselves. The tension was so great that Wavy Gravy of the Hog Farm, a Woodstock veteran volunteering backstage, witnessed two doctors getting into a fistfight over an argument about treatment protocols.

The injured were littered backstage like wounded soldiers. The Angels kept a cordoned-off area as a jail where they held especially unruly concertgoers under guard. They had found the naked fat man and took out his teeth with pool cues. He wandered around, still naked, his face and chest dripping with blood. The Burritos had hidden him in their trailer for a while. Likewise the naked woman who kept hugging people was beaten. She walked around backstage, also bloodied and still naked, but dragging behind her the blanket they had given her at the medical tent.

Nobody was immune to the chaos, and even the film crew got caught in the action. Cinematographer Stephen Lighthill had been onstage in the middle of the Airplane fracas, and though the Angels had been glaring at him, he used a shoulder brace that allowed him to point the camera one way and look in a different direction. They couldn't tell what he was filming. Soundman Nelson Stoll was trapped on the light tower with his Nagra recorder and had no way to communicate with anyone else on the crew. George Lucas and Walter Murch remained perched high on the hill, fiddling with their finicky camera, under the impression that it was a lovely, peaceful day—like many people on the hill, blissfully unaware of any problems around the stage. Another cameraman closer to the action was yanked off the top of a bus by a Hells Angel.

Rolling Stone photographer Baron Wolman couldn't take the violence. He told managing editor Burks that he didn't sign up

to be a war photographer and headed for the highway, where he hitchhiked back to San Francisco.

AT THE FERRY Building in San Francisco, the Dead had been hanging around, smoking pot, waiting for a helicopter large enough for their party, when the Stones showed up. Lenny Hart went up to Mick Jagger.

"Have you met Jerry?" he said, taking Jagger over to where the Dead and their girlfriends were arrayed along a wall. The cordial Jagger was raised to have proper manners.

In a tangerine-colored ruffled shirt under a cape, Jagger exchanged brief banter with Garcia, who was draped in a lavender poncho, a joint between his fingers. Drummer Billy Kreutzmann, in a cowboy hat and rancher's coat, sat next to him. The other band members and their girlfriends milled around in the cold. The pair were a study in contrasts: the jolly, messy San Francisco hippie and the cocky, aristocratic British rock star.

"How long have you been here?" Jagger asked Garcia.

"Upward on a couple of hours," said Garcia, cackling. "It won't be long now."

Jagger checked the time on an antique watch he wore around his neck and conferred with Stones road manager Ian Stewart about the arrival of helicopters.

"Ten minutes," he said. "Right, film people, let's do something."

Jagger took a young girl out of the party and posed her at the end of the pier. Directing Al Maysles behind the camera to go "tighter, tighter, tighter, tighter" on the girl's face, a hippie headband across her brow, Jagger leaned into the frame and planted a kiss on her forehead. He instructed beleaguered drummer Charlie Watts to do the same thing, but Watts shook his head.

"Love is a much more deeper thing than that," he said, only half joking. "It's not to be thrown away on celluloid. No."

A few minutes later, the Stones boarded their copter and flew to Altamont.

A squealing pack gathered as the Stones landed in a whirlwind of dust on the speedway track. Photographers and television cameramen crowded around as Mick Taylor, Charlie Watts, and Mick Jagger stepped out of the KSFO traffic helicopter. Jagger, chewing gum, strolled into the crowd with a benign smile. One of the nurses from the nearby bad trips tent stood there with a bouquet of flowers she had taken from the tent, where they were intended to help acid overdose victims. Face-to-face with Jagger, she panicked and froze.

"Are those for me or not?" said Jagger, smiling.

She stuck her hand straight out to give him the flowers and ran away frightened as soon as he took them.

A young man stepped into Jagger's path. "Fuck you, Mick Jagger," he screamed. "I hate you." He punched Jagger in the face. Down Jagger went. The kid twisted away, but one of Jon Jaymes's security guards wrestled him to the ground.

"Don't hurt him," said Jagger, who was back on his feet, looking concerned, maybe even a little reproached. He hadn't been at Altamont two minutes and somebody had already assaulted him. If that gave him pause, Jagger didn't let on. Quickly, he disappeared into the Airstream trailer that would be the Stones' dressing room. Richards in a T-shirt followed him inside. The rest of the band walked across the speedway, past the fat naked guy with his face bathed in blood, the Flying Burrito Brothers singing "To Love Somebody" in the background. Tony Funches and a drunken Hells Angel stood guard in front of the closed door.

The Dead showed up on the next helicopter. Michael Shrieve of Santana caught up with Garcia as he walked off the speedway. Shell-shocked Shrieve was on his way out. His bandmate Gregg Rolie was already gone, having grabbed his girlfriend and taken the first outbound helicopter after the band played. Shrieve

filled Garcia in on what had been happening. Garcia took it all in, while swirling through his head was the heroic dose he had taken of STP, a special Owsley concoction much more powerful than LSD.

"Oh, that's what the story is here?" Garcia said. "Oh, bummer."

"Really, man," said Shrieve. "It's scary."

Bassist Phil Lesh walked up. "Who's doing all the beating?" he asked.

"Hells Angels," said Shrieve.

"Hells Angels are doing beatings on musicians?" said Lesh.

"Marty got beat up," said Shrieve. "Right onstage."

"Really?" said Lesh.

"It's really weird," said Shrieve. "Really weird."

This was an upside-down world the Dead couldn't comprehend—Angels beating musicians?—coming from Shrieve moments after they touched down at the speedway. As they walked backstage past people who shouted at them about the Angels, warning them the bikers were out of control, Garcia looked over at Lesh. "When are the Angels ever under control?" he said.

Once the Dead arrived backstage, where their crew, friends, and family were waiting, they saw Bert Kanegson with his head wrapped up like a mummy and that ridiculous cowboy hat perched atop it. The reality of the situation began to sink in. Their trusted roadie Rex Jackson was skulking around with a black eye. They had never seen anything like this. The band climbed in the back of their metro van to confer. Most of the gear had not been unpacked.

Rock Scully, distracted, high, and skittish, talked to the band about playing. He had made his way to the concert site sometime during the night after the Dead finished playing at the Fillmore West. Jangled and traumatized, Scully had been running around all day trying to make things right without any success. He was dazed by cocaine, a healthy supply of which he had delivered to the Stones' trailer, and had been wandering through

the scene, trying to make himself useful but largely failing. He was distressed and anxious. Whatever he had in mind that night in London staying up with Keith Richards, this was nothing like what he imagined. The Altamont location horrified him. He had long before been left behind in the mad rush to make this concert happen. When decisions were being made that morning, he was nowhere to be found and nobody went looking for him. Once the concert moved to Altamont, Rock had been left behind. He was feeling like he had been played for a patsy.

Rock's frolic in the park had gone sour weeks before, as forces in the Stones camp took over. Scully had tried to enlist the entire San Francisco rock community and had included Emmett Grogan of the Diggers in all the planning and meetings from the earliest stages to broaden support for the concert. He gave the enterprise the credibility and organization it needed to get off the ground, but Scully soon found himself—and Grogan—pushed to the side as the Stones marched toward this inexorable event. Scully had been fine with Sears Point as an alternative to Golden Gate Park, but the sudden switch to this dump on the edge of the earth terrified him. He felt the whole thing had finally spun out of control and it was all he could do to hang on. All the drugs he was taking didn't ease his growing panic. He knew the Angels well enough to know that whatever madness and mayhem they had started was only going to get worse. By the time the Dead showed up, he was thoroughly freaked out and he urged the band not to play. They wanted to think about it before deciding what to do.

They sat inside their van, puffing on joints and debating. Lesh felt that playing music was only going to continue the cycle of violence between the audience and the Angels. The Dead had planned to take the stage before the Stones, and Lesh felt if the band didn't play, it would clear the way for the Stones to take the stage earlier and bring the whole debacle to a close sooner. Scully emphasized how unpredictable the Angels had been all

day. He was shocked by what he'd seen, and he had been around the Angels for years. As if to help make his point, one of the San Jose members closed the van door and refused to open it, trapping the band inside for a while.

Lesh's equipment had been loaded on the back of the stage. Mickey Hart, Phil Lesh, and their equipment guy Ramrod huddled behind the amps with their Hells Angel pal Terry the Tramp standing in front of them, snapping his whip around like a snake to keep people away. Terry was close friends with the Dead. He worked closely with Bear, distributing his product. Tramp was depressed and angry at what his fellow Angels had wrought. He had spent some time sitting by himself in the audience, sulking. He wasn't going to let anything happen to his friends. The band members could tell that this was obviously scary even to Tramp. The Dead decided not to play.

This had always been designed as the Dead's party, but now they were begging off playing, abandoning Rock's grand scheme at the last minute. Whatever glorious thoughts the band entertained about the show and the San Francisco-meets-London global connection had been dashed. They were deeply disturbed by what they saw, distraught over the violence, the beatings of Bert Kanegson, Rex Jackson, and Marty Balin, the rampaging of the Angels, whose atavistic nature they knew too well. This was no concert in the park. Terrified of what would happen if they took the stage, they knew they couldn't protect themselves and they would be putting themselves and the crowd in some kind of terrible jeopardy. They made the difficult decision to bail and make their way back to San Francisco for the show at the Fillmore West that night.

Back in the Stones' trailer, thick with smoke, blissfully isolated from all the realities outside their walls that the Dead were just now fully confronting themselves, Jerilyn Brandelius's five-year-old daughter, Christina, sat on Keith Richards's lap, happily drawing on his arm.

"I'm going to beat you up," she told Richards cheerily.

"Don't beat me up," said Richards.

Largely oblivious to the chaos and mayhem that had been taking place all afternoon, the Stones settled in the cramped and crowded trailer to wait. Mick Taylor and Charlie Watts lay across the bed in the back. Jo Bergman and Ronnie Schneider were talking on the phone. Jagger stood, nervously pacing. Every so often, he would open the door and peer out. Squeals would come from the crowd surrounding the trailer. He and Richards slipped out to briefly watch the Burritos from the wings, but all they saw was quiet and calm.

Unbeknownst to Jagger, his Miss Pamela was out in the crowd watching the Burritos. She had grabbed a ride up from Hollywood with a friend and was disappointed at the mood of the crowd. She had expected a Woodstock-style sharing and caring community, but found a rude, pushy bunch of drunks and creeps. Hells Angels spilled beer over her outfit, and as soon as the Burritos were done, she was splitting. She didn't want to wait to see the Stones or take her chances backstage. Maybe she'd make a call to the Stones' hotel suite later that night, but for now she was done. Even the most renowned groupie of her age knew that this show was going nowhere good. Besides, she hated going to shows without the band.

16

CSNY

Nobody was waiting when the helicopter carrying Crosby, Stills, Nash & Young touched down at the Tracy airport, which was little more than a runway, a shack, and a windsock. Also on board was attorney Melvin Belli. The entire airport was empty, except for a pickup truck parked in the corner of the lot. CSNY road manager Leo Makota started to hot-wire the truck, but Belli went crazy. As an officer of the court, he explained, he could not possibly be a party to grand theft auto. After Belli got everyone involved to swear to secrecy, Makota went ahead and started the pickup. David Crosby got behind the wheel.

Crosby approached the speedway from the rear, and when he drove over the hill, all he saw was solid people. He drove down through the crowd a short distance and stopped. Makota took over driving and slowly, carefully, backed up the hill and went around the side, where the crowds were thinner. Crosby and Stills took positions on the front bumpers and yelled out the group's name as they eked their way toward the stage. The crowd stepped aside in front of them.

Neil Young had only joined Crosby, Stills & Nash in August. Woodstock was one of their first gigs. A month later, in September, Crosby's beautiful young girlfriend died in a car crash, and he went into a tailspin of grief and drugs. By the time the four had assembled in November at Wally Heider's Studio in San Francisco to begin recording, Crosby was only marginally improved, given to sudden crying jags and inhaling monstrous amounts of dope. Graham Nash, who had recently broken up with his love, Joni Mitchell, had moved to San Francisco and worked hard to keep up with Crosby. Young had bought a ranch in La Honda, about sixty minutes south, while Crosby was living in Marin County. Jerry Garcia personally called Crosby to ask if CSNY would play the free concert with the Stones.

Crosby, Stills & Nash's self-titled first album had not only been one of the big hit records of 1969, it had also restored acoustic music to the bestselling charts and opened the way for a raft of singer-songwriters with guitars. The addition of Neil Young, Stills's former partner from Buffalo Springfield, who had already released two well-received solo albums, stirred considerable excitement with the public and introduced the term "supergroup" to the popular lexicon. The album they were recording was a guaranteed hit, but the members of the group were struggling just to get through everyday life.

As they slowly pushed their way into the Altamont crowd, Stephen Stills immediately sensed trouble. He smelled it in the sulfurous, rancid drag strip air. Stills had never served in the military—although he liked to tell people he had—but he felt like they had landed in a war zone. When they finally arrived backstage, they heard about the Angels beating Marty Balin and learned of the Dead's decision not to play. The tension was palpable.

The group took the crowded, scary stage and Stills opened with a funky version of "Black Queen." After the relative calm of the Burritos' set, the beatings started almost immediately

during the CSNY performance. Pool cues flailed the crowd. One Angel held one hippie from behind while another Angel pounded his stomach. Belli, watching from the stage, cringed at what he saw, his face a mask of horror. Crosby was upset. He knew some Angels personally and was distraught over what was happening. He implored the crowd.

"Please stop hurting each other," Crosby said. "You don't have to. You can always talk, man."

Crosby's pathetic plea went entirely unheeded. He watched in shock as the beatings continued in front of his face. The group swung into "Pre-Road Downs," followed by a poignant, pertinent "Long Time Gone," Crosby urging the crowd to "speak your mind, that is, if you still have the guts." The band concluded with a lengthy version of Young's "Down by the River," which led to an extended jam to finish their short set.

A plastered Hells Angel sat on the side of the stage with a sharpened cycle spoke, and every time Stills stepped forward to sing, the Angel would stab him in the leg. By the end of the half-hour performance, streams of blood streaked his legs and soaked through his pants. Bill Belmont from the Stones tour sneaked over and, when the bombed Angel wasn't looking, stole his cycle spoke. The whole scene had descended into fear and chaos. At the end of the truncated show, the musicians couldn't get out of there fast enough.

Stills started barking orders. He grabbed two guitars. Young took another guitar and his wife, Susan, and they blew out of backstage to where the helicopter was waiting. They had to make connections to fly to Los Angeles for a concert that night at UCLA's Royce Hall. Stills, drained and distressed, fainted after the L.A. show.

AFTER THE CSNY set at the shank of the afternoon, the temperature began to drop. It had been unseasonably warm, but would quickly cool off. The audience settled on the ground shoulder-

to-shoulder, anxious for the Stones' arrival. It would be a long wait.

Conditions were wearing the crowd down. There was precious little food or water, only what people had brought. The producers had managed to get one hundred portable toilets, hardly adequate for a temporary city the size of Fresno. Most concertgoers were taking care of business in the field. The neighbors loved that.

The violence had been confined to the area directly in front of the stage, and even with protestations coming from Kantner, Slick, and Crosby, plus Cutler's calls for medical attention, there was little widespread recognition of the situation through the vast reaches of the audience. The sound system was muddy, the dialogue garbled. Rumors flickered through the crowd. No announcement concerning the expected appearance by the Dead came from the stage, but word filtered out from backstage that the band was not going to play.

As the crowd sat back to wait, a confused, unsettled air floated through the break in the performances. At one point, Animal wandered out to a microphone and blew an abrasive, dissonant flute solo—equal parts stoned war cry and arrogant show of power—that may have made no sense to the audience in the far reaches of the hills, but made it abundantly clear to everyone on the stage that the Angels were the ones running this show.

Sitting out in the crowd waiting for the Stones was Denise Kaufman, a twenty-two-year-old who was five months pregnant. Kaufman belonged to an all-female rock group called Ace of Cups that played bills at the Fillmore and Avalon. They were the angel choir of the city's rock scene and added vocals to records by the Airplane and others. She was married to jazz musician Noel Jewkes, who was reluctant to go to the free concert when his wife suggested it that morning. She talked him into it, packed a picnic lunch, and grabbed a blanket, and they

drove out to Altamont. They settled into a spot on the hill after CSNY played.

Kaufman noticed the crowd's edgy mood turning restless, bored, and uncomfortable. There were no concession stands to get any food or drink. People were shoved up against one another, nowhere to move, sitting on the scrubby ground in the sun. She extracted a carrot from the picnic and nibbled at it, looking out at the sprawling mass of humanity. The next thing she knew, she was lying facedown on her husband's lap and couldn't see.

Some asshole farther up the hill had lobbed a full can of beer skyward, throwing it as high and hard as he could, and it had come down and struck Kaufman from behind on her temple above the ear. She never knew anything hit her. Everything turned dark and blurry.

Her husband led her, barely able to see, down to the medical tent, a precarious, long walk over all the bodies on the hill. Backstage she was taken to a station wagon full of moaning people on bad trips about to be driven up the hill to the medical tents. They offered her some aspirin. She lay down in back. Her husband went off to collect their stuff where they had left it.

The wagon drove up to the tents and parked, but Kaufman lay in the back unattended, everything still blurry, her head spinning, until she sat up and weakly shouted, "Help!" Somebody escorted her to a cot. When the doctor rolled his thumb across the injury, she could hear the crackling.

The doctor got on the radio to arrange a helicopter for a medical evacuation. They waited for word until they finally heard back that no helicopter would be available. An ambulance was called, which eventually arrived and transported her to a hospital in Livermore. Her husband had not returned, so she went alone. Physicians at Livermore quickly determined she needed brain surgery and they lacked the facilities. She was ambulanced to Mount Zion Hospital in San Francisco.

Surgeons at Mount Zion prepared to operate. They asked her

if she had eaten anything. She told them about the carrot. That ruled out general anesthetic. An intravenous local anesthetic would endanger her pregnancy, they told her. She refused the IV, so the surgeon picked little pieces of skull out of her brain, giving her no more painkiller than he would someone getting her teeth cleaned. She stayed awake through the surgery, hearing little hammers in her head, like somebody was doing road work in there, another unrecognized casualty as evening grew nearer.

As the sun started to descend over the hills and the temperature at the speedway began to drop, Oakland Hells Angels chapter president Sonny Barger was finishing up the monthly OM—Officer's Meeting—at the Oakland Hells Angels clubhouse, along with all the other ranking Angels. While the San Jose renegades and their prospects were running wild at Altamont, this key cadre of tribal elders was sequestered taking care of club business. The meeting over, Barger and his pack swung by his Oakland home to pick up his girlfriend, Sharon, a twenty-one-year-old beauty only two years before named Maid of Livermore. Barger led his fellow officers to the speedway through the congested traffic past Livermore and off the roads, over the hills, to the top of the bowl above the speedway, arriving about five o'clock, just as the sun was setting.

The people could hear the Harleys before they could see them, the rumble of revving engines roaring above the crowd noise. At the top of the hill, Barger turned his bike into the crowd and eased his way down. A dozen others followed him. The people parted and cleared a lane. Sort of. Down the side of the hill for all to hear and see, the Angels brass paraded noisily through the thick of the crowd.

On the stage, Sam Cutler took the microphone. "The Rolling Stones won't come on until everyone clears the stage," he said. Nobody made any apparent movement to leave.

The Angels procession proceeded with few incidents. One brutish Angel swung a tire chain over his head to clear the path.

A female fan cursed the Angels as they plowed through the crowd. An Angel stopped his bike and turned to his girlfriend on the back.

"Honey, you aren't going to let somebody say that about the Angels, are you?" he said.

His girlfriend dismounted and socked the other girl in the jaw.

Barger paused at the foot of the hill to accept the gift of a drink of wine from someone in the crowd. He lifted the giant jug to his lips and drank deeply. For once, he was fairly straight, having spent the afternoon dealing with sober Angels business. He led his posse to the front of the stage. He was under the impression that the Angels had been invited to park their bikes there. They cleared out the front rows as much as forty feet from the stage and arrayed their gleaming choppers.

This made perfect sense to the Angels. The bikes would provide a natural barrier between the stage and the crowd. Everybody knew what happened to people who messed with Angels' bikes. Nobody would dare touch them.

Two people who watched Barger's arrival were Patti Bredehoft and Meredith Hunter—Murdock. The couple, who had been at the show for hours, had been watching the Angels wearily. As soon as they'd walked into the speedway that afternoon, they'd passed a group of Angels, and Patti had seen the disapproval in their eyes. She had seen stares like that before when she was out with black men. She knew what they were thinking.

She and Murdock had found a place in the crowd about fifty feet from the stage, but Patti was uncomfortable from the start. Everybody was jammed together and jostling for space. She saw the Angels whipping people with pool cues. The crowd was rough and rude. They'd never caught up again with Ronnie and Judy. She stayed for a while and then walked back to the car by herself. She took a nap.

After an hour or so, Murdock came to get her. The Stones were coming on. Worried about the Angels, Patti was reluc-

tant to go. He told her they were really acting crazy, but not to worry—he would keep her safe. The couple walked back and worked their way up close to the stage in time to watch Barger and his gang ride their bikes through the crowd and to wait for the Stones. Patti wasn't comfortable in the thick, unruly crowd and wanted to leave, but Murdock insisted they stay.

From the stage, Tony Funches saw the jazzy-looking black cat with the cute white chick. Who could miss him in that green suit? He noticed the Angels checking them out too.

17

Sympathy for the Devil

I nside the smoke-filled trailer where the Stones were seques-
tered, Sam Cutler swept through the crowded dressing room,
clearing out people who didn't belong. Shortly thereafter, Keith
Richards, emerging from the bathroom, asked Cutler what had
happened to the little girl who had been drawing on his arm.
Cutler said he had sent her away.

"Well, get her back," said Richards. "She's the one good
thing happening here today."

Bill Wyman, who'd been shopping in San Francisco with his
girlfriend, finally arrived shortly before sunset. They walked
into the trailer with a woman who worked for the Stones in Los
Angeles. At the sight of two ladies entering the room, Southern
gentleman Gram Parsons automatically stood up.

Wyman's absence had only increased the tension inside the
Stones' tin bunker, where the band had been hearing fractured,
whispered reports about what had been going on outside. The
mood walking backstage had been ominous enough, but the bits
and pieces filtering into the trailer offered the Stones only a par-

tial picture of what had been happening. They heard that the Angels had disturbed the Jefferson Airplane set and knocked down the singer. Michelle Phillips sat in the trailer, telling tales of Angels running wild in the crowd. She painted a grim picture of Hells Angels beating up civilians, women, each other—the whole horror show. At the same time, Charlie Watts chatted amiably with Parsons, who had been sitting on the bed in the other room, passing the time singing old country songs with Richards.

The Stones had always planned to take the stage after sunset, but with Wyman missing from the scene, there was no chance the band could take the stage early. He didn't really arrive any later than expected and the concert wasn't running very far behind schedule, at least by Stones standards.

Outside, the crowd was growing impatient. It had been nearly two hours since CSNY left the stage. The sun went down and cold winds started to blow through the valley. The Stones had made a habit of arriving late onstage during the tour, making the audience wait as part of the heightened drama of the experience. No doubt taking full advantage of Chip Monck's brilliant lighting for the filming was part of the equation tonight as well. Everybody else played during the daylight. The stars come out at night.

Cutler made several announcements, his exasperation increasingly evident, trying to clear the crush of bodies on the stage.

"Everyone standing along the back of the stage," he said over the microphone for all to hear, "and everybody else who is on the stage will be getting off now. Can we kindly get that together now? We're wasting time and the sun is setting and the Rolling Stones want to get on the stage and play some music." His pleas were totally ineffectual.

Sonny Barger took stock of the situation. Shortly after Barger and his lieutenants had pulled up, they'd been ushered back for

a summit meeting with Jagger and the rest of the Stones. The musicians came out of their trailer and politely shook hands, stood around uncomfortably for a few minutes, then went back in. Barger was liking the whole thing less and less. The Stones' people didn't have another word to say to him, so he sat on the stage drinking beer and brooding.

A hardened veteran of a thousand fights and hundreds of crazy scenes he had made with the Angels, Barger knew instinctively that the circumstances were dangerous. The old tiger might have personally resisted the unleashed ferocity that the younger, more impetuous members and prospects had been dishing out all day, but once an Angel starts a fight, it is every Angel's fight. Barger sat down next to Sweet William. Barger wore a stern expression on his face.

"We're keeping this stage," he said. "Do you realize that if all these people had their minds together, they could crush this thing?"

The band moved from the trailer into a yellow tent guarded by Hells Angels a few yards away, where they began to tune their instruments. People peeked in the tent as they walked by. One kid stuck his head between the flaps, only to be punched by a Hells Angel. Sweet William came into the tent to speak with Jagger. He didn't mince words.

"You better get the fuck out there before the place blows," he told Jagger. "You've tuned up enough."

Jagger told him they were "preparing" and they would go on when they were ready.

"I'm telling you," Sweet William said. "People are going to die out there. Get out there. You've been told."

Jon Jaymes wobbled into the tent to tell Jagger he had four Highway Patrol cars waiting backstage for him and the band to make their exit.

"Not with cops," Jagger said. "I ain't going out with the cops."

Jaymes smiled. "I knew you'd say that," he said.

Minutes before the Stones were to take the stage, one of the Maysles film crew popped into the Dead's recording truck, where a forlorn Bob Matthews slouched behind the board with the useless sixteen-track recorder. Matthews had shown up on Friday with his recording equipment, but when he plugged everything together and turned on the machine, the tape speed was wandering all over from the wavering power supplied by the generators. Useless. He didn't think there would be a recording until one of the cameramen gave him a 60-hertz tone and he was back in business. With the reference tone, Mathews would be able to properly correct in postproduction any wavering speed from the intermittent power supply. He sat up, ready to tape the concert.

Sam Cutler was still trying to clear the stage. He spoke to the crowd, his voice flat, fatigued, defeated. "The reason we can't start is that the stage is loaded with people," he said. Nobody moved.

Sonny Barger walked to another microphone. "Alright, everybody off the stage, including Hells Angels," he said, and the stage started to clear.

When word was passed that the Hells Angels should come backstage and escort the Stones to the stage, Barger didn't budge. He wanted nothing to do with playing honor guard for the little squirt and the other sissies. He assumed a position on the edge of the stage where he could keep a wary eye on the situation.

Keith Richards picked up his guitar and headed for the stage. Julio Ortiz, a dark, oily biker from the S.F. chapter, met him at the tent entrance.

"I'll take you there," he said, leading Richards through an impossible crowd backstage thirty feet to the stage, where they squeezed between the people jammed behind the amplifiers and Richards assumed his place onstage. Cutler had nothing left. He simply said, "The Rolling Stones."

As the Stones took the stage, the entire seated audience stood on their feet. A wave rippled through the audience down toward the stage from a mile away, as the entire sea of roiling, churning bodies surged forward, a wave that washed up at the Hells Angels' motorcycles in front of the stage. Bikes started to founder.

At this point in the band's career, seven years after the first few fitful gigs in London pubs, the Rolling Stones thought they had seen it all, but nothing could have prepared them for this. A thousand shows, some hairy episodes, many close calls and near misses, but there was nothing in the band's past that would be helpful, no experience to draw from, no precedents to follow. So much had gone wrong to bring them to where they were, and the worst was yet to come. They were going to have to do the show. In front of the biggest audience of the band's career, under the most harrowing and fearful conditions the group had ever faced, these five rock and roll musicians were going to go out on that stage and play their set. No matter what. The show must go on.

The drums clattered. The electric guitars belched. Jagger shouted, "Whoa, yeah." Richards lashed into the opening chords of "Jumpin' Jack Flash" and the concert was under way.

The musicians were starkly illuminated by forty-eight thousand watts of white light from the spotlights that Chip Monck had stacked at the rear of the stage. The dazzling backlight was reflected onto the stage by the first few rows of the audience, giving a gauzy, pale sheen to the musicians. With only follow spotlights in front, the Stones looked like ghostly visions ringed in luminescent halos. The sound wavered throughout the valley, but their presence was monumental.

Jagger looked out at the audience. Without spotlights blinding him, the singer could see the vast, endless expanse of people leading into the darkness. A broad grin slithered across his face. He burst out laughing.

"Oh, babies," he said. "There's so many of you. Just be cool down in front and don't push around. Just keep still. Keep it together." He giggled. "Oh yeah."

Richards quickly hit the Chuck Berry licks that announced "Carol," the tour's standard second number. Nobody can play Chuck Berry like Richards, not even Berry. He made those tired riffs sing, driving the song to a close. Jagger plucked a bottle of Jack Daniel's off an amplifier and raised it.

"I'd like to drink one to ya," he said, taking a swig.

Richards plunged ahead into his slashing, syncopated intro-duction to "Sympathy for the Devil," Jagger swirling across the stage in his black-and-orange cape. He started to sing: *Please allow me to introduce myself, I'm a man of wealth and taste . . .* On the side of the stage, Sonny Barger spied smoke coming from Julio Ortiz's motorcycle. Some idiot was kneeling on the bike's seat and causing a short. Barger yelled at the fool, but he didn't hear. Barger charged into the crowd.

A number of Hells Angels jumped down behind him, not knowing what Barger was doing, but clearing the way. Barger knocked the guy off Ortiz's bike and snuffed the fire, while the other Angels whipped into the crowd. People were screaming and flashing the peace sign while the Angels laid waste. The chorus of shrieks, moans, and grunts was clearly audible over the din of the band.

With the front rows bathed in the wash from the massive backlights, the sudden explosion of violence was starkly visible from the bandstand. Angels stormed over the stage into the fray, crowding around the lip of the stage in front of the band. Rich-ards, absorbed in his guitar playing, didn't notice and plowed ahead loudly, even as the other band members stopped playing, aghast. Jagger dashed over to Richards.

"Keith . . . Keith," said Jagger. "Will you cool it and I'll try and stop it."

Richards stopped playing and Jagger pleaded with the crowd.

"Hey, people," he said. "Sisters, brothers and sisters, brothers and sisters. Come on now. That means everybody, just cool out. Will you cool out, everybody?"

He was shouting. Richards muttered something to Jagger.

"I know, I'm hip," he said, turning back to the crowd. "Everybody be cool now. Come on. All right? How are we doing over there? All right? Can we still make it down the front? Is there anyone there that's hurt? Everyone all right? Okay. All right. I think we're cool. We can go. We always have something very funny happens when we start that number."

Never before in their lives had these men felt so vulnerable, so helpless, or so life-sized. The musicians hid inside the music. Richards lit up the opening riff again and Wyman and Watts locked down the beat. Taylor dove into the roar with a second guitar. This was the Rolling Stones in full-lock power drive.

Jagger sang his ass off. The music took him over. Richards burnished the searing six-minute performance with bristling, piercing guitar lines. During the instrumental passage, a giant bearded Angel wearing a Pilgrim-style hat baldly walked out to whisper in Jagger's ear, a beast towering over Jagger, who held still for the interruption and then danced away. He danced around until he glanced into the crowd and saw a beating taking place only yards in front of him. The real world shattered his reverie. His body stopped. The music left him and he stared for a long moment into the heart of the melee. He snapped out of it, whirled across the stage, and smiled as he went back into his dance, ad-libbing over the extended close, *get on down . . . everybody got to cool on down, cool on down.*

The song ended, but there was no applause, only a chorus of groans and screams coming from the audience.

Mick Jagger had never lost control of an audience in his life. Rather just the opposite—he controlled the audience. His confidence had never been called into question. His command and authority had never failed him. Now he seemed lost. He

sounded on the edge of desperation as he scolded the audience, emphasizing every word.

"Uh, people—I'm mean, who's fighting, what for?" he asked. "Who's fighting and what for? Why are we fighting? Why are we fighting? We don't want to fight. Come on. Do you want— who wants to fight? Who is it? Hey, you know, I mean like every other scene has been cool . . ."

Richards, angrily conferring with Sam Cutler, charged out to the microphone and pointed to one of the Angels in the audience. Surrounded at close range by Hells Angels in every direction, puny Keith Richards called him out. He couldn't have been thinking about his own safety at that moment. Jagger had been much more circumspect. Richards simply exploded and spoke out. If he had thought about it first, he probably wouldn't have done it.

"Look—that guy there," he shouted, pointing his finger. "If he doesn't stop it, man—listen, either those cats cool it, man, or we don't play. Come on."

Angels were standing in front of the band on the stage. Animal leaned over to talk to Jagger. Another one of the Angels grabbed a microphone. "Hey, if you don't cool it, you ain't gonna hear no music," he said. "Now, you all want to go home or what?"

The full enormity of the situation was crashing down on the Stones finally. The rushed preparations for the show, the absence of a police presence or any sort of practical security for that matter, the low stage, the scorched earth from the campfires of burnt garbage, the bad drugs and strong wine, the physical harm to the members of other bands who'd played that day, and the very real danger that the Angels posed—all of it seemed to converge in this moment of the Angel grabbing the microphone. The audience and everyone around the stage had known for hours that Sam Cutler was not in charge of this show; now it was clear that the Rolling Stones were not in charge either.

At the realization that the circumstances were beyond their

control, the band recoiled. In front of the group's largest audience ever, Angels felt free to walk across the stage, take the mike, and speak to the crowd, something not even the most arrogant Eastern European storm trooper the Stones previously faced would have dared. Large, intimidating Angels surrounded the Stones, glowering at them like caged animals at feeding time, and the menace was real. The Angels wouldn't stop beating people in full view of the band. They paid no attention to Jagger's entreaties or Richards's empty threat to stop playing. This frightening raw violence seemed so American to these British musicians. Newcomer Mick Taylor was so scared he couldn't speak. Everybody knew that leaving the stage was not an option, but the end of the show seemed like a long way away.

Stones road manager Ian Stewart called from the stage for a doctor to come down front. He wandered over to exchange words with Richards. The concert had totally broken down. For the first time in the band's career, the Rolling Stones played some cool-down music. Of course, it would be blues. Mick Taylor and Keith Richards started it off, a rolling, loping Jimmy Reed beat, soon joined by Bill Wyman and, eventually, Charlie Watts with a light touch. After a few choruses, Jagger joined in, singing the lyrics to Reed's "The Sun Is Shining," an easygoing if lascivious blues.

People started sitting down, but of course, by the end of the song, the audience was standing again. People shouted for them to sit, but nobody paid attention. The Stones stayed low-key with "Stray Cat Blues," a nervous Jagger fluffing some of the lyrics. Still in the blues mood, with lighting director Monck drenching the stage in cool blues and dark scarlets, Jagger and Richards reprised their acoustic version of Robert Johnson's "Love in Vain" from the tour, Mick Taylor on slide guitar. The band disappeared in the shadows. The tide seemed to have ebbed, the mood subdued. Jagger was encouraged.

In the crowd, Nurse Jane and her young charge, the acid

overdose victim, had walked into the crowd to listen to some of the Stones. She had been feeling slightly resentful that she had spent all day in a frenzy without hearing any of the music. She gently eased her patient into the crowd with her, hoping he could withstand the pressure and not revert to his psychotic state. They were in the thick of the crowd when the music stopped and the Angels erupted nearby. They saw fists swinging, the crowd parting, people fighting, and a cluster of Hells Angels surrounding the violence. People were screaming, "Help! Get help!"

The young man freaked out. He grabbed her skirt and balled it tight in his fists. He began shaking and crying. Nurse Jane pushed her way back out of the crowd, the young man still attached to her skirt, until they made it back to the medical tent. She sat on the ground outside the tent with the shaking young man and reassured him everything was all right, even though she knew it wasn't.

"I think there was one good idea that came out of that number," Jagger said, "which was that the one way to keep yourselves cool is to sit down. If you can make it, I think you'll find it's better. So when you're sitting comfortably . . . Now boys and girls, are you sitting comfortably?"

The band started "Under My Thumb," the ominous introduction to the new arrangement they had been playing on the tour rolling out like heavy machinery. Jagger started to sing, but lost his way once again. As the audience erupted in fighting in front of the stage, the band staggered to a halt. Jagger was a much chastened man. He had never been so humble onstage before. His voice dropped. He was no longer shouting. He was pleading.

"It seems to be down to me," he said. "Will you listen to me for a minute, please? Will you listen to me for just one second? First of all, everyone is going to get to the side of the stage now, apart from the Stones, who are playing. Everyone, please, can you get to the side of the stage, if you're not playing? That's a start."

"I cannot see what's going on," he said, although the front rows were lit up like daylight from behind him. "I just know that every time we get to a number, something happens. I don't know what's going on, who's doing what. It's just a scuffle. All I can ask you, San Francisco, is like the whole thing—like this could be the most beautiful evening we've had for this winter, you know, and we've really—why, don't let's fuck it up, man. Come on. Let's get it together.

"I can't see you on the hillside. You're probably very cool. Down here, we're not so cool. We got a lot of hassles. I just want every cat—we can't see you, but I know you're cool. We're trying to keep it together. I can't do any more than just ask you, to beg you, just to keep it together. You can do it. It's within your power, everyone. Everyone. Hells Angels, everybody, let's just keep ourselves together. You know, if we are all one, let's fucking show we're all one."

Sam Cutler pulled Jagger aside for a word and walked away.

"There's one thing we need, Sam," Jagger said over the microphone. "We need an ambulance. We need a doctor by that scaffold there. If there's a doctor, can he get to there? Okay. We're going to—I don't know what the fuck we're doing. When we get to, really, like the end and we all want to go absolutely crazy and, like, jump on each other, then we'll stand up again, you know. I mean, everyone keep the—sit down. I mean, just keep cool and let's just relax. Let's just get into a groove. Come on. We can get it together. Come on. Sit down."

The crowd did not sit. The band started up "Under My Thumb" a second time, the yawning maw of the introduction opening like the gates of doom.

18

Under My Thumb

Cinematographer Joan Churchill had crawled out from under the stage at the end of the afternoon. After eight hours, she had ridden out the worst of her accidental LSD overdose and was chagrined to have missed out on the filming. It had been a terrifying trip for her. She spent some considerable time simply hanging on the leg of her boyfriend, cameraman Eric Saarinen. There were a few other lonely, freaked-out souls also hiding under the stage, but nobody came near her or spoke with her. The violence in front of the stage was not only fully visible, but the screams and moans echoed through the space under it.

Reporting back to duty, Churchill was assigned her own guardian Angel and posted at the back of the stage, presumably to keep her out of trouble. She had returned to a fairly stable state, no longer lost in the wilderness of her mind. Her Angel watched over her and she felt confident in his care. He was a sweet, large man who took his custodial duties seriously.

If she hadn't been concentrating on what she saw through her lens, she might have been more scared, but behind the camera,

Churchill was fearless. Her field of focus was limited to what she was seeing and how it was going down on film, lending her a liberating emotional detachment from filming scenes of mayhem and horror, as she now found herself doing. Looking with her left eye as the lens blocked her other eye, she could only see through her viewfinder. Still, even from the back of the stage she could see the swarms of people parting in the front of the crowd, pool cues rising and falling.

As the Stones started "Under My Thumb" the second time, she noticed a young bearded hippie in a paisley shirt and leather vest onstage amid the Hells Angels. She focused in on the man's face as he struggled to maintain any kind of composure. His lips were pursing. His fists were clenched. He wiped his hands over his face. His tongue lolled out of his mouth. He stripped off his vest. He looked like he was about to explode. Clearly he was under a heavy dose of some powerful psychedelic and was having problems dealing with his reality. He was wearing the struggle on his face. Churchill had found the poster boy for the day's insanity. She zeroed in on the man's face as, in the foreground, out of focus, Mick Jagger darted in and out of the frame while he sang the song. As Churchill's camera unflinchingly captured this young man's agony, Bob Roberts, S.F. chapter president, grabbed the kid and showed him to the edge of the stage.

The song was wafting across the speedway as Grace Slick and Paul Kantner of Jefferson Airplane and their buddy David Freiberg of Quicksilver Messenger Service boarded their helicopter to leave. Airplane road manager Bill Laudner had started to worry about their exit as the Stones began to play. He realized that if he waited too long, only the Stones would fly out and he and his musicians would be left stranded. As his charges watched the Stones from the monitor mixing board inside a truck at the back of the stage, Laudner grew more nervous. He convinced his party to head for the helicopters. They had already seen the Stones a couple of weeks before at Madison

Square Garden. Freiberg, who had driven out to the show from Marin, would leave his car and spend the night at the Airplane mansion in San Francisco. Kantner would drive him out again the next day. As Laudner expected, the pilot told him the copter was reserved for the Stones.

"Yes, but this is Grace Slick," Laudner said, and the pilot relented.

As the helicopter lifted off, the pilot circled over the crowd for one last view of the stage. They looked down. The crowd in front of the stage spread apart before their eyes. A large, visible space opened and quickly closed up again. They watched as the mass of people spread apart and fused back together in a single seamless movement. The Stones didn't seem to be playing or even on the stage. They watched the crowd swirl and foam like a tidepool and flew into the night. They had no idea they had just witnessed the killing of Meredith Hunter.

When the Stones took the stage, Murdock and Patti were trapped in the sea of people. The tightly packed crowd would swell in a wave and carry their bodies along. They were close to the stage in front of Keith Richards. Patti didn't know that Murdock was loaded on speed. Murdock had already tried to climb on the stage and been thrown back. The dirty looks the Angels had given the couple earlier in the afternoon had only gotten worse. They were in the thick of the mess, jostled and pushed at every turn. Patti couldn't be sure where Murdock was, but felt like he was nearby. Every few seconds, a jolt would go through the crowd. It was hard for her to keep her footing.

With the surge of excitement as the Stones began to play, people in the crowd pressed forward and began to climb up on the speaker boxes at the front of the stage and the nearby scaffolding. The Angels pushed back and yanked them down. Murdock worked his way forward. Patti saw him through the crowd telling people to get down from the speakers. One of the Hells Angels by the stage grabbed his ear and hair and shook his head.

The Angel laughed. Murdock wrenched himself loose and gave the man a cold, hard stare. The Angel smashed him in the face.

Murdock fell back in the crowd and the Angel jumped after him. He tried to scramble into the audience, but four or five more Angels pounced on him. He managed to get up and started to run away through the crowd to his right toward the scaffold. Stumbling, hurt, out of breath, he pulled the gun from his waistband. He didn't get the chance to even aim the gun. His legs crumpled under him, and he tumbled sideways, the gun in front of him pointed to the ground. The crowd parted and, as everybody else scattered, Patti was reaching for him. People were screaming. "Don't shoot anyone," pleaded one girl.

Al Passaro had left his position on the stage when he saw someone throw a jug of wine that knocked over one of the Angels' bikes. He was standing by the motorcycles with his friend Ron Segeley from the S.F. chapter. He saw Murdock fall from the stage and watched as he got loose and went for his gun. There was no time to think. Passaro acted strictly from instinct, his lifelong athleticism springing to the fore. Like a ballet dancer, he swiveled around, reaching down to his foot and pulling out the hunting knife he had stashed in a sheath at his ankle. In a single, smooth movement, he spun around a second time, leaping through the air, grabbing Murdock's hand, pulling him around, and plunging the knife into Murdock's neck behind his ear. They tumbled to the ground together. Passaro kept stabbing Murdock in the back.

Segeley pulled the gun out of Murdock's hand. Murdock got up, staggered a couple of steps, and went down to his knees. Another Angel grabbed his shoulders and kicked him in the head until he fell down face first. Murdock turned over and looked up at the towering, raging Angel.

"I wasn't going to shoot you," he said.

"Well, why did you have a gun?" the Angel yelled.

The Angel grabbed a garbage can, a cardboard box in a

metal frame, and slammed it down on Murdock. Inflamed with anger, drugs, and violence, he kicked the garbage can away and started kicking Murdock's head. Several other Angels circled around and stomped him. One of them stood on his head—the same Angel who had punched him in the face to start—and they walked off.

Patti was screaming and crying. "Don't hurt him," she pleaded with the Angels.

"Don't cry over him—he's not worth it," said Segeley, who showed her the gun he had taken from Hunter and roughly shoved her back into the crowd.

Passaro was knocked away without being certain his knife had penetrated Murdock's back. He had stabbed him five times before Murdock got loose and the other Angels swarmed over him, blocking Passaro's view of what happened. He got up, cleaned off his knife by stabbing it in the ground, put it back in the sheath, and walked off.

As the Stones played the final chords of "Under My Thumb," the first part of the fight was clearly visible from the stage, although when Hunter headed for the scaffold, he plunged into the shadows. Richards saw it and blew up. He exploded on mike while the last guitar chord was still ringing.

"We're splitting," he shouted. "We're splitting if those cats don't stop beating up everyone in sight. I want them out of the way, man."

One of the Angels onstage leaned over to Richards. "Somebody out there's got a gun," he said.

Richards backed up from the microphone. The thought that somebody in the audience could be shooting at the stage brought a tidal wave of panic to an already fraught scene. The stage filled with Angels and Jaymes's and Carter's security guards, who had been lingering on its edges. The show dissolved, again, into chaos.

Michael Lang of Woodstock, who had been standing around the stage uselessly all day, took the microphone.

"Hey, people," he said. "Hey, people. Come on, let's be cool. People, please. There's no reason to hassle anybody. Please don't be mad at anybody. Please relax and sit down."

The Woodstock spirit was not going to work today. Sam Cutler tried hopelessly to restore order. "If you move back and sit down," he said, "we can continue and we will continue. We need a doctor under the left-hand scaffold as soon as possible, please."

People on the stage could see Murdock pull out the gun. Some even hit the deck. Mickey Hart of the Dead, standing behind the amplifiers, watched the entire episode unfold after he saw Hunter thrown back from the stage by the first Angel. Halfway up the light tower, soundman Bob Cohen had been trapped for hours with his terrified girlfriend. Cohen, already scared and anxious, was horrified to see the killing right in front of his eyes.

Onstage, cameraman Eric Saarinen saw the assault clearly from where he was shooting. He reached for his zoom button and pressed the wrong button. He zoomed out. Behind the stage, shooting on top of the Dead's equipment van in prone position, was Baird Bryant. He and soundman Peter Pilafian had long before come down off the LSD they accidentally ingested that morning and were settled comfortably on the roof of the van, safe from the action, but perfectly positioned to view the entire stage and front rows.

Bryant also had the fight in focus, and he too hit his zoom button. Only Bryant hit the right button and caught Passaro's leap into infamy. It was his Abraham Zapruder moment, but at the time, he didn't know what he had or even what had happened.

Paul Cox, who had come up to Altamont on Friday night to secure his front-row position to see the Stones, had been standing next to Hunter when the first Angel smacked him in the face. Cox ran toward the scaffold, and as the attack unfolded, Murdock ended up staggering toward him. Cox could only watch in horror as the Angels finished him off, refusing to let Cox help the stricken Hunter.

"Don't touch him," he was told. "He's going to die anyway. Let him die. He's going to die."

Cox and another concertgoer rolled Murdock over anyway to inspect his wounds. Blood was seeping through his clothes. They tore open his black shirt. One lingering Angel glared at them, but walked away. Cox grabbed Murdock's legs and another couple of people from the crowd took his arms and they made their way toward the stage, hoping to pass him over it to medical help backstage. People in the crowd were shouting at Jagger about the medical emergency. He leaned over to try and hear. They raised Hunter's body to the tip of the stage.

All the way across the stage, Betty Cantor of the Grateful Dead crew watched in shock. She had kept an especially vigilant eye on the stage because her responsibility was the Dead's equipment. She saw the body flopped on the stage a few feet in front of Keith Richards, whose eyes widened in panic. As a scrum of Hells Angels raced to push the body back into the crowd, Jagger covered his face and looked away.

Standing at the edge of the stage was Dr. Robert Hiatt, a first-year resident at Public Health Hospital in San Francisco. When he first heard the call for medical attention from the stage, he had shoved his way through the crowd, who made way for the doctor. The Angels pushed Murdock's body into Hiatt's arms and he carried him backstage around the scaffold, staggering under the weight. For the next week, his arms would ache, but now he was running on pure adrenaline. He managed to get Murdock to the Red Cross station before he collapsed.

Murdock was loaded onto a stretcher into the back of a station wagon and driven to the medical tent. His face had been badly beaten and he was breathing with difficulty only through his mouth. Dr. Fine took a quick look—thin, weak pulse—and realized he would need to be airlifted to a hospital. He required immediate surgery and they had no facilities to care for him at the scene. Dr. Fine turned the emergency treatment over

to another doctor and went to locate a helicopter. Murdock's wounds were probably mortal, but his only hope was a hospital. Without that, he had no chance.

With nobody in charge, Dr. Fine ran up immediately against the festival's chaotic hierarchy. The helicopter pilot would not leave without authorization, but Dr. Fine could not locate anybody who was responsible enough to make that order. He could not find anybody definitively in charge enough to even answer his question about getting a helicopter. When he was finally told the helicopter was reserved for the Stones and would not be available to him, he called for an ambulance. Nobody was willing to turn over the helicopter being saved for the Stones, even in the face of a life-or-death medical emergency. Hunter had a very small chance of surviving his wounds, but without the airlift he had no chance. He died waiting for the ambulance.

Dr. Fine pronounced him dead around six thirty, halfway through the Stones' performance, which could be heard continuing in the background. Patti followed Murdock's body backstage. The doctor told Patti he had died and gave her a sedative. The body was moved to the speedway office, where Paul Cox washed off Murdock's blood with hot coffee because there was no water. A call reporting the stabbing reached Eden Township substation, and the watch commander dispatched by radio a couple of officers who had been watching the concert from up the hill.

For once, cowboy cop Tom Houchins of the Alameda County Sheriffs had no idea what to do. He and his unit had spent the whole day outside their bread truck on the hill passing around binoculars. They were cowed by the sheer size of the crowd, the lack of controlled access, the utter, unthinkable chaos on the far edge of their jurisdiction. The police made no arrests all day—they didn't know where to start. They stood by helplessly, huddled together too far from the scene to even know what was actually transpiring.

With the report of a murder, for the first time that day, suddenly police officers were on the scene, conferring with Dick

Carter, Jon Jaymes, a few of the private security guards Jaymes had imported, and Highway Patrol officers, who also suddenly appeared out of nowhere. Jaymes refused to give his first name or any further identification, only "Mr. James [*sic*]." Stones tour director Ronnie Schneider, his guardian Angel struggling to keep up, was running to look for an ambulance backstage. A cop stopped him.

"You don't need to run," he told Schneider. "He died."

BACK ONSTAGE, THE show had completely stalled and fallen apart. The musicians had been blown off track. They had all seen the body for that brief, horrible moment. They were stunned, sickened, and had no idea what to do next. Mick Taylor made a suggestion.

"Why don't we do the new one?" he said.

The band had only recorded the song that Tuesday and only written it on Monday, but the idea seemed good enough and Jagger introduced the song.

"We're going to do one for you which we just—you never heard it before 'cause we just wrote it," he said. "I don't know how good it's going to be, baby, 'cause this is the first time we've played it. The very first time."

He turned around for a brief conference with the band and turned back to the audience, addressing the crowd double-time in his ringmaster's voice, trying as hard as he could to pump some life back into the deflated show and his own tired heart.

"And-we're-going-to-do-one-for-you-now-which-we've-never-played-ever-before-which-we-are-going-to-play-for-the-very-first-time-called-'Brown-Sugar.'"

The concert leaped back to life on the first guitar lick.

The Stones followed "Brown Sugar" with "Midnight Rambler," the big showstopper on the tour, where Jagger delivered his impression of a rapist and murderer. The irony tonight couldn't have been lost on him—any more than singing "scarred old slaver, he's doing alright" in "Brown Sugar"—but he poured

himself into the part. The beatings in the audience continued—"scuffles," Jagger had called them—and the song ended to a smattering of applause and more screams.

"Stand up, if you can keep it cool," Jagger said. "One more drink to y'all," he said, hoisting his bottle.

The whole event had turned into some oblique rite of passage, an ordeal to be endured by band and audience alike. The promise of love was vanquished, and in its place, the specter of evil loomed. In a single day, Altamont had turned the myth of Woodstock inside out.

Cinematographer Stephen Lighthill left his position on the stage to go backstage to the truck and change film magazines. As he walked back to the stage, he noticed a glint of light coming from beneath the stage. He crouched down and looked. He saw light reflecting from the eyes of dozens of people hiding underneath.

"Would you like to live with each other?" Jagger said. "I mean, you're really close to each other. Wow." The band launched into "Live with Me" from the new album. A naked woman danced in the front row. As the song ended, she started to climb over the audience onto the stage. Several Hells Angels struggled with extricating her as the song ended. Jagger looked displeased. Richards spoke up.

"Man, I'm sure it doesn't take three or four great big Hells Angels to get that bird off the stage," he said.

Jagger chimed in with a more conciliatory tone. "Hey, fellas," he said, "like one of you can control one little girl. Come on now. Like, just sit down, honey." He spied people in the crowd trying to help her down. "Fellas, can you clear out? Let them deal with her. C'mon."

Sonny Barger, who was in a very bad mood by this time, walked over and kicked the girl back into the crowd.

And with that, Richards turned and hit the opening chords to "Gimme Shelter."

19

Gimme Shelter

Greil Marcus had had enough. It had been a horrible day.

Not long after the guy knocked his sandwich in the dirt, the *Rolling Stone* staff reviewer found himself trapped with one leg in the air in the sardine can crowd without enough room to get the leg back on the ground. He wobbled uncertainly on one leg, struggling to stand on two feet for what seemed like ages, but many minutes did pass. Nobody cared or helped. He got loose from the ugly crowd.

The day had only deteriorated from there. He'd watched the Hells Angels beat the naked fat guy into a bloody pulp and was disgusted at the crowd's docile reaction, flashing peace signs and spreading out, moving away from fights with the speed of displaced water. During the day, he had left the concert and driven to Livermore to phone home and check on his pregnant wife. He found no special problem driving back and parked close to where he had that morning.

When he returned, the Jefferson Airplane was playing and the Angels were going crazy. On his way back to the show, Mar-

cus had heard on his car radio how beautiful and groovy the vibes were out at Altamont. That wasn't his impression, and he was distressed to think that people didn't know the truth about how awful it was. The crowd knew. All afternoon, he kept hearing people wonder aloud when was someone going to die. Later, he caught another glimpse backstage of the naked fat man, his face a bloody mess, his teeth gone. Once the Stones took the stage, he could hear the crowd screaming in terror over their songs. He found himself watching the band while standing on top of a VW bus with a large number of other people crowded on the roof, many carrying tape recorders to record the concert. Without warning, the roof collapsed and dumped everybody on top of each other inside the car. They could not open the locked doors, so they were forced to climb out through the jagged shards of metal.

He decided to leave. The Stones were playing, but he had heard and seen enough. He walked out from backstage and up the dark, pockmarked hill, heading toward his car. There were no lights or pathways. His foot hit a pothole and he fell down. With his face pressed into the dirt, Marcus heard two things.

First, he heard thousands of footsteps of other people leaving the concert. The earth crackled with the sound.

Second, he heard the Rolling Stones start to play "Gimme Shelter." As he lay there, he thought to himself that he had never heard music more powerful in his life. He was mesmerized. His face to the ground, he stayed put and listened.

The men in the Stones played like their lives depended on it, a hoary cliché that may never have been more true. They buried themselves in the music, the only safe place onstage. There was nothing more they could do but play, and they played as if nothing else mattered. They channeled all their fear and anxiety into the music. Jagger's vocals were razor edged, not the kind of loopy exaggerations he often lapsed into at large concerts. His face was fixed in a rigid, intent stare. He was singing

like he meant it. The imaginary dark world of the Stones' songs had come to life. These were not pretend devils who had been around since Jesus Christ or melancholy young poets deliciously contemplating the properties of the color black. This was genuine evil, staring back in their faces. These demons were dancing in front of them. The musicians couldn't wipe the terror off their faces. The more frightened they became, the more they bore down on their music.

Never has the song been more suited to the circumstances or the terror of the song been more real. On the tour, the band had turned the number into a haunting, eerie, majestic showpiece. Without the many guitar parts used on the record, the arrangement stripped down Richards's intricate guitar weaving to two synchronous parts. He and Mick Taylor ground together like gears. Jagger delivered the song with all the horror in his heart.

"Rape . . . murder . . . it's just a shot away," he sang. Many times.

Two Hells Angels sat on the side of the stage next to a pile of long-stemmed roses waiting for Jagger to shower the crowd with them at the finale. In the middle of the song, the Angels threw them into the audience like they were tossing out garbage.

But as the song ground to its close, Jagger seemed changed, lightened, almost optimistic, as though the tune had made everyone forget what had come before.

"Are we okay?" asked Jagger hopefully. "I know we are."

Richards hit the chugging rhythm that started "Little Queenie," a leering Chuck Berry romp about sex with underage girls that, after the cathartic "Gimme Shelter," served as the Stones' idea of a light touch. It also meant the band was turning the corner and heading for the close of the show. Jagger knew the end was near.

"Thank you very much," he snapped, as the band slammed into "Satisfaction," the epic stinging guitar riff slicing through

the night air. The crowd perked up. Charlie Watts laid down the beat like the Otis Redding version. Mick Taylor soared briefly above Keith Richards's driving rhythm, but dropped back down in the engine room and joined forces with Richards to give the song a long, chugging tail, Jagger shouting over the raucous, powerful sound of the band. He paused only briefly for a quick conference with the helicopter pilot.

"We'd like to say, well, there's been a few hang-ups," Jagger said, "but I mean, generally, you've been beautiful. You've been beau-ti-ful. You have been so groovy. All the loose women may stand with their hands up. That's not enough. We haven't got many loose women. What are you going to do?"

The sound system, never fully functional all day, chose this moment to cut out entirely. The stage went silent for a moment. Buzz, zap, pop. "There," said Jagger. "We got it back."

Richards hit the downstroke and ignited "Honky Tonk Women." In the midst of all the madness and mayhem, the Stones had never played better. They not only played with surgical precision, but they infused the performance with burning intensity. Inside the music, they were fierce, determined, brave. Jagger prepared to leave.

"We're going to kiss you goodbye," he said introducing the final number, "and we leave you to hug each other goodbye. We're going to see you again."

The band launched the finale, "Street Fighting Man," a cynical piece of self-justification that had probably never sounded more hollow ("What can a poor boy do?"). Or more real. Jagger didn't care. He only wanted to get out of there.

The Stones party hustled through the backstage, shortcutting through a hole in the cyclone fence, Ronnie Schneider yelling instructions, and climbed into a waiting ambulance and station wagon. They were driven slowly through the exiting crowd to the speedway.

They walked past Patti Bredehoft, bawling and babbling, and

a Red Cross worker trying to comfort her. The men from the coroner's office arrived about eight o'clock to pick up Murdock's body. Patti had ridden to the medical tent in the Red Cross wagon with Murdock, and the ambulance driver stayed with her. He would eventually drive her home to Berkeley, waking up her parents and telling them what had happened.

As the Stones piled onto the helicopter, there was not enough room, but everybody clambered aboard. Gram Parsons and Michelle Phillips squeezed in. The overloaded helicopter carrying seventeen people lurched into the air and came down hard a short ride later at the Tracy airport, where the party would transfer to a fifteen-seat airplane for the hop to San Francisco.

It was a quiet ride, not much chitchat. Sam Cutler couldn't keep his mind off Meredith Hunter. *Who brings a gun to a rock and roll show?* he thought. Then he realized—he did. The thought sickened him.

On the ground in Tracy, Richards strode away under the spinning blades cursing the Hells Angels.

"They're sick, man," he said. "They're worse than the cops. They're just not ready. I'm never going to have anything to do with them again."

Jagger slumped in a wooden bench in the airport building. He was dazed, bewildered, drained. He did not understand the Hells Angels. "How could anybody think these people were good," he said, "think they're people you should have around?"

"Some people are just not ready," said Richards, who had slipped off the red Nudie shirt he wore at the concert and slung it over his shoulders. He could have been talking about the Stones.

"I'd rather have cops," said Jagger.

THE GRATEFUL DEAD scurried out of the speedway with their tail between their legs. They slipped away in the darkness before the Stones finished their set and, like the Airplane, commandeered the aircraft for the short hop before the pilot could say

no. This had been a traumatic day for the band. They felt a certain degree of responsibility, although they had come to realize that the thing had been out of their control from the start. The helicopter carrying the Dead and their family members out of Altamont lifted off in stony silence. Inside the copter, the noise of the rotors reverberated, but nobody spoke. Everybody was stunned solemn. Mountain Girl pointed out the window at the skies.

"Does anybody know where the constellation Cancer is?" she said, loud enough to be heard over the roar.

Taking the lead, Mountain Girl proceeded to conduct a tour of the heavens, trying to keep everybody's minds' off the sordid reality they had just left behind on earth.

The Dead would have finished playing the Stones concert before nightfall and were still scheduled to perform that night at the Fillmore West. Over dinner at a fancy steakhouse in San Francisco, the band debated whether to play or not. Nobody had the heart for it, but it took drummer Billy Kreutzmann to call it off. He announced he wouldn't play, grabbed his wife, and left the restaurant. The other drummer, Mickey Hart, seconded Kreutzmann's motion, and the meeting was adjourned.

The rest of the band and their associates went to the Fillmore West to give the news to Bill Graham. They sat glumly in the dressing room—Rock Scully sprawled out on the floor, dazed and depleted, sucking on a tube connected to a tank of nitrous oxide. He had not slept the past three nights and stayed awake by using prodigious amounts of cocaine. He felt like a battle-weary general in defeat, but at least he was beginning to relax when Bill Graham stormed into the room. Graham's virulent opposition to the free concert had been well established, and he crashed into the midst of the Dead. Graham pointed at Scully. "You're a murderer," he said.

Scully stood up and shoved Graham out of the room, closing the door behind him.

SPENCER DRYDEN OF the Airplane was surprised that bandmate Paul Kantner wanted to stay to watch the Dead and the Stones after their own catastrophic set. Vocalist Marty Balin shipped out immediately following the performance, his bell having been rung hard. Dryden, who was not getting along very well with his fellow band members, wandered off, sky high on acid, with bassist David Brown from Santana. Dryden hadn't wanted to be there in the first place and was distressed and disoriented. He and Brown decided to leave, but that didn't turn out to be as easy as they thought. They walked over to the speedway, where the cars and people had overrun the helicopter landing pad. They walked by the madness and frenzy of the medical tent. Everywhere they went was a total mess.

Sometime shortly before the Stones went on, they finally met some hippie in the crowd who volunteered to drive them to the Tracy airport. They hiked out to the kid's car and took off. Neither Dryden nor Brown knew the area. Dryden got in the front seat and tried to help give directions anyway. They had no idea the kid didn't know where he was going. They also didn't know he was stuffed full of mescaline and mushrooms and barely able to maintain. They rolled along dark, lonely highways in the flatlands east of the speedway for more than an hour before approaching the wrong airport many miles away in Modesto.

The hippie confessed to Dryden and Brown that he was high and lost.

"I don't know if I can see real good," he said.

Dryden, who decided he wasn't as high as the kid, took over driving and headed back toward San Francisco. Running on a couple hours' sleep after flying across the country the night before and coming down off acid, Dryden was fried and crusty. He could barely manage to operate the vehicle. They drove back through the entire Altamont traffic bottleneck, finally arriving at the Airplane mansion around midnight. The hippie hung out

for a while before going home. Everybody else was asleep in bed. Nobody in the band had missed Dryden.

THE CROWD FLOODED out in all directions. People were falling over themselves in the dark, trying to figure out where they had parked their cars, which way to go. Everybody was stoned and tired. The roads were choked with traffic. Mass confusion reigned. A few hardy souls remained behind, tending little campfires and settling down for the night. George Lucas and Walter Murch finally got their experimental camera to hold focus long enough to tuck away the one shot of theirs that would make the movie, a spacey, ethereal pan across the crowd exiting over the hill, the moon in the background.

Stagehands crawled all over the stage, pulling apart equipment, packing up trucks. Lee Brenkman and A. C. Smith from the Family Dog crew were used to the routine. Soundmen were the first to show up at a job and the last to leave. They packed up their gear, nervous, tired, and stressed. Both of them, veterans of many free concerts in the park, felt traumatized by the day's events. As they finished loading their truck, a couple of Hells Angels were eyeballing the Rolling Stones' custom-made purple rug that had survived the entire tour and now sat rolled up on the side of the stage.

"This would look good in the clubhouse," Smith overheard one Angel say to the other.

As he pulled away in his truck, Smith glanced back in the rearview mirror and saw the Angels heaving the rug on top of a pickup truck that had two Harleys in the back. They laid the giant rug across the bikes and it stuck out over both the tailgate and the top of the cab.

Tour director Chip Monck also saw the Angels load the rug on their truck. He made a beeline for the two gentlemen. Monck was educated in East Coast prep schools, studied at Harvard, and worked on the college theater company. He knew nothing

about Hells Angels before today, and what he had learned terrified him. He had never seen such violence. He was scared, but he gulped it down. There was no way he could let them leave with this expensive piece of stage property that belonged to the Rolling Stones.

He introduced himself and started talking. He explained that the rug belonged to the Stones and that it was his duty to see that it was returned properly. The Angels bantered with the goofy guy with the big mustache and the aristocratic mid-Atlantic accent. Monck made his case. The Angels finally laughed and started to get in the truck to drive off. Monck couldn't allow that. He stepped to the back of the truck, grabbed the end of the huge rug and yanked it off the truck. One of the Harleys came off with the rug and crashed to the ground.

The Angels fell on Monck mercilessly, whipping him across the face with a pool cue. They left him a bloody mess, missing his front teeth, lying in the dirt, as they loaded the bike—and the rug—back on the truck and drove off.

Some Angels built a large bonfire in the center of the field and continued to party. Every so often, a misguided hippie would wander into their midst, looking to join the fun, and wind up getting his ass kicked. The stagehands packing up the gear could hear their screams all night.

JIM MCDONALD, THE nineteen-year-old surfer who had hitchhiked up that morning from Santa Cruz, said goodbye to his high school buddies. He had had a great time. He could tell Mick Jagger was bumming out during "Sympathy for the Devil" and there had been some problems with the Hells Angels around the stage. He had heard about the kid drowning in the canal, but the music had been great. He thought the Stones played better than they had at the Oakland Coliseum the month before. He was coming off the acid, but he felt awake and alert, pumped up by the excellent concert, ready to make his way back home to Santa Cruz.

He wandered aimlessly through the pitch dark up the hill. He didn't know where he was going, but there were plenty of people walking in the same direction. He joined the herd as it moved toward the horizon. He followed the pack until somewhere along the crest he ran into a side road. A few cars slowly made their way through the crowd.

McDonald walked up next to a packed, slow-rolling car with three people already sitting in the backseat. The girl in the front seat had a year-old infant on her lap. He casually asked if they could give him a ride. She told him they could take him to San Francisco. That sounded great to McDonald. He could get back to Santa Cruz easily from the city. As he climbed in, a voice came out from the backseat.

"Always room for one more," someone said.

Not everybody in the car knew each other. The two guys sitting next to McDonald were pals, Richard Salov and Mark Feiger. They were about two years older than McDonald and had moved to Berkeley that summer from New Jersey. They exchanged friendly chatter with McDonald about the show as the car inched toward the highway at the top of the hill. When they finally reached the intersection, about ten minutes later, the highway was still disappointingly crowded. They decided to pull over across the road and wait out the traffic.

They built a small campfire by the side of the road and settled around it. The wintry night air chilled McDonald, but he had come prepared. He had well remembered how cold the Altamont Pass could get and was glad he had made sure to bring something to keep him warm. He reached for his blanket. He threw it over his back and pulled it tight across his chest in his fists.

The next thing McDonald knew, somebody was touching his shoulder and speaking.

"Hey," the voice said, "this one is still alive."

He had no idea how long he'd been out or what had happened.

What had happened was that some acid-crazed maniac had stolen a '64 Plymouth and roared up the hill at speeds up to sixty miles an hour, the Highway Patrol later calculated, pedestrians on the road spilling away and spreading out. At the crest of the hill, when he hit the crown of the road, he launched into the air. The car flew across the road and crashed down on the campfire where McDonald and his new friends were sitting. Salov and Feiger were killed. Candy Sue Johnson, the young mother from the front seat, was badly injured. Her infant and the other two passengers were unharmed.

The police talked briefly to the overdosed driver. He told the cops the Hells Angels—who were already going to get blamed for a lot of things that happened that day—were chasing him. The driver quickly slipped back into the crowd, making off in the night before the cops could apprehend him.

McDonald was airlifted to the nearby Valley Memorial Hospital in Livermore by the Highway Patrol chopper. He had broken ribs, a compound fracture of his leg, and severe head injuries. He thought he was in an ambulance. He couldn't tell it was a helicopter. He told the medic attending him he couldn't breathe.

"Don't die on me now," the medic said.

At the emergency room, McDonald checked in DOA, but doctors managed to revive him and wheel him into surgery. He would survive, little worse for the wear in the long run, but he showed up at that emergency room with zero vital signs. His mother arrived sometime later. They presented her with his belongings. His blanket was a dirty, bloody mess. One side of his body had been outlined in squirts of blood. On the other side were tire tracks.

PART

PART

3

20

The Day After

High atop Nob Hill in San Francisco, the Stones party gathered in a suite at the Huntington Hotel. Richards turned on the TV news and fumed about Rock Scully, the man who started all this.

"If Rock Scully don't know any more about things than that, man, to think that the Angels are—what did he say? Honor and dignity?" he said.

On the way in from the airport, the band had heard radio reports of Hunter's death. After arriving at their hotel, they solemnly watched the eleven o'clock TV news reports of the festival. Richards paced the room.

"He's just a childish romantic," Richards said of Scully. "I have no time for such people."

He turned off the television and put on the tape of recordings from the band's Muscle Shoals sessions. By the time the midnight room service meal showed up, he was ranting about the Angels.

"They're homicidal maniacs," Richards said. "They should be thrown in jail."

Jagger, still in shock, caught a call in the suite from a reporter from the *San Francisco Chronicle*. "If Jesus had been there, he would have been crucified," said a stricken Jagger. "I know San Francisco only by reputation. It's supposed to be lovely—not uptight. What happened? What's gone wrong?"

The band sat around, largely quiet, stunned and traumatized. Everybody was sleepy and irritable, but nobody wanted to go to bed. Nobody wanted to be alone. Even the customarily reclusive Charlie Watts did not retire to his own room. Gram Parsons, who had been cozying up to Michelle Phillips in the limousine from the airport, had lost her attention and was standing around in black leather and eye makeup. The only ones to leave the group were Ronnie Schneider and Jo Bergman, who went to the airport to pick up the band's plane tickets for the following day.

Sam Cutler, his white turtleneck still stained with blood, slouched on a sofa. Since they'd left Altamont, Cutler had managed only a brief conversation with Jagger during which it was decided Cutler would stay behind in San Francisco and represent the Stones in what was sure to be the maelstrom coming. Jagger assured Cutler the Stones would handle his expenses. After staying awake with everyone in the suite, Cutler eventually passed out on the couch, waking to the sound of Richards telling him to go to his room. Cutler simply changed chairs and passed out again.

That night, the lovely Miss Pamela also called the suite and got Jagger on the phone. She was alarmed at how flipped out he sounded.

"Don't you know what happened?" he said. He told her he had been shot at and that someone in the crowd had been knifed. He was surprised to learn she was in town and invited her over. "Please come right away," he said.

When she arrived, she joined Jagger on the sofa and listened, while he held her hand, to everybody rehash the horror of the day. She didn't know what to say, so she sat quietly and hoped

that her presence would help reassure Jagger, who was clearly agitated.

Richards put on a tape of old blues, and as they listened to Elmore James and Sonny Boy Williamson, they talked quietly until four in the morning. People started to slip away. Tony Funches excused himself. The hotel was unhappy that Funches had two female guests with him in his one room, so he booked a second room. Jagger, too, may have been shaken by the day's events, but he still kept his eye on his more private needs. He had attracted the fancy of Michelle Phillips and sent her ahead down to his room. Jagger waltzed Miss Pamela into the hallway, where he slipped his tongue into her mouth and suggested she join the two of them for a three-way. She declined and said good night to Jagger in the hallway. She didn't want to share him.

On Sunday morning, Jagger and Jo Bergman left for an early flight to Geneva with the entire take from the tour in cash stowed in a handbag made to look like a football. It was $1.8 million, plus or minus a couple hundred thousand, which Bergman and Ian Stewart had counted the night before in the kitchen of the tour's logistics man, Bill Belmont. The rest of the party reconvened in the sitting room of Richards's suite and enjoyed a breakfast of cocaine and Old Charter bourbon before taking limousines to the airport and leaving the country.

Sam Cutler woke up in the hotel that morning with $300 left in his pocket. The band and everyone else around them were gone. He had a white Lincoln Continental convertible, rented for the Stones, waiting downstairs in the garage, his gun and his stash in the glove compartment. He slipped away without paying his hotel bill and drove to Mickey Hart's ranch in Novato. Later that afternoon, he went back out to Altamont to check on the cleanup. It was there that KSAN disc jockey Stefan Ponek caught him on the phone and recorded an interview for later that night during a special broadcast Ponek had planned about the concert.

Less than a day after the show's final note was played, people were already pointing fingers and assigning blame for the day's events. It was a discussion that would play out in the days, months, and years ahead as writers, journalists, police officers, lawyers, filmmakers, musicians, and fans alike would turn back to that Saturday in December 1969 to assign guilt and greater meaning for both the music and the culture it had come to represent. While no one knew the day after just how long Altamont's shadow would be, it was clear to most that what had happened would bring about a reckoning bigger than any of the bands intended. The Rolling Stones might have skipped town and left Cutler to do the literal and figurative cleanup, but the fight over Altamont's legacy was just getting started, and it broke into the open that night over the airwaves of local FM underground radio station KSAN.

KSAN was not an ordinary radio station. Started in June 1968 by disc jockey Tom "Big Daddy" Donahue, a six-foot-five, 450-pound giant who virtually invented underground FM radio on KMPX in San Francisco in 1967, KSAN quickly became the nerve center of the San Francisco hip community. The disc jockeys were culture heroes, and the programming was truly free-form, eclectic, unpredictable, and crazy. The entire hip scene tuned in. KSAN was the voice of the underground.

Ponek was the program director, a classical music deejay who had made the transition when Donahue took over the station. He brought a welcome touch of earnest elegance to the staff full of stoned hippies and crazed idealists. Ponek, who'd also attended Woodstock, had spent the day at Altamont and issued occasional reports. He'd seen firsthand what was going on, initially trying to stay upbeat and optimistic, but gradually turning to more distressed accounts as the day wore on. Most of the KSAN staff on the scene had dropped acid. Ponek, who didn't, still managed to press the wrong button on his tape recorder and record the broadcast of a local Top Forty radio station rather than his own comments he made while the Stones played.

Even before Hunter's death, Ponek had planned to produce a four-hour special on Sunday night for the station. As he got to work on Sunday, he was buoyed by other KSAN staffers in the booth, and he began to mix prerecorded interviews, on-air guests, and phone calls from the audience. The whole city listened. With more than enough blame to go around, the effort to parse Altamont's wreckage for answers had officially begun.

During his call, Cutler, sounding phlegmatic and distant, drained, told Ponek he wanted the station to put out an "urgent appeal" for volunteers with their transportation to come to Altamont and help deal with what he estimated was thirty tons of garbage, thousands of sleeping bags and blankets, tens of thousands of broken jugs of Red Mountain wine.

"I personally feel that the violence—and only a small amount of the people here were involved—I think the violence was regrettable," said Cutler. "I think there were a number of factors contributing to it, not the least of which was our having to get the show together at the last minute. We had no time. We had to trust people."

Still, he did not offer any strong criticism of the Hells Angels. "I myself feel that the Hells Angels were as helpful as they could be," he said, "in a situation which most people found confusing, including the Hells Angels.

"If you want to ask what the Hells Angels were doing last night, I'm not going to speak for the Hells Angels. You must ask the Hells Angels themselves. If you're asking me to issue a putdown of the Angels—which I imagine a lot of people would be only too happy to do—but I'm not prepared to do that. The Angels did as they saw best in a difficult situation, as I have said before. Now, fifty percent of the people will dig what they did and fifty percent will not dig what they did. I don't need to get into a positive/anti kind of thing. As far as I'm concerned they were people who were here, who tried to help in their own way."

That night on the broadcast, a procession of the principals in the day's events joined the discussion. Emmett Grogan of

the Diggers reported in. He recalled the meeting with Jagger in Hollywood during which he and Scully had talked to him about the initial plans for the concert when it was still going to be in Golden Gate Park. For the radio audience, Grogan explained how he had envisioned a vast festival of the performing arts, including all factions of the city's community: Black Panthers, La Raza, Chinatown's Red Guard.

"Why don't you allow the people of San Francisco to throw a party covering Golden Gate Park," he said he told Jagger, "not just the Polo Fields, but the whole goddamned park, with stages all over the park? And you'll just come on as one of the bands. This way there'll be no concentration of people, no madness."

Grogan blamed the Stones management team for ruining those plans, although even he wasn't sure who was responsible and, like so many others, thought Jaymes worked for the Stones.

"Okay? He [Jagger] agreed. We made a list of artists from Dr. John the Night Tripper to Fred Neil to all these people. The New York office—that's Allen Klein, some guy named Schneider, and a fellow named Jon Jaymes—I said to Jagger the only problem would be getting a permit because they've had a ban on music in the park since an incident midsummer. Ron Schneider and Jon Jaymes—they work for Allen Klein—they said we have no problem getting permits. We can get them in two days."

Of course, Grogan's vision for the festival in Golden Gate Park had not come to pass, but there was one part of his conversation with Jagger that did happen. As he detailed to listeners at home, Jagger had told him he didn't want a single policeman to set foot on the concert site, which had led Grogan and Rock Scully to introduce Sam Cutler to the Hells Angels.

When it came to presenting the Angels' side of things, Pete Knell of the Hells Angels picked up the story, calling the station and explaining on the air how Sam Cutler hired the Angels for

$500 worth of beer, the first time the public heard that story. He was calm, soft-spoken, matter-of-fact, and sounded barely concerned about the events of the day before.

"What happened was, about two weeks ago, Sam Cutler came. He said they were nervous about the crowd, had a little trouble in Florida, and so on. What they did was ask us would we come and keep the people off the stage . . . We ain't into that, security. He was a sincere fellow. We said we would go there and take care of the stage, and we did that. At first it was a little hectic, but we settled in. Pretty much the next thing that happened, a guy was waving a gun and he was taken care of. I'm sorry that happened."

Knell answered a couple of questions, but remained unconcerned about the Angels' behavior. He didn't see the controversy.

"If we say we're going to do something," he said, "we do it."

Ponek asked him if he didn't feel badly about the death.

"I feel very badly about it," Knell said. "I really do. I'm sorry it happened."

Knell said he had no direct knowledge of the killing ("I was in the backstage dancing," he said), but he wasn't going to let the incident mar his impression of the day. "To me, it was a very enjoyable day," he said, "good, sunshiny day."

With the radio show blasting across the Bay Area, somebody phoned Sonny Barger at his home in East Oakland and told him to tune in to the show. He took all the cocaine he had in the house and went to his bedroom. He dialed up the station, and the station, after figuring out who they had on the line, put his call on the air. Barger came across as reasoned, centered, and plainspoken, even though he was clearly jacked up on drugs. He wasn't angry or argumentative, but he wanted to stick up for the Angels. As a cocaine-fueled Barger barreled through his side of the story, he brushed aside any attempts to interrupt his flow ("Let me finish, then you can ask me anything you want," he said, although he never finished). Talking about his connection

to his motorcycle, he sounded like a cowboy speaking about his horse.

"I don't know if you think we paid fifty dollars for them things or steal them or pay a lot for them or what," Barger said, "but most people that's got a good Harley chopper's got a few grand invested in it. Ain't nobody going to kick my motorcycle. And they might think because they're in a crowd of three hundred thousand people that they can do it and get away with it, but when you're standing there looking at something that's your life and everything you've got is invested in that thing and you love that thing better than you love anything in the world, and you see a guy kick it, you know who he is. And if you have to go through fifty people to get to him, you're going to get him. And you know what? They got got."

Barger instinctively realized that the Angels were going to be blamed for the whole huge horrible mess, and that the Stones had effectively turned them into their stooges. He took charge of outlining the Angels' view on the matter. He offered explanations, not excuses, in a surprising display of public relations awareness from the head of an organization that made a point of not caring what people thought of them. On the radio, Barger pressed his case. He picked up speed, rolled over attempts to interject questions, and, never raising his voice, emanated a quiet authority.

"I ain't no cop," he said. "I ain't never going to pretend to be a cop. And you know what? I didn't go there to police nothing, man. They told me if I could sit on the edge of the stage so nobody would climb over me, I could drink beer until the show was over, and that's what I went there to do. But you know what? Some cat throws something and dings my bike, or some cat kicks my bike over—he's got a fight. And you know what? You can say anything you want and you can call them people flower children and this and that, and there was three hundred thousand people there approximately or whatever they say, and

I guarantee you that the largest majority of them were there to have a good time, but there was a couple thousand of them that was there looking for trouble."

Ponek: Sonny, just about that question . . .

"Some of them people out there ain't a bit better than what some of the people think of the worst of us, man, and it's about time they realized it, and they can call in and call us all kind of lousy dogs, like we shouldn't be at these places and this and that, but you know what? When they started messing over our bikes, they started it."

Ponek: Sonny, you've got it right there, man. You've got it by letting people know exactly where you're at . . .

"And I am not no peace creep by any sense of the word, but you know what, man? If a cat don't want to fight with me and don't want to hassle with me, you know what? I want to be his friend. If he don't want to be my friend, then outta sight. Don't even talk to me. But if he don't want to be my friend and he's going to get in my face, I'm going to hurt him or he's going to hurt me. And you know what? It really doesn't matter if he hurts me, because I've been hurt before. And you know what? I've been hurt by experts, but over the years I've learned how to get up and do it again."

Ponek: Okay. Thanks a lot, man. I think you've done a lot to enlighten a lot of people as to just what was going on.

Bill Graham also took to the airwaves to weigh in on the concert. Voluble, proud, and furious with the Stones, Graham had never liked outdoor events, and his vitriol for this one in particular boiled over. What Graham liked was selling tickets—and

maybe a few Cokes—to the orderly crowds he hosted at his Fill-mores. Still stinging from the Stones' snub of him—both in his bid to produce the entire tour and backstage between shows at the Oakland concert—he sounded off, antagonistic, combative, and all too willing to let listeners know that, to him, the blame lay almost exclusively with the Stones.

"I would offer Mr. Jagger $50,000," Graham said, "to go on coast-to-coast television or radio with me, not stoned, not cop-ping out, but sit down, mister, and rap, open, for an hour. I'll ask you what right you had, Mr. Jagger, to walk out onstage every night with your Uncle Sam hat, throw it down with complete disdain, and leave this country with $1.8 million? And what right did you have in going through with this free festival? And you couldn't tell me you didn't know the way it would have come off. What right did you have to leave the way you did, thanking everyone for a wonderful time and the Angels for helping out? He's now in his home country somewhere—what did he leave throughout the country? Every gig he was late. Every [bleep] gig he made the promoter and the people bleed. What right does this god have to descend on this country this way?

"It will give me great pleasure to tell the public that Mick Jagger is not God Jr. And it's worth it to me. I am not trying to blast at someone that is ten thousand miles away, but you know what is a great tragedy to me? That [bleep] is a great entertainer."

Scully, the manager of the Grateful Dead, who dreamed up the free concert
Keith Richards. *Photo by Rosie McGee*

h Richards, Mick Jagger, and producer Jimmy Miller in the *Let It Bleed*
at Elektra Studios in Hollywood, October 1969. *Photo by Robert Altman*

The Grateful Dead on horseback at Mickey Hart's ranch in Marin County, California. *Photo by Rosie McGee*

Jagger announcing the free concert at a New York City press conference (*background left, Jon Jaymes; second from left, Ronnie Schneider*) Photo by David Fenton/Getty Images

s Point Raceway from the vantage point of where the stage would have been,
Courtesy of Sonoma Raceway

Attorney Melvin Belli, aghast,
onstage during the CSNY set.
Photo by Arthur Rosato

Altamont raceway owner Dick
Carter poses for *Rolling Stone* in his
office the day before the concert.

Crews erect the sound
tower in the dark on
Friday night.
Photo by John Pierce

Fans wait outside the gate. *Photo by Beth Bagby*

hael Lang of the Woodstock festival observes an early-morning drug casualty
le Sam Cutler stands at the mike. (Note how the stage sections are tied together

The Los Angeles–based *Gimme Shelter* film crew in Berkeley. *Photo by Eric Saar*

Patricia Bredehoft

Patti Bredehoft's senior photo, 1970. *Courtesy of the Berkeley Historical Society*

Meredith Hunter at the Monterey Jazz Festival, September 1969. *Courtesy of Dixie Ward*

Alan Passaro in f grade. *Courtesy o Linda Passaro*

y in the morning, a piece of string still holds back the front row. *Photo by Robert Altman*

e string long gone, Santana opens the show. *Photo by Jim Marshall*

Paul Kantner and Grace Slick of Jefferson Airplane. *Photo by Eamonn McCabe*

Jefferson Airplane vocalist
Marty Balin, minutes
before being knocked out
by a Hells Angel.
Photo by Robert Altman

ce Slick watches in horror as Hells Angels stomp a fan in front of the band. *to by Beth Bagby*

Gram Parsons of the Flying Burrito Brothers in his Nudie suit jacket. *Photo by Eamonn McCabe*

Graham Nash, David Crosby, and Neil Young during the short CSNY set.
Photo by Robert Altman

Bobby Weir of the Grateful Dead greets David Crosby backstage.
Photo by Arthur Rosato

...et William (*left*) and Animal (*right*) in his coyote hat onstage.
...to by Beth Bagby

Terry the Tramp (*center*) on top of
the San Francisco chapter bus.
Photo by Don Armfield

...helle Phillips (*below*) of the Mamas and
...as accidentally dosed herself on acid.
...to by Arthur Usherson

Photo by Bill Owens

Jagger covers his face as a scrum of Angels pushes Meredith Hunter's body off the stage; an Angel walks in front of the band; a dog crosses the stage; Jagger tries to calm the crowd. *Photo by Beth Bagby*

Keith Richards: "Either those cats cool it, man, or we don't play." *Photo by Beth Bagby*

...er looking shaken. *Photo by Beth Bagby*

The Stones from the crowd. *Photo by John Cumiberti*

21

The News Breaks

The Monday after Altamont, reporters from *Rolling Stone* huddled with publisher Jann Wenner over lunch at the magazine's San Francisco offices, trying to decide how to cover this story that was looming large as the biggest in its short history.

In the two years since the bimonthly newspaper's founding, *Rolling Stone* had skyrocketed from the San Francisco underground into the single most influential media outlet in the world of rock music. Founded by Wenner, previously a rock critic for UC Berkeley's *Daily Cal,* the magazine had raised its head above the underground through relentless cheerleading of the new rock movement.

Since its inception, the magazine had quickly developed a wildly enthusiastic, devoted, growing readership, leading Wenner into a mother lode of advertising support from record labels. With these twin engines of support, *Rolling Stone* had become a hip, saucy, but ultimately optimistic—almost innocent— mouthpiece of the scene. The company's finances were still touch and go, but Wenner's music magazine was on the cusp

of major media success as readership closed in on one hundred thousand.

With employees from all sides of *Rolling Stone* in the audience at Altamont, the magazine was well poised to cover the show that everyone hoped would live up to the expectations. The ambitious twenty-three-year-old Wenner had even booked a helicopter to take him and a select group of friends to the Stones concert, but debated all Saturday morning in his Pacific Heights mansion whether or not to go. When his arrangements for a helicopter fell through, he decided to stay home, forcing him to rely on his journalists to report the story.

On Sunday, as people sifted through the morning-after wreckage, Wenner had listened to managing editor John Burks rage indignantly on the phone about what he'd witnessed firsthand. Burks, who had been dubious about the Hells Angels' involvement from the beginning, was furious.

"We've got to tell people what these fuckers did," he kept saying. Wenner was skeptical, but told Burks to pull together the staff for a meeting for Monday.

Part of Wenner's skepticism came from the fact that Burks's description was the exact opposite of the account Wenner had read on the front page of the Sunday edition of the *San Francisco Examiner,* which ran the headline 300,000 SAY IT WITH MUSIC. Say what? The article didn't specify, nor did it have much to say about the horrific events of the day. Instead it focused on a much cleaner and simpler story.

"The two mysteries of life—birth and death—were present yesterday as 300,000 rock fans spread across the autumn brown Alameda county hills and arid valley for a day of music and love," wrote Jim Wood in the *Examiner.* Wood, an old-time reporter out of a black-and-white thirties movie, went with the prefabricated "Woodstock West" narrative. He noted the fatal knifing of an as yet unidentified victim by a Hells Angel, but grotesquely miscalculated the significance.

"But for the stabbing," he wrote, "all appeared peaceful at the concert by the Rolling Stones and other members of Rock 'N Roll royalty including the Jefferson Airplane and the Grateful Dead. The record-breaking crowd, probably the largest in the history of Northern California, was for the most part orderly, but enthusiastic."

Wood also cited a Red Cross spokesman as saying three babies were born at the festival, although that countermyth has never been proven. No mothers checked into area hospitals for postnatal care, and Dr. Fine was unaware of any births recorded during the event. Wood offered the rumored births as a kind of balance to the murder at the top of his story, as if these supposed births somehow mitigate the loss of other lives.

"If this was a Kingdom of Young People, as one of the songs suggested," Wood wrote, "it was one that was civil and fun. As spectators repeatedly shouted during the concert, 'We're really getting it together.'"

The *Examiner* wasn't alone in its glowing, clueless coverage. "We think it was beautiful," said KFRC radio news reporter Ron Naso. "Things went smoothly and people were happy. When you have a big amount of people together a couple of things happen, unfortunately. It's nothing anybody can do anything about. After all, look what happens every day in Vietnam."

Even the august *New York Times* reported a similar story on Sunday (200,000 ATTEND COAST ROCK FETE; "The crowd, considering its size, was well behaved"), adding only as a footnote that one concertgoer died after a stabbing. From coast to coast, the West Coast Woodstock myth seemed to be prevailing.

But the newspaper reports contradicting Burks's account were only one part of Wenner's hesitation about how the magazine should cover Altamont. In editorial matters, Wenner was especially reverential of the movement's most popular leaders—The Beatles, Dylan, the Stones—and had even partnered with Mick Jagger to produce an ill-fated British edition of *Rolling*

Stone that Wenner had closed only the month before. He'd had the unenviable task of informing the Stones frontman that his entire $40,000 investment had been lost. His personal relationship with Jagger was as a result somewhat rocky and needed to be taken into consideration in any article that was written. Wenner had to carefully weigh the politics of his judgment.

But at lunch that Monday, Burks was not the only *Rolling Stone* staffer who found the existing coverage frustratingly inadequate. Greil Marcus was similarly infuriated with the press and radio reports, and while Wenner and Burks had a more contentious relationship, Marcus was someone Wenner respected. Unlike Burks, who had superior reporting experience stemming from his time at *Newsweek* and was more of a news professional, Marcus belonged to the audience. He represented the reasoned, intelligent viewpoint of somebody who understood the mentality of the magazine's readership.

"It was the worst day of my life," a physically shaken Marcus told Wenner at the lunch meeting. "I don't care if I never hear another rock and roll record ever again."

The conviction of Marcus's words was echoed in the corrective account in Monday morning's *San Francisco Chronicle.* Under the terms of a joint operating agreement with the *Examiner,* the *Chronicle,* the Bay Area's newspaper of record, did not publish a news section on Sundays. The stodgy, old-time *Examiner* had the day-after story. The *Chronicle,* by virtue of the publication schedule, was relegated to follow-ups. Of course, the *Examiner*'s coverage left a lot for the *Chronicle* to cover.

Chronicle reporter Michael Grieg reached Jagger on the phone at the Huntington after the concert. In addition, cityside writer Jackson Rannells offered a thorough, professional police journalist's wrap-up of the deaths and destruction. A sidebar inside featured an interview with a photographer who had been beaten by Angels. Most notably, in the entertainment section, music writer Ralph Gleason excoriated the Rolling Stones in a column with the headline THERE WAS A TAB, IN EGO AND MONEY.

"The name of the game is money, power and ego," wrote Gleason, "and money is first and it brings power. The Stones didn't do it for free, they did it for money, only the tab was paid in a different way. Whoever goes to see that movie paid for the Altamont religious assembly."

It was Gleason's article, more than any other coverage, that caught Wenner's attention. Gleason was Wenner's hero and role model during his time as a rock critic at the *Daily Cal*. Not to mention he was a father figure, a contributing editor to *Rolling Stone* since the first issue and one of the magazine's original investors. Gleason and Wenner had actually spoken on the phone on Sunday, and during the conversation, Gleason had urged Wenner to forget about whether or not his friend Mick Jagger would have his feelings hurt.

"We either go out of business right now or we cover Altamont like it was World War II," he told Wenner.

The reality of Altamont was becoming impossible to avoid. At lunch, Wenner listened to his staff and issued orders that would change the course of the magazine's history:

"We are going to cover this thing from top to bottom," he said. "And we are going to place the blame."

Burks coordinated the effort. Staff writers John Morthland and Langdon Winner fanned out. Greil Marcus, an academically trained cultural critic more than anything, was drafted for shoe-leather journalism. He visited Alta Mae Anderson, the mother of victim Meredith Hunter, and discovered that nobody from the Stones had communicated with Hunter's family since the concert. When Marcus told that to Wenner, the *Rolling Stone* boss cut a check for $500 and put it in the mail for Hunter's family. In a stroke of luck, *Rolling Stone* film reviewer Michael Goodwin had had the presence of mind at the concert to repeat into a tape recorder all Jagger's stage announcements. He realized the stage sound was too garbled to reproduce on his recorder and saved the day by preserving Jagger's remarks to the crowd—quotes that would reverberate through the magazine's account.

Their big break, though, came out of nowhere when Burks received a phone call from Paul David Cox, who provided a breathless, vivid, close-up eyewitness account. Cox, who approached *Stone* because he was engaged to someone who worked at the magazine, was terrified of reprisals by the Hells Angels and refused to even fully identify himself to Burks. He was referred to only as "Paul" in the article.

A lot of the basic journalism was done by John Morthland, a graduate school dropout who had interviewed for a position at the magazine a week before Altamont and was told to come back in February. He had attended the concert with a couple of pals, but strictly as an observer. Morthland had worked for his hometown daily in San Bernardino and had some actual journalism experience, which led *Rolling Stone* to give him a call months ahead of schedule. He ended up covering the hospitals and the police for the story, while also conducting various interviews, even speaking with Sonny Barger.

The resulting article, almost twenty thousand words long, was a glorious mess, a colossal, sprawling epic that kicked the door open on what actually went down that day. The story carried no byline; a joint credit at the end of the piece listed eleven contributors in alphabetical order. Burks oversaw the production with Wenner watching over his shoulder, and pieced together the crazy-quilt piece of journalism, leaving changes of voice, sudden shifts of perspective, and collapsing narrative intact. Burks opened with a thousand-word transcript of his phone call with Cox, the kind of brilliant, gripping newsmagazine-style lead that drops the reader into the center of the story from the start. With their staff photographer Baron Wolman having bailed midway through the day, the magazine put out a call to freelance photographers and received photos from more than fifty.

They called it "rock and roll's worst day." They painted a stark portrait of reckless irresponsibility. They blamed Sam Cutler for hiring the Angels. They named Rock Scully as the

person who had brought the Angels to the party. And they blamed Wenner's friend, Mick Jagger, for failing to take responsibility.

"All these things happened, and worse," the article concluded. "Altamont was the product of diabolical egotism, hype, ineptitude, money, manipulation, and, at base, a fundamental lack of concern for humanity."

The magazine hit the streets in a hurry on December 21, only weeks after the concert, but it quickly proved to be a journalistic masterstroke. The coverage pulled back the curtain on the catastrophe, offering the first detailed account to portray the true dimensions of the disaster. Not only did the *Rolling Stone* article completely reshape public opinion of the event, but it lifted the music magazine out of the underground and established *Stone* as a respected journalistic voice. After this article, *Rolling Stone* was no longer just a broadsheet for musicians and rock critics, it was now a microphone for the counterculture capable of amplifying issues affecting its readership to the national stage. The Columbia School of Journalism would recognize the piece with a special award. Jann Wenner was a made man.

The magazine's first serious effort at investigative journalism almost instantly changed the public perception of Altamont. The terror reflected in the photos alone told the story in a graphic and vivid way that brought the violence of the day home to readers. It was a cold, hard slap in the face to the hippie mentality that had suffused much of the innocent rock scene. The *Rolling Stone* report placed the Altamont narrative at the polar opposite of the Woodstock myth and utterly destroyed the "Woodstock West" story that went out the first day after. Shock and horror rippled through the rock world.

THE BACKLASH THAT the *Rolling Stone* article would reveal was still two weeks offshore when the British press greeted Keith Richards at London's Heathrow Airport on the Monday after

the concert. They were not interested in Altamont—instead the rabid jackals of Fleet Street had fresh controversy for him. His girlfriend, Anita Pallenberg, an Italian citizen, had told the assembled press waiting for his arrival that the British Home Office had threatened her with deportation if she and Richards didn't marry. Her passport had been seized. As he cleared customs, Pallenberg held up their baby, Marlon, and screamed, "Keith, they're throwing me out of the country."

One transatlantic flight after blowing out of San Francisco as quickly as he could, bone-weary from the cataclysmic end of the exhausting tour, his girlfriend sobbing on his shoulder and holding their baby, Richards faced the press.

"It's a drag that you are forced into marriage by bureaucracy," he said. "I refuse to get married because some bureaucrat says we must. Rather than do that, I would leave Britain and live abroad. But if I want to continue to live in England, and that's the only way Anita can stay, we'll get married. I've got nothing against marriage—I'd as soon be married as not. We'll get it straightened out sooner or later, but first I've got to get some rest."

Both Altamont and America seemed to be behind him—his only comment on the concert was a decided understatement. "The concert was basically well handled," he said, "but people were tired and a few tempers got frayed."

A week later, by which time the news of Altamont had begun to reach foreign shores, Richards was more open. He gave an interview to Ray Connolly of the *London Evening Standard* at his Cheyne Walk home, on the eve of a pair of Christmas concerts by the Stones at London's Lyceum Theatre on December 21, where he sounded uncharacteristically naïve about life in America.

I thought the show would have been stopped but hardly anybody seemed to want to take any notice. Oh yes, there were people selling acid. That's the way it is at those free concerts.

There are so many people there that the police just stay away, ya know. They just try to keep the traffic going ten miles away. In a way, those concerts are a complete experiment in social order—everybody has to work out a completely new plan of how to get along.

The violence just in front of the stage was incredible. Looking back, I don't think it was a good idea to have the Hell's Angels there, but we had them at the suggestion of the Grateful Dead, who've organized these shows before and they thought they were the best people to organize the concert.

But to be fair, out of the whole three hundred Angels [*sic; police later estimated around 40 Angels were present*] working as stewards, the vast majority did what they were supposed to do, which was to regulate the crowds as much as possible without causing any trouble. But there were about ten or twenty who were completely out of their minds—trying to drive their motorcycles through the middle of the crowds.

Really the difference between the open air show we held here in Hyde Park and the one there is amazing. I think it illustrates the difference between the two countries. In Hyde Park, everybody had a good time and there was no trouble. You can put half a million young English people together and they won't start killing each other. That's the difference.

In Switzerland the Monday after the show, Jagger and Jo Bergman deposited the tour's cash in a Swiss bank account and took off in a private jet for the south of France. Jagger's other girlfriend, Marsha Hunt, was waiting there for them (Marianne Faithfull was still in Rome, shacked up with her Italian artist boyfriend). Jagger went looking for a house to rent. Facing ruinous taxes, irksome drug charges, and an almost complete lack of privacy, he had decided to leave England and live life in exile. At the disastrous close of the American tour, Jagger needed to pull together the splintered ends of his life—personal, financial, and

musical. The tour may have solved their most immediate needs for money, but the band and the musicians still faced daunting problems, and it would be up to Jagger to lead them out of the wilderness.

The Stones may have left with the bag of money, but back at the Huntington Hotel, the full scope of the damage was just beginning to take shape. A couple dozen people loitered around the hotel lobby carrying sheets of paper in their hands, invoices they hoped to have paid. They had rented the Stones trucks, equipment, and helicopters and provided various services for the free concert. They had been told to come to the hotel on Monday to be paid. When they arrived, the Stones and all their associates were long gone.

Although Chip Monck had paid the crew in cash each night from proceeds on the tour, the Stones had rampaged across America leaving a stack of unpaid bills. The band booked travel through one agency, mounting up more than $40,000 worth. The number of cancellations and unused tickets made accounting nearly impossible while the tour was ongoing, and after paying only a portion of the travel bill, the band switched agencies midway through the tour and didn't pay the second travel agency either. They'd left Jon Jaymes's cars from Dodge strewn all over Los Angeles, parked in airport lots, around town, wherever. Earlier, in the middle of the tour, Jo Bergman had spent a harried day before rejoining the band trying to find at least some of the fifteen cars the group had lost. Car rental bills in other cities all went unpaid. Again, the band simply switched from Hertz to Avis midway through the tour. No hotels were paid either. The Stones never checked out; they simply left.

With the Stones invading America like a ship of pirates full of more than their ration of grog, ravishing vixens in every port, and making away with all the loot they could get their hands on, there were bound to be legal repercussions. On Tuesday night at Forester's Hall in Livermore, about a hundred angry ranchers

and neighbors of the Altamont Speedway gathered for a meeting led by a lawyer who represented a number of the ranchers, Alameda County supervisor Robert Hannon. Mrs. Connie Jess, whose family owned the ranch immediately adjacent to the speedway, complained that her family had had to move their cattle as far away as possible, but lost track of them when darkness fell. Three days later, they had still not been able to account for all the cattle. Their grass had been trampled, rendered unfit for grazing. "I've never had my privacy so invaded in my whole life," she said. "We just couldn't keep the people out."

Another neighbor said his five-acre ranch had been severely damaged. He said concertgoers had even burned the sheriff's NO PARKING signs for firewood. He was threatened by people when he had cars towed. Eventually a handful of deputies had to surround his house. "I talked to some people in that crowd and some of the scum of the earth," he said. "I saw things you wouldn't believe possible out of a human being."

Dick Carter was there. He told the group he had never expected a crowd larger than fifty thousand. He asked the ranchers to compile a list of damages. He said he would be attending a meeting soon in New York with concert producers and would straighten out everything. Carter also promised to pay the $3,000 bill for the ambulance service that made twenty-five calls to the concert, including five false alarms. "I have been told by the groups involved that they would repair damages," he said.

The meeting broke up suddenly when a voice in the back of the room shouted out that Joe Jess's barn was burning down. The room emptied instantly, although the report of the fire turned out to be false.

Despite this outpouring of anger from his neighbors, Carter's brush with the big time had left him more delusional than chastened. He actually thought he was going to a meeting in New York. He told *Rolling Stone* he wanted to bring The Beatles to Altamont for a three-day free concert in the spring. He said

he had already spoken to Jon Jaymes with his Young American Enterprises about the prospects.

"Of course, nothing's definite," he said, "but if all things go right, the will of the people will win out. They want The Beatles; we'll give them The Beatles."

Even *Rolling Stone* felt compelled to note that Carter sounded a little out of touch with reality when he started talking about Shirley Temple.

"Now I've just been reading this book called 'Naked City,' from around 1945, and about when Frank Sinatra was at Coney Island. It's all the same, the exact same complaints—a few bad guys getting all the headlines, the security problems. These are all very minor. I was just reading in the paper where Shirley Temple says you have a good person if you have a happy person. And, you know, she's trying to make people happy. She's for the Indians, and she wants to let eighteen-year-olds vote, and we think she's right and we want to make everyone happy so they'll be good. Maybe we can get Shirley to help us out on future festivals."

Whatever additional hallucinations about future shows Dick Carter suffered from were officially snuffed out a month later in January, when Meredith Hunter's mother, Alta Mae Anderson, appeared before the Alameda County Planning Commission, who were holding hearings on the speedway's permits. She proposed that the land be turned into a public park and named after her son. The commission voted to allow the Altamont Speedway to continue to hold races, but limited the crowd to three thousand capacity for all events. Any further rock concerts at Altamont were banned.

Dick Carter would eventually be named in forty-one different lawsuits. He wrote a lot of bad checks to cover expenses for the concert. He struggled on with the track, but in July 1970 he closed the speedway and went back to selling used cars. Altamont bankrupted him, but he had been right about the concert putting the place on the map.

ALTAMONT

Weeks after the concert, the speedway and surrounding landscape remained a carpet of broken wine bottles and rubbish. A handful of volunteers chipped away at collecting the garbage, ultimately spending three months cleaning the hillside. The neighbors resisted efforts by the volunteers to clean up their land; they'd had enough of hippies.

22

Crime Story

Alameda County sheriff's lieutenant James Chisholm and detective sergeant Robert Donovan went to the morgue on Monday morning to view the remains of murder victim Meredith Hunter.

A couple of seasoned homicide investigators, Chisholm and Donovan were old-time cops who knew nothing about rock music, squares dressed in tweed sport jackets. They had caught the case late Saturday night, but declined to drive through the traffic to attend the scene of the crime that evening. Officers dispatched to the scene at the time met with Altamont operator Dick Carter, a "Mr. James," and a freshman police science student at Contra Costa Junior College named Frank Leonetti, a witness who had helped move Hunter's body and report the crime. Leonetti, still wearing a shirt stained with blood, subsequently appeared later that night at the Eden Township substation in Hayward to elaborate on his statement.

From these early discussions, the police were aware that Hunter had brandished a weapon. Leonetti told the cops that

261

after witnessing the end of the attack, he approached one of the Hells Angels involved and asked what happened. The Angel produced a blue-steel revolver with a six-inch barrel and showed it to Leonetti.

"I took this from him," Leonetti said the Angel told him. "He wanted to shoot everybody." Leonetti thought he might be able to recognize the Angel who had showed him the gun.

After taking this slender handful of initial statements with people on the scene, the investigation essentially did not move forward for another two days, while the detectives assigned to the case got around to driving out to the remote substation where the call originated. Another problem was that the slight police presence at the scene had lacked the resources to conduct any kind of thorough investigation on the spot. While it was hard to fault the cops—incredibly outnumbered and with no clear directive—for staying perched on their hill as the day's events unfolded, once it was clear that a murder had been committed they did not respond with the expected focus or numbers that the investigation required. As a result, the detectives were playing catch-up from day one.

Similar issues also arose with the two vehicular manslaughter deaths in the incident that had almost killed Jim McDonald. The following day the police learned that the car used in the crime had been stolen, but because the cops had allowed the killer to escape the scene there was little for them to go on. The case fell in a jurisdictional crack between the Alameda County Sheriffs, who caught the Hunter killing, and the California State Police, who took over the crash on the roadside from the Highway Patrol.

With little to go on, the police did almost nothing about investigating the case. McDonald was never even interviewed by police after the accident. His father, a city official in the East Bay town of Richmond, kept in touch with the police about the case for a number of years and managed to keep the file open, but no action was ever taken.

In all, four people had died at Altamont, but with two of them coming in the chaos of the exit from the speedway, they were almost entirely forgotten by the police and virtually unnoticed by reporters. Those two deaths may not have had the headlines of the Hells Angels, but it was no surprise that one of the day's biggest culprits—bad acid—was involved. The drugs had wreaked havoc on the audience all day. They were almost certainly involved in the drowning of nineteen-year-old Leonard Kryszak. At the end of the day, toxic psychedelics had also claimed another pair of victims with the hit-and-run case.

In the end, though, neither the drugs nor the crime ended up mattering to authorities. Not only did the vehicular manslaughter case go unpunished, but the police barely even investigated it. The killer was never found and the case remains unsolved and open to this day.

Though the case of Hunter's death provided more substantive leads and was impossible for police to ignore, from the start there still was quite a bit of confusion given the sheer numbers of possible witnesses. Early Sunday morning, Patti Bredehoft had gone out to the substation with her parents to give a statement, but did not meet with Chisholm and Donovan, who wouldn't even visit the scene of the crime for another couple of days. She described the assault as she witnessed it, including seeing Hunter pulling his gun out of his waistband. She never heard the gun go off, but she did think she saw an orange flash come out of the muzzle at one point, she said. Like Leonetti, an Angel had shown her a gun that he said he took from Hunter and shoved her back in the crowd, telling her to let him die. Patti also suggested that some of the animosity directed toward Hunter by the Angels had to do with the fact that he was black. She gave them a description of where they had parked Hunter's car. Police located the vehicle and towed it off for evidence.

Later Sunday afternoon, police had reached attorney Melvin Belli over the phone at his office and learned that the concert had been filmed from cameras positioned on towers in front of

the stage. Belli told police he would ascertain where the film was and when it would be processed, promising to make the footage available if it held any evidential value.

While the police would have to wait for their glimpse at the footage, the Maysles brothers were certain they had the murder captured on as many as three cameras—all they needed now was to examine the dailies when the film was developed. On the day after the show, the brothers had flown from San Francisco back to New York with Ronnie Schneider, negotiating their agreement en route. What nobody outside the Maysleses knew was that they didn't have the film with them. It had already been sent to Los Angeles for processing.

With everybody from the cops to the Stones to the Hells Angels anxious to view the film and know what could be seen, the film producers proceeded in secret. Once the film was processed, the dailies were taken from the lab to filmmaker Haskell Wexler's place in Malibu, where editors looked at the film and matched the shots. Everything was hush-hush. They kept everything quiet and nobody knew what was happening—not even the cops.

As the editors went through the film, they discovered that Baird Bryant had indeed captured the killing of Meredith Hunter, while Saarinen had pressed the wrong zoom button, rendering his footage useless. Hunter also showed up in other footage, clearly visible in his lime suit and bushy Afro, pushing his way to the front of the stage, looking dazed, slowly licking his lips. This was no longer simply footage from a concert movie, but evidence in a murder case.

The murder may have been on film, but until Chisholm and Donovan could get their hands on it, they faced an unusual dilemma. They had a murder victim stabbed to death with three hundred thousand people watching but had no real eyewitness. The assailant had been clearly identified as a member of the notorious Hells Angels motorcycle club, but they had no idea

who. There were racial issues. And with the murder splashed on the front pages, the case looked like a lot of problems with no immediate answers.

On Tuesday morning, Chisholm and Donovan went to Altamont and met with Dick Carter. He denied hiring the Hells Angels as security, but as usual, he didn't know what he was talking about. Confusing people and stories, he told them that Sam Cutler of Young American Enterprises—Jon Jaymes's company, which had no association with Cutler—had bought $500 worth of beer for the Angels to drink. Carter also told them erroneously that Hunter had climbed up onstage, pulled out a gun, and threatened to shoot Mick Jagger.

They reached Bob Roberts, president of the San Francisco chapter of the Hells Angels. Roberts told them that Hunter appeared to be high and acted quite aggressively. Roberts said he saw Hunter hanging off some of the speakers and pulling up the waist of his pants to act tough. He said he watched Hunter be pushed as he tried to climb the stage, start swinging, and pull out his gun. He thought as many as six Angels plus perhaps three other spectators subdued him. He mentioned Cutler's purchase of beer and steadfastly maintained that he had no idea who had stabbed Hunter.

Meanwhile, on Tuesday in downtown San Jose, police pulled over a suspected stolen vehicle. The two officers overtook the 1964 Pontiac carrying three Hells Angels, and when one of the passengers reached under the seat, the patrolmen radioed for backup, pulled their guns, and forced everybody out of the car. Sitting in the backseat was Alan Passaro. On his belt was an empty knife sheath.

The cops arrested Passaro and the two other Angels, Ronald Segeley and Dennis Montoya, for grand theft auto and searched the car. They found a crowbar, a bolt cutter, a .25 automatic pistol, and, under the seat, a large knife. Passaro, out on bail from grand theft and marijuana charges stemming from two arrests

several months earlier, had his bail revoked and went back to jail on all charges. He gave an empty lot as his address. Passaro was stumbling into the path of the detectives, although they didn't know it yet. They were still trying to figure out what the hell happened. They didn't have a single suspect.

The next day, Wednesday, December 10, Chisholm and Donovan landed what looked to be a big break on the case out of Los Angeles. Police in the working-class suburb of Rosemead on the east side of L.A. picked up a drunk and stoned teenager who appeared to be a runaway with an interesting tale. The young lady, who was found barefoot, disheveled, and without any identification, told police she had left the Auction Bar in Rosemead after an argument with a male acquaintance named Howard. She had moved from Idaho to Mountain View, California, with her boyfriend only the previous week. They had attended the rock festival at Altamont, and after they got into a fight, she wandered off after he dared her to leave. She met two Hells Angels, Howard and Roger, and stayed with them for the rest of the concert. Depressed over the fight with her boyfriend, she agreed to drive to Los Angeles with them. They spent the night at the Oakland clubhouse and drove to Los Angeles the next day in an old Ford that turned out to have been stolen.

In L.A., they stayed at the home of a bartender who worked at the Auction Bar. The next morning, the young woman went with Howard while he made a court appearance on drug charges and returned to the bartender's house, where she heard Howard and Roger bragging about knifing a black man at the festival. Howard showed her a large knife and washed off, in front of her, a fair amount of blood from the blade. She drove with Howard and some associates to a nearby house, where Howard confronted a man over wearing a disputed item of clothing. She watched as Howard stabbed the man. Police were called, but Howard and his people had adjourned to the Auction Bar by the time they arrived.

At the bar, they pumped her full of bennies and reds and gave her beer to drink, but the runaway was frightened and got into an argument with Howard. She walked out, and when the cops stopped her a block away, she told them she was planning on walking back to Mountain View. They arrested her and took her to the station.

Nearby, Baldwin City police reported receiving a call from a stabbing victim, and after an officer recognized the victim, he showed the runaway girl photos of some of his known associates, thinking they might be who the runaway had been with. She readily identified Howard.

"He's the one that killed the negro and stabbed the man down here," she said.

Police found Howard wearing his Hells Angels colors and shooting pool by himself back at the Auction Bar. His description vaguely matched the suspect sought in the Altamont killing. Howard could produce no identification other than some receipts made out to Howard William Clay. When they searched him, they found a sheath with a knife attached to his Hells Angels belt. They immediately arrested him and took him to the Temple City station for booking, where he was apparently well known enough for an officer to recognize him by his real name.

"Hello, Legg," he said. "How's the wife?"

"Oh, hi," he replied. "She's fine now."

Detectives found an outstanding felony warrant for Howard Legg in Santa Anita and held him. They picked up Legg's associate, Roger Jenkins, and contacted the Alameda County Sheriff's office. They had a Hells Angel matching the description of the murderer. They found him with a knife apparently used in a recent stabbing. Legg looked good for the killer.

But after Chisholm and Donovan went south to interrogate the arrested Angels, they didn't like Legg so much as the stabber in Hunter's death. Legg told the officers that he had only claimed to kill Hunter in front of the girl to scare her. And he

didn't match the description as much as they thought. He admitted he was standing close enough to Hunter to have stabbed him, that he had drawn his knife out of the sheath when he saw the fight start, but firmly denied actually knifing Hunter, saying the crowd pushed him to the ground. He also denied taking the runaway to Los Angeles. His pal Roger Jenkins, on the other hand, told the cops that they did take a girl with them and told her lies about the killing to frighten her. Jenkins also backed Legg's story that he had been pushed to the ground when Hunter was attacked. They sent Legg's knife to the lab for analysis, but detectives Chisholm and Donovan went back to Oakland convinced they had gone down a rabbit hole with Legg.

Donovan and Chisholm continued to chase leads. A week after the killing, they finally met with Patti. She basically confirmed the account she'd provided police both the night of the concert and the following morning. They also spoke to one of Carter's security guards working the stage, who told them he saw Hunter pull out his gun and that people around him on the stage dropped to the ground in fear. But it wasn't until the officers visited the offices of *Rolling Stone* in San Francisco on December 18 that they began to get a handle on the investigation and see how far behind they were.

There they met with Jann Wenner, who gave them an advance edition of the "Let It Bleed" issue. One glance at the article made it clear that the *Stone* journalists had covered more ground than the cops. They had interviewed more subjects, dug into the background and the personalities, and laid out a sobering, detailed portrait of the crime. Donovan would later testify he'd read the issue "over and over," especially the opening section with the eyewitness named Paul.

The detectives returned the next day to speak with managing editor John Burks about Paul. Burks told them he never knew the full identity of his witness. His only contact with the subject, he told the detectives, was a phone number on a scrap of paper

he had since thrown away. He gave them a copy of his tape-recorded interview.

The officers went from the *Stone* offices to the Mark Hopkins Hotel to meet with David Maysles, who handed over the footage of the killing. The next day, Donovan, Chisholm, and someone from the district attorney's office went to view the film at the American Zoetrope studios in San Francisco. They made arrangements with Chabot College in Oakland to make photographs of the individual movie frames that were relevant to the case.

They were stunned at what they saw. The entire incident was captured in full frame. Hunter was shown clearly and the assailant jumping into the frame wielding a knife, taking Hunter down. Everything was visible. Although the facial features of the attacker weren't in close focus, his clothing and basic description were obvious. The killer wore concho-studded leather pants. And just before Hunter went down and fell out of view, his hand holding his pistol was outlined against Patti's white crocheted jumper. The killing was fully illustrated in sixteen-millimeter film. The veteran detectives had never seen anything like it on any previous homicide.

Two and a half weeks after the killing, the cops finally found their first eyewitness. Chisholm and Donovan located Paul David Cox—the "Paul" of the *Rolling Stone* story—by tracing the number he had used to call the magazine. It was a friend's phone, a friend who finally convinced him to talk to the police. The detectives took his reluctant statement. Cox, who seriously feared reprisals by the Hells Angels, repeated the gruesome story he had told John Burks.

After the New Year, they found another witness, a fifteen-year-old high school student from Hayward named Denice Bell. She had seen the whole episode, starting when she first noticed the black man in the lime-green suit kneeling by the stage. She watched as the Hells Angels shoved him from the stage and

chased him into the crowd. She saw Hunter pull his gun and heard somebody shout, "He's going to kill Mick Jagger." Then she saw the Hells Angel leap from behind him and stab him in the back with a knife. She described the Angels swarming over Hunter, one throwing a garbage can at his head, and then walking away. She said she thought she could recognize the killer.

With the introduction of these new witnesses, as well as the Maysles footage, the investigation began to gain steam. Chisholm and Donovan had been looking hard at Julio Ortiz, a badass biker with a serious record. Ortiz had been arrested a couple of years before for shooting his girlfriend, but never faced the charges. He had been arrested for carrying a knife. The Angels weren't going to tell the cops they had the wrong guy. Ortiz told police he never even saw the killing. He was onstage the whole time in his mink-lined Angels colors and trademark gloves with the fingertips cut off. They showed him a photograph of the attack. He denied it was him and denied he knew who it was. He said he hadn't carried a knife in more than six months.

They gave Ortiz a polygraph examination and confronted him with the results. Even though he refused to answer questions about whether he knew who stabbed the victim or if he knew the man in the photo, the lie detector indicated significant deception. Ortiz, who did not deny that he recognized the suspect in the photograph, told them it was up to the president of the club to name the man. Angels hated snitches. They all knew who did Hunter, but they would never say.

That didn't mean the Angels didn't cooperate in the effort to clear their brother. Through the Hells Angels, San Francisco police had come into possession of a gun that may have been Hunter's. It was a blue-steel .22 Smith & Wesson with western-style grips and a six-inch barrel. It fit the description of Hunter's gun. Hells Angels and police had a long-standing weapons exchange program, where the police would take guns delivered

to them by Angels off the street without prejudice. This cooperation would be noted in the event of any Angels facing criminal charges and would usually result in a lighter sentence or even dismissed charges. Cops encouraged these kinds of backroom deals with the Angels, and San Francisco police assigned one homicide investigator as an unofficial liaison with the club. Bob Roberts brought the officer the weapon.

On January 23, Chisholm and Donovan visited Alan Passaro in state prison at Vacaville, where he was starting his two-to-ten-year sentence for grand theft and marijuana possession and awaiting trial on the grand theft auto from San Jose. They were led to Passaro by their interrogation of Ortiz and some stray confidential information supplied by the San Francisco police. Passaro admitted he was wearing leather pants with silver conchos down the sides at Altamont, but also said they were identical to a pair worn that day by his friend Ronald Segeley. He said the pants and jacket turned up missing after he was booked into Santa Clara County Jail on December 9.

Although he claimed to have been high on pot and not able to recall much about what happened at Altamont, the police report noted that Passaro could remember certain details. He knew he didn't have a knife, but he did admit he carried a .25 automatic in his waistband. He also told the cops he had cut his hand slicing some meat the day before. He said he didn't return to San Francisco with the rest of the Angels, but drove home to San Jose by himself, where he was stopped and cited for a defective taillight on his way to Fremont. He also told them that he heard it mentioned at a club meeting that the killing had been done by someone from the Los Angeles chapter. They showed him a still photograph taken from the Maysles footage and he denied the photo was him or that he had ever owned a sweater or jacket like those in the shot.

Three days later, the detectives interviewed Dennis Montoya, the crime-mate and childhood friend whom Passaro had

been staying with when they went to Altamont together. Montoya told the officers he had been smoking marijuana and taking LSD and Seconals at the concert. He and Passaro got separated early after arriving together, and according to Montoya, he didn't even know about the killing until he got home. That night, after the show, when Montoya arrived back home, Passaro was already there. He looked at a photograph from the film footage and allowed it did bear some slight resemblance to Passaro, but he couldn't say for sure.

They gave him a polygraph test and the examiner was certain that Montoya knew who did the killing and who was pictured in the photograph, Alan Passaro. They were hot on Passaro now.

They showed a selection of photographs to Paul Cox and he identified Passaro. They asked Denice Bell to look at photos and she instantly singled out Passaro. Patti Bredehoft thought he looked familiar, but couldn't say if he was the killer.

They also showed Patti the film of the killing. She couldn't believe what she saw. In her mind, she had been watching everything happen from a distance, a long way away. She was shocked to see the film showing her standing beside Murdock, holding on to his arm, trying to support him. Her memory was like watching through a pinhole. What she saw happening in the film she had entirely blocked out of her mind. It was like it happened to someone else.

On March 17, they brought Passaro down to Oakland for a lineup. He shuffled into the bright lights with four other subjects, blinking and twitching. Although Patti Bredehoft and Denice Bell couldn't pick out Passaro, Paul Cox immediately identified him as the killer.

A week later, on March 24, more than three months after the death of Meredith Hunter at Altamont, detectives Chisholm and Donovan drove to Soledad Prison, where Passaro had been transferred. They had talked to a thousand people all over the state. Having heard testimony from witnesses and experts, the

grand jury had returned an indictment. A shackled Passaro was brought to an interrogation room to meet with Chisholm and Donovan. There they arrested Alan David Passaro for the killing of Meredith Hunter. He was moved to Alameda County jail, where he was held without bail for first-degree murder.

THE WEEK AFTER Altamont, Meredith Hunter was buried in an unmarked grave in a small cemetery in Vallejo, a working-class community north of Berkeley on the edge of the Bay Area. His family had invited Patti Bredehoft to their home the day after he was killed. She went by herself and sat, uncomfortable and nervous, across from his family. They didn't blame her for his death, but they wanted to talk to her. She was apprehensive about attending the funeral, but once there, she was swarmed over by other young women who wanted her to console them over the loss of Murdock. Patti knew he had been a ladies' man, but she was overwhelmed at the open displays of emotion by these girls.

Neither Patti nor Meredith Hunter's family ever heard a single word from the Rolling Stones.

23

New Speedway Boogie

Gloom shrouded the Grateful Dead in the wake of Altamont. The band wallowed in guilt, depression, and shame. What had started out as a lark in the park had devolved into this catastrophic monstrosity out of their control. Now, in the early months of 1970, they tried what they could to pick up the pieces of what they'd wrought. But instead of their finding hope, initially things only seemed to get worse.

Returning to Novato, the Dead and those around them quickly encountered a very different scene than the one they'd left. The band had been traumatized, not only by what they saw when they landed at Altamont, but also by the beatings to their own family members such as Rex Jackson and Bert Kanegson. The Grateful Dead didn't really care about public relations and they were not under any particular legal exposure from the events, but they had fronted for the Stones inside their own community, and that was a serious disappointment to the band. Outside of the Rolling Stones themselves, pretty much everybody who had participated in the debacle did so at the encouragement of the Dead.

Distraught as they were, perhaps no one in the group took the blow from Altamont as hard as Rock Scully. He had been at the center of the band since the beginning, but everyone knew the Stones concert had been his baby. Though Garcia had backed his play, the band had committed the entire Grateful Dead organization—including their goodwill in the community—on Rock's say-so. Their association with the day had been his doing. While Garcia had watched in detached bemusement as the slow-motion car crash careened toward Altamont, nobody could have expected what happened. As they weighed the consequences and contemplated the karma, the band emerged profoundly shaken, and they definitely blamed Scully for it.

But beyond simply the fallout from the event itself, the mood around the band felt drastically different. Relations within the group suffered as paranoia entered their scene. The band closed ranks. They wouldn't speak to outsiders for weeks. Their comradery with the Angels was destroyed. The band's brush with the big time left them scorched. After much discussion and soul searching, they came together. They were determined to move through this darkness.

Most immediately, there was the question of what to do about Sam Cutler, who'd been left stranded by the Stones. His calls to Jagger were not returned. His salary went unpaid. He had been cut loose without a word or a dime, left behind in California to fend for himself. Meanwhile, the cops wanted to talk to him, and worse, the Hells Angels were looking for him, eager to get their hands on the Maysleses' film footage.

When Jerry Garcia heard about Cutler's difficult situation, he unofficially adopted him, inviting Cutler, who'd been hiding out in Mickey Hart's barn since the day after concert, to move in with him, Mountain Girl, and the kids. Garcia liked rogues, and Cutler—tough, sarcastic, and streetwise—certainly was that. Garcia also counseled Cutler to avoid the rehearsal hall and keep out of sight until the storm around Altamont subsided.

While Cutler gratefully stayed behind at Garcia's home in Larkspur, the Dead spent the rest of December on the road, returning after New Year's from an East Coast swing. Two weeks later, the band left again. They were losing a member. Keyboardist Tom Constanten had announced his intention to depart after the current series of dates. After a week playing shows and a few additional days in the sun in Hawaii (Cutler went along for that part of the trip), the band pulled into New Orleans on January 30. Even with the Hawaiian respite, the road had been hard on them this time. The men were tired and disoriented, with Altamont never far from their thoughts.

They played a local psychedelic dungeon called the Warehouse with the British blues-rock band Fleetwood Mac. After the show that night, the band repaired to a suite in their hotel to relax and party. Immediately they broke out the dope. Road manager Jon McIntire was cleaning out pot in the bottom of a bureau drawer when a large group of New Orleans police unlocked the band's hotel room door and burst into the room. They placed everybody under arrest and searched all the rooms. Only nonusers Pigpen—the burly blues singer of the band whose real name was Ron McKernan—and keyboardist Constanten escaped going to jail because their room came up clean. The entire band and crew—including, most disastrously, Owsley "Bear" Stanley, who had been free on bail while appealing his federal conviction on LSD manufacturing charges—were handcuffed together and paraded in front of press photographers on a perp walk. They spent the night in jail before the promoters could raise the bail.

The following night, both bands performed in a bail-raising benefit at the Warehouse. Guitarist Peter Green of Fleetwood Mac joined the band for the last song of the night, a workout of Pigpen singing "Lovelight." Drummer Mick Fleetwood, stoned out of his mind, wandered out onstage shirtless, banging on anything he could reach, with a sign hanging on his neck reading OUT OF ORDER.

The New Orleans bust not only left the musicians facing jail time (the charges were eventually dismissed), but, more important, it deprived the band of one of the key nonmusician players in Bear. After the New Orleans bust, his bail was revoked and he went back to jail until he lost his appeal and was sent to federal prison. Bear was a huge loss, not only for his audio expertise and psychedelics but also for his irascible, contrary character that was central to the Dead family. The cranky bastard was actually beloved.

The loss of Bear drove the mood in camp further down, but it was the more serious problem of Lenny Hart that truly compounded things, making the months after Altamont a test that nearly ended the band. In January 1970, Lenny moved the Dead management office to Family Dog at the Great Highway, where he was to also assume business management duties for Chet Helms's shaky dance hall. When he refused to show Helms the books, questions were raised. A meeting was called. Lenny Hart faced both Helms and the Dead management. Suspicions about financial mismanagement had first surfaced with the Dead the month before, when Pigpen's organ had been repossessed. The meeting with Lenny Hart was disturbing, but nothing was resolved.

Things came to a head when Garcia was due to receive a check for work he did on the soundtrack for the film *Zabriskie Point*. Mountain Girl, desperate for funds to purchase the house they were renting, called Hart's secretary every day to see if the check had arrived. The day it did, she drove to the office to pick it up, only to discover that it had already disappeared.

Ramrod, the chief of the Dead crew, confronted Lenny Hart over Garcia's check. That encounter went so poorly that Ramrod declared to Garcia that either he or Lenny Hart had to go. Garcia dismissed Hart, but, in typical Dead fashion, gave him a week to put the books in order. An hour later, Lenny Hart and all the files had disappeared, along with his girlfriend, a bank

teller who had been working as his accomplice. He left the band penniless.

But more than the money, the band was devastated by Lenny Hart's deceit. As Mickey Hart's father, he had been like family. The other band members were sympathetic to Mickey, but the drummer was inconsolable. In many ways, the Grateful Dead was closer to him than his absentee father, and he had hoped that Lenny's managing the band would help them bond. Now he felt mortally betrayed. Within months he would leave the band, but in the meantime all the band suffered with him. Besides the emotional toll, the financial hardships were real. Billy Kreutzmann was reduced to poaching deer for his family's dinner.

With all this coming on the heels of the most disastrous episode of their career in Altamont, it became clear to everyone that action needed to be taken to ensure the future of the group.

The band reorganized. Road manager Jon McIntire was named manager. Sam Cutler was brought on board as tour manager. Dave Parker, who had played washboard in Mother McCree's Uptown Jug Champions with Garcia in Palo Alto, and his wife, Bonnie, trained accountants, took over handling business matters.

And then there was Rock Scully. Starting in the days immediately following Altamont, he'd been severely marginalized in the group, and this larger reorganization proved a time to push him out even further. He was taken out of management responsibilities entirely. The decision was made to shift him to record promotion and put him on Warner Brothers' payroll, which permanently altered his role in the group. Edged out of the inner circle, Scully would never recover the band's trust.

Surrounded by deceit and uncertainty, the band sought comfort in the music. Inside the music, the outside world went away. Garcia had never cared about money. Only the music was important to him. They turned their attention to recording new

acoustic-flavored songs, the kind of music they had started play-
ing long before they were the Grateful Dead. The psychedelic
electric rock band had turned a page. The series of songs that
Garcia and lyricist Robert Hunter had been crafting were an
oasis of calm in the midst of the turbulence. The new Hunter-
Garcia songs were, first of all, exactly that—songs—and they all
harkened back in some vague but palpable way to the bluegrass
and old-time blues they played in the early Palo Alto days. These
songs were warm, clever, tuneful, and largely played on acoustic
guitars, a distinct departure from the stormy, labyrinthine elec-
tric rock improvisations that had been the band's specialty.

In February 1970, the Dead shuffled through a set of the new
songs in short order over five days in Pacific High Studios in
San Francisco with Betty Cantor and Bob Matthews producing.
These recordings were meant to be sketchbook versions of the
songs. Finished versions would be recorded later for the band's
next album. The first two numbers—"Casey Jones" and "Uncle
John's Band"—promised a new chapter for the Dead. Garcia
likened it to the Bakersfield country-and-western sound of Buck
Owens and Merle Haggard. Melodic and almost lighthearted,
these were numbers the Dead could comfortably inhabit, and
the traumatic episode made it easier for the band to turn away
from the past and start something fresh.

One of the songs, however, was written in the post-Altamont
heat by an outraged Robert Hunter. "New Speedway Boogie"
was a frank and forthright response to the attacks on the band by
columnist Ralph Gleason over Altamont. The band immediately
put the song in their book, first trying it out fresh from Hunter's
pen two weeks after Altamont at the old Fillmore Auditorium.

Hunter abhorred violence more than anything else. He'd
had a bad feeling about Altamont from the start. Everything
he heard about it disturbed him. He was certain it would be
a disaster. He went to the movies that afternoon to catch *Easy
Rider,* instead of going to the speedway. After he learned what

had happened, Altamont disgusted him. He felt the Stones had duped the Dead. He thought Gleason had turned his back on the bands.

He turned his ire to his writing. The opening line of "New Speedway Boogie" was a salvo directed straight at Ralph Gleason (*Don't dominate the rap, Jack, if you got nothing new to say*). There were veiled references to the Stones (*it's hard to run with the weight of gold*). But this was no simple screed. Hunter saw larger themes in Altamont and a classic struggle of good and evil:

> *I saw things getting out of hand, I guess they always will.*
> *I don't know but I've been told*
> *If the horse don't pull you got to carry the load.*
> *I don't know whose back's that strong, maybe find out before*
> * too long.*
> *One way or another, one way or another,*
> *One way or another, this darkness got to give.*

ANGELS DON'T APOLOGIZE for Angels. Angels don't make excuses. Still, as angry as they were to find themselves made scapegoats for the Rolling Stones, they did not feel good about Altamont either. Some amends would be made.

Two weeks after the concerts, Bob Roberts of the S.F. chapter pulled up in front of the Dead's Novato headquarters and unloaded a rolled-up rug. He was returning the custom-made stage carpet that some of his members had stolen from the Rolling Stones at Altamont, the theft that had resulted in the beating of Chip Monck.

Altamont left the Angels with an unwanted increased public profile. As bad as the club's public image was, it didn't seem it could be any worse, but Altamont renewed their notoriety all over. It's not like the cops could crack down on the Angels any more than they already did, but the prospect of a murder investigation looking for one of the club members was not attractive.

The Angels felt duped by Cutler, and they were most interested in seeing what the Maysleses had caught on film. The Dead kept Cutler away from the Angels. Sweet William showed up at Mickey Hart's ranch shortly after Altamont looking for Cutler. When he was told Cutler wasn't there, he asked Hart to get the film from the Maysleses for the Angels to see and rode off.

Of course, in a single stroke, the Angels had severed their relations with the San Francisco rock bands. Where they had been welcome backstage and around rehearsals, treated as fellow dropouts from straight society, now they were fearsome interlopers. Some of the Angels had become deeply involved in the rock scene and were caught in the middle.

Terry the Tramp took it hard. Tramp loved the hip scene. He was Bear's best friend, as well as his trusted business partner in LSD distribution. He was a thoughtful, even-tempered fellow, despite the trademark bullwhip he inevitably carried, who had expressed reservations to Rock Scully about moving the free concert. He had warned Scully that taking the concert out of San Francisco meant shifting jurisdictions, a serious matter in Angels circles. Tramp was a fixture with the Grateful Dead. They were his friends.

At Altamont, after he witnessed the destruction and confusion wreaked by the San Jose prospects early in the morning, he went off by himself, sat among the crowd on the hillside, and brooded. Tramp knew that the worst instincts of the Angels had been engaged, and he was deeply saddened. He watched all day as things got more and more out of control. After the Dead left, he couldn't take it anymore and split. He ran out of gas as he started home that night, and Barger "pegged" him—placing his foot on Tramp's foot peg and leaning the two motorcycles together while Tramp rode his gas-less bike—more than twenty miles to his home in Oakland.

But Altamont had created in him a sadness he couldn't shake. Shortly thereafter, he started using heroin against the strict rule

of the club. A couple of weeks later, he announced his resignation from the Hells Angels. On February 13, 1970, alone in Bear's home in the Oakland hills, he killed himself with an overdose of Seconals. Altamont had claimed its fifth life.

AS THE FULL scope of the tragedy at Altamont became apparent for the Rolling Stones, their fans, and the press, it still failed to dominate the band's immediate attention after their return to England. Instead, it was merely one item on a growing list of problems—personal, legal, and professional—that the Stones faced as 1970 began.

Both Mick Jagger and Keith Richards came home to problems with drugs and women, their private lives in ruins. For Jagger's part, Marianne Faithfull was living in Rome with her cocaine-addled boyfriend, Mario Schifano, and her son, Nicholas, now five years old. She brought her lover and her son to her mother's house in London for Christmas. Jagger, who had been calling every day, stormed the house. A huge scene ensued and Schifano ended up sleeping on the couch, while Jagger went to bed in Marianne's room. The next day he triumphantly brought her and Nicholas back to his house on Cheyne Walk.

Jagger and Faithfull still had to appear in court on drug charges, stemming from an incident in May 1969 when they were both arrested after the drug squad raided Cheyne Walk. They had booked Faithfull on heroin charges and Jagger for cannabis possession. On January 26, the pair faced the magistrate. Jagger was found guilty and fined a nominal amount. Faithfull was acquitted.

But their life together was far from idyllic. Faithfull was not happy with Jagger. She cried endlessly. There were shouting matches and threats of suicide. She dove into drugs, nodding out in her soup at fancy dinners, embarrassing Jagger. She turned to heroin to drown her unhappiness.

Meanwhile, heroin was taking over Richards's life as well. He

came home to discover that not only was his girlfriend, Anita Pallenberg, facing deportation if they didn't marry, but she was morbidly trapped in postpartum depression and treating the symptoms with generous amounts of dope. Richards, always the good influence, simply followed her down that road.

The issues with their girlfriends and drugs were bad enough, but then there was the problem of the band's money. While the tour had earned the musicians some desperately needed cash, they would have to move out of the country before the next tax year began or face paying up to eighty-five percent of their earnings in taxes. With their contracts with both Klein and Decca Records expiring, they needed to negotiate a new record deal or face potential lawsuits with Klein. The band wanted a $1 million advance for any new record contract, which, even after their selling out the biggest tour in U.S. history, was an unprecedented figure.

Before they got to the new deal, though, the first order of business was finishing the live album recorded at Madison Square Garden, the final album on their contract with Decca. Jagger and engineer Glyn Johns spent hours in January editing and mixing the tapes into a double-record set that featured one disc of the Stones and a second disc featuring Ike and Tina Turner and B. B. King. This led to one of the last arguments with Decca Records, which refused to release the second disc and would only put out a single disc by the Stones, *Get Yer Ya-Ya's Out!*

With the Decca deal nearing the end, Ahmet Ertegun of Atlantic Records grew fixated on signing the Stones. He'd first met with Jagger in Hollywood that October, catching up with him at a Chuck Berry show at the Whisky a Go Go. Jet-lagged and quite drunk, Ertegun fell asleep in Jagger's suite later that night when Jagger was ready to talk business. Jagger was charmed. Ertegun had not only made arrangements for the Stones to use the Muscle Shoals studio, but he had also made

sure he was there to greet the Stones when they arrived, a rare appearance by Ertegun in what was mainly his partner Jerry Wexler's territory.

Signing a new record deal would have to wait—there were many complexities beyond the contracts with Allen Klein—but the Stones still couldn't turn their backs completely on Altamont yet either, especially with the documentary moving forward. Initially, the Maysleses had guaranteed Jagger a March 15 opening—he wanted to beat the Woodstock movie, due later in March—but with the complications surrounding the show that was no longer possible. Still, this inevitable delay had an upside: the movie was now a hot property. The murder and attendant publicity had given the film a commercial value it could never have had before, eventually leading Universal Studios to step up with a whopping $1 million offer for distribution rights.

Even with the footage from the show in editing, there was still additional work to be done. After the brothers had provided a copy of the film to the Alameda County police investigating the murder, they made arrangements to screen the footage to both the Stones and the Angels. The filmmakers were terrified of the Angels. They had heard rumors that contracts had been taken out on their lives. They were also nervous about showing the film to the Stones, although for different reasons. The Maysleses retained complete creative control over the film, but they would need the final approval of the Stones.

They brought in collaborator Charlotte Zwerin, a gifted editor and filmmaker who had worked with the Maysleses on *Salesman*. She had not been available to work on the filming, but ultimately earned a codirector credit with her postproduction work. It was her idea to film the reactions at the screenings. In January, they shot Jagger and Charlie Watts sitting at editing decks in a London studio viewing the footage. Jagger watched, pale and hollow, as the slow-motion killing unspooled on the monitor.

"Can you roll that back, David?" he asked and leaned forward a second time as David Maysles pointed out Hunter's gun silhouetted in freeze frame against Patti's crocheted jumper, Jagger's face wreathed in shock and horror, unblinkingly captured by Al Maysles' camera.

Filming the reaction of the Hells Angels a couple of weeks earlier in San Francisco had not gone as well. After the Angels initially agreed to allow the Maysleses to shoot the screening, when the brothers showed up December 30 at the Angels S.F. headquarters on Ashbury Street, the bikers changed their minds. To forestall any further discussion of the matter, after the Maysleses set up their projector, S.F. chapter president Bob Roberts, who lived there, locked the filmmakers in a closet. The Angels were free to watch the film without distraction.

The men enjoyed the screening like a raucous party. A couple of prospects clowned around behind the screen, pantomiming to the knifing. Some of them recognized their knife-wielding brother from San Jose, but they didn't say anything loud enough to be heard. Some of them already knew who did the stabbing. Dennis Montoya, who went to Altamont with Passaro, was there. When they let the Maysleses out of the closet, an upbeat Al Maysles made some enthusiastic comment about how great the killing made the movie. Bob Roberts took offense and hit him so hard, Maysles doubled over, gasping for breath.

While screenings for the Stones and the Angels could not have gone more differently, what each showed in its own way was how deeply intertwined the documentary and its subjects had become. As strange as the entire concert had been, perhaps the most bizarre element was that in the middle of all the madness and indeed even in its aftermath, a movie was being made. With the cameramen as stoned as the audience (of course, so were the bands and the Angels) and the filmmakers subject to the same violent, fearsome conditions, the boundaries between documentarians and subjects blurred. Even now, months after the drama

onstage had come to its disastrous halt, the film remained fundamentally connected to the rapidly evolving mythology of the day. The movie was part of the story, although it was a part of the story the film could never fully tell.

With the film in postproduction, in February the band took several meetings with their accountant, Prince Loewenstein, who carefully mapped out detailed plans for the future. At the first session, the band agreed to the plan they'd been discussing for weeks: to move out of the country before the next tax year to avoid British taxes and remain living abroad for at least twenty-one months. They were also going to have to fight Klein in court over rights to the band's music publishing and master recordings. At a February 19 meeting, the Stones were advised that Klein owned their masters and the publishing, learning for the first time the grim consequences of their original deal with him. The band needed to put together an entirely new financial strategy. Innocent about business matters, the Stones had always trusted managers to make business decisions, but now they had to take matters into their own hands for the first time in their career. Their future was at stake.

It wasn't just the financial future of the band that remained unstable. Altamont had left Jagger frightened. He began to take stock. He had always pushed the limits, but now he realized he could take things too far. He withdrew into a world of calculations. He needed to secure his boundaries. With his legal, financial, and personal problems, he was under attack from all quarters, and for the first time, he had seen how much his arrogance and hauteur could cost. The Stones, already practiced in the art of deception, needed Jagger to construct a new strategy for the band.

Richards held no interest in such matters. His response to the Altamont debacle and all the personal and business pressures bearing down on the Stones was to slip deeply into junk.

As they did onstage at Altamont, the band sought the sanctu-

ary of music. With their lives at home crashing down on them, relations between the band members strained, and their business empire in jeopardy, the Stones went back to making music. In the midst of all this tension and pressure, music was the only place that was still safe for them. It was also what they did best.

They hid out in the recording studio. In March, the entire band retreated to a temporary studio at Stargroves, Jagger's sixteenth-century Berkshire estate where Oliver Cromwell once spent the night. With the tracks in the can from Muscle Shoals and outtakes from the Los Angeles sessions, a new album was well under way.

They turned Jagger's stately home into a rat's nest of cables and cords, equipment and instruments. They moved the Rolling Stones' mobile sixteen-track recording unit into the gravel front courtyard and held sessions around the clock. Richards, always tardy, started keeping junkie hours, showing up at three in the morning. The first track they recorded, "Sway," was cut with Mick Taylor's amp in the fireplace and the microphones hanging in the chimney. Charlie Watts's drum kit was set in a large bay window. Nicky Hopkins played piano, and saxophonist Bobby Keys and trumpeter Jim Price from the Delaney and Bonnie band, in town to do sessions with George Harrison, joined the group. "Bitch" evolved from a jam session between Jagger, Charlie Watts, and Bobby Keys. Late one night on acoustic guitar, Richards strummed the bare bones of a melody he called "The Japanese Thing"; he would be too stoned to make the session six months later when the track was completed as "Moonlight Mile." Decca demanded one further single under their contract with the band. The Stones recorded an X-rated song called "Cocksucker Blues" that Decca duly declined to release.

As they had done several times before, the Stones slowly pieced together an album, in no hurry to put anything out given their legal state. The sessions were haphazard. Progress was intermittent. The band needed to redefine itself. Mick Taylor

had brought a new kind of virtuosity to the band, allowing the group a breadth the Stones never had before. The musicians needed to immerse themselves in music to rediscover who they were.

The Stargroves sessions were fraught with alienation and dissension. Richards, who had been the driving force in the studio behind both *Beggars Banquet* and *Let It Bleed*, sank deeper into the abyss, largely absent, floating in his own orbit. Jagger, distracted by both personal and business pressures, found himself in the uncomfortable role of leading the sessions. Their partnership changed and the axis on which the Stones had always revolved shifted. The band teetered on catastrophe. Bill Wyman was so disgusted with Richards and his reckless drug habits that he stopped speaking to him for ten years.

Back in the United States, the lawsuits started to line up. In March, Jon Jaymes and Melvin Belli had hosted a bizarre joint press conference to announce that Young American Enterprises and Stones Promotions Ltd., Ronnie Schneider's company, were filing an $11 million lawsuit against Filmways. Jaymes chaired the New York end in his office, and Belli spoke to reporters assembled in his San Francisco office via telephone from Johannesburg, South Africa. Jaymes claimed he had a tape recording of an oral agreement he and Schneider made with the management of the Sears Point Raceway, but he didn't play it. Belli fumed that what happened at Altamont was a direct result of Filmways forcing them to break the contract. The Rolling Stones were not party to the suit, which apparently was never actually filed.

Joe Jess, the rancher who owned the land next to the speedway, did file suit against Jon Jaymes and Young American Enterprises for $1 million for mental anguish and $35,000 in actual damages. Another group of fourteen local ranchers banded together to sue Jaymes and his company for $900,000. Only one rancher ever collected anything.

Meredith Hunter's mother, after bouncing around from one

lawyer to another, filed a $500,000 suit in San Francisco Superior Court against Jaymes and his company, the Rolling Stones, Sam Cutler, Alan Passaro, the Napa and San Francisco chapters of the Hells Angels, Altamont Speedway and Dick Carter, Filmways, and others. She would eventually settle her suit for $10,000.

There was also the matter of insurance. Jaymes had promised Sears Point to provide a $1 million insurance policy, and Belli had assured Carter the insurance would be transferred to Altamont. Of course, there had never been any insurance purchased by Jaymes.

As a result, collection was nearly impossible. The lawsuits couldn't find responsible parties to sue. The speedway was out of business. The Stones never signed any documents that would tie the band to the concert. Stones Promotions Ltd., the company Ronnie Schneider started to run the tour, soon vanished and Schneider split town. Jon Jaymes and his Young American Enterprises were left holding the bag.

"Last I heard, Ronnie's somewhere in beautiful downtown London," Jaymes told *Rolling Stone* in November 1970. "I don't know why, when, where or how he decided he didn't want anything to do with the whole mess. I guess he couldn't keep his promises, so he walked out on me."

Jaymes claimed that Schneider left behind an additional $150,000 in unpaid bills from Altamont, ambulance services, helicopter rentals, and various other costs. He threatened to sue Schneider and claimed to be on the verge of bankruptcy, but soon Jaymes, the man who had first arrived on the scene mysteriously with a small army of off-duty cops and a fleet of cars, had disappeared as well. The name of his company might have been on the contract for Altamont, but in the end he was no more accountable for what transpired than anyone else.

While the Stones dodged the litigation around Altamont, they were still responsible for travel expenses from the tour

that had gone unpaid. Travel agency Diners/Fugazi filed suit to recover $24,000 in unpaid bills. The Plaza Hotel in New York claimed the Stones still owed them $18,000. The Huntington Hotel in San Francisco was only looking for $1,857.59, although the hotel got some money from the Stones after first submitting a bill for $4,218 to the band's lawyers.

With considerable persistence, some of the bills were settled over the coming months and the next year. A large number were not settled until after a lawsuit reached court six years later.

As far as the law was concerned, the Rolling Stones had managed to avoid any liability for Altamont.

24

Angel on Trial

On December 16, 1970, Alan Passaro sat in a courtroom waiting to stand trial for the murder of Meredith Hunter.

Passaro, who'd spent the better part of the year preparing for this moment, looked far different than the man who'd ridden his bike up to Altamont a year earlier. In an attempt to help his case however he could, he had shaved off the Fu Manchu mustache and his long, oily hair was now properly barbered. His pretty blonde wife, Celeste, was to sit behind him in the courtroom where the two could exchange warm, intimate glances.

Sitting patiently next to Passaro at the defense table was his lawyer, George Walker, a formidable figure whom the Angels had hired to represent him. Movie-star handsome, tall, and impeccably dressed, Walker cut an impressive, elegant figure in court. At six foot two, he had starred on the 1946 UC Berkeley basketball team that reached the NCAA finals. In the Army Air Force during World War II, Walker survived sixty-three bombing missions over Europe piloting B-26s. He'd started practicing law in San Francisco with Melvin Belli, but quickly

established his own firm, going on to become the city's leading black attorney.

With a black teenager dead and a member of an all-white outlaw motorcycle club on trial for his murder, hiring Walker was a brilliant play in race politics by the Angels. The son of an African American/Cherokee father and a Norwegian mother, Walker looked like a Native American to most people. He had served alongside white soldiers in the segregated army and was the first black basketball player in Cal history, although few noticed at the time. Simply by his presence in court representing Passaro, Walker defused potentially difficult issues.

Passaro would need all the help he could get. Not only had he been identified by eyewitnesses as the killer, but there was a professional-quality film of him doing it. Being a Hells Angel only made it worse for him. He was already serving an especially harsh sentence almost certainly because of his club membership, doing two-to-ten on his first adult conviction. He understood that he would not be a likely candidate for parole anytime soon either, for the same reasons. He figured his Death's Head tattoo alone would keep him in prison an extra year. Alameda County district attorney Lowell Jensen had announced he was seeking the death penalty against him. At age twenty-two, Passaro was facing the gas chamber.

Initially, Passaro, Walker, and Celeste were joined in court that first day by a dozen Angels who'd shown up wearing full colors as a show of support. Over the course of 1970, the Angels had pulled together behind Passaro. Although he had to sell his prized chopper to help pay Walker's fee, the Angels also backed him and helped pay the mounting legal bills. Their girlfriends took Celeste out to eat. But seated in the courtroom, this support took on a very different look—more menace than brotherhood— leading Walker to advise them that such a militant display might not sit well with the jury.

Walker was shrewd, and he knew why he was there—

beginning with jury selection. With the district attorney asking for the death penalty, one prospective black juror after another was disqualified after admitting they could be prejudiced in favor of capital punishment. Walker used some of his preemptory challenges to eliminate other black jurors until he had an all-white jury of eight men and four women. Walker left one retired air force officer on the panel because he suspected the man was an uptight, racist right-winger. District attorney John Burke told the press he was satisfied. "This is a law-and-order jury," he said.

Burke was an extraordinarily courtly prosecutor who never turned his back on the jury, even going so far as to walk backward to take his seat, but his courtesy couldn't hide his confidence in his case. In particular, he liked his film. He felt sure all the evidence he needed to convict was on the screen, production values upfront, as they say in Hollywood. His first witness, cameraman Baird Bryant, was going to introduce this key piece of evidence.

Simply getting Bryant to the stand had not been easy. When contacted by the district attorney's office, the Maysleses claimed they didn't know which cameraman took the footage. Once the prosecutor had figured out who the cameraman was, Bryant proved hard to track down. One of the investigators for the prosecutor finally located him and served him with a subpoena three days before the trial.

Wearing love beads and a powder-blue sports shirt, with hair down to his shoulders, Bryant testified and then the jury was escorted across the street to a small theater at the Oakland Art Museum, where they saw the film for the first of many times. After the damning evidence, Walker began his cross-examination and hit a theme he would strike with witness after witness. He wanted the jury to see that all these people belonged to a criminal underworld that openly encouraged the use of illegal drugs. His straight white jury would never trust such people.

"If you 'smoked a couple of numbers' would you know what that meant?" Walker asked Bryant. "Are you familiar with the jargon I'm using?"

Bryant denied under oath that he had used any drugs the day of the filming, even though in truth he was actually coming down from LSD when he shot the footage. He also explained that he did not have any idea what he had filmed when he shot it.

"Only after I had seen the film was I aware of the nature of the happenings," he said.

Before introducing his next major witness, Burke paraded police officers across the stand who testified to the Hells Angels' practice of taking reprisals on witnesses against them. They told grim tales of Angels' brutality. The officers described the terror Angels could strike when intimidating informants.

"One person told me he would rather go to the state penitentiary for twenty years than be involved with the Hells Angels and get caught at," one officer said.

This was setting the stage for Burke's star eyewitness, Paul David Cox, whose appearance had also proven problematic. After conducting initial interviews with investigators and identifying Passaro at a lineup, an increasingly frightened Cox had disappeared. Deputies could not find him. This was still the case as late as November 1970, less than a month before the start of the trial, when Sergeant Robert Donovan gave up his Thanksgiving holiday to try to serve Cox, but came up empty. Prosecutor Burke even joined the manhunt in the weeks prior to the trial. They only caught up with Cox the week before he testified.

Over the next three days, Cox would shift in his seat, fold and unfold his hands, wriggle his knees, and mutter barely audible answers into the microphone. He wore a double-breasted blue blazer and white cotton twill bell-bottoms. He was sneaked into the courthouse secretly, and the judge was careful not to allow any of his personal information onto the record besides his name. A few Angels, without their colors, watched from the audience with considerable interest.

Walker destroyed a nervous Cox on cross-examination. He introduced a tape recording of Cox's interview with John Burks of *Rolling Stone* and read from a transcript, citing inconsistency after inconsistency with his testimony in court. Cox grew defensive. "I was very nervous, wound up like a clock, agreeing with everything he said," said Cox.

As he had with Bryant, Walker also worked to show that Cox was a part of the same drug-abusing scene that was pervasive at the concert, taking Cox through his use of drug terminology in his phone interview with *Stone*. "Would you know what I meant if I said, 'Mr. Hunter did a couple of numbers and he was straight like the rest of us'?"

"I don't really understand the question," said Cox.

The judge spoke. "Do you understand what the words means?" he said.

"'Straight' means someone with straight ideas," said Cox.

"Have you used those words yourself?" said the judge.

"Some people around me do," said Cox.

"How about 'numbers'?" asked the judge.

"I've had someone ask me if I'd had a number," said Cox. "I'd ask them if they mean 'joint.'"

Walker's tactic was subtle but effective, using the jury to his advantage and putting the drug and hippie culture on a small trial of its own. The Angels might have been reckless, but they were just trying to survive encounters with the drug-addled masses. Much to his advantage, Walker saw that one of the best ways to defend his client was to indict the larger culture that was at work that day, playing on the fears and prejudices of a jury that most likely had little firsthand experience with rock music, hippies, or drugs.

Burke followed Cox with testimony from the medical examiner, but again Walker took the prosecution witness where he wanted him to go. Under businesslike cross-examination by Walker, the medical examiner admitted to finding needle tracks, both new and old, on the arms of Meredith Hunter. He further

testified that the victim tested positive in the autopsy for methamphetamine in both blood and urine, indicating both recent and chronic use.

Under direct examination, the medical examiner had told Burke that the victim had died from "shock and hemorrhage and multiple stab wounds." After walking the medical examiner through a list of symptomatic behaviors of meth users, Walker zeroed in on the cause of death.

"Is shock a factor in a death from overamping?" he asked, using a colloquial term he had previously introduced for speed overdoses.

"It may be," replied the pathologist.

The prosecution kept Patti Bredehoft sequestered in a windowless room waiting to testify. She was brought into the court without advance notice. The pretty young girl had graduated from high school and was working as a teletype operator. She spoke quietly in calm, even tones, occasionally wiping her long blonde hair out of her face. She eyed warily the row of Hells Angels sitting in the back of the courtroom. Her testimony was less important than her presence, the last living link to the murder victim, a star in the film clip the jury had seen over and over the past two weeks. She told the same story she always did, including not being able to identify the killer. She wondered in the back of her mind if people thought she was saying that because she was scared of the Angels. She *was* scared of the Angels, but she truly did not remember. It all happened too fast and she was too traumatized.

Burke wound up his case with routine introduction of evidence. The San Jose police who arrested Passaro told of finding the knife. A blood specialist testified to finding traces of blood near the hilt of the knife that were "extremely probably" human blood in the same blood type as the victim's. Sergeant Donovan testified about receiving from the San Francisco police the gun that had been handed over by the Angels and that they said had

been Hunter's. Patti Bredehoft had testified that she had seen an orange flash while Hunter was struggling with the Angels. On the stand, Donovan told the court he had determined that Hunter did not fire the gun. Under cross-examination, Walker asked what tests the detective made to conclude the victim never fired the gun.

"I ran the standard clean-and-swab of the barrel," Donovan said.

"You used no chemicals and no microscope?" asked Walker.

"No," said the detective.

Walker opened his defense by calling a couple of Dick Carter's rent-a-cops from Altamont who saw the victim pull a gun from where they were on the stage. Neither could identify the attacker. Denice Bell, the Hayward high school student eyewitness, testified she couldn't identify the killer either. Hells Angel Larry Tannahill told the jury he saw Hunter pull a gun as he watched from the stage.

Out of everybody's sight, Sam Cutler waited in the sequestered witness room. The man who hired the Hells Angels had never even been interviewed by the police. Walker did interview Cutler, but never ended up calling him to the stand. Cutler could testify to the chaos and disorder of the scene, and he was supportive of the Angels, but his testimony could also open up wider issues around Angels violence that Walker would rather avoid. He didn't need Cutler.

Walker didn't think much of the prosecution's case. It came down to one shaky eyewitness that Walker had largely discredited and some flimsy physical evidence. The rest had been pointless window dressing. He had cast doubt on the cause of death, the science of the investigation, the mental condition and drug habits of witnesses. As for the film footage, Walker thought that it simply showed that his client had acted in self-defense. The prosecution had showed the footage repeatedly, brought out blown-up photos taken from frames. The jury saw the shadowy

film so many times it lost its emotional impact and they grew numb to it. Walker didn't think the jury thought it showed what the prosecution intended. He didn't need to march a parade of witnesses across the stand to convince the jury that Altamont had been an out-of-control disaster.

In the end, Walker had only one witness who mattered, Passaro himself. Putting Passaro on the stand was a risky move. He would be exposed to a withering cross-examination. Passaro was certain he was losing the case. He wanted to testify. Walker weighed his options scrupulously. The district attorney only learned that Passaro would testify an hour before he took the stand.

Dressed in a sharp leather jacket with gold sleeves, gray slacks, and well-shined black shoes, Passaro had gained more than thirty pounds lifting weights in prison since Altamont. His parents watched from the courtroom. His father had promised to deed a hotel he owned in Italy to his son if he won the case. The jurors shifted forward in their seats. For weeks, they had been watching Passaro at the defendant's table, seeing him identified repeatedly in the film footage, and hearing about him from witnesses. Now they would listen to him tell the story. He spoke in a low, manly baritone.

Alan Passaro had never hid who he was, and now, in the witness stand on trial for his life, was no time to start. He was calm, matter-of-fact under questioning by his attorney, Walker. He described the events that took him from the stage into the crowd after somebody pushed over a motorcycle. He talked about seeing the victim pull his gun. Veteran reporters covering the trial were astonished to hear him admit to the crime on the stand.

"I went for my knife," Passaro said. "I attempted to get his gun hand. I tried to shake the gun loose. I struck him in the upper shoulder with the knife—struck at him."

Passaro said he stabbed Hunter twice. Walker asked him if he knew the knife had penetrated the body.

"Honestly, I don't know," Passaro said.

District attorney Burke began his cross-examination by asking Passaro why he left the stage and went into the crowd.

"For one thing, the motorcycle was lying on its side," Passaro said. "Maybe we had to have a little talk with the guy that knocked it down."

Burke took him through the grimy details of the crime. How much blood was on the knife? Why did he take off his jacket? Had he been smoking grass? Had he been drinking? Passaro answered each question quietly, without emotion, straightforward. His voice rose to a more intense pitch only as Burke started to ask him about his motives.

"Why did you strike at Hunter with a knife?" Burke asked.

"I think some fear came over me," said Passaro.

"For your own safety?" said Burke.

"For mine and my brothers," said Passaro.

"Were you worried about yourself?"

"I was looking after my people."

After some legal wrangling over evidence, Passaro returned to the stand following the weekend. Burke questioned him over inconsistencies between his testimony in court and the statement he first gave police. Passaro wasn't about to be trapped in a web of his own devising. He simply admitted he "made a story."

"It was a lie?" asked Burke.

"Yes, it was," said Passaro.

After resting his defense, Walker argued that the jury be instructed to only consider a manslaughter verdict since the prosecution had clearly not shown any premeditation necessary for a first- or second-degree murder conviction. The judge denied his motion and the jury retired to consider the verdict after seventeen days of testimony.

After seven hours the first day, the jury was locked up for the night. After lunch the next day, the jury viewed the Maysles brothers' footage one last time and asked to have some of the

Patti Bredehoft testimony reread to them. Shortly before five in the afternoon, after more than twelve hours of deliberation, the jury returned. Passaro put his hand across his face as the verdict was read.

When he heard "not guilty," Passaro shrieked, "Yeeeoooowww," and pumped his fist in the air. He leaped out of his chair and hugged a jubilant Walker. His wife, Celeste, burst out laughing and crying. Jurors were in tears. Passaro and his wife exchanged fond looks. His parents were not in the courtroom, thinking they could not bear the pressure of hearing the verdict. Passaro couldn't believe it. "I didn't think I had a chance," he said to a bailiff.

Walker never had a doubt. He was certain from the start that his jury would never find Passaro guilty of murder. He radiated that confidence with his sedate, cool courtroom demeanor. But Passaro's case was never a foregone conclusion. Walker had skillfully navigated the evidence and mastered the courtroom narrative. He thoroughly undermined the state's case. With a murder committed in plain sight of hundreds of people, the police could find only one eyewitness. The prosecution had to watch helplessly as Walker made mincemeat of a nervous, frightened Paul Cox.

But Walker's lethal blow was turning the prosecution's most crucial piece of evidence—the Maysleses' film—into his own coup de grâce. No matter how many times they showed the film or blown-up stills of individual frames to the jury, the most resonant image was of Meredith Hunter's gun outlined against Patti Bredehoft's crocheted sweater.

Passaro was found not guilty, but he was not free. He was quickly taken from the courtroom to his cell on the tenth floor of the courthouse. A jailer gave him a cigar. Wearing a giant smile, he talked with reporters.

"I'm more glad for my mother than for myself," he said.

25

Love in Vain

The Maysles brothers' movie, *Gimme Shelter,* was released the first week of December 1970, a week before Alan Passaro's trial began and almost a year to the day since Altamont. They had initially toyed with the title *Love in Vain,* but apparently thought better of it. It opened at the Plaza in New York City.

None of the Stones attended the premiere. They did not care to be reminded of the concert, but they were also in a peculiar position. They owned the film in partnership with the Maysleses and had already made considerable money on the movie deal, with more to come. But they could not embrace the film in any meaningful way without raising uncomfortable questions.

Immediately upon release, the film set off a firestorm of controversy among movie critics. Under the headline MAKING MURDER PAY, *New York Times* critic Vincent Canby dismissed the film as depressing and self-serving. "It is touched by the epic opportunism and insensitivity with which so much of the rock phenomenon has been promoted, and written about, and

with which, I suspect, the climatic concert at Altamont was conceived," he wrote.

But it was Pauline Kael in *The New Yorker* who devastated the movie with a poison-pen letter that would remain one of the most famous reviews in her long and auspicious career. "How does one review this movie?" she wrote.

> It's like reviewing the footage of President Kennedy's assassination or Lee Harvey Oswald's murder. This movie is into complications and sleight-of-hand beyond *Pirandello,* since the filmed death at Altamont—unexpected, of course— was part of a cinema-verité spectacular. The free concert was staged and lighted to be photographed and the three hundred thousand who attended it were the unpaid cast of thousands. The violence and murder weren't scheduled, but the Maysles brothers hit the cinema-verité jackpot.
>
> If events are created to be photographed, is the movie that records them a documentary or does it function in a twilight zone? Is it the cinema of facts when the facts are manufactured for the cinema? The Nazi rally at Nuremberg in 1934 was architecturally designed so that Leni Riefenstahl could get the great footage that resulted in *Triumph of the Will.*

When a reviewer opens a critique by comparing the filmmakers' work for the Rolling Stones with similar services provided to Adolf Hitler, you know you're in for a tough review. The Maysleses were outraged. They met with *New Yorker* editor Wallace Shawn, but nothing came of that. They composed a detailed response to the Kael review, although *The New Yorker* did not print letters at the time.

"Miss Kael calls the film a whitewash of the Stones and a cinema verité sham," the Maysles wrote. "If that is the case, then how can it also be the film which provides the grounds for Miss Kael's discussion of the deeply ambiguous nature of the

Stones' appeal? All the evidence she uses in her analysis of their disturbing relationship to their audience is evidence supplied by the film, by the structure of the film which tries to render in its maximum complexity the very problems of Jagger's double self, of his insolent appeal and the fury it can and in fact does provoke, and even the pathos of his final powerlessness. These are the filmmakers' insights and Miss Kael serves them up as if they were her own discovery. Rather than giving the audience what it wants to believe, the film forces the audience to see things as they are."

Kael's factual errors in her premise notwithstanding—the film crew had nothing to do with the staging and lighting—her revulsion stems from the film's candid, almost neutral depiction of the violence in front of the stage and the way the Maysles (and codirector Zwerin) milked the murder of Meredith Hunter for their film's climax. The filmmakers used their material brilliantly to construct a story, but they tell only a slender slice of the entire drama and if it is not exactly a lie, it is far from the whole truth.

Gimme Shelter opens onstage at Madison Square Garden, and from the first minute the audience is dropped into the sweeping majesty of the Stones in concert. A heroic single camera shot tracks Jagger through the beginning of "Jumpin' Jack Flash," a riveting, lingering look where the camera cannot tear itself away from the singer and his expressive face, his body filled with the music. From that orgiastic opening sequence, the movie follows the Stones to Muscle Shoals and settles into the recording sessions with uncommon intimacy, before arriving in California for the big free concert. When the film moves to Altamont, the establishing shots strike a festive, joyous mood with happy hippies making their way to the concert. Santana refused to allow footage of their performance in the movie, so the violence first emerges in the film with the Jefferson Airplane performance. In the movie, the relatively peaceful set by the Flying Burrito

Brothers comes before the Airplane, not after, as it actually did. The beating of Marty Balin happens so quickly onscreen, it is easy to miss, but there is no mistaking the fear in Grace Slick's tremulous dialogue.

The film soon moves to the nighttime performance by the Stones, with careful, dramatic edits of Jagger's pleas to the crowd. Some incidents from later in the set were edited into early parts of the show to make the film lead to a climax of Baird Bryant's filming of the killing of Meredith Hunter. The Maysleses don't linger on any musical part of the Stones' performance and completely ignore the rest of the concert after Hunter is killed, no matter how great the band played. In filmmaker Charlotte Zwerin's brilliant idea, the film cuts from the killing at the concert to the editing room, where David Maysles is showing the piece of film to Mick Jagger.

The movie rushes to the finish from there with the Stones' harried exit, and, just after the spacey, otherworldly panoramic sweep of concertgoers stumbling out of the concert in the darkness that was the one shot from George Lucas in the entire movie, *Gimme Shelter* memorably closes by returning to Jagger having watched the footage of the killing, as the ashen-faced Stones vocalist is caught in freeze frame leaving his chair at the editing desk.

The film works to absolve the Rolling Stones, demonizes the Hells Angels, and barely mentions any involvement by the Grateful Dead, who were almost entirely responsible for the concert production. The Stones are portrayed as almost innocent victims, helpless in the face of the brutal Angels, whom the filmmakers cannot resist playing up as villains. Since the Maysleses were not privy to any of the planning of the concert, they may not have even known what the Dead's involvement was. The only clip of the band in the movie shows Jerry Garcia and an anxious Michael Shrieve of Santana speaking briefly as Garcia exits the helicopter at Altamont. Rock Scully is never

seen in the film, but an unidentified Jon Jaymes shows up in scene after scene.

Mick Jagger told *Rolling Stone* that the film represented the vision of the Maysleses, not the band. "What can you say, it's so hard-hitting. It's *their* film. It was just so unpleasant to watch. Does anyone want to see it? I mean, I'm not rushing around, collecting people for a party for the premiere."

The Maysleses are not apologists for the Stones, but the filmmakers couldn't help but be sympathetic to the people who were eventually going to have to sign the releases for the movie. Despite their reputation as honest independent documentary filmmakers, the Maysleses made a movie that is their cinematic vision more than a journalistic account, freely ignoring much of the real story, shifting chronology to suit their narrative, opting for easy images over complicated issues. One basic fact of Altamont—that if Jagger had not insisted on keeping all the money from the film, the concert could have taken place at Sears Point—is never dealt with honestly. In the film, Filmways' demands for distribution rights to the movie and a portion of the proceeds, along with the apparent reasons for why the show moved from Sears Point, are not presented. Those are large facts to ignore. Yet *Gimme Shelter* served as the official record of Altamont, the accepted version.

Rarely, if ever, in cinema history has a documentary film become so deeply enmeshed in the fabric of the story it is supposed to be telling. Also, despite a prerelease publicity smokescreen that trumpeted contributions to charities from the proceeds, the film was always a for-profit enterprise, just as the Filmways executives suspected. The Stones had gone so far with that charade as to tell Jefferson Airplane that they didn't want to make any money from the movie, both by telegram and in a visit with Jagger when the Airplane was in London during the summer of 1970. By that point, the Stones desperately needed the Airplane to sign their releases; the footage of the Angels beat-

ing up Marty Balin was crucial. At first the Airplane refused to allow their performance to be included, but changed their minds after being assured that the proceeds from the film would go to charity. But make no mistake, while the show might have been free, the movie was always about money.

That said, *Gimme Shelter* remains one of the great rock documentaries. The gutsy, intimate handheld cameras' view of the Rolling Stones onstage at the peak of the band's considerable powers made for some of the most potent, intense rock music ever filmed. With the filmmakers' straightforward documentary approach—no voice-over narration, no interviews—the movie followed the path laid out by filmmaker D. A. Pennebaker's groundbreaking music documentaries, *Don't Look Back* with Bob Dylan, and *Monterey Pop,* his record of the historic 1967 pop festival with Jimi Hendrix, Otis Redding, and others. *Gimme Shelter* stands on its own, even if does not present a truly accurate account of the events.

The filmmakers never penetrated the veil of the Stones' world. There are no personal moments. The Stones are always seen working. They are either coming from or going to a performance, performing, recording, or traveling to more work. No drugs. No sex. Only rock and roll.

WITH THE FILM'S release and the subsequent acquittal of Alan Passaro, the story seemed to be at an end, but in truth the reckoning with the day had just begun. What would follow was a generation of cultural criticism that would turn to the day, and the mythology around it, to uncover a much larger symbolism: the figurative and literal end to the sixties and all that the decade came to represent. In a single day, the innocence of a generation was shattered. If Woodstock had been rock's Promised Land, Altamont was its Hell. The sunny tribalism of Yasgur's farm had been supplanted by an evil, dark ceremony complete with blood sacrifice. For the rock and roll generation, Altamont

proved to be a pivotal point, lodged in the popular imagination as the day the sixties died.

But, looking back, Altamont was not the end of anything. It was not the end of the Rolling Stones or the Grateful Dead. It wasn't the end of free concerts or rock festivals. It wasn't the end of the Hells Angels, and it certainly wasn't the end of the sixties in some definitive, apocalyptic way as it is so often portrayed. All the ideas and aspirations for the evolution of consciousness that were at the heart of the movement still remain. That dream never died.

This common view that Altamont was the end of the sixties and the death of the hippie dreams doesn't hold water under close inspection anyway. The events at Altamont were the result of the convergence of many fissures running through the counter-culture, and as such, it was more of a symbol of unresolved conflicts that had been quietly warring in the underground: the reality of money, the lack of leadership and unity of purpose, the role of drugs, and the rejection of authority and the police. All this was compounded by the grotesque misunderstanding of the Hells Angels, again itself a reflection of the almost determined naïveté that helped undermine the movement.

The killing of Meredith Hunter so flagrantly flew in the face of the Woodstock myth—all men do not live like brothers—that his death was shocking for many reasons. It pointedly represented the failure of Altamont, which was far broader and deeper than the unfortunate death of one concertgoer (or four). Hunter also injected the painful specter of race into what was already a disaster for the underground. A great many bills came due that day, as the axioms of the Summer of Love were put to test and failed like a wet paper bag. That they failed is perhaps not as surprising as that they got as far as they did—all the way to otherwise rational humans believing that they could erect a stage, pull together more than a quarter million people overnight in some cow pasture in the middle of nowhere, and have everybody come in peace. How pretty to think so.

Altamont brought the Achilles' heel of the hippie movement into sharp focus. As hopeful, optimistic, and encouraging as the perception of Woodstock had been in the public breast, Altamont struck a harsh, frightening, and discordant note. It was a bad day where tawdry reality clashed with innocent fantasies. These disparate forces had been running on a collision course in the culture for some time. Making a new world required a lot more cooperation than people were getting, and there was considerable disagreement about what the new world should be. And Altamont wasn't even the day that dispute broke into the open or the Wild West Festival would never have been torpedoed. Signs were everywhere. Altamont was only a symptom of much deeper, systemic cultural issues that burst to the surface that day like a nasty carbuncle. Altamont dramatized these conflicting undercurrents, but didn't cause them. Or resolve them.

For all of the main players in the Altamont drama, nothing was ever the same after that fateful day at the broken-down racetrack. The Rolling Stones may have recovered, but they were changed. After finally signing with Atlantic Records in 1971 for the million-dollar advance, their next album, *Sticky Fingers,* was a commendable, worthy successor to the monumental *Let It Bleed,* although the meat of the album ("Brown Sugar," "Wild Horses," "You Got to Move") had been recorded in Muscle Shoals before Altamont. The band's work after Altamont would take on a self-conscious shadow never present in their work before. Even on *Sticky Fingers,* as they appropriate the Santana sound for "Can't You Hear Me Knocking," the band sounds like they are *trying* to make a Rolling Stones record, something that previously came almost instinctually.

Some essential, invincible flame that burned deep in the band's engine room had been extinguished. Conjuring the dark arts through simulated ritual, ribald costumes, and pulsating music was one thing. Coming face-to-face with its real-life power for destruction was another, and it shook the band to their souls. They would never again risk such fearlessness. Yet it

was that exact fearlessness that had given their music such vivid, explosive power.

Over the course of their 1969 American tour, the Stones found themselves catapulted to the pinnacle of the rock world when rock stars could walk the earth like gods. The experience caught them by surprise. The band was entirely unprepared for how the American rock scene had changed in the past three years. The hubris must have been irresistible, the folly unavoidable.

Running for cover, they would disappear into the south of France and a cloud of heroin, but, almost miraculously, emerge and find the momentum to become one of the great well-oiled and enduring machines of rock history. They mastered both their own demons and the business of rock. Yet as a unique and driving force in rock music, the band would no longer truly matter. If the Stones had never made another record after *Sticky Fingers,* their legacy would still be intact.

Whatever they lost at Altamont, they would not get back. The Stones would play out their days like tigers in the shade, challenging neither themselves nor their audience. Instead of a cultural force, the Stones settled for being caricatures of themselves, a raucous and colorful but ultimately meaningless sideshow, prancing onstage with props, costumes, and elaborate stage sets in cavernous football stadiums, no more simply five men and the music.

IF ALTAMONT MAY have served to make the Rolling Stones more cynical, it might also be said to have made the Grateful Dead more human.

Like the Stones, the Dead came out of the crucible of Altamont a different band. It wasn't simply the music. The tuneful warmth and melancholy of *Workingman's Dead,* released in June 1970, by far the group's best-received album, freed the Dead from the growing limits of their psychedelic electric blues-rock, opening up possibilities for them as musicians.

Rather than run and hide, the Dead absorbed Altamont as

a lesson. They not only sought comfort in their music, positive energy that would propel them into a brighter future, but they also learned once and for all that they wanted no part of show business—at least as the mainstream defined it.

Especially after Lenny Hart embezzled the band broke, the Dead became committed to conducting their business on their own terms. Altamont had burned the band. The Stones played a different game—fame and fortune, ego and greed. The Dead wanted none of that. They had different goals and they determined to take their own path. They knew they could run their organization themselves inside the hip community, and they became dedicated to speaking exclusively to their own audience. They henceforth refused to cater to the mainstream and were both surprised and amused to see their following grow over the years, creating an entire cult of single-minded devotees.

While they would go on to play decades' worth of festivals and shows, with a host of bands around the world, the Dead would never appear on another bill with the Stones.

THE HELLS ANGELS did not recover from Altamont. Already targeted by police as public enemy number one in California, the Angels earned worldwide infamy from Altamont. They were such easy, paint-by-numbers villains. The club was rocked by the glare of notoriety. The specter of one or more of their members being wanted for murder didn't help anything. The police were all over them, even more than they already had been.

The club slowly slid into a downward spiral. Sonny Barger buried himself in an avalanche of cocaine. He grew increasingly involved in crazy drug deals and criminal activity. His former right-hand man, George "Baby Huey" Wethern, had quit the club just before Altamont and moved with his wife and kids to a remote ranch 150 miles north of San Francisco. He was headed into the Witness Protection Program. Altamont solidified the Angels' growing reputation as a looming criminal threat, even

eclipsing the dreaded Mafia in the public's fevered imagination. Whatever cachet the Angels had in the underground vanished with Altamont, but members continued to flourish in the drug business. As the club gravitated increasingly toward drug sales and other criminal activities, the cops came down even harder on the Angels. Barger himself beat a couple of raps before copping a plea on several beefs and going down on a fifteen-to-life sentence in 1972.

Acquitted of Hunter's murder, Alan Passaro served his sentence for grand theft and marijuana possession, but died in 1985. He was found drowned with $10,000 in cash in his pockets, presumably assassinated. He was a wild, uncontrolled man whose destiny collided with Meredith Hunter's that cold December night. He and Hunter were star-crossed archetypes—the blue-collar white thug and the flashy black gangster—and they played their parts like somebody else wrote the script. They were pawns in the game.

Altamont seemed to infect every participant, shaking even those with a more passing connection to what had happened. CSNY vowed not to play any more festivals. Santana refused to appear in the film. The Burritos were about done. Gram Parsons struggled through the recording of a new Burritos album, the high point of which was his version of the Stones song "Wild Horses." Parsons had first heard the Stones recording of the tune in the Huntington Hotel the night before Altamont and begged Jagger and Richards to let him record it. His other contributions to the album were minimal and his attitude worsened until in June 1970 he was fired from the band he cofounded.

Perhaps the greatest band casualty was Jefferson Airplane, who were permanently rocked by the day's events. After being left behind at Altamont by his contentious bandmates, drummer Spencer Dryden, who married his girlfriend, Sally Mann, in lavish hippie elegance at the Airplane mansion in January 1970, was thrown out of the band the next month. Likewise,

after his severe beating at Altamont, Marty Balin never regained his equilibrium with the Airplane. He turned more inward and uncommunicative. In October of that same year, he played his last show with the band he founded—the same night Janis Joplin died of a heroin overdose in Hollywood. The Airplane splintered. New members came and went. Kaukonen and Casady devoted more time and energy to their side project Hot Tuna and the whole band finally gave up the ghost in 1972.

Even those not onstage that day were profoundly shaken as well. Greil Marcus of *Rolling Stone* couldn't listen to rock music for more than year. Instead he subsisted on a steady diet of old country blues, an immersion that would lead to his music criticism masterpiece, *Mystery Train*.

The issue of affixing blame for the catastrophe confounded analysts. The organization and structure of the event was so shadowy, the chain of command so circuitous, and the work so improvised, nobody could ever tell who was in charge. When there is nobody in charge, nobody is at fault. Anybody who did later attempt to take, at least, a portion of the responsibility—Sam Cutler, Dick Carter, Sonny Barger—was pilloried. The cops mysteriously escaped scrutiny; the police decision to stay out of the fray received surprisingly little criticism, perhaps understandable considering how outnumbered they were. And, after exhausting all other possibilities, of course, everybody could point in shock and horror to the Angels. They were the easiest to blame.

But when all the facts are presented, it's hard to see true responsibility lying with anyone but the Rolling Stones. The simple truth is that Stones were always in charge of the concert, with Mick Jagger clearly making the calls behind the scenes. They were pushing for it to happen, trying to latch on to the allure of the San Francisco music scene. Many agents acted on their behalf—obfuscation was part of the strategy—but they all were doing Jagger's bidding.

The Stones brilliantly, intentionally it would seem, positioned themselves to be in control, but not be responsible. The band carefully distanced themselves from any legal responsibility by letting Jon Jaymes—someone they didn't even actually know—sign the contract with Carter for Altamont. They also avoided the day-to-day decision making that went into the planning, while still keeping their fingers on the strings behind the scenes. Like capos in the criminal underworld, they built deniability into the system.

While it is apparent that the Stones were responsible for the event, the question of blame is almost beside the point. The far more interesting question is, why did the Rolling Stones go through with the concert? That crucial decision—and the underlying determination that went into it—made the difference in everything that happened at Altamont. There is only one plausible reason: the final scene to the concert movie.

There is no other good explanation for why Jagger and company proceeded with this concert in the days before the show as it unraveled in front of their eyes. They didn't care what Ralph Gleason wrote. The Stones had been subjected to too much vile gossip and innuendo from the vicious Fleet Street crowd for some old tweedy boho jazz critic from San Francisco to get under their skin. Sam Cutler told the Angels the concert was a gift from the Stones, but this band had never before shown any generous impulses toward their audience. They had no problem selling their concert tickets at twice the going rate. It is simply not true that this free concert was some magnanimous, beneficent gesture. The Stones wanted something out of the deal, and what they wanted was a big finish for their epochal movie that they hoped would document their magnificent return to glory.

The movie only fell into place on the last week of the tour. It was the final piece of the evolving Stones plan for world domination. Without the free concert, there would be no movie. The Maysleses shot the band's Madison Square Garden concerts, but

the film needed a cinematic finale, something that would elevate the Stones movie above a simple concert film, such as a massive, Woodstock-like free concert. The concert had to happen.

Initially the plan that Jagger had insisted on was that the Maysleses complete the film in time to beat *Woodstock* to the market. The Woodstock movie was a big-budget major studio production. The Stones and the Maysleses were making a quick and inexpensive documentary and Jagger clearly hoped to steal—maybe even overshadow—some of the Woodstock thunder. With the Hunter killing and the million-dollar distribution deal with Universal, the movie now also started to produce serious revenue. Jagger knew what he was doing. Of course, he had envisioned this grand finale. He could see the whole thing vaulting the Stones into a stratosphere never dreamed of before. Bigger than The Beatles? And the Hells Angels, not only a salve to Jagger's intense paranoia about police, also provided colorful set dressing for his cinematic epic.

All this came together late in the tour, as Jagger began to realize the opportunities. Before the tour, meeting with potential filmmakers in Hollywood, he seemed less motivated, but as the tour came to an end, the plans for the free concert began to materialize, and the group was looking at a giant new audience they hadn't expected, the film began to loom as a key piece to completing the triumph.

Jagger seemed unconcerned about not having a location for the concert when he announced the free show at the New York press conference, the day after Golden Gate Park fell through. Without the park, proper police support, public transportation, and a functioning infrastructure also vanished.

Although they had been playing with the idea since before the tour began, even as late as four days before the concert, when the band was still recording in Alabama, there was still no site and yet plans went ahead. If Jagger had been willing to make a deal with Filmways to distribute the movie, the concert could have

also taken place at Sears Point in Sonoma, where the large crowd could have been accommodated, the Hells Angels wouldn't have been in control, and the staging was already in place, but he wouldn't consider giving up movie profits from a distribution deal. Jagger was going to make this concert happen, no matter what, and maintain his arm's-distance control. So he was willing instead to risk everything on a desperate last-minute move to some oil blotch on the far edge of the San Francisco Bay Area with no police, infrastructure, or medical provisions, a decision that would prove disastrous.

Jagger had made the fatal error of believing his own hype. He bought into the myth of Woodstock, but he also believed that he could do it better. Woodstock had been a crowning achievement, but the Rolling Stones were not a part of it. Now they could write their own place into the history, and he expected that his concert would continue the good vibes and perhaps even be a bigger show of hippie values. Jagger wanted to cultivate the underground; being considered cool by cognoscenti was new for the Stones. He was coming to San Francisco for a coronation.

This was sheer media manipulation by a master. It backfired, of course, but Kael's comparisons to *Triumph of the Will* may be more apt than the Maysleses would like to admit. Jagger wanted to be filmed strutting the stage as the emissary of the Dark Lord before his adoring masses. The Stones were determined to star in their own extravaganza. The people at Altamont were simply unwitting participants in their titanic vision.

"The Stones, man, they wrote the script," Rock Scully told *Rolling Stone*. "They got what they paid for. Let it bleed, man. There's never going to be another one like it. Anyone should have seen this would have happened—this whole trip, man—if somebody tried to buy another Woodstock. We should have seen it, but we couldn't see that."

Ralph Gleason wrote about the film *Gimme Shelter* in his *Rolling Stone* column. Gone was the indignation and outrage. In

reviewing the circumstances and context of Altamont, Gleason had found his compassion. Finally, he saw the bigger picture—the death of a dream and the disillusionment of a generation—and he offered both an absolution and a mea culpa.

"There are no specific guilty parties for Altamont," he wrote. "We were all guilty, myself included."

The enduring legacy of Altamont is forever tied to the Rolling Stones. Something in the band's character created Altamont—arrogance, greed, ignorance, and naïveté. At the height of rock's golden year, 1969, the Stones did reign as the world's greatest rock and roll band. An open-air free concert in Golden Gate Park might have made a picturesque victory lap, but Scully's innocent hippie dream was not to be. Instead, the band blindly, willfully stumbled into catastrophe.

"Altamont—it could only happen to the Stones," Keith Richards told Robert Greenfield of *Rolling Stone* in 1971. "Let's face it. It wouldn't happen to the Bee Gees. It wouldn't happen to Crosby, Stills and Nash."

It could only happen to the Stones.

AFTERWORD

Anyone who has driven from San Francisco to Los Angeles down Interstate 5 has ridden right past the derelict Altamont Speedway. As the interchange exits Highway 580 to the giant interstate running through the middle of the state, the old asphalt track and stands sit off to the side of the highway about a hundred yards from the freeway. I have never been able to make the drive without glancing over and thinking about that cold day in December long ago.

I knew better than to go to Altamont. A couple of friends from college were driving up and asked me to join them, but I declined. I'd caught the Stones the month before at the late show at the Los Angeles Forum, in what was one of the greatest rock shows I have ever seen. Having grown up around concerts in the parks in San Francisco and Berkeley, I had watched that colorful parochial custom descend from happy hippie frolics to wasted, drunken ordeals. It didn't sound promising.

My pals returned with a good review. Stuck far away from the action on the hill, they said there was some kind of disturbance during "Sympathy for the Devil" and that the band had had to start the song over. They laughed about Jagger's saying that something always happens when they play that song, but my friends knew nothing about what had really gone on. They

had a good time and a long drive, but it wasn't something they talked about much beyond the brief, largely upbeat report they brought back the next day.

But over the years, the subject of Altamont came up again and again—from musicians who had played the event, stagehands who had worked the show, and people who had attended. The day had been seared into all their memories. One young lady, Reva Frederickson, a Berkeley teenager at the time, remembered burning her clothes in the backyard after she got home, including a favorite pair of pants. Everybody who went to Altamont came back with a story.

The Stones first returned to San Francisco three years later in 1972 to play four shows at Winterland, a tiny 5,400-seat former ice rink operated by Bill Graham. The intimate shows, an anomaly on the band's tour that year, were a kind of apology to the rock fans of San Francisco. For a tenth-anniversary story in the *San Francisco Chronicle,* I went to the Altamont site and toured the grounds with former proprietor Dick Carter. He was making a living selling and installing solar heating. The track had been closed and was abandoned. We had to climb over the fence to gain admission. A rabbit skittered across our path.

"That jack rabbit runs it now," said Carter. "He's the general manager."

For my 1994 book, *Summer of Love,* I collected many accounts of the day from subjects I interviewed, as the event figured prominently in the lives and careers of several of the San Francisco rock bands I was chronicling. The Stones concert exploded dramatically in the narrative of the San Francisco sixties' rock scene and played a pivotal role in that book. That was where I first sat and listened to Spencer Dryden tell me his convoluted story, to Rock Scully explain how he started the ball rolling in the first place, and to Marty Balin talk about getting knocked out a second time by the Hells Angels.

When Sam Cutler turned up back in the Bay Area in 2013 promoting his memoir, *You Can't Always Get What You Want,* we did an onstage interview at a Santa Clara art gallery. We spent the evening plumbing his recollections of the event almost as if the audience wasn't there. By that time, I had already been considering this book and started collecting research, but listening to Sam that night helped me realize just how much of a story was there.

Altamont would simply not go away. The catastrophic free concert lingered over the Stones like a gray cloud they could never entirely lose. It stood out like a broken and bruised chapter in the otherwise rather glorious history of rock music, a catastrophic debacle never to be forgotten, but not revisited after the release one year later of the Maysles brothers' documentary, *Gimme Shelter.* That movie became the accepted account of the day, the official record of history, despite the fact that the Rolling Stones themselves were partners in the film's production. History averted its eyes from the ugly episode. It was not something people wanted to talk about.

But the long shadow of Altamont never disappeared. The concert grew in symbolic stature, coming to represent the end of the heady decade of the sixties that had reached a crescendo four months earlier in August with the massive Woodstock festival, the moon landing, and the Manson killings all taking place within days of each other. Altamont was the coda. It was a stain that wouldn't wash out of the fabric of the music.

The story needed to be told, as fully and completely as possible. The tangled threads of the movie and the concert needed to be unbraided. The Hells Angels needed to be portrayed as they were—real people with names who were placed in a treacherous, untenable situation—not cardboard cutout villains. The role of the Grateful Dead and their ultimate betrayal by the Stones needed to be detailed. The police had never been heard from. The massive use of toxic drugs was not examined. Meredith

Hunter and his girlfriend, Patti Bredehoft, were forgotten victims. The deaths of two concertgoers by vehicular manslaughter was never thoroughly investigated or reported in the subsequent news coverage.

The tale of Altamont left much to be told.

—*Joel Selvin, March 2016*

ACKNOWLEDGMENTS

When editor Matt Harper of HarperCollins encouraged me to think about a book about Altamont, the idea certainly seemed worth pursuing, but after spending a splendid day with former Grateful Dead manager Rock Scully in Monterey—only months before his death, as it sadly turned out—I became completely convinced there was a big story lying behind the event that had never been told. For starters, the world never knew that the show was almost entirely a production of the Grateful Dead; since the band didn't play that day and barely appeared in the movie, most people had little idea that the Dead had anything to do with the event.

After initial research turned up a news clipping about an Alameda County Sheriff's homicide investigator who closed the cold case on the Meredith Hunter killing in 2006, I located Scott Dudek in Hayward, where he had retired from the sheriff's department after a long career and gone into private practice. He was fascinated with the prospect of digging around some more in the old case, and he started to open doors the day I first contacted him. Private investigator Dudek, who had previously known nothing of the vehicular manslaughter deaths at the festival, was surprised to find no relevant official records relating to the case, but he nevertheless was able to locate survivor James McDonald.

ACKNOWLEDGMENTS

Pamela Turley was the first reader and conducted the first edit. Her touch is throughout the book. But it was Harper-Collins editor Matt Harper, the champion of the book, who took me to school. An avid Stones fan and immensely knowledgeable about rock music, he knew what was important about this story and would not stop until he saw it on the page.

Dennis McNally, former Grateful Dead publicist and the band's top biographer, helped sort out the map to the Dead world. Bill Belmont, who worked in the inner circle of the Stones' 1969 tour, decoded the financial and business dealings, as well as many of the personalities, and dug up old files and documents.

A number of the interviews were drawn from the 1990–1993 sessions I did with research assistant Nick Meriwether for *Summer of Love*. Not only were the recollections more fresh at that time, but a number of the people we interviewed have also subsequently died.

A quarter century later, people were incredibly generous with their time. Sam Cutler patiently handled numerous inquiries. Patricia Bredehoft trusted me with some of the most painful memories anyone could have. Dixie Ward, Meredith Hunter's sister, welcomed me into her home to stir up uncomfortable recollections. Bob Matthews played me his extraordinary mix of the sixteen-track live recording he made of the Stones' performance at the festival.

Kita Curry dug out of storage the incredible photos her late sister, Elizabeth Sunflower, who called herself Beth Bagby at the time, took that day as a stringer for Associated Press, bravely photographing from the thick of the action onstage. She was a helluva shooter, and I'm sorry she didn't live to see one of her photos on the cover of a book. Grammy-winning art director Hugh Brown did yeoman's duty on the scans.

Many people assisted from the extended Grateful Dead family: Eileen Law, Nicki Scully, Sat San Tokh, Gail Hel-

ACKNOWLEDGMENTS

lund Bowler, Ron and Susan Wickersham, Betty Cantor, Rosie McGee, Dan Healy, Carolyn Garcia, Jerilyn Brandelius.

Musicians who contributed included Gregg Rolie, Michael Shrieve, and Michael Carabello of Santana; Marty Balin, Jorma Kaukonen, Paul Kantner, and Jack Casady of Jefferson Airplane; David Crosby of CSNY; David Freiberg of Quicksilver Messenger Service; Mickey Hart of the Grateful Dead.

From the Stones tour: Tony Funches, Bill Belmont, Ronnie Schneider, Chip Monck, Steve Leber.

Backstage: Herbie Herbert, Steve Parrish, Bob Cohen, Wavy Gravy, Dorge Bond, Lee Brenkman, A. C. Smith, Pete Slauson, Bruce Hatch, Doug McKechnie, Eugene Schoenfeld, Bill Laudner, John Villenueva.

The medical crew: Dr. Richard Fine; Dr. Robert Hiatt; Dr. Frank Schoenfeld; Dr. Bob Baron; Dr. Steve Levine; Jane Baron-Sorensen, RN.

From the film production: Stephen Lighthill, Walter Murch, Joan Churchill, Eric Saarinen, Peter Pilafian, Nelson Stoll, Porter Bibb, Bob Elfstrom, Haskell Wexler, Howard Chesley.

From the police: Sonny Thompson, Cliff Dias, Leonard Levitt, Iver Edwall, George Vien, Bill Foster, Dale Smith, T. J. Houchins, J. D. Nelson, Hal Liske, Gene Saper, Pete Shelton.

Journalists covering the event: John Burks, Baron Wolman, Greil Marcus, John Morthland, Robert Altman, Michael Goodwin, Bob Simmons, Jason Bezis.

From the audience and Berkeley High School: James McDonald, Denise Kaufman, Carl Margolis, Van Jarvis, Scott Engel, Reva Frederickson, Dave Seabury, John Cuniberti, David Fechheimer, Robert Bennett, Mike Goldner, Rob Betts, Swami, Dave Luce, Steve Wasserman, Constance Rivermale, Sitting Dog, Lisa Brenneis.

Others: George Walker, Gordon Grow (Flash HAMC), Linda Passaro, John Bocchetti, Sally Mann Romano, Bob Carter, Peter Coyote, Dr. David Smith, Michael Lang, Ron Polte, Brian

Rohan, Bernie Orsi, Vicki Cunningham, Willy Cashman, Bob Greenfield, Rita Gentry, Diane Brennan of Sonoma Raceway.

Special thanks to everyone at Dey Street/HarperCollins who has helped to make this book a terrific experience: in editorial, assistant editor Daniella Valladares and director of creative development Lisa Sharkey; my publisher, Lynn Grady; production editor Rachel Meyers and copyeditor Roland Ottewell; and my extraordinary publicity team of Sharyn Rosenblum and Emily Homonoff.

Thanks to the San Francisco Public Library and big love to Bill Van Niekerken of the *San Francisco Chronicle* library, who provided much crucial research assistance. David M. Hardy of the FBI filled the FOIA request.

Frank Weimann of the Literary Group has represented me since my first book when we were both young men. His unflagging enthusiasm for this project meant a lot.

BIBLIOGRAPHY

Three journalists accompanied the Rolling Stones on the band's 1969 U.S. tour and provided first-person accounts: Stanley Booth, whose 1984 book *Dance with the Devil* is a paragon of rock journalism; Michael Lydon, whose extensive report first appeared in *Ramparts* magazine and was later collected in his anthology *Rock Folk;* and photographer Ethan Russell. All three provided portals to private scenes and personal recollections. The journalism of reporter John Burks, who covered every detail of the Stones tour and its aftermath for *Rolling Stone,* proved to be an invaluable guide. Burks lived and breathed the cliché that journalism is the front lines of history.

Although more than one hundred interviews were conducted specifically for this book, there are no attributed quotes in the text. I have abandoned the journalistic convention of breaking the frame for confirmatory comments from eyewitnesses in favor of keeping the focus on the narrative drive. All quotes are as carefully reconstructed by parties who were present. In addition to first-person recollections, this book drew on many previously published accounts.

BIBLIOGRAPHY

BOOKS

Aeppli, Felix. *Heart of Stone: The Definitive Rolling Stones Discography, 1962–1983*. Pierian Press, 1985.

Anderson, Christopher. *Jagger: Unauthorized*. Delacorte Press, 1993.

Anson, Robert Sam. *Gone Crazy and Back Again: The Rise and Fall of the Rolling Stone Generation*. Doubleday, 1981.

Aronowitz, Al. *Bob Dylan and the Beatles: Volume One of the Best of the Blacklisted Journalist*. 1st Books Library, 2003.

Barger, Ralph (Sonny), with Kent Zimmerman and Keith Zimmerman. *Hell's Angel: The Life and Times of Sonny Barger and the Hell's Angels Motorcycle Club*. William Morrow and Co., 2000.

Bockris, Victor. *Keith Richards: The Biography*. Poseidon Press, 1993.

Bonanno, Massimo. *The Rolling Stones Chronicles*. Plexus Publishing Ltd., 1997.

Booth, Stanley. *Dance with the Devil: The Rolling Stones and Their Times*. Random House, 1984.

———. *Keith: Standing in the Shadows*. St. Martin's Press, 1995.

Brightman, Carol. *Sweet Chaos: The Grateful Dead's American Adventure*. Clarkson Potter, 1998.

Charone, Barbara. *Keith Richards*. Futura Publications Ltd., 1979.

The Complete Annotated Grateful Dead Lyrics, annotations by David Dodd. Free Press, 2005.

Coyote, Peter. *Sleeping Where I Fall*. Counterpoint Press, 1998.

Crosby, David, and Carl Gottlieb. *Long Time Gone: The Autobiography of David Crosby*. Doubleday, 1988.

Cross, Phil and Meg Cross. *Gypsy Joker to a Hells Angel*. Motorbooks, 2013.

Cutler, Sam. *You Can't Always Get What You Want*. ECW Press, 2010.

Dalton, David, ed. *Rolling Stones: An Unauthorized Biography in Words, Photographs, and Music*. Amsco Music Publishing Co., 1972.

Davis, R. G. *The San Francisco Mime Troupe: The First Ten Years*. Ramparts Press, 1975.

Davis, Stephen. *Old Gods Almost Dead: The 40-Year Odyssey of the Rolling Stones*. Broadway Books, 2001.

Des Barres, Pamela. *I'm with the Band*. Beech Tree Books, 1987.

Doggett, Peter. *There's a Riot Going On: Revolutionaries, Rock Stars, and the Rise and Fall of the '60s*. Cannongate, 2007.

Dimmick, Mary Laverne. *The Rolling Stones: An Annotated Bibliography*. University of Pittsburgh Press, 1979.

Draper, Robert. *Rolling Stone Magazine: The Uncensored History*. Doubleday, 1990.

Einarson, John, with Chris Hillman. *Hot Burritos: The True Story of the Flying Burrito Brothers*. Jawbone, 2008.

Eisen, Jonathan, ed. *Altamont: Death of Innocence in Woodstock Nation*. Avon Books, 1970.

———. *Age of Rock 2: Sights and Sounds of the American Cultural Revolution*. Random House, 1970.

Elliott, Martin. *Rolling Stones: Complete Recording Sessions*. Blandford, 1990.

Faithfull, Marianne, and David Dalton. *Faithfull: An Autobiography*. Little, Brown and Company, 1989.

Fey, Barry. *Backstage Past*. Lone Wolfe Press, 2011.

Fong-Torres, Ben. *Hickory Wind: The Life and Times of Gram Parsons*. Pocket Books, 1991.

Frame, Pete. *The Complete Rock Family Trees*. 2 vols. Omnibus Press, 1980.

Gatten, Jeffrey N. (compiled). *The Rolling Stone Index: Twenty-Five Years of Popular Culture, 1967-1991*. Popular Culture Ink, 1993.

Getz, Michael M., and John R. Dwork. *The Deadhead's Taping Compendium: An In-Depth Guide to the Music of the Grateful Dead on Tape, Vol. 1, 1959–1974*. Henry Holt and Company, 1998.

Goodman, Fred. *Allen Klein: The Man Who Bailed Out the Beatles, Made the Stones, and Transformed Rock & Roll*. Houghton, Mifflin, Harcourt, 2015.

Graham, Bill, and Robert Greenfield. *Bill Graham Presents: My Life Inside Rock and Out*. Doubleday, 1992.

Greenfield, Robert. *S.T.P.: A Journey Through America with the Rolling Stones*. EP Dutton, 1974.

———. *Dark Star: An Oral Biography of Jerry Garcia*. William Morrow, 1996.

———. *Exile on Main Street: A Season in Hell with the Rolling Stones*. Da Capo Press, 2006.

———. *The Last Sultan; The Life and Times of Ahmet Ertegun*. Simon & Schuster, 2011.

———. *Ain't It Time We Said Goodbye: The Rolling Stones on the Road to Exile*. Da Capo Press, 2014.

Grogan, Emmett. *Ringolevio: A Life Played for Keeps*. Citadel Underground, 1990.

Guralnick, Peter. *Sweet Soul Music: Rhythm and Blues and the Southern Dream of Freedom*. Harper & Row, 1986.

Heylin, Clinton. *Bob Dylan: Behind the Shades—The Biography—Take Two*. Viking, 2000.

Holland, Jools and Dora Loewenstein. *The Rolling Stones: A Life on the Road*. Penguin Studio, 1998.

Jackson, Blair. *Garcia: An American Life*. Viking Press, 1999.

Jagger, Mick, Keith Richards, Charlie Watts, and Ronnie Wood. *According to the Rolling Stones*. Chronicle Books, 2003.

Hundley, Jessica, and Polly Parsons. *Grievous Angel: An Intimate Biography of Gram Parsons*. Thunder's Mouth Press, 2005.

Johns, Glyn. *Sound Man: A Life Recording The Rolling Stones, The Who, Led Zeppelin, The Eagles, Eric Clapton, The Faces . . .* Viking, 2014.

Krieger, Susan. *Hip Capitalism*. Sage Publications, 1979.

Loewenstein, Prince Rupert. *A Prince Among Stones*. Bloomsbury, 2013.

Long, Pete. *Ghosts on the Road: Neil Young in Concert, 1961–2006*. Old Homestead Press, 2007.

Lydon, Michael. *Rock Folk: Portraits from the Rock 'N Roll Pantheon*. Dial Press, 1971.

McDonough, Jimmy. *Shakey: Neil Young's Biography*. Random House, 2002.

McGee, Rosie. *Dancing with the Dead: A Photographic Memoir*. TIOLI Press & Bytes, 2013.

McNally, Dennis. *A Long Strange Trip: The Inside History of the Grateful Dead*. Broadway Books, 2002.

MacPhail, Jessica Holman Whitehead. *Yesterday's Papers: The Rolling Stones in Print, 1963–1984*. Pierian Press, 1986.

Makower, Joel. *Woodstock: The Oral History*. Doubleday, 1989.

McElhaney, Joe. *Albert Maysles: Contemporary Film Directors*. University of Illinois Press, 2009.

Meyer, David N. *Twenty Thousand Roads: The Ballad of Gram Parsons and His Cosmic American Music*. Villard, 2007.

Nash, Graham. *Wild Tales: A Rock & Roll Life*. Crown Publishing, 2013.

Norman, Phillip. *Sympathy for the Devil: The Rolling Stones Story*. Simon & Schuster, 1984.

Reich, Charles and Jann Wenner. *Garcia: A Signpost to New Space*. Straight Arrow Books, 1972.

Richards, Keith. *Life*. Little, Brown and Company, 2010.

Rogan, Johnny. *Neil Young: Zero to Sixty*. Calidore Books, 2001.

Rowes, Barbara. *Grace Slick: The Biography*. Doubleday & Co., 1980.

Russell, Ethan. *Let It Bleed: The Rolling Stones, Altamont, and the End of the Sixties*. Springboard Press, 2009.

Sanchez, Tony. *Up and Down with the Rolling Stones: The Inside Story*. Carroll and Graf Publishers, 2003. First published 1979 by William Morrow.

Sanford, Christopher. *Keith Richards: Satisfaction*. Carroll and Graff Publishers, 2004.

Santelli, Robert. *Aquarius Rising: The Rock Festival Years*. Dell Publishing, 1980.

Savage, Jon. *The Kinks: The Official Biography*. Faber & Faber, 1984.

Schaffner, Nicholas. *Saucerful of Secrets: The Pink Floyd Odyssey*. Harmony Books, 1991.

Scott, Stuart, John W. Dolgushkin, and Mike Nixon. *DeadBase IV*. DeadBase, 1990.

Seay, David. *Mick Jagger: The Story Behind the Rolling Stone*. Birch Lane Press, 1993.

Selvin, Joel. *Summer of Love: The Inside Story of LSD, Rock & Roll, Free Love, and High Times in the Wild West*. EP Dutton, 1994.

Shadwick, Keith. *Led Zeppelin: The Story of a Band and Their Music, 1968–1980*. Backbeat Books, 2005.

Shapiro, Marc. *Carlos Santana: Back on Top*. St. Martin's Press, 2000.

Smith, David E., M.D., and John Luce. *Love Needs Care: San Francisco's Haight Ashbury Free Medical Clinic and Its Pioneering Role Treating Drug Abuse Problems*. Little, Brown and Co., 1971.

Spitz, Bob. *Dylan: A Biography*. McGraw-Hill, 1989.

Spitz, Robert Stephen. *Barefoot in Babylon: The Creation of the Woodstock Festival, 1969*. Viking, 1979.

Stanley, Rhoney Gissen, with Tom Davis. *Owsley and Me: My LSD Family*. Monkfish Book Publishing, 2012.

Tamarkin, Jeff. *Got a Revolution: The Turbulent Flight of the Jefferson Airplane*. Atria Books, 2003.

Wethern, George, and Vincent Colnett. *A Wayward Angel: The Full Story of the Hells Angels by the Former Vice President of the Oakland Chapter*. Lyons Press, 2004.

Whitburn, Joel. *Top Pop Albums, 1955–1985*. Record Research, 1985.

Wolfe, Tom. *The Electric Kool-Aid Acid Test.* Farrar, Strauss and Giroux, 1968.

Wyman, Bill, with Ray Coleman. *Stone Alone: The Story of a Rock 'N' Roll Band.* Viking, 1990.

Wyman, Bill, with Richard Havers. *Rolling with the Stones.* DK Publishing, 2002.

Zimmer, Dave. *Crosby, Stills & Nash: The Biography.* Da Capo Press, 2008.

MAGAZINES, NEWSPAPERS, AND OTHER SOURCES

Alameda County Sheriff's Office, Eden Township Substation, Investigations (police report).

"Altamont Was a Catastrophe," *California's Health,* January 1970.

Bess, Donovan, "Suspect Identified; First Witness at Altamont Trial," *San Francisco Chronicle,* December 13, 1970.

———, "East Bay Trial; Cops, Hells Angels and 'Reprisals,'" *San Francisco Chronicle,* December 22, 1970.

———, "Altamont Witness Tells of Killing," *San Francisco Chronicle,* December 24, 1970.

———, "Altamont Stabbing Victim Was on Speed, Doctor Says," *San Francisco Chronicle,* December 25, 1970.

———, "Testimony on Altamont Victim's Gun," *San Francisco Chronicle,* December 29, 1970.

———, "Altamont Trial; Cop Tells of Knife in Car," *San Francisco Chronicle,* December 30, 1970.

———, "Altamont Trial; Blood Expert's Evidence Told," *San Francisco Chronicle,* December 31, 1970.

———, "Altamont Guard Tells of 'Fear' of Victim's Gun," *San Francisco Chronicle,* January 5, 1971.

———, "Girl Talks About Scene at Altamont," *San Francisco Chronicle,* January 6, 1971.

———, "A Hell's Angel Testifies at Altamont Trial," *San Francisco Chronicle,* January 7, 1971.

———, "Hell's Angel Says He Used Knife," *San Francisco Chronicle,* January 8, 1971.

———, "Altamont Trial Near End," *San Francisco Chronicle,* January 13, 1971.

———, "Rock Festival Death; Jury Ponders Altamont Case," *San Francisco Chronicle,* January 14, 1971.

———, "Hell's Angel Acquitted of Altamont Killing," *San Francisco Chronicle,* January 15, 1971.

———, "The Altamont Trial," *Rolling Stone,* April 1, 1971.

Bezis, Jason, "Altamont Rock Festival of 1969: '60s Abruptly End (Part I of II)," *Livermore Heritage Guild,* March/April 2010.

———, "Altamont Rock Festival of 1969: The Aftermath (Part II of II)," *Livermore Heritage Guild,* January/February 2011.

Burks, John, "In the Aftermath of Altamont," *Rolling Stone,* February 5, 1970.

Burks, John, et al., "Let It Bleed," *Rolling Stone,* January 21, 1970.

Burks, John and Loraine Alterman, "Free Rolling Stones: 'It's Going to Happen!'" *Rolling Stone,* December 27, 1969.

Canby, Vincent, "Of Sticks and Stones and Blood at Altamont," *New York Times,* December 7, 1970.

———, "Making Murder Pay?" *New York Times,* December 13, 1970.

Carpenter, John, "The Rolling Stones Are Coming to LA," *Los Angeles Free Press,* October 17, 1969.

———, "Rolling Stones Hold Press Conference," *Los Angeles Free Press,* October 25, 1969.

———, "Stones Will Play Free," *Los Angeles Free Press,* November 14, 1969.

———, "Mick Jagger says: 'I Don't Like the Beatles' New Stuff Very Much'," *Los Angeles Free Press,* November 21, 1969.

———, "Stones Slate Freebie Saturday," *Los Angeles Free Press,* December 5, 1969.

———, David Maysles interview, *Los Angeles Free Press,* March 19, 1971.

Darlington, Sandy, "'Mick Jagger Used Us for Dupes'—Hell's Angels," *San Francisco Good Times,* December 11, 1969.

Elwood, Phillip, "Ambitious Festival Plans," *San Francisco Examiner,* July 14, 1969.

Fagan, Kevin, "Seeking Shelter from a Memory; Nostalgia Absent on Altamont's 30th Anniversary," *San Francisco Chronicle,* December 6, 1999.

Gleason, Ralph J., "'The Wild West' Comes to S.F." *San Francisco Chronicle,* June 22, 1969.

———, "The Rich and Rocky Odyssey of Entrepreneur Wolfgang Grajonka," *San Francisco Chronicle,* September 21, 1969.

———, "Inequities in the Concerts," *San Francisco Chronicle,* October 19, 1969.

———, "Rock: That's Where the Big Money Is," *San Francisco Chronicle,* October 26, 1969.

———, "What Price The Rolling Stones," *San Francisco Chronicle,* October 29, 1969.

———, "Tina, B.B. and Mick—The Unbeatables," *San Francisco Chronicle,* November 12, 1969.

———, "Second Thoughts on the Stones," *San Francisco Chronicle,* November 16, 1969.

———, "Stones' Plans for Free SF Concert," *San Francisco Chronicle,* November 24, 1969.

———, "Something or Other on Rolling Stones," *San Francisco Chronicle,* December 3, 1969.

———, "The Rolling Stones Are Right On," *San Francisco Chronicle,* December 5, 1969.

———, "There Was a Tab, in Ego and Money," *San Francisco Chronicle,* December 8, 1969.

———, "The Lesson of the Altamont Disaster," *San Francisco Chronicle,* December 28, 1969.

———, "The Pop Year Belongs to San Francisco," *San Francisco Chronicle,* January 4, 1970.

———, "Maysles Brothers Still Filming Stones," March 4, 1970.

———, "Aquarius Wept," *Esquire,* August 1970.

———, "Perspectives: Altamont Revisited on Film," *Rolling Stone,* April 1, 1971.

Greenfield, Robert, "Keith Richards: The *Rolling Stone* Interview," *Rolling Stone,* August 19, 1971.

Grieg, Michael; "New Site of Stones Concert," *San Francisco Chronicle,* December 6, 1969.

———, "A Forlorn Jagger Asks, 'What Went Wrong?'" *San Francisco Chronicle,* December 8, 1969.

Hilburn, Robert, "Stones, Fans Spend the Night Together," *Los Angeles Times,* November 11, 1969.

———, "Fan Backlash from Rolling Stones Date," *Los Angeles Times,* November 14, 1969.

Holden, Joan, "The Wild West Rock Show: Shooting Up a Rock Bonanza," *Ramparts,* December 1969.

Holtzclaw, Barry C., "Stones Concert: 'Lucifer and Angels' Lay the Soul to Waste," *Spectrum,* December 13, 1969.

Honeybear, "Magic Message," *San Francisco Good Times,* December 11, 1969.

BIBLIOGRAPHY

Hopkins, Jerry, "The Stones Tour: 'Is That a Lot?'" *Rolling Stone,* November 15, 1969.

——, "Kiss Kiss Flutter Flutter Thank You Thank You," *Rolling Stone,* December 13, 1969.

Horstkorta, Gary, "At the Brink: The Early History of Sears Point Raceway, Part One," *Vintage Motor Sports,* September/October 2011.

——, "At the Brink: The Early History of Sears Point Raceway, Part Two," *Vintage Motor Sports,* November/December 2011.

Joyce, "Layin' Them in the Aisle," *San Francisco Good Times,* December 11, 1969.

Kael, Pauline, "Beyond Pirandello," *The New Yorker,* December 13, 1970.

Lee, Henry, "Altamont 'Cold Case' Is Being Closed: Theory of Second Stabber Debunked by Sheriff's Dept." *San Francisco Chronicle,* May 26, 2005.

Marcus, Greil, "They Put the Weight on Mick and He Carried It," *Rolling Stone,* December 13, 1969.

Martinez, Don, "Altamont Slaying Near Jury; Arguments in Final Stages," *San Francisco Examiner,* January 10, 1971.

"Mick Jagger—The King & The Queen," *Los Angeles Free Press,* December 19, 1969.

Rannells, Jackson; "Cops Probe Four Deaths at Stones Big Concert," *San Francisco Chronicle,* December 8, 1969.

"Rock Concert's Statistics: Four Dead and Two Births," *New York Times,* December 8, 1969.

The Editors, "The Stones Have Not Acted Honorably," *Rolling Stone,* April 30, 1970.

"The Love Generation Hype in the News," *Rolling Stone,* January 21, 1970.

"Has Mel Belli Got the Crabs?" *Rolling Stone,* March 7, 1970.

"Mick Jagger's Triumph in Court," *Rolling Stone,* September 25, 1975.

"Stones: 'The Money Is Superfluous To Them,'" *Rolling Stone,* September 3, 1970.

"Altamont Movie Before Christmas," *Rolling Stone,* November 26, 1970.

"The Stones and the Gathering Madness," *Rolling Stone,* November 19, 1969.

Sander, Ellen, "The Stones Keep Rolling," *Saturday Review,* November 29, 1969.

"Altamont Death: A Hells Angel Held in Killing," *San Francisco Chronicle,* March 25, 1970.

"An Impasse in Light Show Beef," *San Francisco Chronicle,* August 1, 1969.

BIBLIOGRAPHY

"A Pause in Light Show Strike," *San Francisco Chronicle*, August 4, 1969.

"A Jittery Witness at Hell's Angel Trial," *San Francisco Chronicle*, December 23, 1970.

"Dispute over Altamont Testimony," *San Francisco Chronicle*, January 9, 1971.

"Eclectic 'Wild West'; S.F. Festival for All Life-Styles," *San Francisco Chronicle*, June 17, 1969.

"Hell's Angels Recruiting in Britain," *San Francisco Chronicle*, December 14, 1968.

"Police Halt Mob of Stones' Fans," *San Francisco Chronicle*, November 12, 1969.

"Rock Show's Grim End," *San Francisco Chronicle*, December 2, 1969.

"Rolling Stones On—At Sears Point," *San Francisco Chronicle*, December 4, 1969.

"Rolling Stones Concert Is On, After Confusion," *San Francisco Chronicle*, December 5, 1969.

"'Wild West' Festival Called Off," *San Francisco Chronicle*, September 14, 1969.

Schoenfield, Frank, et al., "Management of Adverse Drug Reactions at a Rock Festival," (unpublished research paper).

Selvin, Joel, "The Rolling Stones Concert; A Performance by Demigods," *UCR Highlander*, November 11, 1969.

Silvert, Conrad, "One Sunday Evening: The Rolling Stones," *The Daily Californian*, November 14, 1969.

Sragow, Michael, "'Gimme Shelter': The True Story," Salon, August 10, 2000.

Stern, Sol, "Altamont: Pearl Harbor to the Woodstock Nation," *Scanlon's*, March 1970.

Taubin, Amy, Stanley Booth, Georgia Bergman, et al., *Gimme Shelter* DVD booklet, The Criterion Collection, 2000.

Wasserman, John L., "Bill Graham—'Sick and Tired,'" *San Francisco Chronicle*, August 22, 1969.

Wood, Jim, "300,000 Say It With Music," *San Francisco Examiner*, December 7, 1969.

Wright, Robert A., "200,000 Attend Coast Rock Fete; Free Concert Causes Huge Jam Near San Francisco," *New York Times*, December 7, 1969.

INDEX

Note: Unless otherwise qualified, entries in italics indicate albums. Those in quotation marks indicate song titles.

INDEX

INDEX

INDEX

"Lucille," 183
Lynch, Thomas, 83

Madigan, Frank, 124
Madison Square Garden concert,
 91–95, 99–101, 214
 as documentary film opening,
 305, 315–16
 live album from, 284
 ticket sell-out, 44, 94–95, 172
Makota, Leo, 193
Mamas and Papas, 169, 182
Mann, Sally, 173, 313
Manny's Music (N.Y.C.), 92
Marcus, Greil, 135–36, 223–25, 250,
 251, 314
Margaret, Princess, 19
marijuana, 5, 7, 11, 128, 158, 272,
 283
 Grateful Dead arrest for, 277–78
Marin County, 80, 108, 194
Mason, Nick, 24
Matthews, Bob, 204, 280
Mayall, John, 18, 65
Maysles, Albert and David, 167,
 168, 187, 204
 Altamont site visit and, 130, 140
 background of, 93
 filming of Stones tour by, 56,
 93–94, 99, 101, 103, 106
 film's release and, 303–7
 footage of Hunter murder and,
 264, 269–70, 271, 276, 282,
 285–86, 294, 295, 299–302
 See also Gimme Shelter
McCartney, Paul, 10, 22
McCune Sound, 126
McDonald, Country Joe, 28
 See also Country Joe and the Fish
McDonald, Jim, 147–49, 231–32,
 262
McDowell, Mississippi Fred, 105
McGee, Rosie, 140–41, 177
McGuinn, Roger, 48
McIntire, Jon, 39, 277, 279

McKechnie, Doug, 136
McKernan Ron ("Pigpen"), 277,
 278
"Me and My Uncle," 129
Medical Committee for Human
 Rights (MCHR), 143–44
Medium Cool (film), 56
Merry Pranksters, 40, 41, 81–82,
 174
Miami Pop Festival (1968), 113
"Midnight Rambler," 52, 64, 221
"Midsummer High Weekend"
 (London free park concert), 9
Mile High Stadium (Denver), 60
Millard Agency, 31
Miller, Jimmy, 18, 52
Miller, Pamela. See Miss Pamela
Millikin, Chesley, 6–7, 13, 92
Miranda, Carmen, 44
Miss Mercy (groupie), 51
Miss Pamela (groupie), 51, 57, 69,
 88–89, 192, 238–39
Mitchell, Joni, 194
Moby Grape, 28
Mofos (motorcycle club), 85
Monck, Chip, 20, 21, 55, 103
 Altamont communication and,
 136
 Altamont lighting and, 56–57,
 110, 127, 131, 134, 138, 139,
 202, 205, 209
 Altamont staging and, 61, 77, 131
 background of, 44–45
 cash payments for crew and, 256
 free concert site search and, 106,
 107–8
 Hells Angels beating of, 230–31,
 281
Monkees, The, 43
Monterey Pop (film), 56, 93, 308
Monterey Pop Festival (1967),
 27–28, 29, 31, 34, 139
 significance of, 28
Montoya, Dennis, 154, 265, 271–72,
 286

349